OBJECTS AS ENVOYS

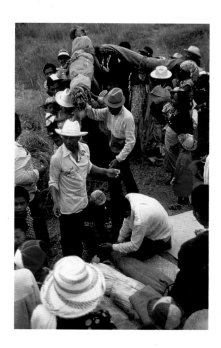

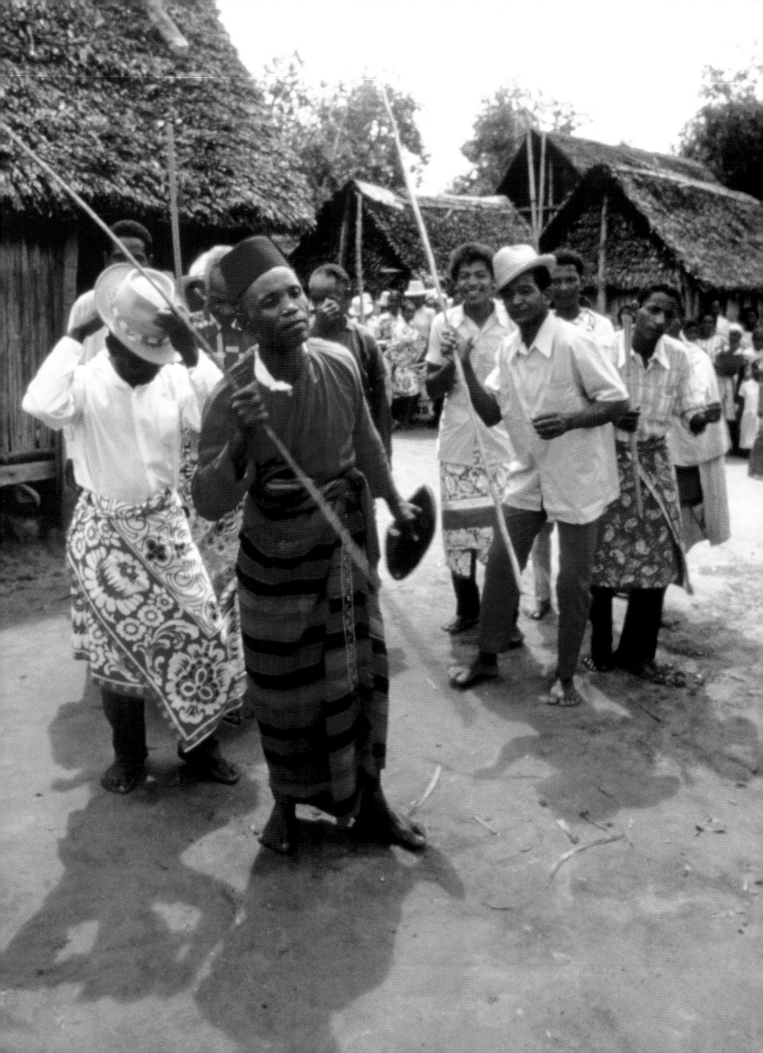

OBJECTS AS ENVOYS

Cloth, Imagery, and Diplomacy in Madagascar

Edited by

Christine Mullen Kreamer and Sarah Fee

Smithsonian Institution
National Museum of African Art
Washington, D.C.
in association with
University of Washington Press
Seattle and London

This book is published in conjunction with a 2002 exhibition, "Gifts and Blessings: The Textile Arts of Madagascar," organized by the National Museum of African Art, Smithsonian Institution.

Library of Congress Cataloging-in-Publication Data
 Objects as envoys : cloth, imagery, and diplomacy in Madagascar / edited by Christine Mullen Kreamer and Sarah Fee.
 p. cm.
 Includes bibliographical references and index.
 ISBN 0-295-98196-2 (alk. paper)
 1. Textile fabrics—Social aspects—Madagascar. 2. Textile fabrics—Madagascar—History. 3. Ceremonial exchange—Madagascar. 4. Madagascar—Social life and customs. I. Kreamer, Christine Mullen. II. Fee, Sarah, 1963–.

 NK8888.9.M3 O25 2002
 746'.09691—dc21 2001057667

CONTENTS

6 Foreword
Zina Andrianarivelo-Razafy

9 Foreword
Shirley E. Barnes

12 Acknowledgments

15 **Objects as Envoys**
An Introduction
Christine Mullen Kreamer

25 1 . **Madagascar**
Background Notes
Jean-Aimé Rakotoarisoa

33 2 . **Cloth in Motion**
Madagascar's Textiles through History
Sarah Fee

95 3 . **Gifts from the Queen**
Two Malagasy *Lamba Akotofahana*
at the Smithsonian Institution
Mary Jo Arnoldi

121 4 . **Madagascar in the Minds of Foreigners**
The Case of United States Consul John Lewis Waller,
1891–1895
Edgar Krebs and *Wendy Walker*

149 5 . **Views from Outside and Inside**
Representations of Madagascar and the Malagasy,
1658–1935
Christraud M. Geary

180 Chronology of Main Events

183 Glossary of Malagasy Terms

186 References

198 Contributors

200 Index

Zina Andrianarivelo-Razafy
Ambassador Extraordinary and Plenipotentiary
of Madagascar to the United States

FOREWORD

HISTORY RECORDS THAT SOME TWO HUNDRED YEARS AGO, A MALAGASY KING OFFERED a gift of cloth to a faithful councilor. In acknowledging the gift, the councilor replied, "If you give me cloth it will wear out; if you give me silver it will be used up; but it is the mark of honor that endures. It will give my children stories to tell and be a source of joy in the future."

This book, which accompanies the Smithsonian exhibition "Gifts and Blessings: The Textile Arts of Madagascar," provides a splendid opportunity to commemorate and "tell the stories" of another historic relationship that has been marked by gifts of cloth: that between Madagascar and the United States. The early relations between our countries culminated in the visit of a delegation of Malagasy ambassadors to Washington, D.C., in 1883. In their meeting at the White House with President Chester Arthur, they gave him gifts of silk cloth, "not as items of value in themselves, but as tokens of friendly respect." Queen Ranavalona III would, in 1886, send textiles to President Grover Cleveland.

I was greatly honored when the exhibit organizers asked me to write this foreword. However, the task also left me with a few sleepless nights. It is not easy to summarize in a few words the importance—sentimental, emotional, even political—that cloth has held for the Malagasy. To appreciate this, one has only to turn to the many proverbs, songs, and flourishes of traditional oration (*kabory*) that take their meaning from cloth. Or glance at the fifteen-page entry for *lamba*, that multipurpose rectangle of cloth, in the *Firaketana*, the encyclopedia compiled under the direction of Gabriel Rajaonah in the 1940s, which remains an inexhaustible source on Malagasy culture and history. Cloth has always been a vehicle for certain messages: a symbol of authority and power, an expression of personality, a marker of historical epochs or even political doctrines.

Although in presenting gifts of cloth in the past, the Malagasy downplayed its nature as a material good, today we, "the children," can appreciate the great artistic achievement of the women of Madagascar who made handwoven textiles. This book helps the uninitiated, such as myself, understand the many skills and the knowledge women needed to master in order to transform rough materials into soft, beautiful fabric. In presenting cloth from around the island, the book demonstrates the richness and diversity of Madagascar's cultures and their arts, and the unity within that diversity. Malagasy textiles indeed give us many stories to tell.

Like cloth, the history of relations between the United States and Madagascar is a complex topic that has been treated by others more qualified than I. It is only fitting to use this opportunity to remember and honor some of them: Frank Vincent, author of *Actual Africa, or the Coming Continent* (1895); G. Michael Razi, former diplomat and director of the American Cultural Center in Antananarivo, author of *Malgaches et Américains: Rélations commerciales et diplomatiques aux XIXe siècle* (1983); and Philip Allen, former diplomat and dean of Frostburg State College in Frostburg, Maryland, who has written two works on the contemporary history of Madagascar, *Security and Nationalism in the Indian Ocean* (1987) and *Madagascar: Conflicts of Authority in the Great Island* (1995). Their research and writings have allowed us, and will continue to allow future generations, to fully understand the relations that have linked our two countries at opposite ends of the world for several hundred years.

It is largely economic activity that has been at the basis of Malagasy-American relations. Having to plead ignorance on the fronts of both weaving and diplomatic history, this is a domain to which I might be able to humbly contribute. I draw on my several years of experience as head of the Embassy of Madagascar in Washington, D.C., where I am in charge of promoting cooperation between the two countries. Administrative reports may be dry, cold, and devoid of sentiment, but they nonetheless have their value, not the least of which is accuracy. One such report that, to me, captures the spirit of this cooperation between Madagascar and the United States qualifies the relation as "one of serenity."

Today we have a new phase in Malagasy-American relations to celebrate: the African Growth and Opportunity Act (AGOA), established by the U.S. government in 2000 to strengthen America's economic ties to Africa. For me, as both an ambassador and a trained economist, it is this event—as no other— that symbolizes the continuing "serenity" in relations between our two nations, and our hopes for the future. Madagascar is home not only to fine handmade products and rich natural resources but also to an expanding sector of light industry. If Madagascar in the nineteenth century was an important market for American manufactured textiles, the reverse holds true today, with the United States a growing client for factory-made cloth and clothing "made in Madagascar."

Does history repeat itself? It would seem so, for the gift of silk cloth that Queen Ranavalona III gave to President Cleveland in 1886 as a sign of respect and friendship has many affinities with the AGOA convention. Both are emblems of the *fitia mifamaly*, "reciprocal friendship," that is so essential to diplomatic relations. American friends of Madagascar have made good on the adage cited at the beginning of this foreword: cloth may wear out, but the mark of honor endures and becomes a "source of joy" for future generations. Both the gift and the convention exemplify the *fifanomezam-bonihahitra*, "mutual giving of honor," and *fihavanana*, "kinship," that lie at the heart of Malagasy culture and bind friends and family.

This book is a wink of complicity to our forebears as we commemorate the material gifts that they exchanged, only to draw attention to the nonmaterial, priceless ties of *fihavanana* that they created.

I could not close this foreword without expressing my gratitude to the organizers of the exhibit and book and to the Smithsonian Institution's National Museum of African Art. Their great dedication in sharing Malagasy textiles with the public promotes awareness of the arts and peoples of Madagascar and ensures that the *lamba*—that distinctive element of Malagasy culture—does not "wear out" but is preserved for future generations.

As Madagascar's official representative in this country, I gladly give my *tso-drano*, or blessing, for this endeavor, that it may know great success.

Shirley E. Barnes
Ambassador of the United States of America
to the Republic of Madagascar, 1998–2001

FOREWORD

IN HIS *HISTORY OF MADAGASCAR* (1995), SIR MERVYN BROWN CALLED THIS ISLAND country "a world apart." Many, many years ago, this probably was an apt description. Indeed, one theory holds that some 100 million to 200 million years ago the island—measuring 1,000 miles from north to south and about 350 miles from east to west at its widest point—was formed when gigantic tectonic shifts caused Madagascar to separate from the mainland African continent. For thousands of years it drifted slowly apart from the mother continent, to its present position in the Indian Ocean. And for many years its people were considered by outsiders to be "inward looking." Even during the seventeenth and eighteenth centuries, relatively few outsiders knew much about Madagascar. This is no longer the case. Indeed, for almost two hundred years the United States has had cordial relations with Madagascar, and today the country is increasingly open to playing a constructive role in regional and international affairs. As the United States ambassador to Madagascar from 1998 to 2001, it has been both a pleasure and an honor for me to have had the opportunity to continue this tradition of maintaining positive ties.

It is also an honor for me to have been approached by the Smithsonian Institution to contribute these introductory words to this book that accompanies the exhibition "Gifts and Blessings: The Textile Arts of Madagascar." The circulation of cloth as gifts reminds me of early experiences in Togo, West Africa, in the 1960s, when I was part of a Crossroads Africa project assisting villages in building schools. When we left, one of the most touching moments came when we were presented with gifts. They were neither elaborate nor costly, but gifts from the heart. Many of them were gifts of cloths, woven by the villagers themselves. Simple, beautiful, meaningful. The same expression from the heart is part of what Malagasy have expressed when they honor a much-respected, well-liked person with a gift of cloth. The exhibition and this book, which recognize the symbolic gesture of defining good relationships through gifts of cloth, serve to heighten our appreciation of Madagascar's marvelous culture and traditions.

Both exhibit and book are also an excellent conduit, opening for many of us a door to the history of Madagascar and the history of Malagasy–United States relations. I am proud to be among the succession of American diplomats who have served as U.S. chief of mission to Madagascar. In the early days

of U.S.–Malagasy relations, American interests were mainly commercial. As far back as June 1866, the United States government established official relations with Madagascar through the presence of Major John P. Finkelmeier, an American commercial agent who had been living in Toamasina (formerly Tamatave), the country's leading port city. By February 1867, Finkelmeier had concluded a "Treaty of Friendship and Commerce" with Antananarivo's Merina government; it was endorsed by Queen Ranavalona II on August 1, 1868.

Another active representative of the U.S. government in Madagascar was William W. Robinson, who served as consul general in Toamasina. From October 12, 1875, until 1886, Colonel Robinson unstintingly carried out U.S. representational duties, which further strengthened American political and economic relations with Madagascar. Among his numerous achievements was reinforcement of the original Treaty of Friendship with a new Protocol Section that very much impressed the Malagasy government. Merina officials referred to it in Malagasy as *raharaha lehibe,* or "big business" (Mosca 1995).

One of the most interesting U.S. representatives to Madagascar was John Lewis Waller, who was also among the first African American diplomats. He served as consul general to Madagascar from 1891 to 1894. This became a sad period in the history of the Malagasy: the nation lost its eighty-year struggle with European powers and became a French protectorate. Waller attempted to promote Malagasy independence and strove to establish an African American colony in Madagascar, but he ran into serious difficulty with the French because of his political activism. His is an intriguing story that deserves the attention of a wider audience. The second African American envoy to Madagascar was Mifflin Gibbs, who served from 1901 to 1904.

As the U.S. ambassador to Madagascar from 1998 to 2001, I was continually struck by the endurance of the United States' long relationship with this beautiful country. Present-day ties are solid, as is our mutual commitment to the continuance of our firm partnership. One of the two countries' top priorities in Madagascar is economic development, which in turn helps to reduce poverty. At the same time, the United States has consistently worked with the Malagasy to promote democracy, good governance, and protection of the environment. More than 80 percent of all ecological species in Madagascar are found nowhere else

on earth. Our two governments continue to make concerted efforts to conserve Madagascar's unique flora and fauna.

One of the most recent and outstanding examples of this cooperation is the work our two countries have done to assure that Madagascar takes full advantage of the African Growth and Opportunity Act (AGOA). Passed by the U.S. Congress in May 2000, this legislation is an impressive example of the Clinton administration's commitment to forging a strong Africa policy. Besides allowing Madagascar and other eligible African countries an unprecedented opening of their products to the U.S. market—tariff free—it offers a corresponding opportunity for introducing the splendid array of high-quality Malagasy apparel and textiles to the American consumer. Therefore, in addition to U.S. aid projects, the trade dimension offered by AGOA will, I hope, provide Madagascar an opportunity for sustained and deep-rooted economic growth and prosperity. It is most appropriate that two of Madagascar's major export products, which are the focus of AGOA, are apparel and textiles. Thus, through the intermediary of cloth, we will continue, as in the past, to demonstrate our ties and friendship.

There is a Malagasy proverb that beautifully describes the relationship between cloth and friendships: "Aza atao fihavanam-bato, ka raha tapaka, tsy azo atohy; fa ataovy fihavanandandy, ka raha madilana, azo tohizana" (do not liken your friendship to a stone: if it breaks, you cannot put it together again; but liken your friendship to silk, for if it frays, you can still stitch and mend it). As we embark on this trip through the new millennium, the Smithsonian's "Gifts and Blessings" exhibit and the accompanying book, *Objects as Envoys*, are a timely way to reemphasize U.S.–Malagasy friendship, expand Americans' knowledge of Madagascar, and augment our appreciation of Malagasy history and culture. The United States and Madagascar, no longer a "world apart," can be proud of their enduring and firm connections, which, I am sure, will continue throughout the centuries to come.

ACKNOWLEDGMENTS

FOR THEIR GENEROUS ASSISTANCE IN RESEARCH AND COLLECTING, WE WOULD LIKE to thank the following people and organizations in Madagascar: Dr. Jean-Aimé Rakotoarisoa, director, and Mme. Bako Rasoarifetra, Mr. Ramilisonina, Mme. Chantal Radimilahy, and Mme. Bodo Ravololomanga of the Institute of Civilizations–Museum of Art and Archeology, University of Antananarivo; the Ministry of Culture; Mme. Razoharinoro (director, National Archives); Mr. Fulgence Fanony (director, CERL Tamatave); Mme. Mirana Abraham Andriamanantena (Hay Landy); Mme. Zo Razakaratrimo (Zo Artiss') and Mr. Misa Ratrimoharinivo; Mme. Suzanne Ramananantoandro (president, Professional Silk Association of Madagascar); Mme. Félicité Razafindandy Rakotovololona (Création Landy Hasina); Jocelyn Aimé and Bakolitiana Rakotomalala (Maison Rakotomalala and Son–Lambamena), Mme. Raharivao (Mama Rahary) and Marie Lovasoa (Maison Lambamena); Mme. Zena Ramampy (mayor, Ambalavao); Mr. Jaona Ratsimbazafy (mayor, Ambohimahamasina); Mr. Olivier Ramonja and Vero Andriantsiferanarivo (CCDN Namana, Ambalavao); Mme. Denise Cleroux; Mme. Pascale Reiss; Mme. Ramisandrazana Rakotoseheno (director, prime minister's cabinet); Professors Solo and Lala Raharinjanahary, Céléstin Razafimbelo, Désiré Rasamoelina (ENS III); Mr. Simon Peers (Lamba SARL); Father Courau (Catholic Mission, Ambositra); Mr. Rakotondrainibe Martial (Arivonimamo); Mme. Emélie Rakotondramanana (Ambohidrabiby); Mr. Rabarison and family (Andriakely atsimo); Mr. Gilbert Randrianomeny (mayor, Vangaindrano); Mr. Florentin Mahazatry Fanatera (Vangaindrano); Dr. Fenomanantsoa "Tiana" Ratianarijoana (Arivonimamo); Mme. and Mr. Bako and Jean-Réné Rason (Sandrandahy); and Mme. Ramanantenasoa, Florine Ramainty, Félicité Rasoazananay, Mairie Louise Razafininandriana, Ravelomananoro, Mama Landy, and the other weavers of Andina, Ambalavao, Ampasimpotsy, Fonohasina, Ambohimarina, Sandrandahy, Arivonimamo, and Ambohimahamasina.

We would also like to express our thanks to colleagues in Europe and the United States who assisted us with various stages of this project. In London, they are John Mack (senior keeper, British Museum), Philip Thomas (University College, London), and Rosemary Seton (archivist, School of Oriental and African Studies, University of London). In Paris, they are Pierre Vérin, Narivelo Rajaonarimanana (INALCO), Claude Allibert, Philippe Beaujard (CNRS),

Nicole Boulfroy (Musée de l'Homme), Christine Athenor, Jean-Luc Lory (Maison des Sciences de l'Homme), Sophie Blanchy (CNRS), and Maurice Bloch; and in Strasbourg, Noël Gueunier (University of Strasbourg). We are grateful to colleagues at museums in the U.S. who facilitated our review of Malagasy textiles in their collections: Dorren Martin-Ross (registrar) and Chap Kusimba and Bennett Bronson (associate curators), Department of Anthropology, Field Museum of Natural History, Chicago; Judy Odland (Chicago); Enid Schildkrout (curator) and Vuka Roussakis (textile conservator), Department of Anthropology, American Museum of Natural History, New York; Susan Haskell (ethnographic collections manager) and Allyson Stanford (administrative assistant), Peabody Essex Museum, Salem, Massachusetts; and Dwaune Latimer (Africa Section, University of Pennsylvania Museum of Archaeology and Anthropology). We would also like to acknowledge the generous assistance of Barry Singer (New York), Randall Bird (Harvard University), Gerald Berg (Sweetbriar College), Rebecca Green (Bowling Green State University), Lesley Sharp (Barnard College), Lisa Gezon (State University of West Georgia), Andrew Walsh (University of Toronto), and Gillian Feeley-Harnik (University of Michigan). In Washington, D.C., we were greatly assisted by David Patterson (historian, Department of State), Milton Gustafson and James Zeender (National Archives), and by the following colleagues at the Smithsonian Institution: Melodie Sweeney (collections manager, American Museum of Natural History), Robert Leopold (National Anthropological Archives, National Museum of Natural History), Susan Crawford (Department of Anthropology, National Museum of Natural History), Donald Hurlbert (photographer, National Museum of Natural History), Lawrence Dorr (Botany, National Museum of Natural History), Ann Shumard (assistant curator of photographs, National Portrait Gallery), Scott Cheshier (Eliot Elisofon Photographic Archives, National Museum of African Art), Allyson Purpura (intern, National Museum of African Art), and Franko Khoury (photographer, National Museum of African Art).

On behalf of all the authors, please accept our deepest thanks.

Christine Mullen Kreamer Sarah Fee
August 2001

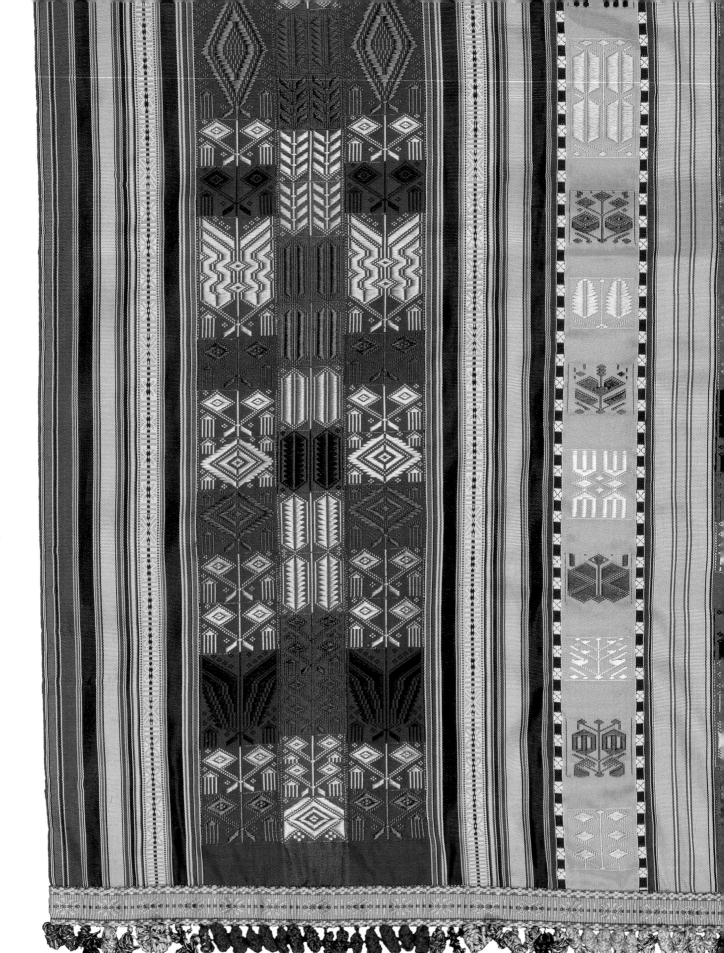

Christine Mullen Kreamer

OBJECTS AS ENVOYS
AN INTRODUCTION

THIS BOOK DISCUSSES THE PEOPLE AND HISTORY OF MADAGASCAR THROUGH INTER-related essays on historic and contemporary cloth production, diplomacy, and nineteenth-century photography. The idea for the book, and the related exhibition on the textile arts of Madagascar organized in 2002 by the National Museum of African Art, arose as several of its authors researched Malagasy textiles and historic postcards and photographs in the collections of the Smithsonian Institution. Through collections-based grants and pre- and postdoctoral fellowships, the Smithsonian Institution affords curators and scholars the opportunity to conduct research into important collections of artifacts, images, and documents in the light of the most current scholarship and critical new theories about objects, their histories, and their contexts both within and outside of museums.

In the late 1990s, predoctoral research conducted by the American anthropologist Sarah Fee focused on the Malagasy textile collections in the National Museum of Natural History. Fee reclassified two early silk textiles given as diplomatic gifts in 1886 by the Malagasy queen Ranavalona III to U.S. President Grover Cleveland (the topic of the essay by Mary Jo Arnoldi in this volume). She also uncovered archival material that illuminated this historic diplomatic exchange. The research fit well with an ongoing Smithsonian interest in material culture studies and in enhancing scholarly and public awareness of the history and importance of Smithsonian collections. Working in collaboration with curators at the National Museum of Natural History and the National Museum of African Art, Fee revealed larger stories behind the queen's gift—stories of the history of United States–Madagascar diplomacy; of ways in which objects, particularly cloth and images, constructed power relations and conveyed multiple meanings to the Malagasy and to outsiders; and of how museums mediate in the interpretation of objects. This book, the result of that research and scholarly collaboration, explores how, in the circulation of cloth, images, and ideas, the

FIGURE 43 (DETAIL)
Contemporary revival *akotofahana* cloth woven by Martin Rakotoari-manana, Antoine Rakoto-arinala, Daniel Rafidison, and Sylvain Ratefiarison of Lamba SARL, a highland Merina weaving group that replicates nineteenth-century *akotofahana* cloth, now based in Antananarivo.

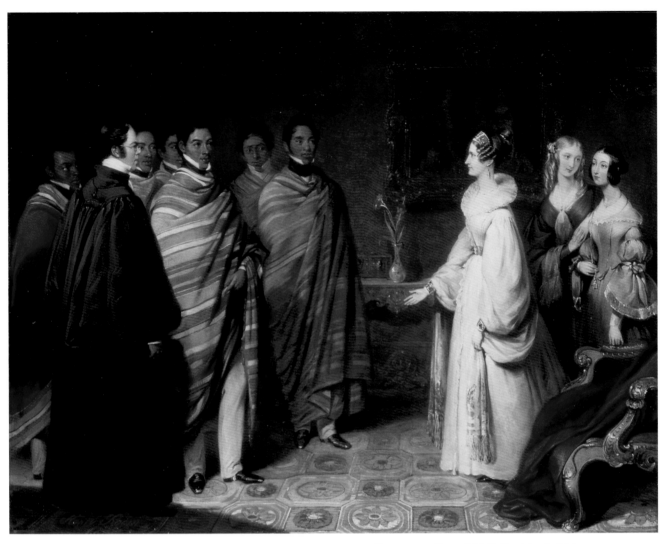

FIGURE 1 *Queen Adelaide Receiving the Malagasy Ambassadors at Windsor Castle in March 1837*. Oil on canvas, by Henry Room (British). © Crown copyright: UK Government Art Collection. Courtesy of the Government of the Republic of Madagascar.

Malagasy have forged relationships both with each other and with the wider world.

Addressing Madagascar's history and material culture sets this book apart from a recent outpouring of popular publications and visual images that emphasize the island's ecological richness and environmental challenges. This natural history approach has carried over into the vast majority of popular television broadcasts and videos about Madagascar. Many such treatments refer to Madagascar as "a world apart," "a lost world," or one of "the last unspoiled places on earth," creating a false sense of separateness and timelessness in an exotic and isolated locale.[1] In the popular imagination—shaped by popular media—the Malagasy people are often overlooked, their voices silenced, and their active engagement with a complex and contemporary world left unstated.

Madagascar is not, and never has been, a world apart. Jean-Aimé Rakotoarisoa's overview of Madagascar in the next chapter informs us that for nearly two thousand years it has been engaged with the wider world through migration, economic trade, and cultural interaction. The island was an important part of centuries-old Indian Ocean trade routes linking Africa with Asia and the Arab world. Arab, Indian, and Swahili traders were active in Madagascar from the beginning of the second millennium c.e., particularly on the island's west coast—long before the arrival of Europeans in the sixteenth century. Europeans, who were concentrated on the east coast and in the highlands, tended to under-report and under-estimate these links, a trend continued by many modern historians, perhaps contributing to the "world apart" misperception.[2]

European contacts with and knowledge of the island have also been more extensive than one might be led to believe. Since 1500, when Portuguese explorers first touched the island, Madagascar's history has been closely intertwined with that of European nations. Malagasy leaders used gains from trade and contact with Europeans

to advance their political goals and expand their kingdoms. This was particularly true of the Merina empire, which harnessed British technology and know-how to subdue much of the island. As early as 1837 the Merina sent delegations to the powerful nations of Europe to press for guarantees that the island would not be invaded and that Madagascar's independence would be respected (fig. 1). By 1861 it had permanent consular offices in Europe. Other Merina strategies for interacting with Europeans included projecting the illusion of a popularly supported centralized government, adopting Western dress and poses in certain contexts, and recognizing Christianity. Indeed, Madagascar successfully resisted European political and economic domination for centuries—up until 1896, when the French finally wrested control over the island from the Merina. The ensuing sixty years of French colonization (Madagascar achieved independence in 1960) served to separate the island from the English-speaking world, but Madagascar has never been a world apart.

The essays in this book address two broad and related points: how Madagascar has for centuries been actively engaged in the international arena of political, economic, and cultural exchanges, and how objects have been used to create and maintain relationships and to represent, both internally and externally, something of the complex identities of the island's diverse peoples. The historical time frame for much of the book is the mid- to late nineteenth century, a time when Madagascar was struggling to assert its independence from French colonial aspirations. This critical period in Malagasy history is examined through the evidence provided by several types of exchanges. One of them is the Malagasy's giving of cloth, both to each other and to foreigners, in ceremonial contexts. Textiles—their own handwoven textiles—are dear to the Malagasy people. They are important economic goods that, through circulation, are transformed into valued symbols of relationships forged between individuals and

among families and communities. Much as the weaving of cloth is a time-consuming and creative process, so, too, is the making of the social world—through greetings, through the exchange and circulation of materials. It is a world that must be regularly created and re-created. The Malagasy social world is located in relationships that are established in many ways, often through the exchange of gifts. The ultimate gift, from a Malagasy perspective, is cloth.

In the past, a second type of exchange occurred when Europeans made photographic images of the Merina court. What was the intention behind those images? Were the Malagasy passive subjects, or did they find ways to manipulate this new technology to their own benefit? A third order of exchanges that this book explores took place in the diplomatic sphere at a time when the United States was one of Madagascar's most important commercial partners.

The essays share an emphasis on historicizing the role of material culture in Madagascar's internal and external relations and in representations of Malagasy identity. The essays on cloth break new ground by providing an integrated framework for considering historical and contemporary textile production in Madagascar and the multiple meanings assigned to cloth as it has circulated, and still circulates, among Malagasy and Western consumers. By documenting the dynamism of textile production in Madagascar, the essays undermine the notion that specific centers of production are associated with particular ethnic groups. Instead, the book takes a more holistic approach to understanding the broad circulation of materials, techniques, ideas, and innovations that are part and parcel of the network of cloth producers and users on the island, both historically and today.

What is it about cloth that lends itself to cultural symbolism, scholarly inquiry, and connoisseurship? A significant body of literature is devoted to the study of textile production and how cloth is used in multiple contexts to maintain relationships and define notions of power and identity.[3] The technology of textile production and cloth's pliable, fragile qualities have often been viewed as metaphors for human society and the connectivity and fragility of human relationships. Not surprisingly, then, cloth features prominently in many facets of human interaction. It forms significant objects that are created, displayed, and exchanged in ceremonies commemorating passage through the cycle of life; it marks ethnic identity or group affiliation; it serves as an emblem of status and prestige; and it represents material ties to the world of ancestors and spirits.

As products of social life, textiles reflect links with the past as well as present-day changes and innovations in technology, design, aesthetic concepts, and meanings. The meanings of cloth vary according to the contexts in which it is made, evaluated, and used (Schneider and Weiner 1989:3). The technology and designs of cloth serve to link the technical skill and material and aesthetic knowledge of present-day weavers to those of past and future practitioners. As a valued commodity, cloth enhances social and political standing through exchange and gift giving. Imbued with symbolic meaning, it confers power or legitimacy in rites of leadership and authority. Using cloth, human cultures "construct and reproduce ideas about their social world" (Renne 1995:3). Textiles offer important insights into how people identify themselves at particular times and how they define and symbolize notions of personhood, gender, and power through objects.

Our exploration of Malagasy textiles shows that all these domains of meaning are in evidence in Madagascar, and the essays reveal some of the specific ways in which this is so. Sarah Fee's chapter on historical and contemporary cloth production introduces us to the long history and the materials, technologies, and forms of some of Madagascar's most important textile arts. Fee details the ecological zones in which raffia, bark,

reeds, cotton, and raw silk are found, and she describes the environmental knowledge and technical expertise required to process these raw materials into threads and woven products and to produce natural dyes.

By surveying textiles throughout Madagascar, Fee highlights styles, traditions, and areas that are usually ignored in textiles studies, which tend to favor the spectacular silk cloth made in the central highlands—the cloth with the greatest appeal for Western aesthetic tastes. Fee also explores some of the ecological and socioeconomic factors that, rather than any cultural "superiority," gave rise to the highlanders' mastery in the arts of textile production.

Using stunning examples of late-nineteenth-century and early- to mid-twentieth-century textiles from important museum collections in Madagascar and the United States,[4] Fee shows how aesthetic concepts of color, patterns, fibers, and techniques are linked to the social, economic, and political contexts of cloth. Taken together, these provide important insights into the value and complex meanings of cloth in Madagascar's past and their relevance to contemporary cloth production. Fee also points out the close association between women's identity and the work of weaving, and the cloth metaphors both men and women use when speaking about courtship, sexual relationships, and the bonds of marriage. Women and weaving are also linked to concepts of female power—economic, political, and symbolic—as woven textiles accrue value on the basis of their circulation and their diverse contexts of use.

An important Malagasy notion is that to be clothed is to be human, and certain categories of textiles are deemed most appropriate for clothing the dead and for enacting the obligations linking the ancestors to the living.[5] Malagasy cloth, along with silver chains, coins, and other significant objects, is used in a number of ways to influence and mediate relations among the living and between the living and the dead. All of these are associated with the deeper meaning of giving gifts, namely, the dispensation of both blessings and ancestral protection that lies at the heart of gift exchanges in Madagascar. Whereas the roles of cloth in seeking ancestral blessings have already been largely documented, Fee's essay newly reveals the important roles that gifts of cloth played in building relations between Merina sovereigns and their subjects, including the Europeans who sought to establish ties with the court.

Against the backdrop of nineteenth-century textile production in Madagascar, Fee examines the continuities between historical cloth traditions and contemporary textile production throughout the island, focusing on contemporary textiles in the collection of the Smithsonian Institution's National Museum of African Art. She convincingly demonstrates the enduring importance of the *lamba* as a versatile cloth wrapper used by both the living and the dead. But she also conveys the dynamism and creativity of contemporary textile production, which incorporates new materials and functions and new sources of inspiration—such as popular television programs and Western fashions—in the creation of woven products. These contemporary textiles function in multiple contexts, much as their nineteenth-century counterparts did. They serve as markers of affection and commitment in marriage ceremonies and as wrappers for the dead in funeral rites. Today, traditional cloths are also modified to serve as accents for home decor or are tailored into familiar items of Western attire, such as ties and vests, geared both to young Malagasy and to a growing number of tourists eager to return home with Malagasy souvenirs. Remarkable examples of woven textiles are created as fine art. Some artists re-create the techniques and patterns of older royal cloths (see cover and page 14), whereas others look forward to new concepts of what Malagasy textile arts are and can become.

In Mary Jo Arnoldi's essay, we embark on the fascinating journey taken by two nineteenth-

century Malagasy cloths currently residing in the collection of the Smithsonian's National Museum of Natural History. Arnoldi adopts a life history approach in tracing these two silk textiles from their presentation in 1886 as prestigious gifts from Queen Ranavalona III to President Grover Cleveland as part of diplomatic exchanges between Madagascar and the United States.[6] By reviewing museum records and diplomatic correspondence, Arnoldi traces the cloths over the course of a century from their original status as diplomatic gifts to their redefinition and reclassification as linen tablecloths, shawls, robes, and, finally, handwoven silk textiles known as *lamba akotofahana.* Her essay encourages us to consider the changing histories of objects in the societies of those who make and use them and in repositories such as museums that preserve and interpret objects for future generations.

Arnoldi also directs our attention to the diversity and dynamism of Malagasy textile production in the nineteenth century by illustrating textiles collected by two Americans, Mason Shufeldt and William Abbott, in the central highlands and southeastern Madagascar in the late 1800s. These early collections document locally popular cotton and raffia products and also illustrate how Malagasy weavers drew on new sources of inspiration—including motifs copied from imported European damasks—in creating their textiles.

An underlying theme of the essays in this volume is that cloth circulates through various contexts and acquires a life history as it moves from one context to the next. In Madagascar, gift giving has been and remains an important context for the circulation and changing valuation of Malagasy textiles. Arnoldi's chapter fits well with current scholarship focusing on the dynamics of gift exchanges.[7] Annette Weiner (1992:6) distinguished between commodities that are easy to give and other possessions "that are imbued with the intrinsic and ineffable identities of their owners, which are not easy to give away." The importance

of the gift is linked to its value, something that is implicitly understood by the giver but may not necessarily be communicated to or understood by the receiver. This need not be an impediment to the effectiveness of the gift-giving process, for the gift is meant to confirm what is already understood: "a relationship [that] is anchored in a framework of mutual recognition of the participants' social and personal identities" (Cheal 1988:22).

In this context, Arnoldi demonstrates the critical place of cloth in the Merina's efforts to assert their authority over other ethnic groups in Madagascar and in expressions of Merina political aspirations to outsiders. Indeed, Merina royals used cloth as an appropriate gift to cement both social and diplomatic relations. As Arnoldi points out, in nineteenth-century diplomatic exchanges, American and Malagasy leaders gave gifts representing something of each nation's sense of identity. These gifts communicated mutual respect and the expectation of a deepening of diplomatic relations between the two nations. Arnoldi makes it clear that the gifts offered by each nation reflected culturally appropriate categories associated with prestige in the giver's society: handspun and finely woven royal cloths from Madagascar, and an industrially produced sewing machine, gold pen and pencil set, and a pair of revolvers from the United States.

The diplomatic gifts Arnoldi describes are examples of the prestigious gift, a familiar category in the literature on exchange theory. Often, an object moves from the status of commodity to a status of greater importance, which can aid in understanding the relationships that are meant to be strengthened through the gift exchange (see Bohannan 1955; Piot 1996). Queen Ranavalona III's gift of cloth to President Cleveland in 1886 was designed, as a prestigious gift, to convey respect but also the expectation of support in Madagascar's efforts to achieve independence from French colonial rule. The more complex

meaning of the gift of cloth, though, is entangled in the dynamics of internal politics and Merina efforts to create the illusion of a pan-Malagasy identity and their position of authority within it. The multiple identities of Malagasy textiles that Arnoldi examines underscore the assertion by Nicholas Thomas (1991:4) that "objects are not what they were made to be but what they have become."

The chapter by Edgar Krebs and Wendy Walker provides a critical historical perspective that contextualizes the diplomatic gift exchanges between Ranavalona III and Grover Cleveland within the broader and more complex political relationship that existed between Madagascar and the United States in the late nineteenth century. The complexity of that relationship is illustrated in the compelling biography of John Lewis Waller, an African American who served the United States as consul to Madagascar from 1891 to 1894. Krebs and Walker offer a rich analysis of Waller's struggle against racial prejudice in the post–Civil War United States and his desire to seek freedom and opportunity overseas in the diplomatic service. As U.S. consul to Madagascar, Waller saw promise for realizing his dream of establishing an all-black colony in Africa.

Krebs and Walker outline Waller's role in diplomatic relations with the Merina kingdom, the challenges he encountered in this position, and his efforts, through his relationship with the Merina court, to secure a concession of land where he could start an agricultural colony for African Americans. Waller's efforts coincided with mounting pressure by the French for control of Madagascar.

To date, little has been written about U.S.–Malagasy relations in the nineteenth century. This is especially true of the crucial period from 1881 to France's invasion of Madagascar in 1895. John Waller was there precisely from 1892 to 1895. His story is an important one from a number of perspectives, not the least of which is its focus on

the little-known history of early African American diplomats. In the poignant details of Waller's biography we see an African American's struggle for equality and opportunity as it was intricately bound to the realities of Madagascar's internal politics and the nation's own struggle for freedom. Although Waller was an African American man of his times, his dreams and ambitions, as Krebs and Walker argue, were nonetheless part of a larger Western tradition of imagining the possibilities of distant lands and populations, and his story parallels many other stories of contact, promise, and disillusionment.

Christraud Geary, too, explores the social, cultural, and political milieu of nineteenth-century Madagascar. Her essay looks at the role of photography in the representation of Madagascar at that time. Drawing largely on the important collections of historic photographs and postcards in the Eliot Elisofon Photographic Archives at the National Museum of African Art and a number of European archives, Geary introduces us to the works of early photographers, both European and Malagasy. She demonstrates how the "gaze" of early Western photographers reproduced that of earlier travel accounts, which tended to focus on two elements of the Malagasy visual landscape that caught outsiders' attention: the sedan chair (filanjana) and Malagasy dress, including woven textiles. Geary's essay points out how objects became material symbols in Western discourse about race and cultural imperialism during the nineteenth century, and how Western interpretations of such symbols might not have been consistent with Malagasy "readings" of the same subject.

In considering nineteenth-century photography in Madagascar, Geary illustrates the interest Malagasy took in the technology and content of Western photographs, and she shows how images and objects brought by foreigners occupied an important place not only in the royal palace but also in the homes of middle-class, urban Malagasy. Early photographs document the adoption

of European styles of dress, posture, and interior decor by Malagasy royals and members of the middle class. These elements should be viewed not as mere imitations of the West but rather as conscious strategies and political choices Malagasy made that revealed their understanding of Europeans and themselves and the nature of power relations. As images by Western and Malagasy photographers alike reveal, the "gaze" went both ways as each tried to understand and digest the foreign ways of the other. Geary also notes the extent to which Malagasy, particularly royals, arranged their own photographic sessions, choosing settings and props to create photographs that served as perfect vehicles for their self-representation. These findings fit well with previous studies of historical photographs and issues of representation, agency, and personhood,[8] and they raise a call for future research on the important images and interpretations she introduces in this volume. Geary's essay also touches on the importance of photographs as gifts that function the way other gifts, such as cloth, do: to create memories and bind individuals to one another in a range of social relationships.

As "the things-in-motion that illuminate their human and social context" (Appadurai 1986:5),

Malagasy textiles and photographic images take on meanings that are varied and context dependent. The essays in this book trace the movement and circulation of textiles and images as potent markers of social relationships, as powerful symbols of political power and global diplomacy, and as significant objects imbued with history and interpretation in museum collections. Textiles, in particular, are goods in Madagascar whose value is transformed through ritual and exchange. Given internally to cement relations between individuals, families, and communities, and given externally as part of international diplomacy, gifts—and their associated morality—are alive and well in Madagascar.[9] The significance of cloth as gift has everything to do with the complexity of meanings associated with cloth's production, use, and circulation. The technical expertise and aesthetic concepts embodied in Malagasy textile production are cultural treasures passed down among families and valued by a nation. One of Madagascar's enduring gifts to the rest of the world is its vibrant and diverse textile arts, a marvelous example of its rich cultural heritage.

NOTES

I would like to thank Sarah Fee, Edgar Krebs, and Wendy Walker for generously sharing with me their considerable knowledge of and insights into Malagasy history and culture.

1. See Jolly and Lanting 1987; Lanting 1990. More recent examples are the 1998 PBS home video *Madagascar: A World Apart* (part of the *Living Edens* series) and Peter Tyson's *The Eighth Continent: Life, Death, and Discovery in the Lost World of Madagascar* (2000).

2. Thanks to John Mack, senior keeper at the British Museum, for pointing out to me this important aspect in the interpretation of Madagascar's trade history and interaction with the wider world.

3. See Renne 1995 and the essays in Weiner and Schneider 1989.

4. We are grateful for permission to illustrate late-nineteenth-century and early- to mid-twentieth-century Malagasy textiles from the collections of the Musée d'Art et d'Archéologie of the Université de Madagascar in Antananarivo, Madagascar; the Field Museum of Natural History in Chicago; the Peabody Essex Museum in Salem, Massachusetts; the University of Pennsylvania Museum of Archaeology and Anthropology in Philadelphia; the American Museum of Natural History in New York City; and the National Museum of Natural History, Smithsonian Institution, in Washington, D.C.

5. In Madagascar and throughout the world, funeral rites are among the most important contexts for bringing together and expressing the multiple meanings of cloth. Studies of the Sakalava people of coastal Madagascar have shown how the dead demand cloth from the living (Feeley-Harnik 1989). Among the Kuba of the Democratic Republic of the Congo, presentations of quantities of cloth ensure the deceased's peaceful transition to the afterlife (Darish 1989).

6. Arnoldi's life history approach recalls the framework set forth by the anthropologist Arjun Appadurai (1986:4) in *The Social Life of Things*, which "examines the conditions under which economic objects circulate in different regimes of value in space and time . . . [and] in specific cultural and historical milieus." In the case of Madagascar, gift giving has been and remains an important context for the circulation and changing valuation of Malagasy textiles.

7. In considering the communicative power of cloth in gift exchanges, one recalls Marcel Mauss's *The Gift* (1990 [1923–24]), which illustrates the many ways in which things are linked to actions and words. Anthropological studies of gift giving emphasize the reciprocal nature of gifts, the implication of a sense of permanence, perhaps even warmth, between parties, and the purpose of creating and maintaining relationships (Bohannan 1955; Piot 1996). The "moral economy" of gifts recognizes social ties and maintains balanced social relationships. The exchange of gifts can be viewed as part of what anthropologists refer to as a "presentational economy, in which the circulation of things-as-gifts . . . create[s] ties to others" (Piot 1996:36). This fits with Mauss's interpretation of the motives and cultural significance of gift transactions, which are linked to controlling others "by maintaining a profitable alliance, one that cannot be rejected" (1990 [1923–24]:73).

8. See Arnoldi, Geary, and Hardin 1996; Geary and Webb 1998; Karp and Lavine 1991; Stocking 1985.

9. The vitality of contemporary gift practices in Madagascar challenges Mauss's early tendency to view gift giving as part of archaic customs and the past (1990 [1923–24]:73), and it underscores how gift giving makes a vital contribution to contemporary social life (Cheal 1988:3).

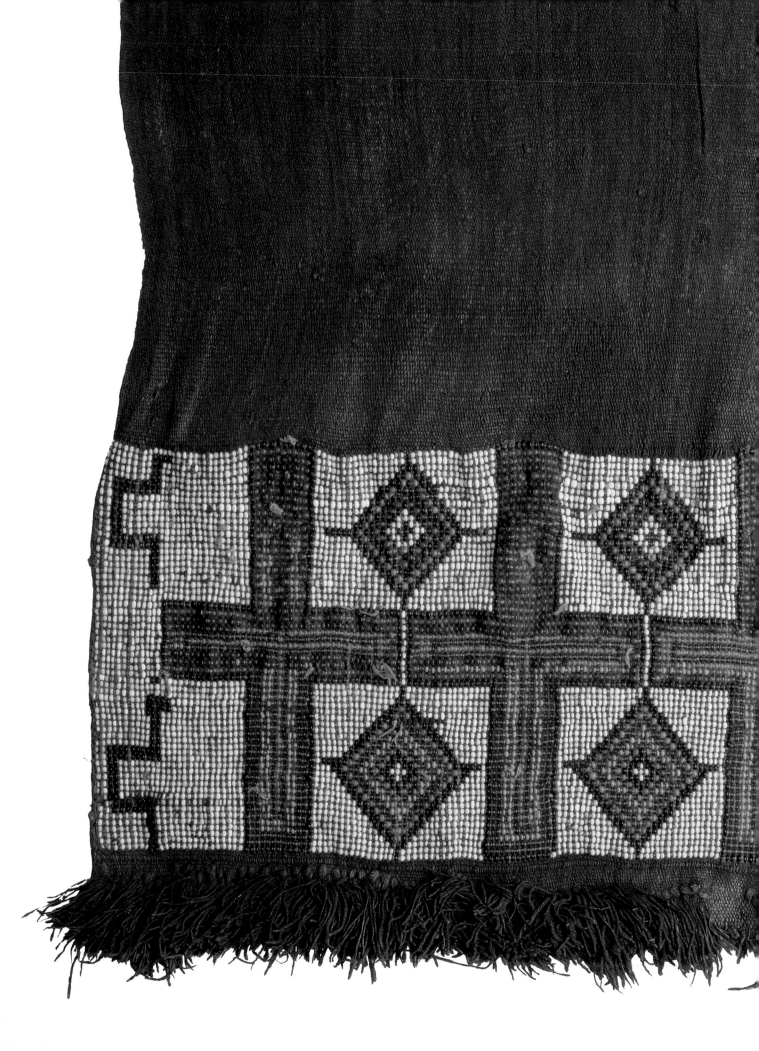

Jean-Aimé Rakotoarisoa

1. MADAGASCAR
BACKGROUND NOTES

THE MALAGASY ARE FROM MADAGASCAR. THIS STATEMENT MAY SEEM A TRUISM, but it actually represents a departure from most scholarship about the island and its people. Past studies have tried to explain and define the Malagasy largely in terms of their overseas origins in East Africa, Asia, and the Near East. The unique culture of the Malagasy, however, has developed in place, on the island, during the nearly two thousand years since the first settlers arrived from those distant points. It is an autochthonous culture that has selectively appropriated and recombined elements—linguistic, material, and cultural—from sources scattered across the vast Indian Ocean and turned them into something new. Though a consuming mystery for scholars, overseas origins play no part in the lore or identity of most rural Malagasy. The only "ancestral land" (*tanin-drazana*) they know and recognize is the island of Madagascar itself; their only ancestors are those residing in the tombs that conspicuously dot the landscape.

This notwithstanding, in order to understand who the Malagasy are and how they came to be requires a certain familiarity with the island's unique and varied natural settings and the history of its human occupation. These brief remarks introduce some of the noteworthy aspects of the land and its people.

The Natural Setting

Lying some 400 kilometers off the coast of East Africa, the island of Madagascar comprises roughly 600,000 square kilometers—an area about the size of the state of Texas—lying entirely within the southern tropics. Measuring some 1,600 kilometers long and 565 kilometers across, it is the world's fourth largest island. This ample surface area makes possible the existence of several different natural habitats (map 1). In general, one can distinguish five regions on the island characterized by their topography, climate, vegetation, and soil. People have adapted their ways of life to the demands and possibilities of each of these zones.

FIGURE 24 (DETAIL) Loincloth with glass beads (*sokotry miloha harea*)

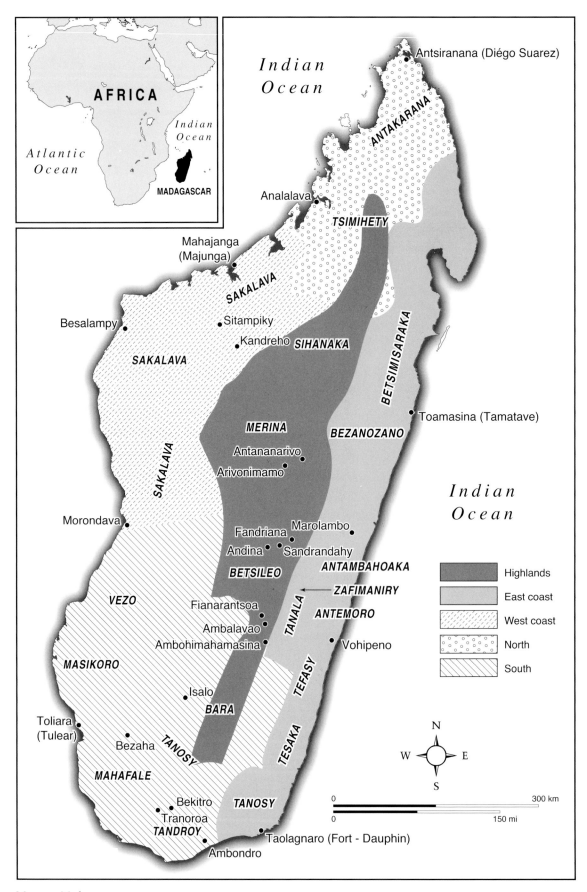

MAP I Madagascar.

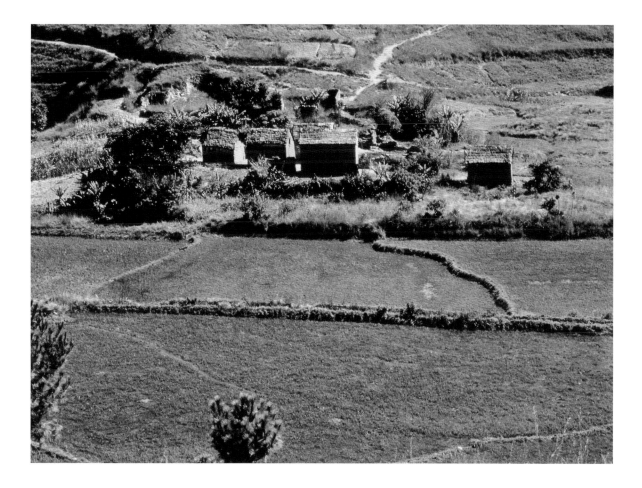

The central highlands (fig. 2) consist of a series of denuded hills of red lateritic soil running north-south down the island's interior. Except in some well-watered valleys and on hilltops that have a sacred character, the primary forest has disappeared, but it has been partially replaced by plantings of eucalyptus and pine. The central highlands literally form the dorsal spine of Madagascar, with an average altitude of 1,500 meters and some summits reaching 2,800 meters. This explains the presence of a marked cool season from June to September (with temperatures reaching as low as 0 degrees Celsius) and the general absence of cyclones (December to March). The highlanders primarily practice terraced rice cultivation.

The east coast, exposed to the tradewinds, registers a heavy annual rainfall, fluctuating between 1.5 and 3.0 meters. As a result, a narrow band of fairly continuous lush vegetation and rain forests lines the entire coast. The material culture

FIGURE 2 **The central highlands of Madagascar, 1991.** Photograph by Wendy Walker.

of this region, consequently, is fashioned largely from leaves, palm fronds, and other plant products. Colonial land concessions and regulations and the increasing poverty of rural farmers, who historically relied on slash-and-burn cultivation, have all contributed to the decline of this forest cover. Much of it has now been replaced by a kind of savanna called *savoka*, which is dominated by *ravinala*, the fan-shaped traveler's palm of Madagascar, and *volo*, bamboo trees. Rice cultivation and the farming of cash crops such as coffee, cinnamon, cloves, and vanilla predominate in this region.

The west coast is characterized by a hot, dry climate (temperatures of 32 degrees Celsius are not uncommon). A dry season of up to seven months is broken by a short but intense rainy season from December to April. Much of the area is a savanna dotted by the *satrana* palm and the occasional towering baobab tree. The open plains have encouraged the raising of Madagascar's humpback cattle, or zebus. But farming is also carried out in *baiboho*, floodplains that provide some of the island's most fertile soil. Fishing from outrigger canoes is a full-time activity for one specialist group, the Vezo.

The north is unique—and fortunate—in receiving a blend of the climates of the east and west. Moreover, the soil is largely of volcanic origin and fertile for many kinds of farming, including introduced cash crops such as vanilla, coffee, cloves, and *ylang-ylang*, a tree whose flowers contain an essential oil used as a base for perfumes. The extended coastline makes fishing another economic possibility. With its proximity to the Comoro Islands and the Swahili-speaking cultures of Africa's east coast, this area has historically felt strong and continual Muslim influences.

The south is the least naturally favored zone, with annual rainfall often less than 30.5 centimeters. The vegetation is stunted and thorny, consisting mainly of fantastic-looking plants of the *Didieraceae* and *Euphorbiacea* families. With their spindly shapes, they have earned the landscape of the south the popular name "spiny forest." The inhabitants of this semidesert have creatively and successfully adapted to their arid homeland by raising cattle, sheep, and goats, some of the finest in all the island. Water is had from cactus fruits and by digging wells down into the dry riverbeds. Corn, manioc, and millet are also cultivated with surprising success. Because of its dangerous coastline and inhospitable climate, the south appears to have experienced the least amount of direct contact with Europeans before the twentieth century.

The paradox of Malagasy culture is the unity that pervades its regional and historical diversity. Despite differences in people's ecological niches, occupations, sociopolitical organization, and links to Indian Ocean trade networks, Malagasy culture nevertheless exhibits great homogeneity. People throughout the island speak a single language of Austronesian origin, albeit with dialectical differences. All Malagasy believe in the power ancestors have over the living, and in their ability to determine the fortunes of their descendants; Malagasy ritual revolves largely around seeking the ancestors' blessings. This is one reason for wrapping the dead in the nicest *lamba* that the family can afford (see Fee, this volume). Some Muslim practices—notably circumcision and an astrological ritual calendar and horoscope—also form core features of the culture throughout the island.

Historical Origins

Madagascar is neither African nor Asian but has been touched by all the diverse societies present in the wider Indian Ocean (Dewar and Wright 1993:419). The island was populated by waves of settlers from Asia, Africa, and the Arab peninsula and, after the sixteenth century, by Europeans. Experts generally agree that the first phase of the peopling of Madagascar began in the first centuries C.E. In successive surges of migration along various routes, Austronesian-speaking peoples

(originally from Indonesia) settled at different places on the island. Each wave brought particular technologies, philosophies, and cultures.

Among the major waves of settlers, there came around the fourth century C.E. an Asian population from Indonesia. Little is known of this early migration to Madagascar—who they were or why they came—although linguistic studies have provided some clues linking Indonesian initial vocabulary roots to actual Malagasy language. In terms of material culture, Malagasy outrigger canoes, musical instruments, and second burial rites also share affinities with Indonesia.

From the fifth to the eleventh century, a second wave of Asian settlers arrived, having probably first stopped along the Indian coast and in East Africa after passing through the Persian Gulf. They brought with them traditions of rice cultivation, rectangular houses, outrigger canoes, and pump-bellow smithing.

Coinciding with the great expansions of Bantu civilization into East Africa and of Afro-Arab Swahili traders in the Indian Ocean in the middle to late first millennium C.E., Africans also made their home on Madagascar, bringing with them cattle and certain musical instruments and games. Many Malagasy terms for introduced domestic animals and material items, including clothing, are of Swahili origin.

For the eleventh to the fifteenth century, we have written sources, specifically the documents of Arab writers. These Arab merchants operated in the Indian Ocean, voyaging as far as China, and their commercial exchanges in Madagascar are attested to in the archaeological record as well. This "Arab era" resulted in the Islamization of several areas in Madagascar, notably the northwest and southeast. Perhaps the Arabs' greatest influence was of a medico-religious nature. Arab divination and astrology spread throughout the island, as did the practice of circumcision. To record these techniques, as well as local political histories, Arabic script was adopted by southeastern groups who subsequently became ritual specialists for kingdoms throughout the island.

The sixteenth and seventeenth centuries saw the arrival of the first Europeans. In 1500, the Portuguese explorer Diego Días became the first European to reach the island, and Dutch, English, and French traders soon followed him. These men tended to make only brief stops to trade for food and other valuables—slaves, unfortunately, among them. Their use of guns and powder as trade goods disrupted and rapidly changed the local political structure of many coastal Malagasy peoples. It was the French in the mid-seventeenth century who first attempted to establish a commercial colony, choosing a point in the southeast, Fort Dauphin (Taolagnaro). They also brought with them Christian missionaries in the hope of evangelizing the local people.

During the eighteenth and nineteenth centuries, Europeans were increasingly drawn to the island for commercial exploration and to evangelize. The English and French were particularly attracted to Madagascar, for it was strategically located on their trading routes to India and was needed to provide staples for their colonial holdings on the islands of Mauritius and Réunion, lying east of Madagascar some 800 kilometers. Until the late nineteenth century, Malagasy leaders were able to bend European ambitions to their own purposes. They exacted anchoring fees and required Europeans to assist them in battles against local rivals. In the highlands, the Merina king Radama I (1810–28) most notoriously used the help of the British government and missionary groups to consolidate his power. With this assistance he trained and armed his soldiers, improved administrative control through schooling (Roman script was adopted at Radama's behest), and boosted state finances through the development of various industrial arts.

Obviously, as important as the movement of people to the island have been movements of

people and other developments on the island itself. These are what really constitute the history of Madagascar. Population growth, climatic phenomena such as droughts, and political changes have all resulted in a continual movement and mixing of peoples. This mixing no doubt accounts for much of the Malagasy's shared cultural core. One of the more important domestic movements of people was that of the Maroseranana royal dynasty, which moved from the southeast of the island along the south coast (the Tanosy, Tandroy, and Mahafale groups) and up the west coast to the northern tip. Wherever it passed, this dynasty established a hierarchical class of rulers, taking advantage of its relationship with foreign seamen and traders during the sixteenth century to increase its power. One of the results was that Sakalava kings became strong enough to dominate a large part of the island from the seventeenth century until the establishment of the Merina kingdom in the mid-eighteenth century.

For administrative and political purposes, the French colonial administration (1896–1960) divided and tried to fix the mobile Malagasy population into eighteen official but completely artificial "ethnic groups." These arbitrary divisions glossed over local distinctions and did not necessarily reflect how identity was viewed and created on the ground. Unfortunately, as in many similar cases, people were manipulated into recognizing themselves in terms of these eighteen groups. Even today, people continue to confound regional interests with ethnic concepts. In the new Malagasy movement to establish autonomy for each of the island's five provinces, it is important to clarify these misunderstandings in order to avoid a variety of problems.

Any discussion of the island's human history must also refer to its latest phase. In 1960, after sixty-odd years of colonial rule by France, Madagascar achieved its political independence and established a republic. The initial euphoria was soon tempered by a growing awareness of Madagascar's continued reliance on the former colonial power, particularly in economics and finance. During times when the balance of trade might have favored Madagascar, bilateral and international help and cooperation met with few results and had no real effect on people's daily lives.

In 1972, a popular movement overthrew the first republic. A second republic endured until 1992, when a new election was called and a new constitution adopted. The population today numbers 14 million, of whom 80 percent are rural farmers. The fluidity of Madagascar's human geography continues to this day, as people move around the island seeking better work prospects and opportunities in higher education. Natural resources are still plentiful, but they will be sustainably managed only when policies become more sensitive and take more fully into consideration what is culturally acceptable for Malagasy communities.

As the pace of globalization escalates, Malagasy society is changing quickly, particularly in certain regions and urban areas. The island's material culture is also changing, in part influenced by the availability and circulation of local and imported goods. Although Indian Ocean influences are certainly evident in Malagasy material culture, cultural imports are not simply adopted but are creatively transformed into new, vibrant examples of cultural expression. A case in point is rap music, which is gaining in popularity, owing in part to the broadcasting of music videos on Malagasy television. Although some urban Malagasy artists are adopting this musical form and a new style of dress that is associated with it, looks can be deceiving. Most of the rap lyrics speak of family, social justice, and other timeless themes of Malagasy oral tradition.

One thing that has remained fairly constant in Madagascar is the attachment people have to their cloth. Most of my countrymen, it is said, are born, live, and sleep for all eternity with a *lamba*, the versatile cloth, either handwoven or factory

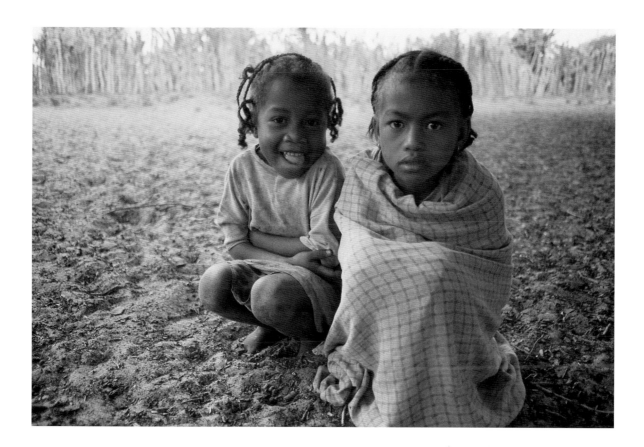

made, that both men and women in many regions of Madagascar wear today (fig. 3). Though there are various reasons for wearing this cloth, one of the more compelling is a real will to promote an important aspect of Malagasy cultural heritage.

FIGURE 3 Tandroy girls, one wearing a cloth wrapper, or *lamba*, in Androy, southern Madagascar, 1995. Photograph by Wendy Walker.

Sarah Fee

2. CLOTH IN MOTION
MADAGASCAR'S TEXTILES
THROUGH HISTORY

Fisikina ro maha-olo.
It is cloth that makes people.
—MALAGASY SAYING

THE HANDWOVEN TEXTILES OF MADAGASCAR ARE ARGUABLY THE ISLAND'S MOST VISUALLY
compelling art form. Of delicate texture and vibrant color, they have long captivated Western viewers. But for the people who make and use this cloth, it is also
much more. The Malagasy use cloth to define the social world, to express various
kinds of identity, and, when presenting it as a gift, to create and sustain social
relations. This essay aims to deepen the reader's appreciation of Malagasy textiles, both as creative works and as objects of great cultural and social significance.

An important first step in this direction is getting behind cloth to look at
its makers and the methods they employed. The first part of the essay maps out
the island's major historic textile traditions, which thrived until some fifty years
ago, and surveys the techniques women used to transform often rough and unassuming materials into complex, colorful fabric. Rather than focus on the possible
overseas "origins" of techniques, terms, or styles—an approach taken by many
other studies of Malagasy textiles—I look primarily toward Madagascar itself to
explore how weaving was closely tied to female identity there and to investigate
the ways in which the Malagasy viewed and classified cloth according to shape,
fiber, striping, and decoration.

The second part of the essay follows the movements of cloth after it leaves
the loom, exploring how "human actions . . . make cloth politically and socially
salient" (Schneider and Weiner 1989:3). It builds on earlier studies (Fee 1997;
Feeley-Harnik 1989; Green 1996; Mack 1989) to examine some of the culturally
specific ways in which Malagasy groups and individuals use clothing to assert
basic kinds of identity. By wearing cloth, Malagasy communicate and assert their
"humanity," rank, wealth, and ethnic affiliation (fig. 4). Most importantly, cloth
circulates among people as gifts. Men and women bestow it on living kin and
ancestors to protect and make them human, to establish and renew ties, and to
define their social worlds. Whereas offerings of cloth to ancestors have been
described by scholars, another, parallel practice has so far been largely ignored.

FIGURE 65 (DETAIL)
Lambamena collected by
William Abbott, 1890.

33

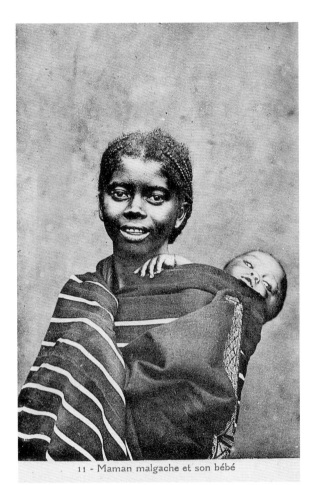

11 - Maman malgache et son bébé

FIGURE 4 **A Malagasy mother and her baby**
(*Maman malgache et son bébé*). For the Malagasy, cloth
is an inseparable "social skin" that clothes, protects,
and identifies a person from cradle to grave. Collo-
type. Photographer unknown, c. 1900. Published by
Procure des Missions. Bulletin Chine, Ceylan, Mada-
gascar, Lille. Postcard collection, MG-20-3, Eliot
Elisofon Photographic Archives, National Museum
of African Art, Smithsonian Institution.

As this essay reveals, in the Merina kingdom
that came to dominate much of the island after
1787, cloth was one of the primary material goods
that flowed from subjects to sovereign and from
sovereign to subjects. The ambiguity in gifts of
cloth, and the potential for their meanings to
change over time, becomes most evident in the
discussion of silk cloths that Merina monarchs
gave to foreigners.[1]

An understanding of the historical roots of
Madagascar's textile traditions is indispensable
for appreciating the current manifestation of cloth
making and use in Madagascar—that is, the con-
tinuity, "revivals," and innovations that form the
subject of the final part of this chapter. Beyond
practices in the region of the nation's capital, little
has been written about contemporary weaving
on the island. Recent field research shows that
despite repeated predictions of its demise and
decline, handweaving continues in various forms,
and cloth continues to be used in old and novel
ways as gifts and as a medium for the expression
and creation of identities.[2]

Weavers: "A Woman Worthy of the Name"

That weaving was so developed, varied, and wide-
spread an art in Madagascar stems directly from
the social and symbolic importance it held for its
creators: Malagasy women. They made cloth not
simply as a technical act but as an integral com-
ponent of female identity. Historically, women
throughout the island practiced weaving,[3] for
clothing the family was one of their many domes-
tic responsibilities. Spare moments between work-
ing in the fields, caring for children, and cooking
were spent working at the loom, which could eas-
ily be rolled up and stored until the next available
moment (fig. 5), or in processing the yarn that
women kept in baskets always near at hand. Espe-
cially prolific or skilled weavers might trade their
surplus at local markets. This economic impor-
tance was greatest in the central highlands, home

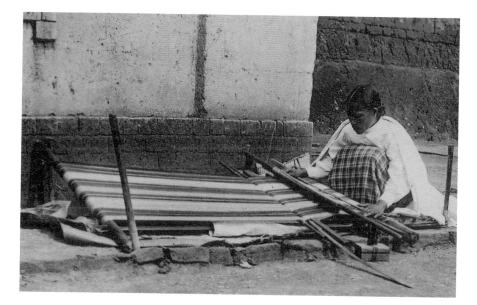

FIGURE 5 **Weaving a** *lamba*, **Tananarive**
(Tananarive—Tissage d'un lamba). In the
past, women throughout the island made
cloth, and weaving was associated with
female identity in numerous ways. Collo-
type. Photographer unknown, c. 1900.
Published by Photo-Bazar, Tananarive.
Postcard collection, MG-4-3, Eliot Elisofon
Photographic Archives, National Museum
of African Art, Smithsonian Institution.

to the Merina and Betsileo peoples, where by the
eighteenth century full-time weaving supported
many households.

In practice and in thought, the Malagasy
unequivocally associate women with the making
of cloth. Indigenous accounts of the sexual divi-
sion of labor oppose women's weaving to men's
warfare or agricultural work (Green 1996; Larson
1992). Throughout the island, in various life-cycle
ceremonies, women were commonly represented
by weaving tools—the spindle or the weaving
sword—and boys, by spears or hoes. These rituals
also emphasized the ideal interdependence of
husband and wife. According to the islandwide
tale of the original union of man and woman, the
wife brought cloth and a mat, and the husband
provided house building and agricultural work.

In the past, people judged a woman's domestic
skills, intelligence, and industry largely by her weav-
ing. It was a mother's duty to teach her daughters
to weave, and a dereliction of this duty reflected
badly on both generations. A famous proverb says
that "if a girl is not dressed in fine banana cloth,
it's not the father's fault." Laziness, too, was
expressed in terms of weaving imagery: "the girl
who won't take up the warp beam," who "doesn't

think to fix the broken threads." Girls became ini-
tiated to cloth making by helping with fiber prep-
aration, as in spinning (fig. 6) or winding yarn on
the shuttle, and by "stealing" a turn at the loom
when their mothers left the room.

The care weavers took to produce fine cloth
also stemmed from the fact that they made it not
for unseen or unknown recipients but for sons,
fathers, and husbands, who were also judged by
the quality of the clothing they wore. For Mala-
gasy women, making clothing was a labor of love.
In the south of the island, the most intricate and
complex designs, made by weft-wrapping (see
fig. 34) and beadwork—among the finest and
most labor intensive of decoration techniques—
are found on men's loincloths. "For what woman
wouldn't know how to do such work, if she is
worthy of the name?" the Merina king Andria-
nampoinimerina (c. 1750–1810) is said to have
asked rhetorically (Callet 1981, 3:168). By offering
cloth as gifts to distant male kin, women who
had no children to support them could also use
it to create ties of obligation and place themselves
in a sustaining network.

But the associations between cloth and women
in Madagascar run even deeper. Although the

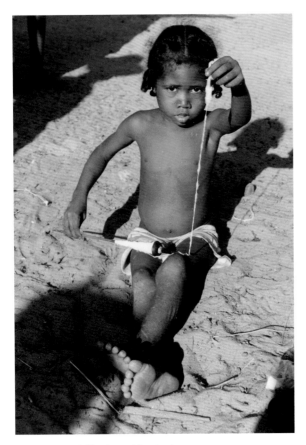

FIGURE 6 **A Tandroy girl spinning cotton
in Ambondro, 1993.** Malagasy girls' initiation to
textile making begins at an early age. Photograph
by Sarah Fee.

Malagasy have no abstract categories for female
and male goods per se, they nonetheless make
implicit associations between soft materials and
femaleness and between hard materials, such as
wood and metal, and maleness (Feeley-Harnik
1989:28). Landy (silk) and Soherina (chrysalis)
are girls' names.[4] Moreover, in both word and act,
cloth evokes the idea of love and amorous rela-
tions in general, and female sexuality in particular
(fig. 7). Among the Merina of the central high-
lands, a young girl used her shoulder wrap to sig-
nal her intentions to suitors: "Wear it on the left,
it means 'come here'; wear it on the right, 'meet me
to the east.'"[5] In a culture that values allusion, a
woman's cloth has stood for love and seduction
in oral literature, from the *hainteny* poems of the
nineteenth century to contemporary popular
songs such as Ratsimbazafy's famous tune "Lam-
banao mikopakopaka," "How your cloth flutters."
In the south of the island, "giving the cloth" is a
standard sign and euphemism for amorous rela-
tions (Fee 1997). But if a southern woman has the
power to "give the cloth," she also has the right to
take it back: if she feels her lover has been stingy,
she will seize his cloth in public and hold it hos-
tage until a council settles the affair.[6]

Yet despite these various levels of association
made between women, weaving, and cloth, it
would be a mistake to associate cloth unequivo-
cally or exclusively with its female makers, as some
authors have been tempted to do. Both men and
women, we shall see, use cloth in many social and
ritual contexts to fulfill their individual goals.

Historic Cloth Making in Madagascar

Until about 1950, Madagascar was home to flourishing and varied weaving traditions. The island's markedly divergent ecological zones made available a wide range of fibers including raffia, reeds, bark, cotton, hemp, banana stems, indigenous silk, and imported mulberry silk. Women spun, dyed, and wove fibers into panels of cloth that they usually left untailored, to be wrapped gracefully about the body. Men wore a narrow panel as a loincloth, and both sexes wore rectangular, striped outer wrappers.

To the untrained eye, Madagascar's striped cloth might appear all alike. The Malagasy, however, have a complex system for classifying cloth, based on its shape, fiber content, striping pattern, and decoration. To illustrate these categories in all their variety, we are fortunate to have two important American holdings of Malagasy textiles collected before 1930: one at the Field Museum of Natural History in Chicago and the other at the Smithsonian Institution's National Museum of Natural History.

KINDS OF CLOTH

The primary article of clothing woven by women was the *lamba*. This is the highland term for cloth, but regional variants also exist, such as *simbo* along the east coast. The *lamba* consisted of two identical panels sewn together along their lengths to form a rectangle measuring about 2.0 by 2.5 meters. The minimal decoration was colored stripes and a fringe. Although the stripes were formed in the warp (or length) of the cloth, when the lamba was worn on the body, they were read horizontally (see fig. 4).

Far from being a stiff rectangle of cloth, the *lamba* "follows all the undulations of the body, all the caprices of gestures" (Dubois 1938:302). The most common mode of wearing the *lamba*, for

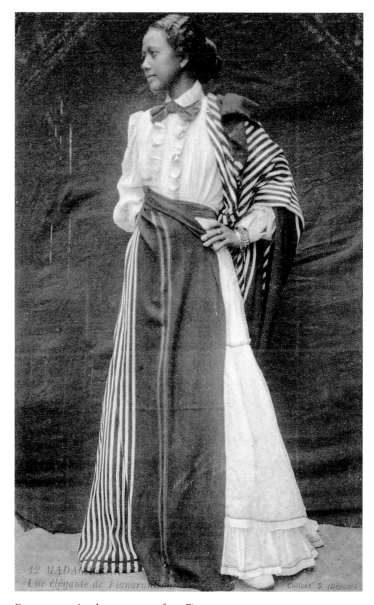

FIGURE 7 **An elegant woman from Fianarantsoa, Madagascar** (*Madagascar—Une élégante de Fianarantsoa*). In song, saying, and practice, the *lamba* has erotic appeal and evokes female sexuality. The woman here models the *arindrano* striping pattern. Collotype. Photographer unknown, c. 1900. Published by Collection S. Déposé. Postcard collection, MG-20-22, Eliot Elisofon Photographic Archives, National Museum of African Art, Smithsonian Institution.

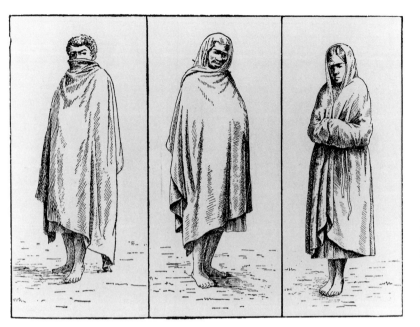

FIGURE 8 Sketches by Edouard Rakoto illustrating the utility and expressiveness of the *lamba*. Covering the face or head protects the wearer from the elements and may conceal timidity or a mocking expression. Reproduced from Dubois 1938:297, courtesy of the Smithsonian Institution Libraries, African Art Branch.

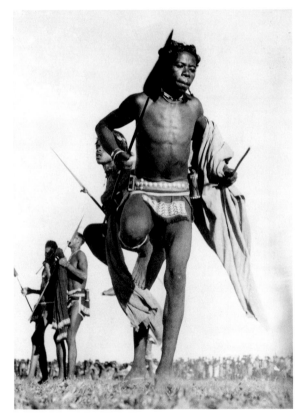

FIGURE 9 **Tandroy man wearing a loincloth.** Throughout Madagascar the primary item of male dress was a loincloth, a narrow band of fabric wrapped between the legs and around the waist to leave the decorated ends hanging above the knees. Photographer unknown, 1939. Courtesy of Photothèque du Musée de l'Homme, Paris, negative no. C.47.721.541.

both men and women, was draped gracefully about the shoulders. But it was also worn in myriad other ways, a fact reflected in the extensive Malagasy vocabulary for wrapping (Koechlin 1987; Ramarozaka 1990). Depending on the physical and emotional needs of the wearer, it could be pulled over the head to protect against cold weather or to hide timidity (fig. 8), or it could be wrapped tightly around the waist to show action and determination. To indicate mourning, it was wrapped in a distinctive manner under the arms. The *lamba* also served for sundry daily needs, as "blanket, apron, scarf, belt, bedding, turban, kitchen cloth, bag or suitcase, tent, awning or shelter" and, for the child on its mother's back, "as the permanent cradle" (Dubois 1938:299).

Other shapes and kinds of clothing varied according to the gender of the wearer. In addition to the *lamba*, men wore a loincloth, a panel of cloth measuring about 30 centimeters wide and 300 centimeters long that was wrapped between the legs and several times around the waist so that the two ends fell before and behind the upper thighs (fig. 9). By the nineteenth century, a man's

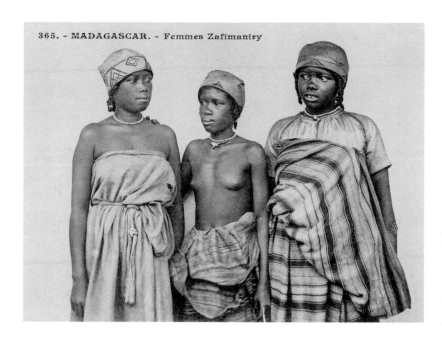

365. - MADAGASCAR. - Femmes Zafimaniry

FIGURE 10 Zafimaniry women, Madagascar (*Madagascar—femmes Zafimaniry*). The standard costume for Malagasy women was a rectangular wrapper tucked at the waist or chest. If made of stiff fibers, like those pictured here, the wrapper was stitched together along the two narrow ends to form a tube that was belted at the waist. Collotype. Photographer unknown, c. 1900. Publisher unknown. Postcard collection, MG-20-45, Eliot Elisofon Photographic Archives, National Museum of African Art, Smithsonian Institution.

costume on the east coast included a large smock (*akanjobe*) ingeniously tailored from a single panel of fabric. Women, meanwhile, wore a smaller cloth (*kitamby, sikina*) wrapped around the waist. Along the east and west coasts, the two narrow ends of a woman's cloth were stitched together to form a loop or tube (*simbo, salôvana*) that was belted with a length of cloth (fig. 10). Until the twentieth century, women throughout the island also wore a small, tight-fitting shirt called *akanjo* that left the midriff exposed and was reminiscent of the Indian *choli* (fig. 11). "Only the poorest of women don't wear it" (Yves [1754], quoted in Grandidier and Grandidier 1928:255).

Textiles clothed not only the living members of Malagasy societies but also the ancestors. As I discuss more fully in the second part of this chapter, in Madagascar ancestors are believed to have the power to either bless or curse their descendants, and a person's fortunes depend on securing their goodwill. Descendants both honor and try to please deceased kin by wrapping their corpses in layers of the finest handwoven cloth, usually made from the costliest of silks.

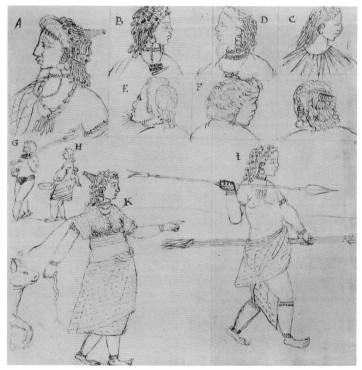

FIGURE 11 In addition to the *lamba*, Malagasy women wore the *akanjo*, a tight-fitting shirt (with or without sleeves) that left the midriff exposed, reminiscent of the Indian *choli*. Sketch by Peter Mundy, St. Augustine (Toliara), 1638. Reproduced from Mundy 1919:pl. 19, courtesy of the Smithsonian Institution Libraries, African Art Branch.

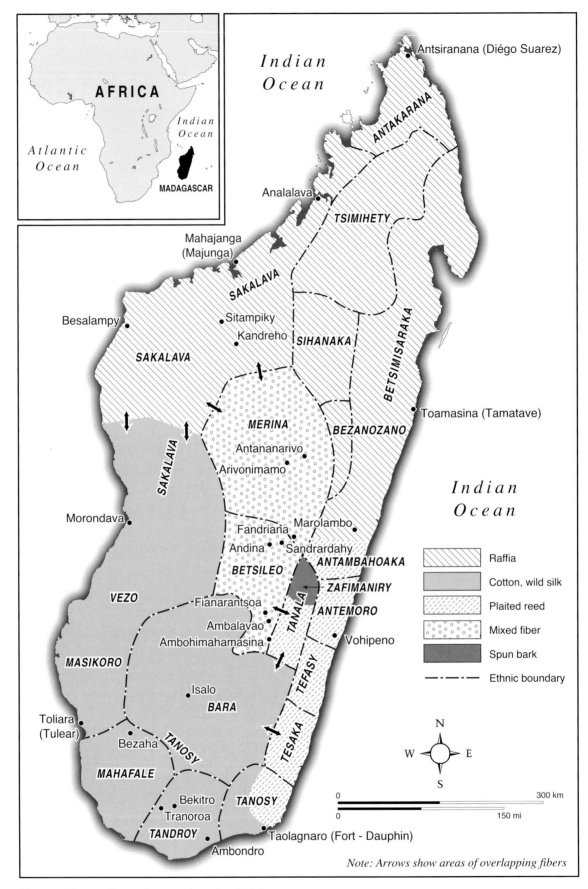

AFRICA

Atlantic
Ocean

Indian
Ocean

Indian
Ocean

MADAGASCAR

Indian
Ocean

Antsiranana (Diégo Suarez)

ANTAKARANA

Analalava

TSIMIHETY

Mahajanga
(Majunga)

SAKALAVA

Besalampy

Sitampiky

Kandreho

SIHANAKA

SAKALAVA

BETSIMISARAKA

Toamasina (Tamatave)

MERINA

BEZANOZANO

Antananarivo

Arivonimamo

Indian
Ocean

SAKALAVA

Morondava

Fandriana

Marolambo

Andina

Sandrardahy

ANTAMBAHOAKA

BETSILEO

ZAFIMANIRY

VEZO

Fianarantsoa

TANALA

ANTEMORO

Ambalavao

Vohipeno

Ambohimahamasina

MASIKORO

Isalo

BARA

TEFASY

Toliara
(Tulear)

TANOSY

Bezaha

TESAKA

MAHAFALE

TANOSY

Bekitro

Tranoroa

TANDROY

Taolagnaro (Fort - Dauphin)

Ambondro

N
W E
S

| | |
Raffia
Cotton, wild silk
Plaited reed
Mixed fiber
Spun bark
Ethnic boundary

0 300 km
0 150 mi

Note: Arrows show areas of overlapping fibers

MAP 2 Historic fiber traditions and peoples of Madagascar.

FIBER TRADITIONS

Fiber content was another way in which the Malagasy classified cloth.[7] Madagascar was home to a remarkably diverse range of textile fibers, a reflection of the island's varied ecological zones—from rain forest to semidesert savanna. The historic distribution of raffia, cotton, silk, and other fibers can be divided into five general zones, shown in map 2. The inhabitants of the first four zones became specialists in the materials locally available, and they were largely self-sufficient in producing their daily clothing needs.

FIGURE 12 **Sakalava women, Madagascar** (*Madagascar—Groupe de Sakalavas*). The three women on the left wear wide panels of raffia cloth. Madagascar's cloth shows regional variety in length, shape, and striping patterns. Collotype. Photographer unknown, c. 1900. Publisher unknown. Postcard collection, MG-20-52, Eliot Elisofon Photographic Archives, National Museum of African Art, Smithsonian Institution.

The East and West Coasts: Raffia

The leaf of the raffia palm (*Raphia ruffia*) was the staple textile fiber for people inhabiting the east coast and northern end of Madagascar, home to the present-day Sihanaka, Tsimihety, Antakarana, northern Sakalava, and Betsimisaraka.[8] Raffia leaves were cut and scraped, combed into narrow strips with a metal instrument, and then knotted end to end. Preferring cloth that reached to the feet and thus conveyed dignity, Sakalava women of the west coast made wide panels for their clothing (Feeley-Harnik 1989:81) (fig. 12). They also made short, square panels to serve as Islamic prayer rugs and impressively large panels, up to 7 meters in length, that were sewn together to form mosquito nets (see *ikat*, below). Weavers on the east coast, meanwhile, made shorter raffia wrappers (*simbo*, fig. 13) and tailored durable raffia smocks (*akanjobe*, fig. 14) for their husbands. Both garments served well in the mud, rain, and standing water of the rain-forest homeland.

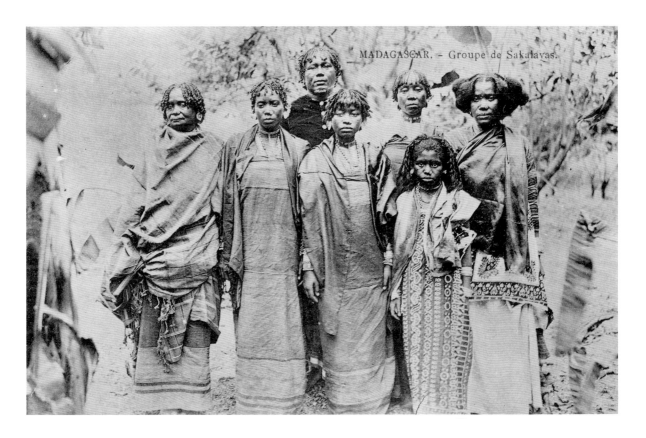

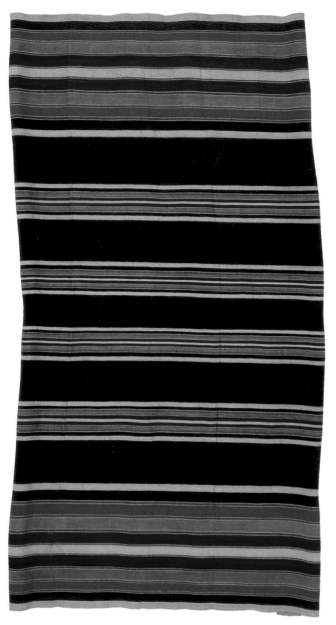

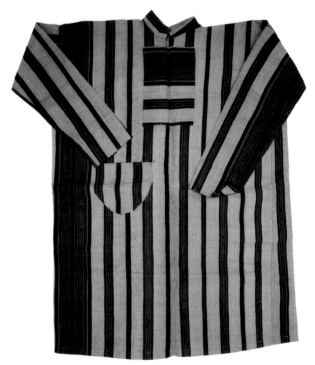

The Southeast: Reeds (Sedges) and Beaten Bark

In the densely populated southeast quadrant of the island, clothing historically was not woven on a loom but made from beaten bark or plaited mats of *harefo* reeds (*Eleocharis plantaginez*). For the Tanala, Antemoro, Antambahoaka, Tefasy, Tesaka, eastern Bara, and eastern Betsileo, mat clothing (*tafitsihy*, fig. 15) was the primary form of dress for men and women of all social categories. The woman's dress consisted of two or three rectangular mats of *harefo* reeds stitched together to form a tube. It could be belted at the waist or pulled up on the shoulders. Young girls reaching puberty, who began "to know shame" (*mahilala henatsy*), wore, in addition, a small breast cover made of *mahampy* reeds. Men wore a tunic or jacket of mats—with long sleeves for older men— over a loincloth of beaten bark cloth. This cloth, known generically as *fanto*, was obtained from a variety of trees, mostly of the *voara* (*Ficus* sp.) family. Men stripped off the inner bark and beat it with a cross-hatched mallet. Although historically in use throughout the island, by the nineteenth century beaten bark cloth was considered the speciality of the southeastern region.

FIGURE 13 **A woman's raffia wrapper (*simbo*) made by a weaver from among the Tanala people of southeastern Madagascar.** Raffia, aniline dyes, 130 by 69 cm. Collected by Ralph Linton, 1926–27. The Field Museum of Natural History, Chicago, catalog no. 185,855. Photograph by John Weinstein.

FIGURE 14 **Man's shirt (*akanjobe*).** Tanala people. Raffia, aniline and natural dyes, 168 by 95 cm. Collected by William Abbott, 1895. National Museum of Natural History, Smithsonian Institution, catalog no. E175,419.

FIGURE 15 **A Tefasy woman's plaited reed mat wrapper** *(sembo tsihy or tafitsihy).* Harefo reeds *(Eleocharis),* aniline dye, 84 by 56 cm. Collected by Ralph Linton, 1926–27. The Field Museum of Natural History, Chicago, catalog no. 186,954. Photograph by John Weinstein.

The Southeast Hinterland: Spun Bark Cloth
Women's skilled hands could also transform the inner bark of various types of trees into an astoundingly soft, shimmering yarn that rivaled the fineness of silk (fig. 16). The best documented of these trees was the *hafotra (Abutilon angulatum),* specifically the *hafo-potsy* variety, used by the Zafimaniry and eastern Betsileo, groups that inhabited the rain forests of the southeastern hinterland.[9] They first dried strips of the white inner bark above a fire, then boiled the strips for several hours and over several sessions. Next they washed the bark on a rock, dried it in the sun, split it, knotted it end-to-end, and rolled it on the thigh to provide twist. After the cloth was woven on a backstrap loom, it was also beaten with a mallet to soften it and add sheen (Dubois 1938:277). *Hafotra* cloth could last for five to six years and thus was suitable for wrapping the dead.

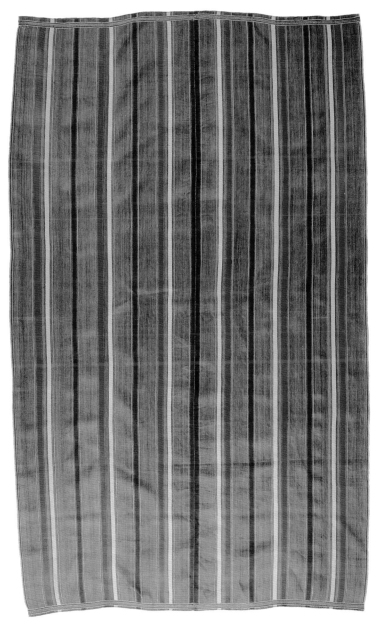

FIGURE 16 **Spun bark cloth** *(hafotra).* Zafimaniry people. Hafotra bark, natural dyes, 245.0 by 86.5 cm. Collected by Ralph Linton, 1926–27. The Field Museum of Natural History, Chicago, catalog no. 185,890. Photograph by John Weinstein.

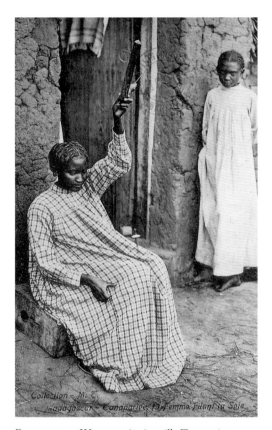

FIGURE 17 **Woman spinning silk, Tananarive**
(*Tananarive—Femme filant la soie*). Preparing yarn
was the most time-consuming step in cloth produc-
tion. Collotype. Photographer unknown, c. 1900.
Published by Procure des Missions. Bullétin Chine,
Ceylan (*sic*), Madagascar, Lille. Postcard collection,
MG-4-7, Eliot Elisofon Photographic Archives,
National Museum of African Art, Smithsonian
Institution.

The South and West: Cotton and Wild Silk

At the opposite ecological extreme, in the arid
south and west of the island, the two main fibers
were cotton and indigenous silk. Cotton was the
mainstay for clothing. To this day women gin it
by hand and spin it with a hand spindle. The Bara
and Betsileo employ a high whorl drop spindle
(fig. 17), whereas southwestern women use a hori-
zontal thigh-supported spindle that is rolled on
the thigh to create twist (see fig. 6).

Beyond its value as a textile fiber, cotton has
other auspicious properties. Throughout the
south and west of the island, newly spun cotton
yarn that has not yet been dipped in a stiffening
solution is called *fole velo*, "living yarn." Healers
(*ambiasa*) tie a simple strand of it about the wrist
as a protective charm, prescribe it as a cord to sup-
port talismans, and sometimes wrap skeins of it
around the bodies of participants in certain ritu-
als, notably circumcision (Fee 1997).

A type of silkworm (*Borocera madagascariensis*)
indigenous to local forests provided another im-
portant fiber for weaving in the south and west.
The Malagasy distinguish the silk—known gen-
erally as *landy*—by the type of tree on which the
worm feeds. In the dry forests of the southwest,
a preferred type of silkworm fed on the leaves of
afiafy and *pisopiso* (*Woodfordia floribunda*) trees. But
it was the *landy* from *tapia* (*Chrysopia microphylla*)
trees in the Isalo region of Bara territory that were
the most highly valued throughout the island.
The yarn made from indigenous silk is usually
quite thick and uneven—it is twisted by being
rolled on the thigh or on a block of wood—and
it resembles dull tussah or even jute. The French
explorer Nicolas Mayeur (1913b:35) spoke for
many Europeans when he complained that *landy*
"has very little appeal in our eyes," for the Mala-
gasy "do not know how to properly de-gum it."
As we shall see later, the creation of a thick,
durable yarn was probably intentional.

The Central Highlands: Hemp, Banana-Stem Fiber, Mulberry Silk

The fifth zone, the central highlands, is the historic homeland of the Merina and Betsileo people. Using a multitude of fibers, they overcame environmental limitations through trade and other strategies. Their area emerged as one of the most important centers of textile production on the island, supplying high-prestige cloth to other regions.

Three types of fibers were indigenous to the area but of limited distribution. Weavers harvested hemp fiber from the stalks of cannabis plants, which thrived in the southern Vakinankaratra district of Imerina (map 2). Hemp cloth appears to have been left undyed, in its natural white color, except for a small red border (Heidmann 1937:100) (fig. 18). Unlike hemp textiles, cloth made from the stem of a variety of dwarf banana (*akondro sarika* or *akondro lambo*) was highly valued; this was one of the most prestigious fibers in Imerina until the introduction of mulberry silk. As fine and glossy as silk, banana-stem cloth could be worn only by nobles, and Merina sovereigns distributed it as gifts until the eighteenth century (Grandidier and Grandidier 1928:168).[10] Among the Betsileo, however, the cloth appears to have served as ordinary costume for commoners (Dubois 1938:275). Processing both hemp and banana stems was labor intensive, requiring beating, boiling, lengthy soaking, washing, knotting, and twisting.

Indigenous silkworms also made their home in the highlands. A much-valued variety lived in the forests of *tapia* trees that stretched along the western slopes of the highlands (Gade 1985). It is probably no coincidence that many of the important highland weaving centers, including Arivonimamo and the Ambositra area, emerged near these resources.[11]

Living at the crossroads of all the ecological zones, Betsileo women had easy access through local trade to all of Madagascar's many fibers, and

FIGURE 18 **Panel of hemp cloth** *(lamba rongony).* Merina or Betsileo people. Hemp, natural dye, 69 by 110 cm. Collected by Mason Shufeldt, 1884. Textile Division, National Museum of American History, Smithsonian Institution, catalog no. E187,672. Photograph by Richard Strauss.

they became master weavers of them all. To the north, the Merina people, inhabitants of historic Imerina, faced a different problem: a paucity of fibers. Their largely sterile, denuded, and landlocked homeland lacked natural resources of any type and was prone to famine. From at least the seventeenth century onward, sovereigns made it part of their political strategy to develop artisanal trades, metal smithing and weaving prime among them, to combat this disadvantage. According to the historian Pier Larson (1992:126), until the mid-nineteenth century, weaving was for highland households probably "the single most important income-generating activity."

Raw fibers such as raffia and wild silk were imported into Imerina in great quantities from the east and west coasts. Weavers developed various grades of raffia cloth for all levels of society. A coarse grade clothed the poorest inhabitants. A more supple fabric called *jabo* combined a warp of raffia with a weft of cotton or silk. The finest grade of raffia was considered suitable as an offering to the sovereign: it was boiled in lye, knotted, and spun, then given a striping pattern as delicate as that used on silk cloth (de la Vaissière 1885:26) (fig. 19).

To promote weaving, sovereigns also introduced and imposed new cultivars—cotton, cultivated pigeon pea silk, and mulberry silk. From at least the late eighteenth century, they required households to grow cotton (Callet 1981, 3:373). Little amenable to the cool highland climate, it was difficult and labor intensive to cultivate, and it became a prestigious fiber (Larson 1992:217; Mayeur 1913b:36). Early Merina sovereigns offered varieties of cotton cloth such as *totorano* and *kilosy* as gifts to foreign leaders (Munthe, Ravoajanahary, and Ayache 1976). The pigeon pea bush (*Cajanus indicus*), known locally as *amberivatry*, was a plant on which indigenous wild silkworms could feed and spin cocoons.[12] Upon the orders of the monarch, people planted extensive stands of it on hilltops. They placed newly hatched silkworms in the

bushes, and dug ingenious trenches around the stands to prevent their escape (Dubois 1938:283; Mayeur 1913 b:35).[13]

Another option available to highland weavers was imported, foreign fibers. From an early date they purchased skeins of Chinese mulberry silk from Arab and Indian merchants to create decorative work on cloth of indigenous silk (Ellis 1838, 1:399). In the 1820s, King Radama I—with the aid and encouragement of artisans sent by the London Missionary Society—introduced and promoted the raising of mulberry plants and Chinese silkworms (*Bombyx mori*) on the island. At a great public gathering in 1823, he distributed cuttings and promised prizes to local leaders who excelled in the activity (Ellis 1838, 1:301).[14] His successor, Queen Ranavalona I (1829–61), had her private artisan, the Frenchman Jean Laborde, work with a guild of male Malagasy weavers to continue experimenting with raising, dyeing, spinning, and weaving varieties of mulberry silk.[15] In one year alone they could produce four hundred pounds of the raw fiber (Grandidier and Grandidier 1928:171).

Although labor intensive, the raising of mulberry silk was enthusiastically taken up by the wider Merina population. The worms had to be raised indoors on specially constructed racks and fed three times a day with finely chopped mulberry leaves. Unlike indigenous silk, *Bombyx mori* cocoons could be reeled, that is, unwound in a single thread just as the worm made it. British envoys introduced the reeling machines that made this possible, and mulberry silk became the most expensive type of silk thread, called *foly tsipay* or *lasoa* (Callet 1981, 3:375). Many weavers, however, chose to recreate the thicker texture of indigenous

FIGURE 19 **A fine and rare example of the highest grade of raffia cloth made in Imerina.** Spun raffia, natural dyes, 120 by 190 cm. Late nineteenth–early twentieth century. Museum purchase 87-9-1. National Museum of African Art, Smithsonian Institution. Photograph by Franko Khoury.

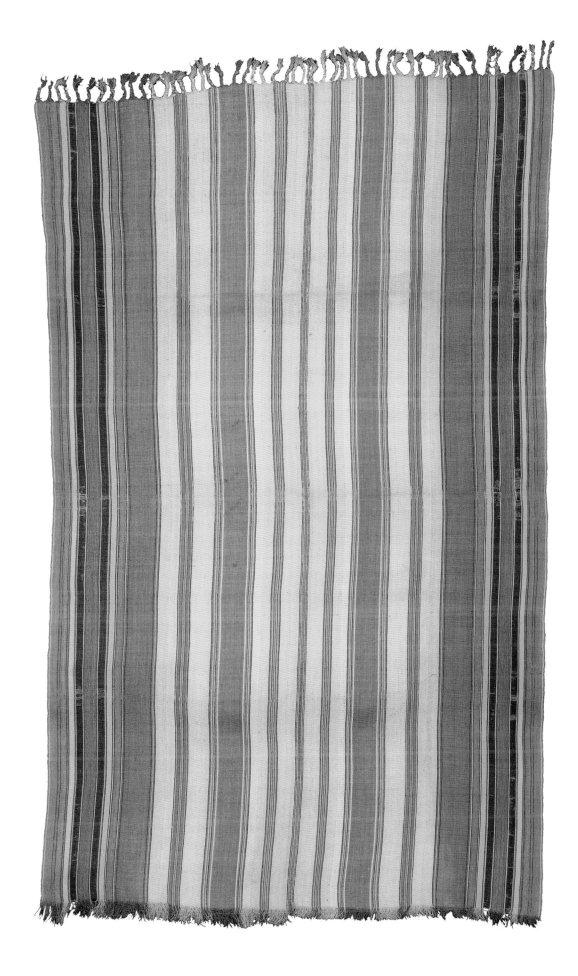

silk: the moths were allowed to pierce the cocoons, thus breaking the continuous filament. The "damaged" cocoons were then carded and spun.

The vast network of highland markets created and coordinated by Merina sovereigns overflowed with these fibers, and the markets also served as points of sale for finished cloth. As early as the seventeenth century, the silk cloth of Merina weavers was being traded throughout the island (Grandidier and Grandidier 1928:561). The income, prestige, and household power that accrued to highland women from the sale of their cloth was substantial (Larson 1992).

NOT ALL STRIPES ARE THE SAME
Colored striping was the primary decoration of Malagasy textiles and the main criterion for distinguishing among the various types and styles of cloth. Women used the island's abundant dye sources to great effect. They most frequently produced the colors black and red (the latter closer to maroon or brown), and to a lesser extent, yellow, green, blue, and orange. The general process entailed soaking or cooking skeins of yarn with a vegetable source, mostly bark or leaves, and then using sunlight and potash to fix the colors.[16] These natural sources produced deep, dramatic

shades on cotton and silk and lighter, even pastel shades on bast and raffia fibers. Imported dyes were also in common use in some areas by the 1820s (Ellis 1838, 1:327). Any further discussion of striping, however, requires a few words about Malagasy looms.

Three loom types were historically in use (Picton and Mack 1989). The backstrap loom (fig. 20), probably of South or Southeast Asian origins, and a double-heddle loom with pedals were employed in limited areas. The predominant loom type was the fixed-heddle ground loom (see fig. 5). As its name implies, it was positioned horizontally, lying close to the ground. For our purposes, what is important to note about Malagasy looms is that the heddling system in most cases produced a plain-weave structure, mostly of a warp-faced pattern, in which only warp (longitudinal) stripes were possible.

Weavers made the most of this, playing with stripe width and combinations of colors to create hundreds of subtle variations in striping patterns. Many Malagasy textiles exhibit distinct, recognizable striping aesthetics. Stripes were grouped in discrete symmetric bands—usually one wide stripe playfully surrounded by numerous narrow stripes (in some areas respectively called "mother"

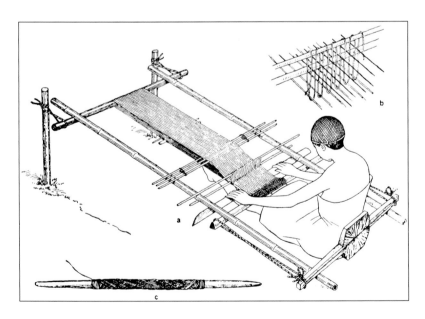

FIGURE 20 **The backstrap loom used by the Zafimaniry for weaving with** *hafotra,* **or spun bark fiber.** Reproduced from Linton 1933:103, courtesy of the Smithsonian Institution Libraries, African Art Branch.

and "child"). These bands were repeated in various sizes and combinations throughout the cloth in a sort of "theme and variation" pattern. Alfred Gell's analysis (1998) of decorative art, with its observation that repetition and symmetry are used to animate the object, can help us to further appreciate these stripes. Weavers' frequent placing of a single yarn of light color next to a wider dark stripe, or vice versa, added great depth and texture. The joining of two identical panels created a symmetrical composition, often of three fields that appear to radiate from the center outward (Fee 2002) (see fig. 19). In the most complex compositions of stripes, attempting to pinpoint how and where the symmetry begins and ends only confounds the viewer and "tantalises our capacity to deal with wholes and parts, continuity and discontinuity, synchrony and succession" (Gell 1998:95).

While European authors wrote vaguely of "striped garments," each warp stripe pattern had, in fact, a specific local name. At any one time in any one area, a limited number of patterns—perhaps five or six—was in fashion. Of the *hafotra* cloth made by the Zafimaniry in 1927, the anthropologist Ralph Linton (1933:94) observed that 90 percent was of one striping model (shown in fig. 16). Weavers demonstrated their skill by replicating these striping patterns and slightly improvising on them; they knew what was central to the design and what was open to modification. Both the cloth of neighboring groups and overseas imports, notably from India, Oman, and Zanzibar, could serve as inspiration for new striping patterns (Noel 1842, cited in Vérin 1985:389).

One notable exception to the replication of established striping styles was found in the cloths woven to wrap the corpses of Betsileo kings. These had to be unique and personalized. According to Betsileo belief, after death the king's spirit was reborn in the body of a seven-headed water serpent (*fananompitoloha*). Kin could recognize the spirit and then pay it proper homage because, as they watched, "the serpent would display . . . the colors

of each of the cloths it had been buried in, one by one" (Callet 1981, 2:371). The Field Museum of Natural History holds a rare example of such a cloth (fig. 21), collected by Ralph Linton in 1926; it exemplifies the required personalization.[17] The striping pattern on this primarily black silk cloth appears to be original and unique. Intricate designs in metal beads are worked on all four sides of the cloth and are used to spell out the owner's name and the date 1915.

In a recent study of Indonesian weaving, Sandra Niessen (1999) observed that scholars have wanted to see non-Western textiles as "authentic," timeless works, not as fashions that can go in and out of style. Cloth making in Madagascar was certainly tied to the whims of fashion; striping patterns emerged, were made for a generation of two, and then died out, replaced by new ones. Historic sources mention dozens of names of *lamba* that no longer exist. Niessen made another observation pertinent to Madagascar: although many styles disappear—part of the natural, long-term rhythm of textile traditions—others emerge as "core styles" that may endure for hundreds of years. Two such examples of core striping styles in the Malagasy weaving repertoire are the *arindrano* and *lambamena*.

Arindrano

This style is named for the southern Betsileo kingdom where it originated. The cloth, of either cotton or silk, is distinguished by a series of narrow black and white stripes at its center, called the *haratsana* (Rasoanasolo 1989) (see fig. 35). At least six varieties are known. The bold colors of the *arindrano* made it a very popular style that was in great demand throughout the island. Ultimately, weavers of other regions incorporated it into their repertoires and produced it themselves, first in Imerina and later in the south (Fee 2002). Worn both as a ceremonial and as a fine everyday *lamba*, the *arindrano* figures frequently in nineteenth-century photographs (see fig. 7).

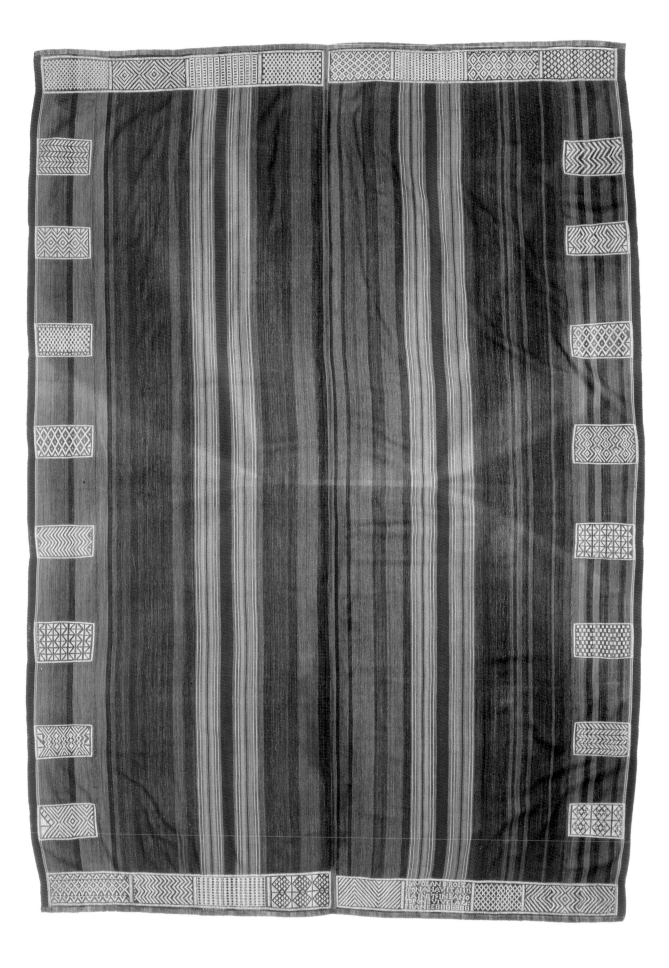

FIGURE 21 **Betsileo "king's cloth."** The cloths used as burial wraps for a Betsileo king had to be highly personalized so that his kin could recognize and honor him in his next incarnation—as a seven-headed water serpent whose skin took on the pattern of the cloth. Wild silk (from the *Borocera madagas-cariensis* silkworm), natural dyes, metal beads, 216 by 150 cm. Collected by Ralph Linton, 1926–27. The Field Museum of Natural History, Chicago, catalog no. 184,093, negative no. A113875c. Photograph by John Weinstein.

Lambamena

Today in Imerina, the term *lambamena*, literally "red cloth," may denote any kind of burial shroud, no matter what its color, even those that are un-dyed. In the nineteenth century, however, the *lambamena* had a more precise form and a much wider usage. It is not redundant to emphasize that the *lambamena* was historically red. Historical sources state unequivocally that it was of "a dark, almost maroon color which is produced by . . . the bark of a tree called *nato*" (Wills 1885:93).[18] Each of the panels was commonly embellished with two wide black stripes edged by narrow green or yellow stripes (or both), and the borders were decorated with either metal or glass beads (see figs. 65, 66). To accommodate reburials (discussed later in this chapter), highland weavers also made *lambamena* of three or more panels. The style appears to have originated with either the Merina or the Betsileo, who traded great quantities of it to coastal peoples, whose weavers in turn produced cotton, silk, and *hafotra* versions of it.

Because of the current strong belief in Imerina that wild silk and *lambamena* can be used only for wrapping the dead, it is worth stressing that historically the *lambamena* was also worn by the living.[19] Throughout the island, a red silk cloth was the unmistakable sign of authority, of the noble or chief. Within Imerina, monarchs assigned its use to particular groups who performed special ritual functions at the court or served as judges. The *lambamena* was also the required dress in many ceremonies, for people who were coming into

contact with sacred forces. The Merina New Year's festival and marriage and circumcision ceremonies all required the central participants to wear *lambamena*.

Associated with authority, high rank, and sacred forces, the *lambamena* became the preferred style of cloth in many regions for clothing ancestors. Indeed, many observers imply that no other type of cloth was used to wrap the dead (Wills 1885:97). In the late nineteenth century, the Merina largely discontinued wearing *lambamena* as clothing, using it solely as burial cloth. The reason for this shift may be tied to the larger sociopolitical upheavals of the time, in what the anthropologist Gillian Feeley-Harnik (1984) has termed the "political economy of death." As a strategy for coping with French domination and colonization, the Malagasy transferred their allegiance from living rulers (whom the French could control) to dead rulers and ancestors (whose authority remained out of reach to the French). Living, French-appointed officials could not claim to take their power from the traditional cosmological system that gave leaders and the *lambamena* their force and meaning. Only ancestors could represent, and were entitled to, the symbols of that sacred power.

ADDITIONAL DECORATION

In addition to their striping patterns, cloth styles could also be named and classified according to other types of decoration, which included *ikat* dyeing, beadwork, weft twining, and supplementary weft floats.

Ikat (laimasaka)

Warp *ikat* was a striking but rare form of raffia textile decoration in Madagascar (fig. 22). Historically, it was produced in only a small area, the Bongo corridor on the Sakalava northwest coast (map 2).[20] The basic technique of *ikat* involves laying out the warp and tightly binding with raffia the area to be left undyed, then running it through

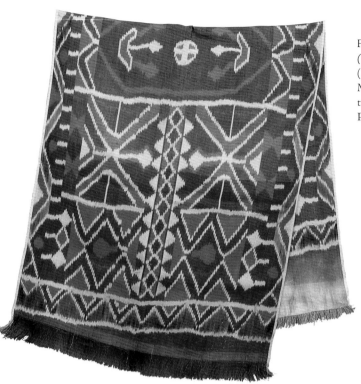

Figure 22 Panel of raffia cloth with *ikat* designs *(laimasaka)*. Sakalava people of Bongo territory (Kandreho). Raffia, aniline dyes, 180 by 71 cm. Museum acquisition 72-1-32. Institut de Civilisation, Musée d'Art et d'Archéologie, Madagascar. Photograph by Iariliva Rajaonarivelo.

Figure 23 Raffia mosquito net or tent with *ikat* designs *(laimasaka)*. Sakalava people of Bongo territory (Kandreho). Raffia, aniline dyes, 311 by 311 cm. Collected by Ralph Linton, 1926–27. The Field Museum of Natural History, Chicago, catalog no. 186,442, negative no. A113879c. Photograph by John Weinstein.

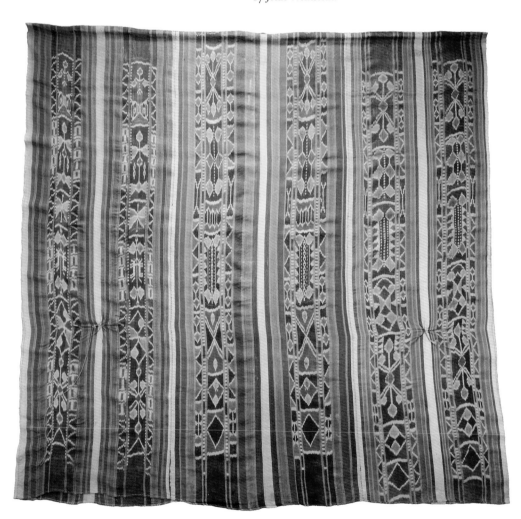

a series of dye baths. In Malagasy *ikat*, humans, cattle, and crocodiles formed some of the distinctive central motifs. *Ikat* cloth was known as *laimasaka*, which means "cooked hanging/tapestry." As the name implies, it was destined not for clothing but for various types of drapery. These included room dividers, tents, mosquito nets (fig. 23), burial shrouds, and Islamic prayer rugs (Mack 1989:42). They may well have played important ritual roles, for tents and hangings are integral to the royal rituals of the various Sakalava kingdoms (Ballarin 2000:79, 81, 104). Sadly, researchers were so preoccupied with finding the overseas origin of Madagascar's *ikat* tradition that no one made a serious field study of it until 1972 (Heurtebize and Rakotoarisoa 1974), when it was no longer being made and only a few old women remembered the techniques. Its past meanings and uses thus remain largely unknown.

Beadwork (firaka, vakana, harea)

Any style of cotton or silk cloth could be embellished and its value greatly increased by the addition of beadwork, using either monochrome glass beads of foreign import or metal beads (tin, lead, or silver) of local manufacture.[21] Several rows of bead designs were generally arranged along the weft (horizontal) edges and center of the cloth or loincloth (fig. 24) and on the back of the woman's upper garment (*akanjo*). The beads were attached by being strung on a separate weft thread and anchored around warp yarns. Although monochrome glass beads were also used for medicinal purposes, to decorate talismans (*mohara*), and as offerings to *vazimba* spirits, their arrangement and use on cloth seems to have been dictated by aesthetic and social considerations, including the display of wealth. In some regions the term for glass beads, *harea*, is a synonym for wealth. In the highlands in the 1770s, the finest, most expensive cloths were those lavishly decorated with metal beads, which were said to be worth six or seven slaves (Mayeur 1913a:160).

Weft Twining (akotso, vahotse)

Weft twining or wrapping was another method by which weavers adorned the ends of cloth with geometric designs. This technique entails manually wrapping separate weft yarns around warp threads. In the south, weavers worked a single yarn across the weft, whereas Betsileo women of the highlands employed a loop of yarn to create two rows at once. It was southern weavers who created the most complex twined designs to decorate the ends of men's loincloths (see fig. 34). These veritable labors of love often employed four colors and showed great variety in motifs. Recently, Simon Peers (2002) for the first time noted and described other sophisticated techniques of warp and weft twining that highland weavers used to finish the ends of cloth—techniques with direct parallels in Southeast Asia (see figs. 43, 44).

Weft twining 1: Southern single yarn technique

Weft twining 2: Betsileo "loop" technique

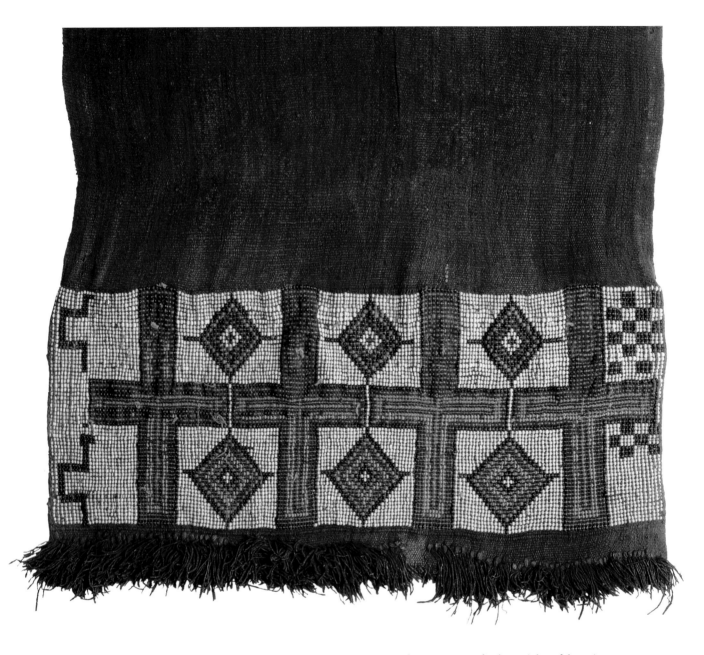

FIGURE 24 **Loincloth with glass beads** (*sokotry miloha harea*). Tandroy people. Wild silk (*Borocera*), natural dyes, glass beads, 252.0 by 35.5 cm. Collected by Ralph Linton, 1926–27. The Field Museum of Natural History, Chicago, catalog no. 186,780. Photograph by John Weinstein.

opposite:
FIGURE 25 *Akotofahana* **cloth.** Merina people. Reeled silk, imported dyes, 177 cm long. Nineteenth century. © The British Museum, London, acquisition no. 1949.Af10.1. Photograph by J. Keeves.

Supplementary Weft Floats (akotofahana)
The *akotofahana* (or *akotifahana*) cloth is named for its geometric designs, which are created by adding colored weft yarns that "float" over the ground weave (see figs. 60, 61). These cloths, of fine reeled silk and dazzling color, became favorite "curios" for European collectors in the nineteenth century. Both the technique of *akotofahana* and the use of the finished cloth remained confined to the Merina.

Often vaguely described as "diamond or coloured work" (Ellis 1838, 1:325), and incorrectly

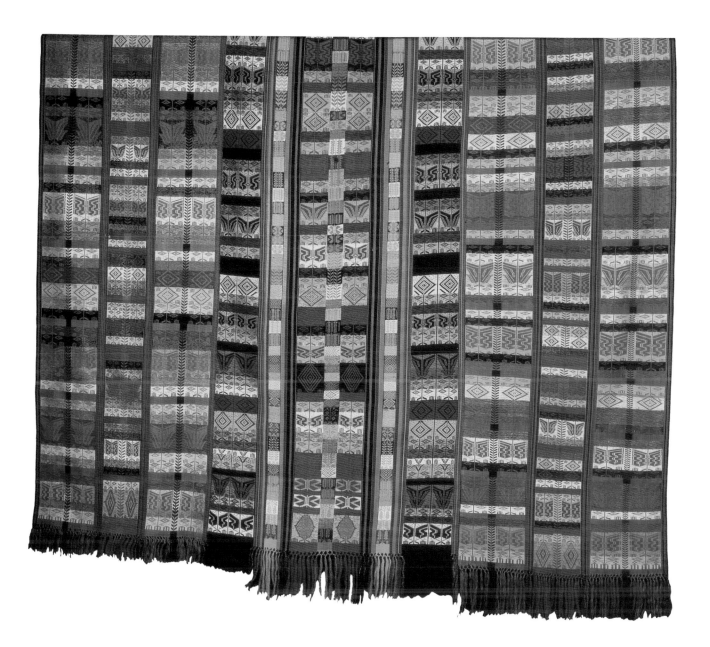

referred to as "embroidery," *akotofahana* motifs are, technically speaking, discontinuous weft floats formed through the use of supplemental heddles held by stands. The weaver lifted a certain number of warp threads and passed a separate weft of low-twist colored silk under them to create the motif. Merina weavers used both local and imported dyes to create dazzling combinations of colors and complex patterns reminiscent of stained glass (fig. 25) or "a setting of sparkling precious stones" (Carol 1898:231).

Although the source of inspiration for these cloths—whether internal or foreign—is yet uncertain, the name *akotofahana* points to an early Arab association. *Akoty* was the Malagasy term for both a type of silk yarn and cloth imported to Madagascar in large amounts from the sixteenth century onward. In the mid-seventeenth century, Indian merchants of Surat annually sent two ships filled with *akoty* to the western port town of Mahajanga (Dumaine de la Josserie 1810:28).[22] Evidence suggests that this imported silk was indeed used to create decorative work (Ellis 1838, 1:279, 339).

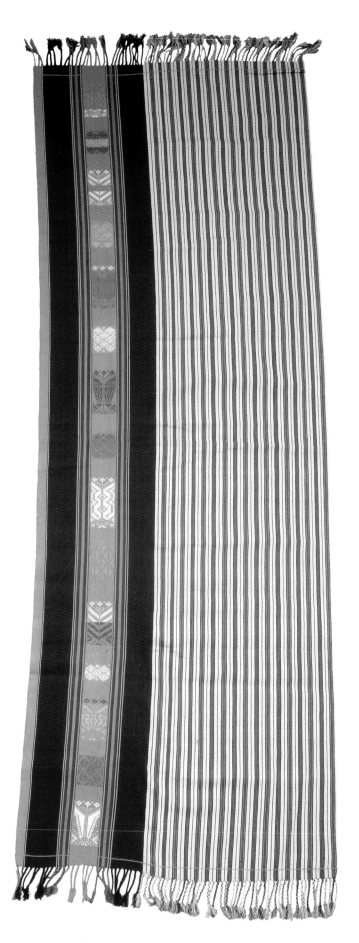

Plants are one of the recurring, recognizable *akotofahana* motifs. Simon Peers (1995a:46) suggested the interesting possibility that they might have taken their meaning from the ranked system of honors accorded by Merina sovereigns in the nineteenth century, called *voninahitra*, literally, "flower of the grass." This imagery, however, appears to have been based more on the opposition of "above" and "below" than on the grass itself, which has negative, asocial connotations.[23] Others see animals in the motifs and impute deeper levels of meaning to them—for example, that they might represent "birds of life" (Philadelphia Museums 1906) or butterflies and ancestral spirits (Green 1996). It appears more likely that the motifs and overall style were of "external and commercial" inspiration (Mack 1987:88), incorporated and appreciated for aesthetic effect alone. Whatever their origin, weavers and wearers have glossed these designs—even abstract ones—with Malagasy names and interpretations.

The Merina highly esteemed the *akotofahana* as "the highest form of dress" (Ravelojaona and Rajaonah 1965:167). Specifically, "these lamba are worn by the non-military chiefs of the people on important public occasions, and by the upper classes of both sexes on special festivals" (Wills 1885:94). They could also serve as burial cloths for members of those groups. Curiously, though, they rarely appear in the visual record. The few that do, along with other descriptions, indicate that *akotofahana* rarely had figures worked across the entire length, but only along the two vertical borders (fig. 26). Like other styles, the *akotofahana* had waned in popularity by the late nineteenth century, when foreigners began to complain of their scarcity.

Figure 26 *Akotofahana* **cloth.** Merina people. Reeled silk, imported dyes, 223.5 by 71.8 cm. Peabody Essex Museum, Salem, Massachusetts, acquisition no. E27,566. Photograph by Mark Sexton.

Cloth in Motion: The Social Significance of Malagasy Textiles

Once cloth leaves the loom, it begins a new "social life," entering new circuits and acquiring new meanings as human actors interpret and use it. As both metaphor and physical object, cloth in Madagascar is a primary maker of identity, defining the person and the social world. It also distinguishes different types of people on the basis of region, rank, and wealth. Another significant role played by Malagasy textiles has so far been largely ignored in the literature: it becomes the "material manifestation" of kinship when it is offered as a gift to create and sustain social relations. Formerly, not just intragroup kin relations but also intergroup and political relations were marked by gifts of cloth. The latter form was most evident in the Merina kingdom of the central highlands, which came to rule most of the island in the nineteenth century. Cloth was one of the items exchanged between Merina sovereigns and their people, including the Europeans who increasingly became part of this world.

CLOTH AS "SOCIAL SKIN"

The uses of cloth give rise to metaphorical associations and adages, which in turn reinforce its uses. The Malagasy consider cloth a second skin, a "social skin." A much-repeated Malagasy proverb likens the cloth of humans to the feathers of a bird, inseparable from the wearer. Cloth covers a person throughout the stages of life, from an infant held in the folds of its mother's *lamba* (see fig. 4) to an old person's final journey to the grave: "Living, you wear it around the shoulders; dead, you are wrapped in it." Like skin, the *lamba* is a protective covering that shields the wearer from threatening outside forces (Feeley-Harnik 1989:83). In saying and in practice, the *lamba* could symbolize the body itself: "What harms the *lamba* also harms the body" (Callet 1981, 2:342). A cloth was thus closely identified with its individual owner. It could stand for him or her in certain rituals, such as the purification rites following participation in

a burial. A man might leave it in the house of a lover to mark his "claim." In some areas, it was considered incestuous for a person to don the cloth of a proscribed sexual partner (e.g., for a daughter to wear or use the cloth of her father).

On another level, however, Malagasy assert that human cloth is categorically different from a bird's feathers. Wearing cloth requires consciousness and actions of which only humans are capable. In Madagascar, self-control and recognition of nakedness and "shame" (*henatra*) are fundamental signs of the socially cognizant person. In this sense, clothing separates humans from animals, the social from the asocial (Fee 1997; Feeley-Harnik 1989). It is the absence of clothing that best illustrates this concept. Young children, still animal-like, unaware of pollution and shame, in the past were generally left unclothed. If an infant died, it was not entitled to burial cloth (Green 1996). Removing the *lamba* is, therefore, for the Malagasy an immediate sign of and prime metaphor for someone who has left the social world. "Throwing off the *lamba*" (*manary lamba*) is a common expression for someone who has gone insane, and "unable to keep the *lamba*" (*tsy mahatan-damba*) denotes a person overcome by emotion (Ramarozaka 1990:31). A determined girding of the loins, on the other hand, is a sign of and metaphor for hard work and purpose. Witches are said to purposefully remove their clothes in order to dance on tombs (Feeley-Harnik 1989:79). Both they and criminals were stripped naked for trial or execution, and their bodies were left unwrapped and unburied (Callet 1981, 3:221). If the accused was cleared of the charge, however, the family waiting nearby immediately asked "'for what is good and for grace,' and they were given back the *lamba*" (Callet 1981, 3:221).

These widely shared associations made cloth a primary metaphor in the political language of the highland Merina kingdom. "Cloth" was a common figure of speech referring to the populace.[24] Just as cloth clothes and protects the person, so

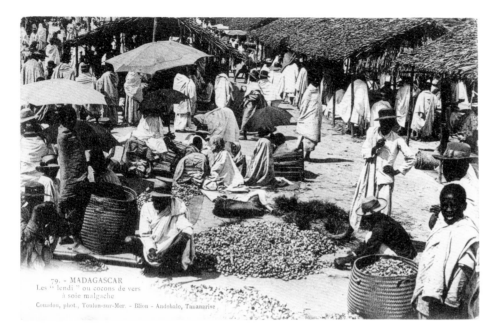

79. - MADAGASCAR
Les " lendi " ou cocons de vers
à soie malgache
Couadou, phot., Toulon-sur-Mer. - Blion - Andohalo, Tananarive.

FIGURE 27 In the nineteenth century, wearing white trade cloth became the sign and privilege of the free classes in Imerina, and the streets of highland towns appeared like "sinuous white streams." This postcard shows a crowd gathered at a silk cocoon market. Collotype. Photograph by Couaudou, c. 1900. Published by Blion, Andohalo, Tananarive. Postcard collection, MG-16-6, Eliot Elisofon Photographic Archives, National Museum of African Art, Smithsonian Institution.

a king's subjects provided a thick, impenetrable mantle around the monarch, who praised his or her subjects in speeches: "Happy, I wear it on my shoulders; angry, I wrap it around my waist." Cloth imagery was also central for expressing treachery and subversion. Capital crimes were known as "a cloth pattern unloved by the sovereign." Turning over or wearing inside out (*vadika*) and concealing (*voho*) were prime expressions for treachery and treason. Thus sovereigns called for their people to be like the guinea fowl, of one feather pattern, or like a fabric that is "easy to wear," "which has neither a front nor a back." By the nineteenth century, Merina commoners indeed were all clad in white calico wrappers (fig. 27), appearing like a single, "sinuous white stream" at public gatherings (Brown 1978:248).

I indicated earlier in the chapter that regional dress could vary by fiber, length, and style. As the Merina attempted to conquer and unify the island

In Madagascar, the human body is the primary locus for aesthetic attention. This is due not to vanity, as many European authors have implied, but to people's use of the body to communicate, and even create, identities related to ethnicity, rank, or wealth.

in the nineteenth century, dress emerged as one of the ways for groups to differentiate themselves and assert regional identity. In contrasting his people to the Merina, and in asking that they be allowed to keep their local customs, one Betsileo leader pleaded, "Here we dress in hemp, tree bark and mats" (Callet 1981, 3:310). This trend was also evidenced in the adoption of foreign fabrics. The Boina Sakalava of the northwest coast, whose ports hosted a sizable population of Indian and Arab traders and whose sovereign converted to Islam in 1824, increasingly incorporated Zanzabarian styles of dress for men and women (fig. 28). The east coast and highlands, with their trade and political ties turned toward the European holdings off the east coast, slowly adopted European dress (fig. 29). Whereas coastal groups preferred brightly colored, printed calicoes for wrappers, the Merina merchants and administrators in their midst kept to sober white trade cloth.

Rank and wealth, too, were expressed through body adornment. The Malagasy largely understand sociopolitical hierarchy in terms of the cosmological notion of *hasina*, a "mystical force of primacy" (Bloch 1986:41). Elders, nobles, and ancestors possess the greatest amount of this life-giving force

FIGURE 28 Indigenous group in elegant dress, Antsiranana *(Diégo-Suarez—Groupe d'Indigenes en grande toilette).* In northwestern port towns, the elites adopted Swahili or Zanzabari styles of dress. These included a skull cap, fitted jacket, and cloth wrapper for men and brightly patterned wraps and fitted blouses for women. Collotype. Photographer unknown, c. 1900. Published by Grand Bazar Charifou-Jeewa. Postcard collection, MG-20-10, Eliot Elisofon Photographic Archives, National Museum of African Art, Smithsonian Institution.

FIGURE 29 Malagasy family, Fianarantsoa *(Fianarantsoa—Famille malgache).* People of the east coast and the highlands adopted articles of European dress throughout the nineteenth century, although the *lamba* was often worn over the Western garments. Collotype. Photographer unknown, c. 1900. Publisher unknown. Postcard collection, MG-20-9, Eliot Elisofon Photographic Archives, National Museum of African Art, Smithsonian Institution.

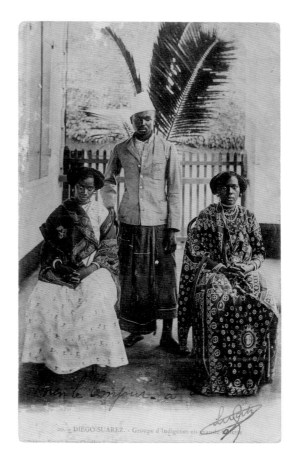

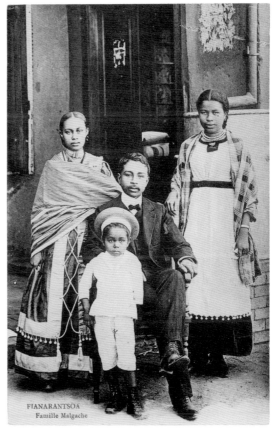

and transfer it to social inferiors in exchange for homage. *Hasina* is not an abstract concept but is manifested in prosperity and wealth. External appearance is inseparable from internal state. In the different regions, certain colors and fibers— or the quality of their preparation—were associated with different elements of the population: nobility, commoners, and the various categories of slaves. Everywhere, though, silk, particularly red silk, was the privilege and unmistakable sign of the noble or chief (Mack 1989:43). A central act of "crowning" a new monarch consisted of dressing or presenting him or her in red before the assembled people (Beaujard 1983; Callet 1981, 4:112). Red hats were another important part of this regalia.[25] The choice of the color red to mark leaders may have resulted from early Indian or Islamic influences in Madagascar (Beaujard 1988). Throughout the island, red is associated with the north, strength, the heavens, and the royal destiny, Alahamaly. The high value accorded to silk, and its association with nobility, stems from other complex layers of association.

Rebecca Green (1996) identified many of the material properties of silk that account for its great value: durability, sheen, and warmth. Durability

appears to be the key consideration, for it assures longevity to the ancestor or sovereign who is dressed in silk; thick, warm cloth is a metaphor for a strong and loyal following. The Malagasy practice of only partially degumming silk may, then, be intentional, to add to its longevity. But silk also has sacred dimensions (Mack 1989:13). In Imerina, the sovereign, the royal talismans (sampy), the ancestors, and silk were all subsumed under one category, Andriamanitra, "perfumed lord," which applied to all that was valuable, divine, or wonderful.[26] Indeed, originally they were one being: silk cloth was an integral component of Malagasy royal sacred paraphernalia. The container of wood or crocodile teeth that housed the royal spirit was attached to, or wrapped in, meters of silk cloth. This was the common form of the Merina royal talismans as well as of the royal relics of the Sakalava and Tanala kingdoms (Ballarin 2000:87, 89; Beaujard 1983:323; Callet 1981, 1:180, 205).

The notion of purity—another Malagasy idiom for social hierarchy—may account in part for the inclusion of silk in the category Andriamanitra. Highland Malagasy consider silkworms to be "clean" animals that, like the sovereign, perish if exposed to bad odors and polluting substances such as excrement, carrion, or corpses. Working with silk fiber required a continued respect for this purity. Women were prohibited from spinning or weaving silk during menses or when a death occurred in the household, in which event the loom and all other implements were immediately removed until after the burial.

In any event, the ties between silk and nobility ran deep, most notably among the Merina of the central highlands. Upon the deaths of nobles and sovereigns, the interior walls of their homes were lined with silk cloths (Green 1996:62). Two low-ranking noble groups, the Andriandranando and Andrianamboninolona, were assigned the task of spinning and weaving silk for the sovereign. Other "privileges" linking nobles to silk might appear more dubious. Unlike common

criminals, Merina nobles were allowed to dress in their finest silk garments before execution. To conform to an edict against the spilling of noble blood, royals who were to be put to death— including King Radama II—were typically strangled with a silk cloth.

It seems, however, that Merina commoners, at least after 1823, also wore silk when in contact with ancestral forces. The *Tantara ny andriana*, or royal history, a collection of nineteenth-century narratives concerning the Merina kingdom first published in Malagasy in 1870 (see Callet 1981 [1873]), carefully specifies the types of cloth worn for ritual and public occasions. Most of the major rites of passage required silk: to carry an infant for the ceremony of first hair cutting, to drape the bride and groom at marriage, and to dress the main actors in circumcision ceremonies and the week-long New Year's Royal Bath. For the last event, only "traditional" objects such as calabashes and wooden spoons could be used, and "as for cloth, only silk could be worn" (Callet 1981, 2:61).

Ascribed rank alone, however, did not determine a person's position, status, or dress. Throughout the island, wealth became a competing base of prestige and power. Cattle, slaves, and cloth were the traditional means of counting wealth, and the newly rich were quick to acquire the silk cloths widely available for sale at markets. In the highlands of 1777, the finest of these textiles— indigo-dyed silk decorated with metal beads— could be had for 150 piasters or six or seven slaves (Mayeur 1913a:153, 160). Jewelry, especially silver chains, was another means of displaying wealth on the person. Once an individual had acquired property, he would invest in silver chains that were "as big and long as he was rich" and wear them conspicuously around the neck, chest, wrists, and waist (Grandidier and Grandidier 1917:178). The growing economic strength of commoners in Imerina eventually obliged King Radama I in the 1820s to lift the sumptuary laws restricting silk to nobles (Ellis 1838, 2:303).

Perhaps in response to this trend, sovereigns came to use not local silks but certain types of imported cloth to mark their status, sanctity, and legitimacy. Among the Sakalava of the west coast, ruling kings and queens had the sole right to wear certain precious and costly Arab silks (Feeley-Harnik 1989). Merina sovereigns, from at least the seventeenth century, employed imported red silk parasols and English scarlet broadcloth (*jaky*) to make visible their sacred status.[27] These items could not be sold or used by others, on pain of death. Foreign fabrics likewise formed an important part of the sumptuary display at the death of a Merina monarch. While the interior of the main palace building was lined with local silks, the exteriors of all five buildings in the palace complex, as well as the walkways and railings, were draped with various types of imported cottons (Callet 1981, 4:93). They also formed an important part of the grave goods, which, in the case of King Radama I, included "eighty suits of very costly British uniforms, hats and feathers . . . sashes, gold spurs . . . silks, satins, fine cloth" (Bennett 1887:312).[28]

The Malagasy population at large, too, increasingly adopted foreign fabrics and articles of dress throughout the nineteenth century.[29] Yet the vast majority of people continued to wear a *lamba*, of either handwoven or commercial fabric, over these articles. Ultimately, in many regions the *lamba* emerged as a sign of adherence to ancestral ways. In rituals that sought ancestral blessings, descendants continued to use objects familiar to them, such as calabashes, wooden spoons, and local cloth, to show their respect and allegiance. In Imerina, for the great annual New Year's Royal Bath, in which people sought benediction from ancestors both royal and personal, the entire audience was required to dress in handwoven Malagasy cloth.[30] Even the Merina queens of the nineteenth century, known for their sumptuous European dress, donned Malagasy female attire—a *lamba* and the chest covering, *akanjo*—for this event (Andriantsietena 1994:94).

As Europeans and their ways became increasingly threatening, in many regions allegiance to "ancestral ways" (*fomban-drazana*) began to take on new and highly political meanings, as did wearing the *lamba*. An early example comes from the highlands. When Radama II took the throne in 1861, he broke with his predecessors to ally himself with Europe openly and completely. Among other radical initiatives, he decreed a law requiring the population to dress in European attire (Grandidier and Grandidier 1956:7). The result was chaos and a popular rural uprising that spread to the capital, demanding the restoration of ancestral ways. Following Radama II's assassination, at the first public appearance of his successor, all the nobles and high-ranking officials—as well as the population at large—appeared conspicuously clad in *lamba* (Ellis 1867:319). Two revolts that would later challenge the French conquest of the island in 1895 used cloth imagery as their rallying point.[31] During the French colonial period (1895–1960), among some Sakalava groups, wearing wrappers and eschewing Western articles of dress for the annual royal rituals emerged as a central act for demonstrating continued allegiance to "ancestral ways"—that is, to the kingdom rather than to foreign polities (Feeley-Harnik 1989).

THE GOODWILL ENDURES
Anthropologists have shown that gift giving is a universal custom. In non-Western societies particularly, exchanging goods is often a crucial part of human relations and an integral feature of ritual. An obligation to give and to reciprocate goods binds people in long-term relationships and expresses the nature of those relations. The particular objects that cultures choose for their transactions often help to reveal that nature.[32]

In Madagascar, gifts of food and livestock are the most common media for creating and demonstrating social ties. But it is gifts of cloth that are required to form and sustain many of the most important relationships. Several cultural

understandings appear to inform the choice of cloth as gift. Like people of most other cultures (Schneider and Weiner 1989:2), the Malagasy see cloth as an object that binds or ties (*mifehy*).[33] Because the Malagasy intimately associate cloth with its individual owner, offering cloth is a way to give oneself to, or imprint oneself on, the other. So, too, giving cloth is a way to protect kin and make them both human and social. A Merina adage used in connection with gift presentation is telling: "Cloth wears out and silver is spent, but the goodwill endures." An exchange of material goods is needed to mark an event and prove the participants' sincerity, but the ultimate "good" acquired in the transaction is the creation of a long-term social tie. The choice of cloth, a perishable material, underscores a belief that human relations are fragile and must be periodically reactivated; as cloth "wears out," there is an obligation to replace it.

Cloth, then, for the Malagasy is the material manifestation of kinship, an "integrative social substance" that "conveys the nature of people's affiliations and their quality" and is used for "making and breaking relations" (Feeley-Harnik 1989:79). Giving cloth was an institutionalized aspect of certain social and political relations, prime among them those between lovers and spouses. As I noted earlier, female weavers conferred cloth on male kin, particularly husbands. But men, too, were expected to make gifts of cloth. Across the island it was the standard item given by a man to his lover,[34] and it was an institutionalized part of bridewealth (Grandidier and Grandidier 1914:184). A groom was required to present an ox to the bride's parents and a *lamba* to the bride, in order to "solemnize" the marriage (Raombana 1980, 1:189). Considered a fragile relationship, marriage at its many critical junctures required further gifts of cloth. A husband offered cloth to cajole an angry wife who had returned to her parents' home, and he gave it to a senior wife as a token of respect before taking a junior wife (Fee 1997). The sealing of a blood-brotherhood

pact might also involve an exchange of cloth between the two participants.

Living humans are not the only players who constitute social life in Madagascar, however. Ancestors (*razana*) and their mystical power are believed to hold the key to an individual's fortunes and misfortunes. Depending on the region, these ancestors may be the immediate forebears of a local household or lineage, or they may be deceased royalty. When pleased, ancestors bless the living with prosperity and fertility. With this power over their descendants' lives, ancestors understandably become the focus of lavish rituals and offerings, including gifts of the finest textiles.

Most Malagasy groups carry out their burial rites in two steps. In the first stage, kinspeople bind the corpse in cloth and bury it in a shallow grave or otherwise leave the body—which is considered "wet" (*lena*), polluting and dangerous—to desiccate. Some months or years later, when the remains have turned to dust and bones, kin transfer them to their permanent resting place, most often a large, above-ground communal tomb.

These funerary ceremonies are some of the most ostentatious and elaborate of Madagascar's rituals. Great public events that involve hundreds of participants, the rites mean many different things to the people involved and are rife with social and political implications that can change over time. They thus defy any simple or single explanation. Because cloth is central to these rites, following its movement through them allows us to identify many of the central players and their various goals. It also supports arguments that Malagasy burial rites may be less concerned with effecting a transformation in the status of the dead than with defining or redefining relations between the living and the dead.

According to Malagasy belief, the dead enter a new world where they live much as in this one. Immediate kin have the responsibility of ensuring the deceased's continued social existence by clothing him or her. Siblings, children, and

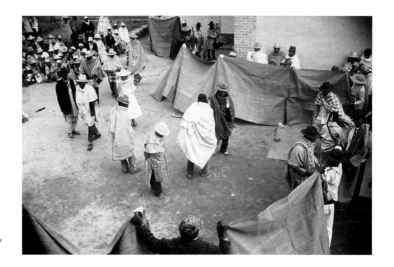

FIGURE 30 **At a preparatory ceremony** *(lanonana)*, **the greater community views and judges woven shrouds** *(lambamena)* **to be used during reburial rites.** Sandrandahy, Madagascar, 1993. Photograph by Rebecca Green.

grandchildren, both male and female, offer *lamba* in which to wrap the body.[35] In return, they receive blessings—especially highland women, whose fertility can be enhanced through contact with shrouds (Green 1996). The presentation of this cloth is also a time for competitive display as individual descendants vie to demonstrate their dedication and wealth; cloth offerings are often paraded conspicuously into the ceremony or held up for the assembly to view and judge (fig. 30).[36] Descendants may have yet another motive for giving the finest cloth available: to avoid ancestral wrath. When angered, ancestors have the power to curse people and to send illness and misfortune. The recently dead, angry at having to leave earthly life, may be especially hostile and may want to take the living with them.

Like other social relations, that between a person and his or her ancestors requires active and periodic demonstration. Descendants make invocations and offerings at various life junctures to obtain benediction for an undertaking or relief from hardship. Rum, honey, and animal sacrifices are the most usual offerings, but in many areas, descendants "remember" ancestors and acquire their blessings through gifts of cloth (Rajaonarimanana 1979). Neglected ancestors appear to their descendants in dreams, complaining that they are cold. To placate them, the family immediately falls to organizing a small ceremony to "offer cloth" *(ati-damba)*. Throughout much of the southeast of the island, among the southern Betsileo, Zafimaniry, Tanala, and Betsimisaraka peoples, descendants solemnly convey the cloth to the burial site and lay it atop the appropriate grave, or they open the communal tomb to place the cloth over the ancestor who has made the demand. In addition, the Betsimisaraka periodically wrap the standing rocks *(tsangambato)* erected in memory of ancestors with a piece of white cloth (fig. 31)—when inaugurating a new rock, and to thank an ancestor for answering a descendant's prayer (Razafiarivony 1995:143).

In the highlands, among the Merina and northern Betsileo, descendants take this act one step further by performing reburials, called *famadihana*.[37] Kin of the deceased open the collective family tomb and remove the ancestral bundles, whose cloth has begun to disintegrate. The closest family members touch, speak with, and cradle the skeletal remains before wrapping them in new cloth. They then dance with the bundles as they return them to the tomb, a ritual practice that has both fascinated and baffled Western observers.

Recently, the anthropologist David Graeber (1995) looked at burial cloth to offer a new interpretation of *famadihana*. According to Graeber, a central purpose of the *famadihana* is not to

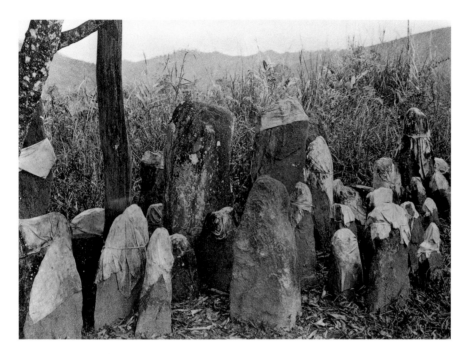

FIGURE 31 **Offerings of cloth to ancestors take several forms in Madagascar.** In the east, people tie pieces of white commercial cloth to memorial stones in order to honor and appease particular ancestors. Courtesy of Photothèque du Musée de l'Homme, Paris, negative no. C.42.2964.15. Photograph by E. Tessonière, c. 1880–95.

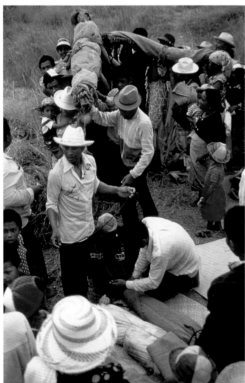

FIGURE 32 **Merina** *famadihana,* **or reburial ceremony.** Once the ancestral bodies have been securely wrapped in new silk cloth, family members dance in a joyous celebration with the newly enshrouded ancestors before returning them to the tomb. Ambatofotsy area, 1993. Photograph by Rebecca Green.

facilitate the "birth" of ancestors, the goal of many seemingly similar reburials in the ethnographic record. Rather, this is a performance that enables the living to come to terms with and actively forget their closest kin. It requires seeing and touching the body in its decayed state—a dramatic confrontation—to "really bring home the fact of their death" (Graeber 1995:269). But *famadihana* are also occasions for the living to "reverse" or "subvert" ancestral authority,[38] and in this cloth plays a vital role. Throughout their lives, children, particularly sons, experience patriarchal authority as an oppressive and constraining force. In *famadihana,* children have the opportunity to overcome this authority and establish a new political order. Women—daughters, to be precise—do this by cradling the ancestral bundles like swathed infants and treating them like children. Sons meanwhile use shrouds to turn violence back on their parents. They violently wrap and bind the corpses, crushing them in the process. Ultimately, shrouds serve to constrain the ancestors, to efface their identity as individuals, to contain their malevolent powers, and to mark them as irreparably separate from the living. Once the ancestors are securely bound in new cloth, there is a palpable shift in mood, and

participants dance joyfully with the bundles as they convey them back to the tomb (fig. 32).

The ambiguous and changing nature of a burial cloth, which begins its life as a pious gift but may ultimately be used to isolate the dead, is evident in funerary practices elsewhere on the island, where cloth or fibers may be cut or ripped to deny the dead access to the living.[39]

CLOTH AS GIFT AT THE MERINA COURT

Whereas the roles of cloth in *famadihana* have attracted great attention, scholars have so far largely ignored another related and highly developed institution of cloth giving. In the Merina kingdom of the central highlands, cloth was one of the primary material goods that flowed from subjects to sovereign and from sovereign to subjects.[40]

The Merina kingdom grew out of King Andrianampoinimerina's unification of the central highlands in the late eighteenth century. Through European aid and military conquest, his successors, including four queens, went on to conquer most of the island's coastal peoples, although their hold over many regions was contested and tenuous at best. In addition to military and administrative control, a major binding force for this sprawling precolonial state was the language and ritual of *hasina* (Berg 1995). *Hasina*, as noted earlier, is a mystical force that links all beings in a sacred stream. Social superiors—elders, ancestors, leaders—serve as the vital links between the heavens and the populace, transmitting the blessings that ensure prosperity and life. The political strategy of Merina monarchs was to reposition themselves at the top of this stream (Raison-Jourde 1991:98). They elevated blessing ceremonies to the level of state ritual, requiring people from all over the island to come and offer homage in the form of an uncut silver coin, also called *hasina*.

Cloth was another important physical medium through which subjects offered up homage in this sacred flow of *hasina*, which was at once a political, a religious, and an economic system

(Raison-Jourde 1991:98). Cloth was one of the "products of labor" that local populations had to offer when the sovereign passed through the countryside. In another category of offering called *satrana*, particular groups were assigned to supply goods—agricultural or manufactured—when required by the palace. Labor, too, flowed to the court in the royal service known as *fanampoana*. Two low-ranking noble groups were charged with spinning silk for the sovereign (Callet 1981, 3:56); other groups gave fine raffia cloth (de la Vaissière 1885:26). Provincial peoples also sent cloth toward the court, either fine handwoven *lamba* or the trade cloth that arrived in their ports (Raherisoanjato 1984:210). Finally, the death of a sovereign, the ancestor par excellence, provoked donations of large quantities of cloth, including ten *lambamena* from each of the six divisions of Imerina and each of the noble clans (Callet 1981, 4:92).

Unlike ancestors, however, living Merina monarchs were not just recipients of textiles. As social actors, they gave cloth as well, to create relations and mark particular events. In the logic of *hasina*, conferring these gifts was at the same time a form of blessing. In his great reorganization of Merina society in the eighteenth century, King Andrianampoinimerina erected stone megaliths and gave out cloth and red hats to mark the new rights and duties of groups and individuals. Many privileges he accorded for loyalty in battle or other special services rendered. Family histories record many instances of such gifts, including the case of a group of Antemoro priests from the southeast of the island, whom Andrianampoinimerina sent for, saying, "Fetch me those famous Anakara to the south; take them 1000 piasters and a piece of red silk cloth and a gold chain" (Mondain 1913:194).[41]

Like other relations, those between the sovereign and his or her subjects had the potential to "wear out" unless periodically "remembered" with gifts. During the second half of the nineteenth

century, the queen and her consort, Prime Minister Rainilaiarivony, conferred gifts of cloth regularly to those who surrounded and supported them. They bestowed fine handwoven silks on the highest military officers. To the vast majority of people, however, they gave imported cotton trade cloth taken from the great stores the sovereign amassed from duties paid in kind by foreign merchants on the coasts. Three times a year, all the court workers (*tandapa*), from water carriers to bread bakers to doctors, were assembled and given meters of trade cloth.[42] In addition, during their nearly daily official audiences, the prime minister and the queen bestowed trade cloth on students, soldiers, and subjects who had performed special services. As a natural extension, sovereigns also provided burial cloth at the deaths of loyal soldiers, servants, supporters, and keepers of the royal talismans—their own as well as those of their predecessors (Callet 1981, 2:501; Domenichini 1985:89, 95).

Royal gifts of cloth to a different category of person emphasized the gifts' latent political message. Bestowing cloth was one of the primary symbolic acts by which the Merina kingdom asserted its dominance over non-Merina people, who actively and consistently resisted its rule. When provincial leaders might finally offer their submission, the Merina sovereign presented them with a valuable red or black silk cloth and a silver chain.[43] The political consequence of accepting the gifts was to accept a subordinate position within the Merina sovereign's cycle of *hasina*.[44] This was underscored by the fact that provincial leaders were explicitly instructed to wear the cloth, a sign to all that their allegiance lay with and their power sprang from the Merina court. As King Andrianampoinimerina explained, "It is by [the red cloth] that you will be recognized . . . as a member of my family" (Callet 1981, 2:405).[45] This relationship was re-created annually when leaders made their mandatory visits to the sovereign's capital, Antananarivo, to repeat their oaths of allegiance and receive in turn new gifts of cloth.

CLOTH AS DIPLOMATIC GIFT TO FOREIGNERS

As another group that sought to forge ties with the Merina court, Europeans were drawn into cycles of gift giving with the sovereign and, after 1868, the nation's true commander, Prime Minister Rainilaiarivony. The many merchants, adventurers, and missionaries who flocked to the highland capital, Antananarivo, after 1820 were incorporated into court ritual and, perhaps unwittingly, into Malagasy logics of exchange. Europeans were expected to play a collective role similar to that of a (high-ranking) Malagasy group. Most notably, they had to offer the silver *hasina* coin at state rituals and official audiences. But to gain special favor at the court, individual foreigners lavished sovereigns with gifts. They tended to offer what they thought would impress the Merina, particularly mechanical gadgets such as clocks and microscopes, along with photographs (see Geary, this volume). Merina monarchs, however, following Malagasy exchange patterns, consistently demanded gifts of clothing. Europeans were soon obligingly spending enormous sums and rivaling each other to supply the finest satin and velvet confections to Merina monarchs.[46]

The basic hospitality provided by monarchs to foreigners consisted of provisions of rice, poultry, and cattle. But special relations were always—throughout the history of the kingdom until its abolition in 1896—marked by gifts of cloth and a chain or other metal object.[47] Among others, the American consul William Robinson, who served in Madagascar for fifteen years (1871–86) and advised the Merina government, received gifts of cloth on numerous occasions (see Arnoldi, this volume; Krebs and Walker, this volume).[48] It was also an established custom that the sovereign present to foreigners, as they left the island for good, a silk cloth and a piece of metal jewelry as a "product of the land they had known" and by which to remember the queen (Aujas 1912:143).[49]

By extension, silk cloth and a metal object became the official state gifts conferred on foreign heads of states and their representatives at momentous events such as the signing of treaties.[50] These tended to be the most lavish and sumptuous of gifts. The two French plenipotentiaries who signed the peace agreement of 1885, for instance, received four silk cloths each. Not only did such gifts reflect relationships, but they were also used to sustain or mend them. At particularly tense points in its foreign affairs—in 1834, 1836, 1863, 1882, 1886, and 1887—the Merina government sent diplomatic missions overseas bearing detailed analyses of the political situation and also silk cloths "to assure that our relations remain unchanged" (Aujas 1912:143).

At first glance, it might appear that these gifts of cloth from Merina sovereigns to foreigners—like those to conquered provincial leaders—served to fix Europeans as subordinates within the cycle of *hasina*. By the 1850s, however, the secular and religious dimensions of royal power were separating (Bloch 1986:161). The Merina government was fully aware of Europe's colonial ambitions and engaged in a battle of realpolitik whereby it tried to retain its independence by playing the French against the British and appealing to third parties such as the United States when needed. Its many gifts of cloth to these nations accomplished a number of new goals and reflected not only traditional Malagasy logic but also an astute sense of international diplomatic protocol and adept political maneuvering.

By getting foreign nations to accept the objects, the Merina government kept them as allies; it also received implicit recognition as the legitimate body to conduct the island's foreign affairs. The latter was crucial, because the French, to advance their own claim to Madagascar, openly disputed the Merina's claim to rule the entire island. The type of cloth the Merina government gave to foreigners points to another, related part of its strategy to retain independence from Europe:

to prove itself to be among the great "civilized" nations. The government believed that emphasizing its status as a Christian, and thereby "enlightened," nation—the court having converted to Christianity in 1869—would help stave off European aggression (Mutibwa 1974). Whereas provincial leaders received red or black silk cloth, foreigners were given *akotofahana*. It will be recalled that these were visually stunning cloths of reeled silk with complex geometric motifs. Europeans commonly cited the *akotofahana* as proof of the Merina's high level of "civilization." Merina monarchs appear to have exploited this association by sending such cloths to their political counterparts.[51] A change in the form of metal objects is further suggestive of this strategy. In place of the silver chain, imbued with many layers of local meanings, sovereigns began offering metal goods such as vases, rings, and brooches (see fig. 57), crafted objects that Europeans believed also demonstrated Madagascar's sophistication.

When Madagascar later became a modern, independent democracy, it would again tailor its official state gift to reflect its needs. In 1896, France invaded Madagascar, abolished the Merina monarchy, and, for the next sixty years, ruled the island as a colony, controlling its internal and external affairs. In opposition to this subjugation, a pan-Malagasy national identity began to emerge, culminating in 1947 in a massive anticolonial uprising. After achieving independence in 1960, the Malagasy government chose a new state gift to reflect its ongoing effort to refashion a national identity. The reeled silk cloth—specialty of the Merina court—was replaced by a mounted fossilized shell, a more neutral and inclusive symbol of the island. State officials may still offer cloth to foreign dignitaries today, but with noticeable differences: it is of cotton, and the *akotofahana* motif depicts *aloalo*, the funerary posts of the Mahafaly people, which have emerged as another national Malagasy symbol.

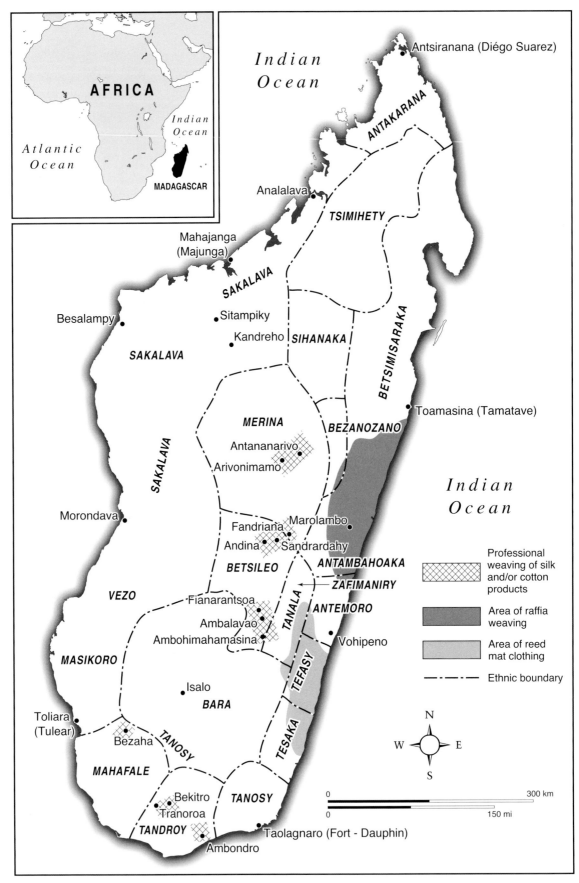

MAP 3 Contemporary textile-producing areas in Madagascar mentioned in the text.

Contemporary Weaving and Cloth Use

Throughout the twentieth century, observers predicted the demise and decline of Malagasy handweaving. At first glance, their predictions might appear to have come true. Nearly all Malagasy today choose to dress in factory-made cloth of Western tailoring. Statistically, few women weave. Fibers such as hemp, banana stem, and pigeon-pea silk disappeared from weavers' repertoires in the first half of the twentieth century, soon followed by *ikat*. Spun bark *hafotra* cloth is rarely woven today.

But the start of the twenty-first century finds resilience and renaissance in the island's remaining handweaving (map 3). The demand for handwoven cloth continues because of its close associations with gender, regional, ancestral, and national identities. Changing economic, social, and religious conditions—and fashion tastes—have also inspired weavers to modify old products and create new ones such as bow ties, bridal gowns, television covers, and coffee-table runners. This final section examines the four faces of contemporary weaving and cloth use in Madagascar and the social values attached to each. First, however, a brief word is in order concerning commercial cloth.

COMMERCIAL CLOTH AND EXPRESSION OF IDENTITY TODAY

The vast majority of Malagasy today dress in factory-made cloth and European-style clothing: shirts and pants for men, dresses for women. But this does not mean homogeneity or loss of meaning. Far from it. Social actors understand and use commercial cloth much as they did handwoven cloth.

Most rural Malagasy continue to wear a rectangular wrapper of commercial fabric about the hips or shoulders. They value its versatility and practicality, claim to feel naked without it, and view its use as positive identification with Malagasy ancestral tradition (*fomban-drazana*). All along Madagascar's coasts, it is the printed

hip wrap, the *lambahoany*, that is today celebrated in song and ritual (see fig. 38). These brightly colored wrappers, made in both Malagasy and foreign factories, depict Malagasy scenes and feature proverbs on the hem. How a person tailors and wears this cloth is a central marker of ethnic identity in the polyglot communities of the northwest coast (Feeley-Harnik 1989).[52] Sakalava women wear two pieces of cloth, a head cover (*kisaly*) and a long wrapper that sweeps the ground, which points to continuing Islamic influences on this group. The Tsimihety are recognizable for the short lengths of their wrappers, and the Merina women in their midst, for their shoulder wraps of embroidered white fabric.

Although handweaving is no longer practiced in the north, both the wearing and the giving of cloth, in the form of commercial fabrics, are still crucial to social life, as Feeley-Harnik has documented in a series of detailed studies (1988, 1989, n.d.). Today, commercially made wrappers stand for the "original clothing of the Malagasy people" (Feeley-Harnik n.d.). Wearing wrappers thus allows people to re-create "Malagasy time" (*faha-gasy*)—a time of glory and autonomy before Madagascar's subjugation by colonial forces and the encroachment of European ways—in the present. It also serves as a visual demonstration of their allegiance to the royal polity: when attending royal ceremonies, subjects are required to wear a hip wrap rather than Western apparel—a dress code common to contemporary royal ritual in many areas of Madagascar, including the southeast and highlands. The special red and white costumes used in the dancing battles that accompany these events both re-create for the audience the history of the kingdom and give expression to current sociopolitical struggles (Feeley-Harnik 1988).

Among the Sakalava, Tsimihety, and Antakarana peoples, cloth is still a significant gift. Throughout courtship, men offer clothing—printed hip wraps, dresses, or even blue jeans—to their beloved, and at marriage a man presents

his bride with a hip wrap in which his female kin dress her after a ritual bath.[53] Commercial cloth also serves as the appropriate offering to spirits. People whose wishes have been granted by the spirits of sacred tamarind trees wrap the trunk with red or white cloth. Cloth and dress are the major means of identifying and giving form to the royal spirits that live on in the bodies of female mediums (Feeley-Harnik 1989; Mack 1989). Finally, both monarchs and subjects continue to offer cloth, along with honey or money, to royal ancestors during the great royal rituals such as the Fanampoabe of Mahajanga (Ballarin 2000:132, 136, 137). Rather than signaling the homogenizing effects of globalization or the decline of "tradition," the Malagasy's adoption of commercial cloth has been a process of appropriation guided by local social patterns.

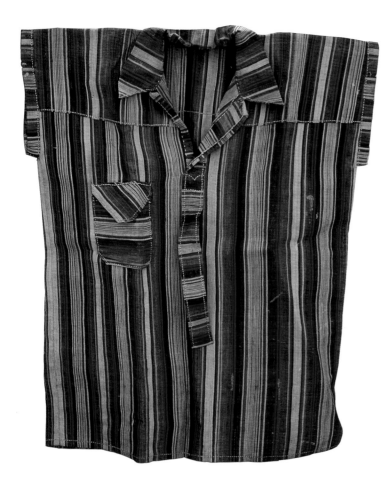

HANDWEAVING FOR DOMESTIC USE

In four areas, women continue to make fine handwoven cloth for local needs (map 3). In the rural southern Betsimisaraka area, ties between weaving and female identity remain strong and keep weaving an important part of women's work. Every year, Betsimisaraka women of all ages are expected to process, dye, and weave raffia work shirts (akanjobe) for their husbands and sons. Because these shirts are worn for heavy labor in the rice fields and forests and are soon covered with dust, it is easy for the casual observer to underestimate them. But they are again a message of love, and the finesse of the work can be astounding. Women insist on using the youngest, finest leaves and on producing an extremely tight weave. A weaver worthy of the name, I was told by Betsimisaraka women, should be able to make a cloth so fine and tight that it can hold water. Superiority in the art is still exemplified in the intricacy of the striping pattern, for even the chemical dyes weavers use today require skill to make and combine. The work shirt shown in figure 33 has a high thread count and complex striping.[54]

Similarly, many Antemoro, Tefasy, and Tanala women of the southeast coast continue to make reed vests and jackets for the daily work wear of their husbands and sons. This costume is valued for its practicality in the rain-forest environment: it does not tear and is water resistant. It may be visually unassuming, but the fine workmanship and personalized details such as pockets indicate that these, too, are gifts of love, as does the fact that women only rarely make mat wrappers for themselves, but rather use a panel of nylon gunny sack about the waist.

FIGURE 33 **Man's work shirt** (*akanjobe*). Betsimisaraka people. Raffia, aniline dyes, 70 by 89 cm. Institut de Civilisation, Musée d'Art et d'Archéologie, Madagascar, acquisition no. 64-1-182. Photograph by Iariliva Rajaonarivelo.

In the far south of the island, in Androy, men's continued use of the loincloth as ceremonial dress in several clans is linked to other facets of identity. First, it remains a sign of wealth: as all local observers are well aware, a ceremonial loincloth—of red silk with metal beads or of white cotton with twined borders (fig. 34)—costs more than an imported pair of jeans. Second, it stands for fidelity to ancestral ways. Most Tandroy men spend an important part of their adult years working far from their homeland, a thousand miles away in the north of the island. When they return, they wear the loincloth at public gatherings to show respect for and allegiance to ancestral custom and to demonstrate continued participation in the local community.

In Androy, as elsewhere, outsiders rarely see the finest handwoven cloth. Weavers make it as an offering to their own personal ancestors, who to this day are believed to have great influence over the living. Older Tandroy weavers continue to make elaborate red silk *lambamena*, cloths that are carefully stored and hidden from view, in preparation for their own death or that of a particularly revered family member. Rebecca Green (1996:27, 172) reported a similar custom in the highlands. The fine *arindrano* cloth shown in figure 35 was created in 1996 by two Merina sisters, aged eighty and eighty-five, for the reburial ceremony of their father, who was especially partial to that style. They spent two years preparing the fibers—growing, spinning, and dyeing the mulberry silk. When the ceremony was unexpectedly cancelled, the sisters, in need of money for medical expenses, decided to sell the cloth and make a new one from the dyed yarn they had ready.

The final place where handweaving continues for domestic use is the southern Betsileo region of Ambalavao, the original homeland of the famous *arindrano* cloth. Oddly, despite its great importance in Madagascar's textile history, this area has gone unnoticed by researchers.[55] Moreover, the sociopolitical importance of handwoven cloth appears there in a novel form previously undescribed for Madagascar—as an object with an individuated history. Families make and conserve a silk cloth called *lambabe* ("great cloth"), which descendants wear for ceremonial purposes as a badge of the local descent line. The older the cloth and the more it has been used, the greater its value.

The *lambabe* today is of one striping style, known as *sarimbo*, which is characterized by its alternating, evenly spaced stripes of black, white, yellow, and orange (fig. 36). Its two narrow ends are lavishly decorated with white geometric designs (*akotso*). These cloths are judged on the fineness of these designs and their size. Their meanings, however, are to be found in the conditions in which they are made and used. To mark and create their status as heads of a new, unique, and prosperous descent line, a married couple makes a *lambabe*. The husband must supply the costly silk yarn for the cloth, a public demonstration of his growing wealth and prosperity. The wife and her people, the "source of life," then make the cloth in her natal village. She and her many female kin work in shifts throughout the day until the cloth is completed, usually in two weeks. Her extended family must make ritual visits to "bring blessings" (*manatitsa tso-drano*) in the form of rice and chickens to feed the workers. When the cloth is finished, the husband can fetch it home only after presenting his wife and her kin with an ox, called *sorom-batritra*, "blessing the weaving sword."

Lambabe become the visible insignia of local families. They are stored in a locked wooden chest in the house of the head of the extended family and are brought out on only three occasions. As the representative of the group, the eldest man in the household wears it folded on his shoulder for official palaver (*kabary*) and other public events. For the first step in marriage negotiations, the bride and groom each come to the ceremony wrapped in the *lambabe* of their respective families. Wearing the cloth immediately

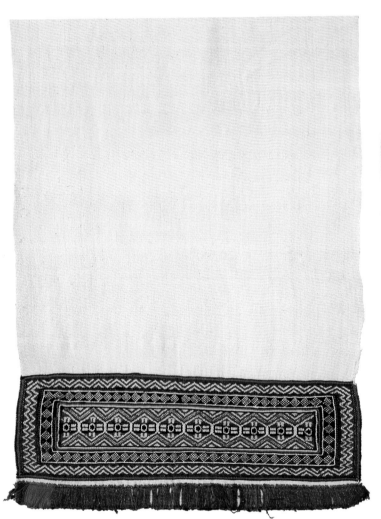

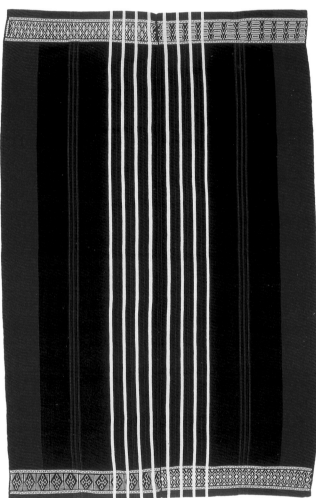

FIGURE 34 Loincloth with twined borders
(*sokotry behofaka*, "great sheep tail"). Tandroy people.
Cotton body with twining in wild silk (*Borocera*)
dyed with natural dyes, in a motif called "bird tracks."
Late twentieth century, collected 1993. Portion shown.
Dimensions 353.5 by 32.0 cm. Private collection.
Photograph by Franko Khoury.

FIGURE 35 Contemporary *arindrano* cloth made
by two Merina sisters. Spun mulberry silk (*Bombyx*),
natural and aniline dyes, 220.8 by 138.5 cm. Collected
by Sarah Fee, 2000. Museum purchase 2000-13-1.
National Museum of African Art, Smithsonian
Institution. Photograph by Franko Khoury.

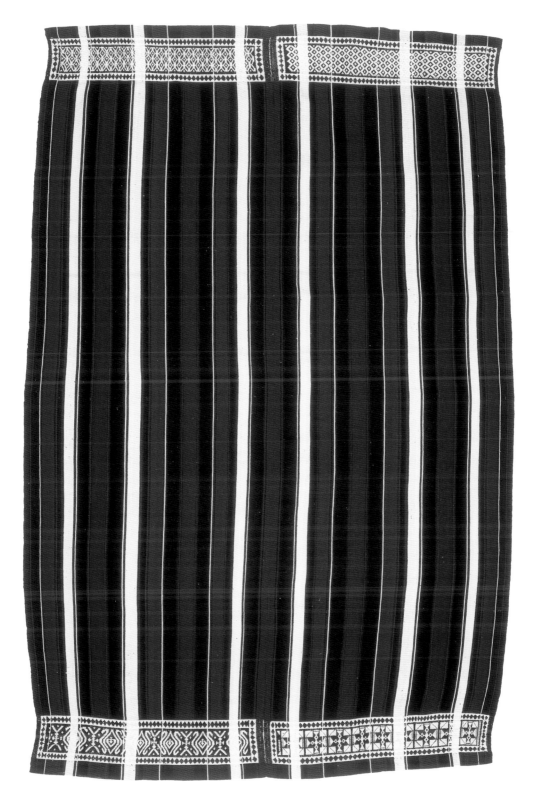

FIGURE 36 A southern Betsileo "great cloth" (*lambabe*) of the striping pattern *sarimbo*. Wild silk (*Borocera*) with natural and aniline dyes, 224.5 by 138.9 cm. Collected by Sarah Fee, 2000. Museum purchase 2000-13-11. National Museum of African Art, Smithsonian Institution. Photograph by Franko Khoury.

communicates both the local descent line of the individual and the status and standing of each family. It also invites and "channels" the ancestral benediction necessary to make marriage prosperous and fertile. At the death of an esteemed elder, *lambabe* are used at the wake to partition the room and hide the body. Wealthy and powerful men may commission or acquire several *lambabe* in a lifetime, and the finest may be buried with their owner.[56]

PROFESSIONAL WEAVING

The weaving of the southern Betsileo region of Ambalavao merits a greater place in textile studies of Madagascar for another reason: for the past fifty years, this area has supplied people throughout the island with the handwoven cloth they require for their rituals and ceremonies. Hundreds of women in villages surrounding Ambohima-hamasina, a small town east of Ambalavao, weave several styles of cotton cloth using factory-spun cotton and chemical and natural dyes. They produce a range of qualities, the lowest having a very loose weave and summary *akotso* decoration. The quality does not reflect on their skill as weavers, however, or indicate "decline," but rather derives from the weavers' knowledge that their products are destined for a rural Malagasy clientele with little purchasing power and must compete with factory-made cloth. Sold at the weekly market in Ambohimahamasina (fig. 37), the finished cloths are purchased by middlemen who travel and sell them in the distant corners of the island.

Although they begin their lives as commodities, once the cloths are purchased they enter new contexts and acquire new meanings as markers of traditional, sacred *hasina* power. The figures who are invested with this power differ from region to region. In the southeast of the island, among the Tanala, Antemoro, Antambahoaka, and Tesaka, sociopolitical life still revolves around regional kings, commoner chiefs, and, among the Islamized Antemoro, elected religious leaders (*katibo*).

To mark their rank and authority, these leaders acquire fine pieces of southern Betsileo cloth for ceremonial dress,[57] wearing them as wrappers over their formal wear (fig. 38).[58] The wives of these men—leaders in their own right of women's delegations—also use Betsileo cloth as wrappers for ceremonial events.

Betsileo cloth from the region of Ambalavao also travels to the west coast, to Sakalava territory, for use in the various kingdoms' royal rituals, notably the bathing of royal relics. The cloth is worn by some royal figures and is used as slings to carry the royal relics to their purifying bath in the river. The vast majority of the cotton cloth made in Ambohimahamasina, however, is destined for the south of the island, for the Mahafaly, Tandroy, Tanosy, and Tesaka peoples, who purchase it to wrap their ancestors. Although these groups do not practice second burials, the first burial requires

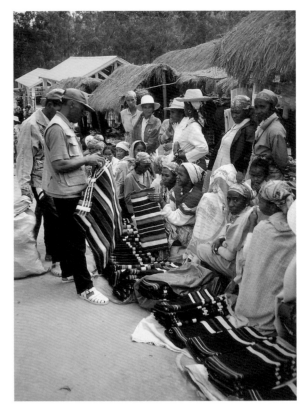

FIGURE 37 **Weavers selling their cloth at the weekly market of Ambohimahamasina, June 2000.** Photograph by Sarah Fee.

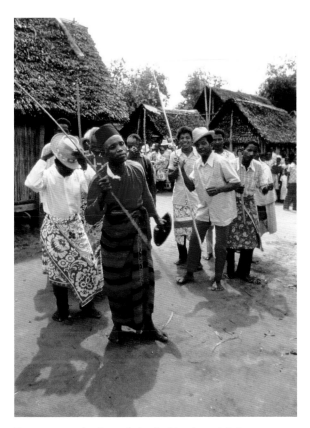

FIGURE 38 An Antambahoaka king *(mpanjaka)* in his ceremonial dress of handwoven Betsileo cloth, leading the procession of the Sambatra circumcision ceremony. As a sign of allegiance, subjects wear hip wraps. Manakara, 1972. Photograph by Philippe Beaujard.

Otherwise, professional weaving is confined to the highlands.

A number of weaving centers still flourish along the historic line of *tapia* forest. Their weavers, however, no longer rely on local *tapia* silk but employ a variety of fibers to create a number of cloth styles. In the northern Betsileo town of Andina, studied in detail by Elie Vernier in 1964, women continue to make "classic" *lambamena* from spun mulberry silk dyed with red *nato* bark (fig. 40, top).[59] Elsewhere, including the two important weaving centers of Arivonimamo and Sandrandahy studied recently by Green (1996), weavers have largely discontinued dyeing with *nato* bark because of its growing scarcity and its time-consuming preparation, which adds to the cost of the cloth. Weavers in Sandrandahy may use chemical dyes to create the classic *lambamena* striping pattern, but most burial cloth is undyed, left in the natural beige shade of the wild silk (see fig. 30). Other factors besides price also influence the form of the cloth: white beads have largely been abandoned as decoration for *lambamena*, because Christian clients profess discomfort with the force they represent.

gifts of cloth from numerous categories of kin. Both the Mahafaly and the Tandroy use it to decorate the coffin (fig. 39).

Professional or artisanal weaving such as that of Ambohimahamasina is now the most common manifestation of the craft in Madagascar. Sustained local demand for handwoven burial shrouds and for interior domestic items such as tablecloths, as well as Europeans' renewed interest in natural fibers, supports several other pockets of professional weavers (see map 3). Most of these are town based, and each has its distinct specialty, tied to local practices and history. In several Tandroy and Mahafale towns of the southwest, weavers make burial wraps of cotton, either factory-made or handspun, with the classic *lambamena* striping pattern and decorations of metal beads (Fee 2002).

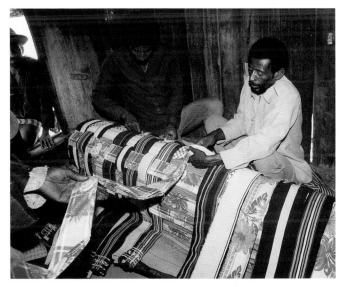

FIGURE 39 Tandroy men wrapping a coffin with Betsileo cloth and commercial fabrics. Ambondro, 1994. Photograph by Sarah Fee.

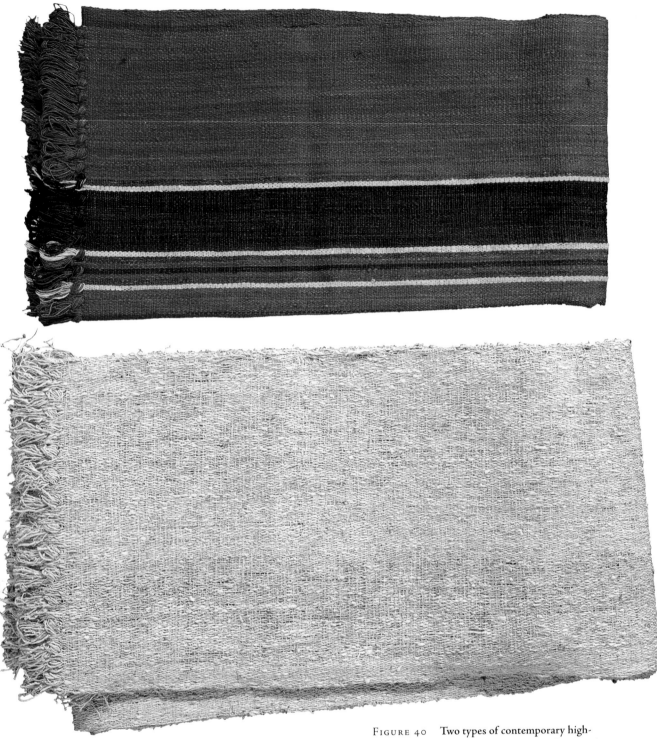

FIGURE 40 **Two types of contemporary highland burial wraps.** *Top*: Spun mulberry silk, natural and aniline dyes, 202.5 by 50.3 cm. Betsileo people. Collected by Sarah Fee, 2000. Museum purchase 2000-13-4. National Museum of African Art, Smithsonian Institution. Photograph by Franko Khoury. *Bottom*: Spun mulberry silk, natural color, 224.7 by 58.5 cm. Merina people. Collected by Sarah Fee, 2000. Museum purchase 2000-13-10. National Museum of African Art, Smithsonian Institution. Photograph by Franko Khoury.

The historic weaving district of Avaradrano, just outside the capital city of Antananarivo, also continues to flourish and to reinvent itself. This area is the homeland of the Zanadoria, Andriandranando, and Andrianamboninolona, clans historically associated with the raising and weaving of the sovereign's silk. Dozens of village households there produce burial wraps of two types. The first is made of undyed, thickly spun mulberry silk (fig. 40, bottom). These are rapidly made but bring a lower price, about $50 each in 2000. The second type is *akotofahana* cloth, made of reeled silk dyed with bright aniline dyes or left white and decorated with three or four vertical rows of large *akotofahana* designs, some historic and some new. The most expensive of all burial cloths, at a price of $120, *akotofahana* are often purchased by the children of the deceased for use as a showy outer covering for the ancestral bundle.

The faces and organization of all these professional weavers, however, have changed from what they were two hundred years ago. For many generations now, some male members of weaving households have actively participated, and many are expert weavers (fig. 41). The entry of men into this sacred domain of women probably stems from its increasing commerciality—its removal from cosmological associations—and from the fact that it was men who were originally trained to make mulberry silk in the nineteenth century. The traditional taboo against both raising and weaving mulberry silk has been largely abandoned as weaving households undertake all steps in cloth production to cut costs. Finally, until as late as 1990 local markets overflowed with weavers' products. Now their goods are less visible, sold mostly from private homes, and much of the supply makes its way to the three great *lambamena* houses of Antananarivo.

Most weaving households and *lamba* merchants in the highlands are finding it difficult to make a living from burial cloth alone. The demand for this cloth is seasonal, because reburial ceremo-

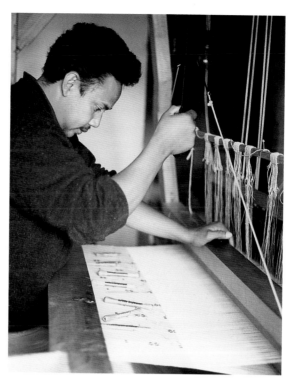

FIGURE 41 Today, European looms are common in and near the capital city Antananarivo, and many men have taken up the art. Pictured here is master weaver Fenomanantsoa "Tiana" Ratianarijaona. Arivonimamo, July 2000. Photograph by Bako Rasoarifetra.

nies take place only in the winter. Moreover, the growing scarcity of wild silk has greatly inflated its price, putting it out of reach of most households. The price of a silk *lamba* in 2000, $100, represented four months of income for the average rural farmer. An increasingly popular alternative is the *lamba tavoangy*, an imported nylon fabric that meets both of the demands of the hand-woven *lambamena* for wrapping ancestors: it provides warmth, and it is indestructible. Although highlanders at first hesitated to use this material, so unfamiliar to their ancestors, they now accept it as an offering from distant kin (Green 1996:362) for use as an intermediate layer between the silk cloth that touches the body and an outer wrapping of silk.

Professional highland weavers responded to changing tastes and times throughout the twentieth century by greatly diversifying their products. Some weavers, such as those in the towns

of Arivonimamo and Ambositra, have turned entirely to the confection of tablecloths, tea sets, bedspreads, television covers, and other fashionable domestic items made of factory-spun cotton or imported synthetic fibers. Although foreign tourists form an important clientele for these products, they are not solely "tourist art," for many urban, middle-class Malagasy acquire them, too. Elsewhere, notably north of Antananarivo, weavers who specialize in reeled mulberry silk alternate between making shrouds and women's shoulder wraps (*lamba fitafy*) with *akotofahana* designs. As we shall see in the final part of this chapter, the resurgence of Merina identity has also fueled a great demand for silk products in a variety of new forms, from bow ties to wedding gowns.

External markets are also giving new impulse to weaving. The reopening of Madagascar's economy in 1991 coincided with increased international demand for natural fibers.[60] Madagascar's raffia is considered the best in the world. Some of it is exported as raw fiber, but much of it is processed and woven inside the country. In dozens of workshops scattered around Antananarivo and the Betsileo town of Fandriana, raffia weaving is carried out on an almost industrial scale, using chemical dyes and European looms. The panels of raffia or *jabo* (of raffia warp and cotton weft) are cut and shaped into wall coverings, hats, women's handbags, and baskets of all shapes and sizes (fig. 42). Each month, dozens of shipping containers filled with these items leave the port of Toamasina, and Malagasy raffia baskets and handbags can today be seen for sale in even the smallest and remotest of French markets.

On the island itself, Madagascar's many haute couture designers, such as Nanou and Kala S., have increasingly drawn their inspiration from local fibers and handwoven cloth. The annual fashion review Manja, held in the capital city since 1986, has emerged as the showcase for the newest and most exciting of these creations (*Revue Noire* 1997–98). In 2000, the youngest generation of

FIGURE 42 Woven raffia products, such as the handbags and hats pictured here at the FOJIMA boutique, are now exported in great quantities to Europe. Fandriana, June 2000. Photograph by Sarah Fee.

talent joined forces to form the Association of Young Malagasy Designers (AJCM); their main goal is to provide wider exposure for their work through various media, including the Internet. Other Manja winners such as Eric Raisina have gone on to successful careers, designing fabrics and apparel for internationally renowned fashion houses, Yves St. Laurent and Christian Dior among them. Raisina also presents his own collections, which typically feature Malagasy fibers, at international fashion reviews. His consuming interest in Malagasy silk has recently taken him to Cambodia to study that country's fiber tradition.

A final source of patronage for Malagasy hand-woven cloth is the international fine art market, with its ever-growing demand for non-Western art. Foreigners have again become patrons of the historically most luxurious of

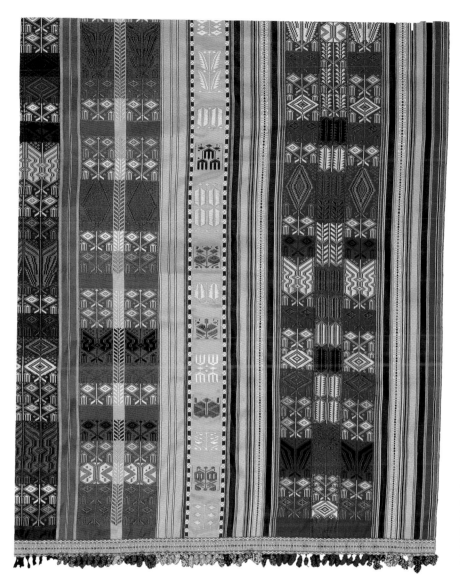

Madagascar's textiles: finely worked *akotofahana*. A small revival of this tradition has been spearheaded by the Englishman Simon Peers. Moved by the examples of nineteenth-century *akotofahana* cloths displayed in a major exhibit on Madagascar at the Museum of Mankind in London in 1987, Peers was determined to see this cloth made again (Czernin 1994). Although the technique of *akotofahana* had continued in Imerina, the cloth and its motifs had become stylistically simple, adapted to the new tastes and lower budgets of its local clientele. After several years of research and experimentation, Peers assembled a group of Merina weavers, called Lamba SARL, who shared his pride in this historic art form. They have replicated various historic *akotofahana*, notably those formerly held in the Queen's Palace in Antananarivo, which have been acquired by renowned museums and private collectors in Europe and North America (figs. 43–45). In its most recent endeavors, the group has revived several distinctive but laborious decorative techniques. For example, in figure 43, the border includes a band of supplementary warp floats that is created separately and sewn to both faces of the cloth ends. The plaited fringe has been knotted into balls. Both of these are techniques that Merina weavers abandoned in the mid- to late nineteenth century.

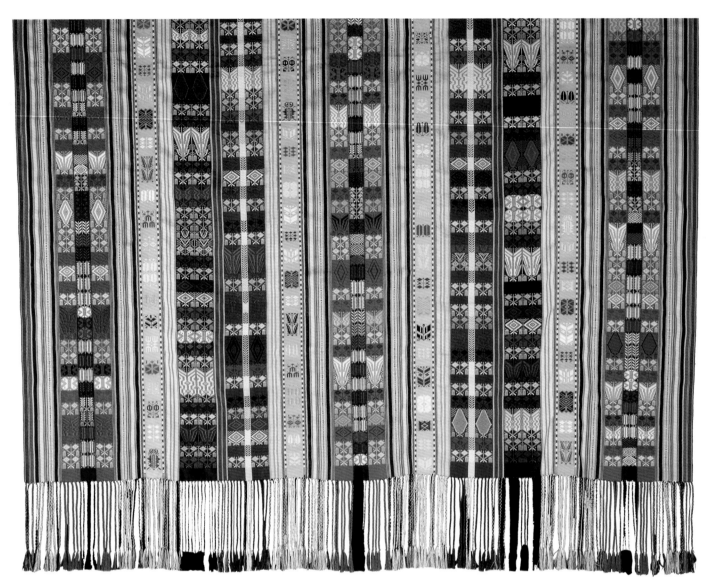

FIGURE 44 **Contemporary revival** *akotofahana*
cloth woven by members of Lamba SARL. Merina
people. Silk, aniline dyes, 282.0 by 195.5 cm. Col-
lection of Paul M. Hoff III and Hazel W. Hoff.
Photograph by Franko Khoury.

Weaving and Economic Development in the Twentieth Century

Since French colonial times, the economic potential of weaving in Madagascar has invited efforts by the state to encourage, improve on, and "revive" certain traditions. Shaped by the concerns of the state, often imposed from the "top down," and lacking a local market, many of these efforts have had only mixed results.

During French colonial times, the project with the greatest lasting impact was the development and extension of mulberry silk farming, formerly restricted to a limited area near the capital. The first French governor, Joseph Gallieni (1895–1906), required communities from Ambositra to Ambatondrazaka, along a corridor some 320 kilometers long, to plant mulberry stands (Prudhomme 1906:37). In addition, he oversaw the creation of a sericulture center and the development of courses in silkworm farming and weaving at the various state schools. Gallieni's major concern was to develop silk to meet the demands of Paris. Succeeding efforts would be more humanitarian and development oriented. A School of Applied Arts was established in 1925 to aid Malagasy weavers in improving on and providing markets for their products (Heidmann 1937). Efforts focused on supporting and "reviving" the two traditions most esteemed by Europeans: the silk *akotofahana* as a decorative item and the *ikat* raffia of the Sakalava region of Kandreho. Because these styles of cloth were no longer in fashion with the local population, however, the project largely failed.

In the face of increasing rural poverty—Madagascar is today one of the ten poorest nations on earth—the independent Malagasy state has likewise tried to promote weaving to increase household income. Beginning with the first republic (1960–75), various governmental bodies such as the Ministries of Industry and

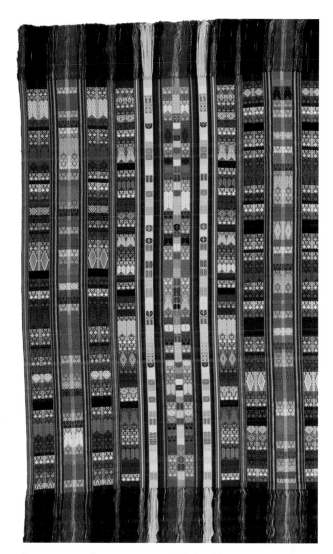

Figure 45 Contemporary revival *akotofahana* cloth made by members of Lamba SARL. Imported, factory-spun and -dyed silk, 182 by 172 cm. Museum purchase 90.2.8601. American Museum of Natural History, New York.

Agriculture instigated efforts to train and promote the country's artisans, including weavers and textile fiber producers. To this day, the Center for Malagasy Artisans (CENAM) serves as the central educational center and commercial outlet for craft producers. The hopes of the second republic (1975–92) to organize weavers into cooperatives that would purchase raw materials and set prices for cloth were not realized, as they ran counter to traditional family-based production. The emergence of the third republic (1992 to the present) coincided with shifts in international aid policy. International donors, including the United Nations, now prefer to bypass bureaucratic state agencies and ministries in order to work directly with local nonprofit groups, known as nongovernmental organizations (NGOs), which have a better understanding of local needs and conditions. Since 1995, dozens of weaving groups and community leaders have formed NGOs to promote local weaving. With charters to assist women and protect the environment (by planting mulberry stands or protecting *tapia* forests), many have received generous support from international donors.

The two largest and most dynamic of these projects are the Trade Place (EMSF) of Antananarivo and the Center for Professional Training in Ambalavao.[61] Both aim to teach marketable skills to their communities' poorest and most vulnerable members. Included in their courses is instruction in the various steps of cloth production. After several years in operation, however, both centers have had to readjust their efforts based on local realities. It takes years to develop proficiency in this art, and apprentices have found it difficult to compete with established weavers. The capital required to purchase a loom and raw materials also remains beyond the means of the poor. Both centers continue to offer classes but have opened them to people from all walks of life who wish to learn—or perfect—skills in weaving.

THE RENAISSANCE OF SILK AND IDENTITY IN ANTANANARIVO

Development projects may come and go, but it is cloth's connection to identity that ensures the future of handweaving in Madagascar. Nowhere is this better demonstrated than in Antananarivo, the bustling, two-million-strong national capital, where the wearing of mulberry silk has been undergoing a remarkable renaissance in recent years. Its popularity is linked to residents' growing desire to assert a Malagasy, and specifically a Merina, identity.

Merina identity was publicly muted throughout the twentieth century. The French government made it a policy to "humble" the Merina and promote other peoples, especially those who had historically aligned themselves with France (see Geary, this volume). In their efforts to contribute to independence from the French and the building of a new nation, the Merina later sublimated their unique historical identity for that of Malagasy. Three recent events, however, have contributed to a growing pride in, and reassertion of, Merina identity. First was the return of civil society and freedom of expression after the popular demonstrations and overturn of the government in 1991. Merina rituals and religious sites—seen as threats to preceding governments—were reopened. Indeed, in 1994 the Ministry of Culture officially sponsored and promoted a reduced version of the Royal Bath at the former royal capital, Ambohimanga. Second was the great fire of 1995 that destroyed much of the royal Merina complex, including the Queen's Palace—arch-symbol of Merina identity—and the royal objects it contained. Recent efforts to reconstruct the palace have led to a renewed interest in Merina history on the part of both the press and many families. Finally, a new generation has come of age, one raised in the nationalist climate of the post-independence 1970s, and one better positioned to pick and chose from the offerings of Western culture.

The most visible manifestation of this resurgent Merina identity is the explosive use of mulberry silk as dress in Antananarivo, in old and novel ways. First among these is younger women's return to the shoulder wrap (lamba fitafy). For their mothers—Merina women born before 1945—a white shoulder wrap is a primary sign of femininity and an indispensable piece of clothing to be worn on public outings. Measuring about 55 by 200 centimeters and made of either embroidered white cotton or handwoven silk (figs. 46, left, and 47), this wrap evolved out of the larger, lightweight cotton wraps worn in the nineteenth century. The aesthetic of wearing this *lamba*

FIGURE 46 **Three types of contemporary women's shoulder wraps** *(lamba fitafy)*. *Left:* **"Traditional" woman's silk shoulder wrap.** Woven by Emélie Rakotondramanana (Merina). Reeled mulberry silk *(Bombyx)*, natural color, 222.2 by 59.8 cm. Collected by Sarah Fee, 2000. Museum purchase 2000-13-14. National Museum of African Art, Smithsonian Institution. *Center:* **Mixed silk wrap.** Woven by Fenomanantsoa "Tiana" Ratianarijaona (Merina). Warp of reeled mulberry silk *(Bombyx)*, weft of wild silk *(Borocera)*, natural colors, 230 by 67 cm. Private collection. *Right:* **Loose weave known as the "Marimar" style.** Woven by Emélie Rakotondramanana. Reeled mulberry silk *(Bombyx)*, natural dye, 224.0 by 58.6 cm. Collected by Sarah Fee, 2000. Museum purchase 2000-13-13. National Museum of African Art, Smithsonian Institution. Photograph by Franko Khoury.

FIGURE 47 Vero Rabokoliarifetra wearing a colorful, contemporary style of shoulder wrap, and her mother, Bakoly Ralisoa, who prefers the more traditional white silk wrap. Antananarivo, March 2001. Photograph by Sarah Fee.

includes a dress and a hairstyle consisting of two braids knotted at the neck. Urban Merina women born after 1945 shunned the *lamba* of their mothers, viewing it as incompatible with the active lifestyle, short hair, and trousers they preferred. It fell out of fashion, remaining an accessory of only older or rural women. Indeed, a belief emerged that to wear silk *lamba* at an early age was to shorten one's life expectancy.

Now urban Merina women in their twenties, thirties, and even forties who have never worn the *lamba* are adopting it for the first time. Many, such as the film producer and television personality Vero Rabakoliarifetra (fig. 47), prefer brightly colored *akotofahana* cloth to their mothers' white version. Vero began wearing the *lamba* on public

occasions after the burning of the Queen's Palace in 1995 and the loss of the Merina culture she had taken for granted.

The shoulder wrap has also reemerged as a means of expressing a general Malagasy identity to the outside world. Women who represent Madagascar to foreign countries at international conferences and meetings tend to wear it. Many high-profile female political figures in Madagascar have also adopted the *lamba*. Ramisandrazana Rakotoariseheno, director of the prime minister's cabinet in 2000, has been wearing a colored silk *lamba* since 1990. Having studied and worked abroad, Rakotoariseheno found herself in an existential crisis. Labeled Hispanic when in the United States, North African when in France, and Chinese when in Japan, she found that wearing the *lamba* allowed her always to feel and express her heritage as Malagasy. For diplomatic and other cultural events, men, too, have recently begun wearing a *lamba*—often a modified *arindrano*—draped on the shoulder.

In response to this demand, and in efforts to appeal to youths and the fashion conscious, textile designers such as Mirana Andriamanantena, Suzanne Ramananantoandro, and Nicole Rabetafika have been working to create new textures, colors, and styles. For all its elegant simplicity, the woman's *lamba* of reeled silk is stiff, slippery, and actually quite difficult to wear. The newest and most popular style of shoulder cloth was inspired by a Mexican soap opera, *MariMar*, which captivated television audiences throughout Madagascar in 1999. A poor orphan, the heroine MariMar goes on to become a successful and powerful businesswoman. Her elegant dress often featured a fine scarf draped about her neck, the two ends hanging loose down the back. To replicate this floating style, designers and weavers developed a loose weave of mulberry silk, dyed in a number of fashionable colors, now called the Marimar (fig. 46, right). Another fine, supple cloth has been created by textile designer Mirana Andriamanantena and

weaver Fenomanantsoa "Tiana" Ratianarijaona by combining a mulberry silk weft with a warp of indigenous silk (fig. 46, center).[62] Although some rural weavers were hesitant to mix the two fibers, the style has proved so popular that it is now available in cloth shops throughout Antananarivo, from the staid *lambamena* vendors to the many exclusive *lamba* boutiques that have begun to appear in the city.

Beyond its use as a shoulder wrap, handwoven fabric is also now widely sought by inhabitants of Antananarivo for tailored clothing and other accessories, such as bow ties and vests. White reeled silk became, in the late 1990s, the preferred material for wedding outfits. The bride, groom, and their parents may all now dress in silk. Urban couples are reviving the use of a *lamba* in the structure of the wedding ceremony itself: the couple is draped with a single cloth to symbolize their becoming a single person (fig. 48). Because only the very wealthy can afford silk, most women buy the next best thing: a handwoven fabric made of a shiny, imported synthetic fiber. While wearing handwoven fabric remains confined to a minority of people, many middle-class households own handwoven tablecloths. More expensive than imported versions, their purchase represents a deliberate effort to display and support the work of Malagasy artisans.

To end this exploration of the history of Madagascar's textile traditions, we can end where we began, with a look at the weavers, this time behind the scenes of Antananarivo's contemporary weaving movement. Emélie Rakotondramanana (fig. 49) is descended from a long line of weavers from the Zanadoria clan north of Antananarivo. She and her extended family, who live in a rural village outside of Ambohidrabiby, use traditional tools—hand spindles and ground looms—to make high-quality women's shoulder wraps and other *lamba* of reeled silk. Her clientele includes many well-known female political personalities. She has recently been experimenting with natural

FIGURE 48 **The wedding of Marotsiresy Randriamampionana and Heritiana Rakoton-dravelo illustrates old and new uses of silk cloth in contemporary urban marriage ceremonies.** The bride designed her own dress of white, handwoven mulberry silk with floral *akotofahana* motifs. The professional orator hired for the event, Samuel Rakotoarivony, wears a modernized version of the *arindrano* in reeled mulberry silk, folded on his shoulder. He performs a blessing ceremony, wrapping the couple in the cloth of the groom's mother to symbolize the creation of their union—a custom now being revived. Antananarivo, July 2000. Photograph by Jean-Claude Razafitrimo.

dyes, including new varieties such as tea leaves, onion, and eucalyptus leaves. Two of the women's shoulder wraps shown in figure 46 are her work. Fenomanantsoa "Tiana" Ratianarijaona (see fig. 41) was a practicing physician before he turned to weaving, a more lucrative activity in the highly educated highlands. Working on a European loom, he collaborates with fashion and interior designers and individual clients to create new textures and designs, including the mix of mulberry and indigenous silk shown in figure 46.

Taking Malagasy fibers and weaving in new directions, and using them to give expression to

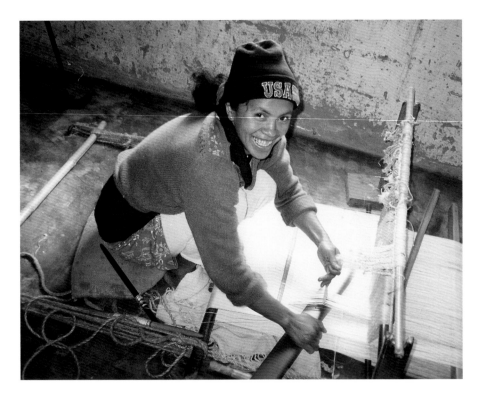

FIGURE 49 Emélie Rakotondramanana weaving the white silk woman's
shoulder wrap shown in figure 46 (*left*).
Antananarivo, June 2000. Photograph by
Sarah Fee.

FIGURE 50 Fiber artists Zoarinivo Razakaratrimo and son Misa Ratrimoharinivo. Antananarivo, June 2000. Photograph by Sarah Fee.

personal identity, is Zoarinivo Razakaratrimo
(who goes simply by Zo), Madagascar's preeminent fiber artist (fig. 50). She took up weaving
late in life as a creative outlet and to supplement
her salary as a cartographer. It soon became a
full-time artistic career. Her goals are threefold
and intertwined: to break through the "limitations" of the two-dimensional weaving plane, to
promote the rich cultural and natural heritage of
Madagascar, and to show the beauty in the ordinary. A weaver may be limited by the warp, says
Zo, but nothing limits the weft.

All of these goals are exemplified in a recent
four-panel creation. The warp is of sisal, a fiber
Zo prefers both for its strength and in order to
promote the use of a local fiber widely available.
One panel uses ordinary bean pods as wefts to
create translucent waves. Another contains eclectic items that have crossed her path: telephone
cards, clothespins, a chain (fig. 51).[63] Two other
panels demonstrate her desire to transcend the
flat plane: the weft of the largest section contains
bulky, three-dimensional items such as unspun

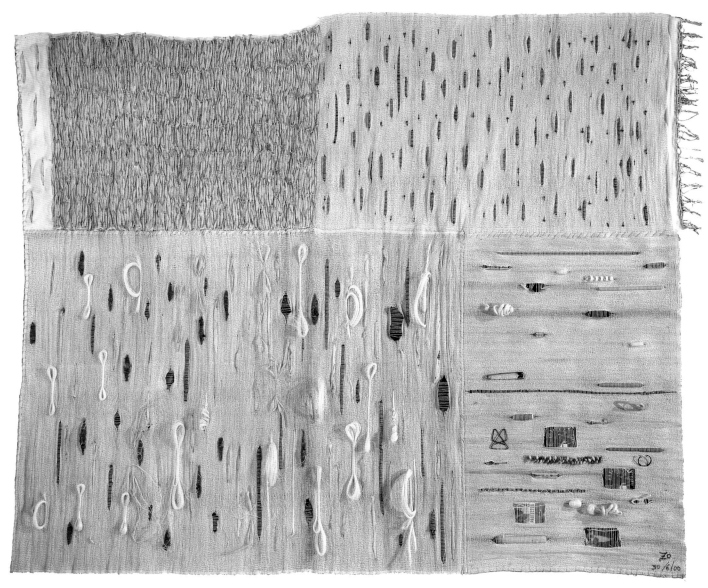

FIGURE 51 Wall hanging or "crazy work"
(*adaladalana*) woven by Zoarinivo Razakaratrimo
(**Merina**), **June 2000.** Warp of sisal; weft of sisal,
raw fibers, spices, bean pods, and various household
objects; 195 by 150 cm. Collected by Sarah Fee, 2000.
Museum purchase 2000-13-45. National Museum of
African Art, Smithsonian Institution. Photograph by
Franko Khoury.

silk, cocoons, reed loops, and raffia bows. The final panel employs scent to reach out to the viewer: vanilla, cloves, and cinnamon, common cash crops of contemporary Madagascar.

For years Zo worked in obscurity. The tableau, or "crazy" works (adaladalana), that she and her twenty-three-year-old son Misa Ratrimoharinivo, an emerging artist in his own right, made were for their own pleasure and rarely shown or sold. Now recognized and solicited by the artistic community of Antananarivo and by European art patrons, her work has been featured in *Elle* magazine and *Revue Noire* and has won prizes at juried exhibits of African art, including *Dak'Art 1999*. Riding the wave of this success, in September 2000, Zo opened her own boutique, Zo Artiss'.

Conclusion

Madagascar's long textile history has been one of continual transformation and motion. This motion mirrors both the changing history of Madagascar's connections to the wider world and the continuing importance of cloth in the delicate language of personal and group exchanges that define Malagasy society and identity. From pre-colonial times, trade moved fibers and finished cloth around the island, weavers selectively incorporated foreign materials, and styles of cloth and clothing went in and out of fashion. But it was not just weavers who set cloth in motion. Most importantly, Malagasy men and women gave it as gifts to kin, using it to begin and maintain relationships and address those fundamental rites of passage upon which the continuation of life depends. Gifts of cloth were circulated between husbands and wives, the living and the ancestors, sovereigns and their subjects, and the Malagasy and other nations. Although the number of weavers drastically diminished in the twentieth century, cloth continues to be used as gifts and to symbolically assert regional and national identities. The current dynamism and creativity of local weavers who incorporate new fibers and invent new colors, textures, and motifs point to an open-ended story. Even as it transforms and changes along with the people who use and create it, handwoven cloth in Madagascar embodies a tradition and a logic that have not dissolved, a tradition that finds precisely in cloth a preferred outlet for expression.

NOTES

1. In considering historic weaving and use of cloth, we need not rely solely on the writings of European observers. Beginning in the 1820s, a large percentage of one Malagasy group, the highland Merina, became literate, leaving behind an important body of correspondence, journals, and family histories. It contains a wealth of information on the historical roles of cloth. The most extensive of these sources include the *Tantara ny andriana*, or royal history (*Histoire des rois*, Callet 1981 [1873]), a collection of narratives concerning the Merina kingdom dating to 1870, and the general records of the Merina government. I thank the director of the National Archives, Mme. Razoharinoro, for granting me access to the latter.

2. My own field research on Malagasy textiles has focused primarily on southern groups, the Tandroy and Mahafale (Fee 2002). I carried out research on contemporary weaving in other areas over several months in 1999 and 2000, and I sent surveys to anthropologists with years of experience in their particular sites. I thank Philippe Beaujard, Maurice Bloch, Gillian Feeley-Harnik, Lisa Gezon, Lesley Sharp, Philip Thomas, and Andrew Walsh for kindly participating.

3. The exception to this generalization was the southeast of the island, where Tesaka, Antambahoaka, Antefasy, Antemoro, and Tanala women generally did not weave but rather plaited reed mats for clothing. Technically speaking, these are not textiles. See Picton and Mack 1989 for a good general discussion of fabric definitions. Moreover, Tesaka men are known to have participated in cotton weaving. As Tesaka elders explained it to me, older men who could no longer work in the fields spent their time spinning and weaving cotton, but women also practiced these tasks.

4. Following the death of the Merina queen Rasoherina (née Rabodo) in 1868, use of the term *soherina* was made taboo, because the names of sovereigns cannot be pronounced after their death. Thereafter, the new term *zana-dandy* was employed for chrysalis.

5. In his work on the *lamba*, the Malagasy diplomat and author Ramarozaka (1990:2) recorded his interesting experience that "as soon as [the word *lamba*] is pronounced at a gathering of Malagasy expatriates, a heavy cloud of silence descends, and there is a flood of nostalgic sighs for the woman of Antananarivo and the voluptuous art with which she wraps her lithe frame in the immaculate folds of her lamba."

6. There is some evidence that the associations the Malagasy draw between women and cloth are not always positive. In the south of the island at least, men may, in certain contexts, deride women's cloth in order to assert their own unique life-giving powers (Fee 1997).

7. Many authors have described in detail the processing, dyeing, and use of fibers. Perhaps the single best source is Dubois's 1938 monograph on the Betsileo. A few fibers other than those I mention were introduced in the nineteenth and twentieth centuries but had limited duration and distribution, and I do not cover them here. They include pineapple, aloe, and mohair goat wool.

8. All the parts of the raffia palm were put to use: the big leaves were used to make ladders, stretchers, and frames; brooms and hoop nets were fashioned from the leaf veins; the fruit served for tobacco canisters; the roots were a source of medicine; and alcohol could be made from a wax of the petals (Dubois 1938:280–82).

9. The geographical distribution of spun bark cloth may have been wider than just the hinterland southeast inhabited by the Zafimaniry and eastern Betsileo. Flacourt (1995 [1661]:168) reported a type called *fotatasrano* (*Barringtonia* sp.), "water trunk," in use among the Tanosy, and a variety called *talimena* was used by the inhabitants of Fiherenena, near Tulear on the southwest coast (Grandidier and Grandidier 1928:170).

10. The cloth of Kelimalaza, the most famous of the Merina royal talismans (*sampy*), was made of banana-stem fiber, as was her guardian's apparel (Callet 1981, 1:352). Each year this cloth had to be replaced, with all the tasks completed in one day. When the cloth was finished, the weaver and fourteen designated men and women laid it over their shoulders and fell into a trance. It was then placed on a mat in the sacred northeast corner of the house and presented to the *sampy*. As the attendants clapped and sang, she took the cloth: "Nobody sees her take [it] . . . and yet it is gone" (Callet 1981, 1:353). The cloth offerings made to Rabehaza, another *sampy*, were also said to roll up of their own accord and go into the *sampy's* box (Callet 1981, 1:432).

11. Other types of plants on which *Borocera madagascariensis* made its home include fandramanana or voafotsy (*Aphloia theoeformis*); guava (*Psidium pomiferum* L.), ambora (*Tambourissa parvifolia* Baker), rafy (*Maesa trichophledis* Baker), tsitoavinam borona (*Tetradenia fruticulosa* Bth), harongana (*Haronga madagascariensis* Choisy), and andrarezina (*Agauria salicifolia* Hook) (Dubois 1938:282).

12. Foreign travelers crossing Imerina in the late eighteenth and early nineteenth centuries invariably commented on the extensive plantations of pigeon peas, for this vegetation was conspicuous on the otherwise denuded hilltops (Coppalle 1909 [1826]:44; Mayeur 1913a:153).

13. By the mid-nineteenth century, the southern Betsileo region of Tsinenimparihy had replaced Imerina as the biggest producer of pigeon pea silk, and it "made their fortune" (Callet 1981, 3:375). The Betsileo's raising of pigeon pea silkworms entailed special ritual. At the beginning of the season, the worms had to be called or summoned with the sacrifice of an ox on the hillside (Callet 1981, 3:331).

14. Unlike his introduction of mulberry silk, King Radama I's efforts to industrialize cotton weaving resulted in failure. The London Missionary Society sent out a weaver, John Rowlands, in 1822 to develop large-scale cotton weaving. He was largely unable to work, however, because of the lack of a steady supply of finely spun cotton. Moreover, he could not replicate the sheen of imported cotton sheeting, which Malagasy consumers demanded. Meanwhile, a Malagasy boy, Raolombelona—one of the Malagasy youths sent by Radama I to be educated in England—was being trained in the modern techniques of spinning, weaving, and dyeing cotton in Manchester. He returned to Madagascar

in 1826 in the company of two LMS artisans and a water-driven cotton spinning machine. This apparatus, too, was ill adapted to local conditions and was soon abandoned. We know little of what became of Raolombelona, save that he remained in charge of a guild that "spun and wove cotton on mechanical looms" (Chapus 1925:230). See Campbell 1988 for the most complete discussion of this weaving and other early industrial endeavors.

15. According to Alfred and Guillaume Grandidier (1928:166), it was Laborde who, with the approval of Ranavalona I, organized skilled artisans into guilds, which continued to function until 1895. Guilds related to textile production included those of indigo dyers, hemp producers, silkworm raisers near Faliarivo (a guild called Fehin-dRainimandranto), and the weavers of cotton on mechanical looms led by Raolombelona (a guild called Tsarahonenana).

16. Iron-rich mud, used throughout the island for a black dye, was the major exception to the otherwise largely vegetable sources.

17. Linton's dramatic label for this cloth, that it belonged to "the last king of the Betsileo," is somewhat misleading. The Betsileo historically had four independent and separate kingdoms, all of which were effectively dismantled in the eighteenth century by Merina conquerors. "Descendant of kings" or "noble" would probably be a better term for the Betsileo man from whom Linton acquired the cloth.

18. For other historic descriptions of the *lambamena*, see Carol 1898:255; de la Vaissière 1885:194; Pfeiffer 1862:246.

19. It was not just in the form of *lamba* that wild silk was worn. Undyed cloth was also a popular fabric for men's suits in late-nineteenth-century Imerina. J. Wills (1885:93) noted: "Coats and trousers are . . . made of the undyed native silk, and these, although not very attractive in appearance, are very durable." Dubois's (1938:304) price list of *lamba* in 1904 includes natural silk cloth, sold for clothing. Prime Minister Rainilaiarivony owned a suit in indigenous silk, dyed red and embellished with gold braid, which he wore for the Royal Bath and which today is in the collections of the Queen's Palace.

20. Apparently, even by the 1920s *ikat* was restricted to only a few towns, namely, Kandreho, Sitampiky, and Ambatomainty (Heidmann 1937:110).

21. Nicolas Mayeur (1913a:160) recorded that the metal was beaten out quite thin and made into beads by use of a punch. William Ellis (1838, 1:77) related: "They [the Betsileo] purchase the metal on the coast, or in the interior, and make the beads themselves." Today metal beads are made on homemade presses outside of Antananarivo for use by weavers in the south of the island.

22. The Malagasy encyclopedia *Firaketana* makes the tie explicit, saying the cloth was characterized by its weft (*fahana*), which was made of imported silk *akoty* yarn.

23. In fact, *ahitra*, "grass," is for the Malagasy a lowly plant, the marker of an uninhabited and thus asocial landscape. One synonym for *ahitra* is "rubbish." I thank Noel Gueunier for pointing this out to me.

24. One provincial Betsileo king submitted to Andrianampoinimerina, saying, "My people of Arindrano are yours, to be your cloth" (Domenichini 1985:221). The *Tantara ny andriana* includes several versions of a story about the rivalry between Andrinampoinimerina and a recalcitrant Betsileo king, Andriamanalianrivo, who sent each other gifts of cloth to make statements about their strength and followings.

25. These red hats took the form of either the "long hat" (*satrodava*), resembling a bishop's mitre with a long tail down the back, or a red turban. See Feeley-Harnik 1988 for a detailed discussion of these hats and the importance of costume in Sakalava ritual.

26. A passage from the LMS Malagasy-language journal *Teny Soa* tells us that *landy* was the highest ranking cloth of our forebears (it was even called Andriamanitra)" (Callet 1981, 1:123). Missionaries would later choose the term Andriamanitra to denote the Christian god.

27. Merina sovereigns employed this scarlet English broadcloth for capes, seats, royal tents in military campaigns, and screens for the ritual Royal Bath. They also presented *jaky* as ritual offerings to several of the royal talismans and their guardians. Unlike commoners, Merina nobles (*andriana*) do not perform reburials. However, every year at the end of the Royal Bath, the royal family opened the tombs of King Radama and Queen Rasoherina and laid out new scarlet *jaky* cloth and mats (Callet 1981, 2:220). Many modern authors tend to confuse the imported scarlet *jaky* cloth with the locally woven red *lambamena*.

28. Most of the grave goods of Merina monarchs, including the cloth and clothing, were removed from their tombs by the French in 1897 and thereafter put on display at the Queen's Palace in Antananarivo (Carol 1898:258).

29. The adoption of European clothing in Imerina was a complex process of appropriation imbued with many layers of meaning and guided by Malagasy aesthetics and sociopolitical considerations. At first, monarchs carefully controlled the use of Western dress. There is evidence that commoners later used Western dress as part of a strategy to bypass noble privilege (Andriantsietena 1994). This phase of Madagascar's costume traditions—which authors have tended to explain in terms of vanity and foppery—merits further study.

30. Europeans were spared the requirement of wearing a *lamba*, although they did have to eschew chairs—deemed untraditional—and sit cross-legged on mats like all others in attendance. Today, however, foreign participants in Sakalava royal rituals are required to dress in hip wraps and remove all Western dress and accessories, including undergarments (Ballarin 2000:109).

31. These two anti-French revolts were the *menalamba* ("red by their cloth") uprising in the highlands and the *sadiavahe* ("loincloth of vines") movement in the far south.

32. For an excellent overview of anthropological interpretations of gift giving and the importance of objects in these transactions, see Thomas 1991.

33. It appears that for the Malagasy it is the cloth itself, rather than the weave structure, that contains this binding force. To aid a woman in labor, her cloth was loosened or thrown back and forth over the house. In the marriage ceremony in the highlands, the couple's two cloths were tied together to symbolize their union (Callet 1981). In the south of the island, at least, people with many social obligations are called "many ties" (*be fehe*).

34. Songs, poems, and even present-day sayings printed on factory-made hip wraps celebrate gifts of cloth from lovers. One example is the woman's refrain, "My lover has arrived, and so I have a new cloth" (Callet 1981, 4:107).

35. In the past, other types of cloths, such as loincloths and women's upper garments, *akanjo*, were also offered at death and buried with the body. Only the Betsimisaraka continue this tradition: descendants place dresses, shirts, jackets, and even hats and shoes in the tomb (Juliane Ranaivarisoa, personal communication, 2001).

36. As early as the 1820s, individuals in the highlands were going into debt in order to provide the most sumptuous silks available (Ellis 1838, 2:303). The larger village community was given the task of setting limits on expenditures, but it too, according to Richard Andriamanjato (1951:37), was motivated partially by fear of incurring the wrath of the deceased.

37. The *famadihana*, in the form practiced today, is most likely historically recent, originating in the nineteenth century. See Larson 1992, Raison-Jourde 1991, and Feeley-Harnik 1984 for discussions of the historical genesis and transformation of *famadihana*.

38. The root of the word *famadihana* is *vadika*, to overturn or subvert. See Bloch 1971, Larson 1992, and Raison-Jourde 1991 for discussions of other forms of subversion that may occur at *famadihana*.

39. The following is a Betsileo invocation used when offering *lambamena* to the deceased (Dubois 1938:278–79): "O So-and-so (and the name is pronounced), you have gone back to become Zanahary [God], follow the golden cord, and don't come to mix among the living. And so here we are to make this sacred presentation of a *lamba*." Then the elder gives the signal by saying "One, two, three, four, five six," and everyone responds, "Seven, the bad has been cut, the good must now come." Another version ends with the blunt command, "Don't come back!" (Razafintsalama 1983:203). See Fee 1997 for other examples of using cloth to cut ties with the dead.

40. Whether coastal leaders exchanged cloth with their subjects is more difficult to establish, because of a lack of written sources. Ballarin (2000:57) reports that cloth was one form of "tribute" from the local population to Sakalava monarchs. It is also recorded that one of the first Europeans to set foot on Madagascar, the master of a Portuguese ship that touched the southeast coast, was lavished with gifts by the local king; these included a thick silver chain, silver bracelets, and a "cotton cloth of the country," given as a "sign of friendship" (Grandidier and Grandidier 1908:34).

41. See Domenchini 1985 for accounts of many other such gifts that were faithfully transmitted through oral and written histories. Descendants would cite these gifts in order to press their interests with the Merina government. Perhaps one of the strangest such royal gifts of cloth was promised by Queen Ranavalona III to one of her ladies in waiting if she could find her a French officer as a lover—a scheme that was later foiled (Carol 1898: 96–97).

42. The largest of these distributions was held at the annual New Year's Royal Bath (Fandroana), the great state blessing ceremony. Registers of recipients of trade cloth—their names and positions—for the years 1881–97 can be found in the National Archives of Madagascar (MM21, MM22). The following were recipients in 1896: three classes of guards, two classes of water carriers, bird hunters, cattle herders, tobacco providers, rice buyers, guardians of water carriers, the sixty-nine court dressers, holders of the royal parasol, women who ironed clothing, and horsemen.

43. Royal gifts of cloth to non-Merina persons were nearly always accompanied by metal objects, most commonly silver chains. The social and symbolic importance of chains in Madagascar merits further research. W. J. Edmonds (1896:472) and the *Tantara ny andriana* (Callet 1981 [1873], 1:70–72) provide the most in-depth descriptions of the types made. Chains appear to have been associated with ideas of closing and joining, and, like other items of silver, notably uncut Spanish pieces of eight, they played roles in many ceremonies. Among Merina people, too, chains were frequently given as gifts (Ayache 1976:90; Ellis 1838, 2:152).

44. The *Tantara ny andriana* (Callet 1981 [1873], 1:135) states that "when Sakalava submit to the [Merina] sovereign, they present an ox of the color *volavita* and a silver gun. . . . The sovereign in his/her turn gives to those who submit a silver chain, a black silk cloth [*lamba tsimaroavaratra*] and a red hat. This is the custom here in Imerina." The historian and court scribe Raombana (1980, 2:269) corroborated that Radama I "bestowed with bounteous hands what He had—His gifts was [*sic*] principally given to Sakalavas, Betsimisarakas and other provincial people who comes up to Antananarivo for to submit themselves to Him, or come up for the purpose of visiting Him—he always meets them at the Silver House, eats with them there, and gives them liberally money, Garments, and other Europeans spotted Garments—These munificence of the King contributed a great deal more to his rapid conquest of Madagascar, than the force of arms." Merina governors posted in the provinces, too, were supplied with cloth to give to local chiefs who came forward to swear allegiance (Callet 1981, 4:56).

45. Though the Merina intended these gifts of cloth and chains as signs of submission, recipients could nonetheless try to reframe them to suit their own purposes. In the ongoing struggles between the Sakalava and the Merina, one queen insisted that the *lambamena* she had accepted were tribute from the Merina, not a mark of her submission (Brown 1978:127). There was room for even greater manipulation and misunderstanding in exchanges between sovereigns and foreigners.

46. See Pfeiffer 1862:261 for a good description of one of these lavish offerings of clothing, the gifts of expensive Parisian fashions made by Joseph Lambert to Queen Ranavalona I and her family. In 1861, Radama II resolved the problem of receiving several sets of clothing for his coronation by wearing the British gift (see fig. 87) and dressing his queen in the gift from the French (Brown 1978:194).

47. The question of who made the dozens of fine silk cloths that the court gave out every year, and how it acquired them, remains unanswered. Although the historical record is expansive on the Merina court's control over many other types of artisanal labor, it is largely silent about weaving. It appears that some forms of cotton weaving were part of royal service (fanompoana): a group of Merina women was charged with weaving cotton to make soldiers' pants and was organized into a "female military" with ranked grades (Julien 1908, 2:124); a royal guild of male weavers was charged with spinning and weaving cotton on mechanical looms (Chapus 1925:230). Another possibility is that the silk cloth came to the court as offerings from the population. Finally, the court might simply have purchased the cloth. The entry in Prime Minister Rainilaiarivony's journal for September 2, 1885, reads, "Purchased three akotofahana cloths" (ARDM, Series PP).

48. Secretaries carefully noted gifts of cloth made to foreigners— the name of the recipient and type of cloth offered—in Prime Minister Rainilaiarivony's journals (ARDM, Series PP). The American consul William Robinson was presented with silk cloth in 1880, 1881, and when leaving the island in 1886. Many other gifts are noted in Europeans' accounts (Chapus and Mondain 1954; Ellis 1858:404; Grandidier 1971; Mullens 1875:275).

49. The number and quality of gifts reflected the closeness and importance of the relationship. In 1881, the French consul Meyer left, in his own words, covered from head to toe in a hat, a lamba, a ring, a chain, silk pants, and shoes (PP, 27 October 1881). Besides the sovereign and the prime minister, nobles at the court and other friends might also offer silk cloth to departing foreigners (Ellis 1867:491–92; 1858:404, 423; Mullens 1875:273–75). One of the most remarkable collections of Malagasy textiles was assembled by the LMS physician William Wilson, who received numerous gifts of cloth from grateful patients when he left the island. His descendants later donated the collection to the Queen's Palace (Christine Athenor, personal communication, 1999).

50. For descriptions of cloth offered during the Merina government's various diplomatic missions, see Munthe, Ravoajanahary, and Ayache 1976 for the 1817 treaty signing; Mondain 1913 for the mission to Zanzibar in 1834; Mutibwa 1974 for the 1863 mission to Europe; Chapus and Mondain 1940 and Razoharinoro 1979 for the 1882–83 mission to Europe and the United States and the rather bizarre mission of Digby Willoughby in 1886; and ARDM PP14 for the 1886–87 mission of Prime Minister Rainilaiarivony's son to France.

51. Perhaps as part of the ploy to induce foreign states to accept their gifts, and also to draw attention to the technical dimension—the complexity of the cloth—the Merina court came to describe the gifts as "articles of Malagasy workmanship." These are the terms in which the gifts were consistently described in accompanying correspondence and discourse after 1830. Malagasy ambassadors to Europe and the United States, for example, were instructed to present their gifts as "handmade things of the Malagasy, to remember the Queen by" (Razoharinoro 1979:135).

52. The anthropologist Lesley Sharp, who works in a Sakalava community in the booming migrant town of Ambanja, north of the community studied by Feeley-Harnik, has made similar observations (Sharp, personal communication, 2000).

53. Lisa Gezon and Andrew Walsh, personal communication, 2000.

54. My own attempts at collecting cloth among the Betsimisaraka in June 2000 illustrate the enduring ties between women and weaving in that region. When a young man offered me a panel of raffia cloth woven by his very young wife, onlookers critiqued its quality—the loose weave and simple striping— raised doubts about her general abilities, and speculated about her dedication to the man. Generally, I had great difficulty in getting men to part with or sell the cloth woven by their wives.

55. The exception is an unpublished master's thesis by R. Rasoanasolo (1989), a native daughter of the area, which describes in great detail all the techniques of cloth making. Unfortunately, the work is largely silent about the uses to which the cloth is put.

56. Families who own several "great cloths" may also, as a last resort, sell some to pay school fees or medical expenses or to pay off debts to avoid losing rice fields. This was the case with the cloth shown in figure 36, which was first sold to another local man in 1996, whose family in turn used it for several marriages.

57. A hat of a bright red material called *sodia* is a second integral part of the Antemoro king's costume. The king-elect purchases a swatch of imported satin-weave fabric called *silimena* and commissions an expert seamstress to sew it. The wives of kings and religious leaders wear a bright red, long-sleeve dress with white trim, made of the same material and called *akanjo zaky mena*.

58. In the past, southeastern leaders purchased silk cloth, but today, because of the high price of silk, they must make do with the highest quality of cotton. The anthropologist Philippe Beaujard (1983) noted that the Tanala prefer the style *telosoratra*, "three marks," because its name and color scheme correspond to Tanala cosmology and ideas of kingship.

59. In 1964, Elie Vernier carefully studied and recorded the techniques practiced by the weaving village of Andina in the belief that the tradition would soon disappear. True, a visit to the town in June 2000 revealed that the number of weavers had diminished from seventeen to six. But young girls continue to learn the trade, and no immediate demise is in sight.

60. Following a popular revolution in 1975, Madagascar largely closed its commercial and diplomatic ties to the West. See Brown 1995 for a good overview in English of Madagascar's recent history.

61. The weaving project of Ambalavao is the result of a long-standing desire by the town's dynamic mayor, Zena Ramampy, to provide the town's single mothers with working skills. She solicited a Malagasy NGO, CCDN Namana, to manage the Center for Professional Training, which offers a number of rural extension programs in addition to training in spinning, weaving, and the raising of mulberry plants and Chinese silkworms.

62. Textile designers' efforts to promote the wearing of indigenous silk (made from the silk of *Borocera madagascariensis*) have met with much less success. In Imerina its use today is strongly associated with ancestors and the dead, and living people are largely hesitant to wear it. The success of the mixed silk fabric may well change this in the future.

63. Zo's past works have included wefts of rolled newspaper, cinemographic film, magnetic cassette ribbons, and even locust wings following an infestation of that pest in 1998.

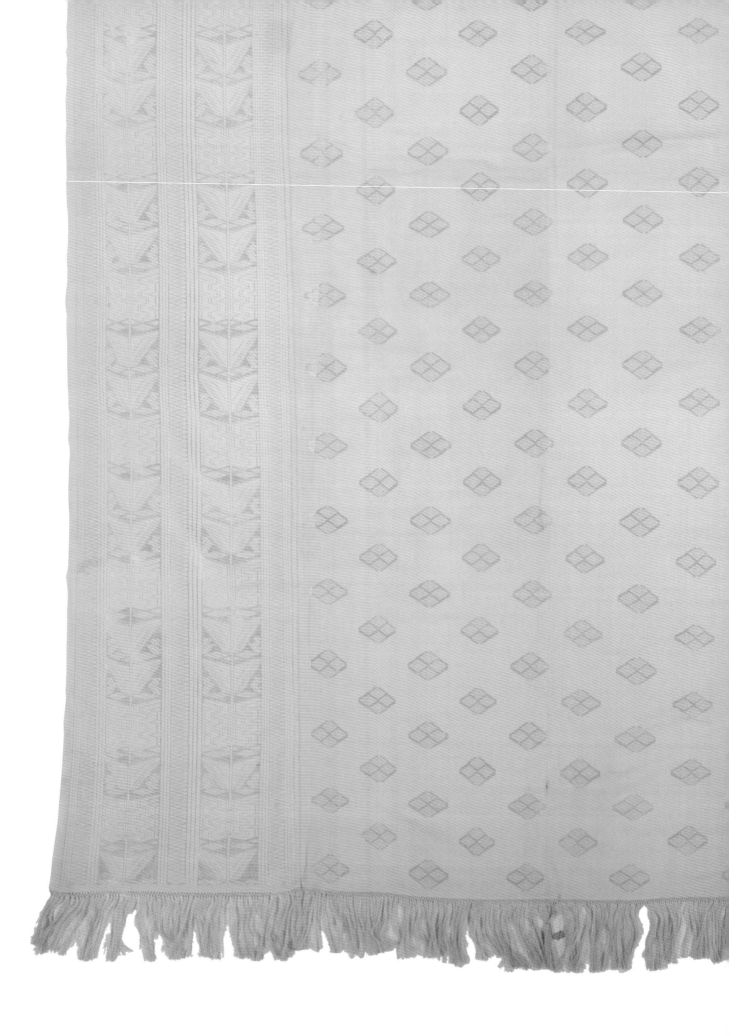

Mary Jo Arnoldi

3. GIFTS FROM THE QUEEN
TWO MALAGASY *LAMBA AKOTOFAHANA* AT THE SMITHSONIAN INSTITUTION

IN 1886, QUEEN RANAVALONA III OF MADAGASCAR SENT GIFTS, INCLUDING TWO *LAMBA akotofahana*, or handwoven silk textiles, to Grover Cleveland following his election to the United States presidency (figs. 52, 53). Cleveland later transferred these textiles to the Smithsonian National Museum, along with the queen's other gifts. The *lamba akotofahana* is a distinct type of Malagasy silk textile that carries an elaborate pattern of weft-faced designs organized in vertical stripes along the length of the cloth. This essay examines the 120-year life history of these two silks and their complex social and cultural biography. It concentrates on the creative recontextualization of the silks at several key moments in their history: their selection by the Merina court as diplomatic gifts, their reception by President Cleveland, and their transfer to the Smithsonian's anthropological collections. The essay explores how these textiles became repositories for different meanings and values as they were differently constituted—culturally, politically, and historically—in Madagascar and the United States over the course of more than a century.[1]

Silk *Lamba* as Gifts and Garments

Queen Ranavalona III's gift to President Cleveland was one in a long series of diplomatic gifts exchanged between Madagascar and the United States that spanned the greater part of the nineteenth century (figs. 54, 55). At different moments these exchanges were initiated by either the Merina royal court or the United States government with the aim of furthering friendly political and commercial relations between the two sovereign states. In at least five instances—1837, 1869, 1883, 1886, and 1893—Merina sovereigns presented the United States with gifts, and in most cases these included textiles. In the nineteenth century, the Merina royal court considered textiles an especially appropriate category for gifts given internally and to foreigners. James Sibree, an English missionary, in 1870 described the queen's custom of presenting textiles to departing foreigners

FIGURE 53 (DETAIL)
Silk *lamba akotofahana.*
Gift to President
Cleveland from Queen
Ranavalona III.

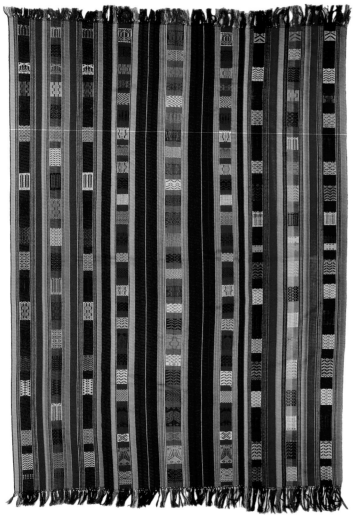

FIGURE 52 **Silk** *lamba akotofahana.* Merina people. Gift to President Grover Cleveland from Queen Ranavalona III. Dimensions 239 by 177 cm. Department of Anthropology, National Museum of Natural History, Smithsonian Institution, catalog no. E165,580. Photograph by Donald Hurlbert.

FIGURE 53 **Silk** *lamba akotofahana.* Merina people. Gift to President Grover Cleveland from Queen Ranavalona III. Dimensions 236 by 160 cm. Department of Anthropology, National Museum of Natural History, Smithsonian Institution, catalog no. E165,581. Photograph by Donald Hurlbert.

under her protection: "In case it was inconvenient to give an audience, a letter was generally sent, with a present of a lamba for the journey" (Sibree 1870:329; see also Fee, this volume).

In nineteenth-century Madagascar, among highland cultures, *lamba* was both a generic term for cloth and a term used regularly to describe an article of clothing. In the latter context, the *lamba*, a large rectangular textile, was wrapped around the body with one end draped over the shoulder. Among the Merina and Betsileo peoples, both men and women regularly wore the *lamba*.

In 1870, Sibree provided this account:

The long flowing lamba folded around the body, and one end thrown over the shoulder, is always graceful; and even children fold their little robes about them with an ease and dignity impossible to a European if he attempts to wear this national garment. . . . There are several slight differences in the way of wearing the lamba; in walking, both arms are covered, and in cold weather it is brought over the mouth and nostrils. In speaking

and preaching, one arm is generally left free, and when working, the lamba is bound round the waist, a literal "girding of the loins." The lamba is worn by both men and women, but somewhat differently arranged. It is usually about eight feet long and six feet wide. (Sibree 1870:218–19)

Later in this account he described how the *lamba* was worn during the period of formal mourning: "All the people also went about with their lambas down below their shoulders, and without the usual shirt generally worn underneath it" (Sibree 1870:264).

European observers such as Sibree described the *lamba* as a national garment. These foreigners,

it must be noted, lived and traveled primarily in areas under the control of the highland Merina kingdom, which emerged in the central highlands at the end of the eighteenth century and continued to expand its control and influence over the island throughout the nineteenth century. Merina domination, however, was never complete, and the kingdom continued to have uneasy and sometimes volatile relationships with groups outside the highlands. Prior to the rise of the Merina kingdom, a number of other polities and kingdoms flourished on the island, including the Sakalava in the west and the Betsimisaraka on the east coast. In the central highlands, the Betsileo, too, were organized into a kingdom, which the Merina annexed in the nineteenth century. The Sakalava most successfully resisted Merina control and

FIGURE 54 **Queen Ranavalona III.** Albumen print. Photographer unknown, *c.* 1895. Madagascar Album, Eliot Elisofon Photographic Archives, National Museum of African Art, Smithsonian Institution.

FIGURE 55 **President Grover Cleveland,** *c.* 1881–82. Probably Buffalo, New York. Photograph probably by B. F. Powelson (1823–85). Graphics File, Department of Prints and Photographs, National Portrait Gallery, Smithsonian Institution.

remained relatively independent throughout the nineteenth century (Kent 1970; Mack 1986:42–53).

The life history of the Smithsonian silk textiles begins within the volatile political climate in Madagascar and on the world stage in the late nineteenth century. During this time the Merina kingdom was internally beset by rebellions of Sakalava and other groups in the northwest of the island, who received support from the French. On the diplomatic front the Merina were struggling to stave off French colonial aspirations in the arena of world politics. As part of its diplomatic strategy, the Merina royal court sought formal recognition by the United States of its sovereignty and legitimacy as ruler over the entire island, and it sought the intervention of the United States as a mediator in rancorous treaty disputes between itself and France (see Mutibwa 1974; see also Krebs and Walker, this volume).

The Different Meanings of Silk Textiles in Madagascar and the West

Silk *lamba*, handwoven by women in the central highlands, were highly valuable objects in Madagascar. Silk weaving has a long history there; it was reported by Europeans as early as the mid-1600s (Green 1996:64). By at least the mid-nineteenth century, the central highlands were recognized as the center of silk production on the island, and both Merina and Betsileo women weavers were the primary producers of silk textiles (see Fee, this volume). Throughout much of the nineteenth century, the Merina kingdom exercised a certain control over internal trade on the island, including the trade in silk cocoons and the circulation of silk textiles.

Among highland cultures and neighboring groups, silk cloths, of which there were several distinct types, made up a special category of objects whose circulation, use, and interpretation operated within a broadly shared cultural framework. These textiles were potent objects in the process of constituting relations between Merina sovereigns and their subjects and between Merina and Betsileo ancestors and the living. Merina sovereigns regularly received silk cloths from and gave them to their subjects. The wearing of silk *lamba* by sovereigns, nobles, and other elites was interpreted as the material symbol of these essential relations. Throughout much of the nineteenth century, *lamba akotofahana* were considered the highest form of dress, although their use in Madagascar was in decline by the late nineteenth century—just when they were being much admired and were beginning to be collected by Westerners.

Along with other types of silk cloths, the elaborate *lamba akotofahana* were also valued as burial shrouds. Silk shrouds in this highly charged ritual context were not restricted to the royal family or to noble families but were used more broadly among highland groups to constitute essential relations between the ancestors and the living. In the central highlands and in areas where the Merina kingdom had extended its influence, handwoven silk textiles exchanged between sovereigns and their subjects, worn as elite clothing, and used as burials shrouds embodied certain essential physical qualities along with a host of complex symbolic associations relating to power, blessing, and personhood (see Fee, this volume).

In 1886, the queen's selection of silk textiles as gifts to President Cleveland followed a long-standing custom in which the sovereign gave handwoven silk and cotton textiles to her subjects and to foreign visitors. Within the local milieu, the queen's gifts to foreigners certainly resonated with the complex set of meanings the textiles embodied as they circulated across the island. Local people would have understood gifts of silk cloths and other key items, such as silver chains, as manifestations of the queen's power to bestow blessings on the recipient. These cultural associations, however, would have been totally lost on foreigners, a fact of which the Merina court, whose members were politically savvy in their

interactions with foreign powers, were certainly aware. Judging from the court's diplomatic relations with the West in the nineteenth century, both on the island and in European capitals and the United States, I suggest that the court was well aware of the values that Westerners assigned to silk textiles, and that its selection of such textiles as diplomatic gifts played strategically into these Western meanings for the court's own political ends.

For Western recipients, these silks were highly desirable commodities that fell within the category of luxury goods as Arjun Appadurai has defined it: a special register of commodities "whose principle use is *rhetorical* and *social*, goods that are simply *incarnated* signs" (Appadurai 1986:38). Since the Middle Ages, silk and silk textiles had been luxury goods aggressively sought after in Europe, and European desires fueled an active international trade in these commodities. The gift of silk textiles from the Merina royal court to President Cleveland, in the context of the charged political climate of the late nineteenth century, also served to communicate the royal court's high regard for the United States in the person of its president, and it underscored the royal court's desire to further diplomatic relations with the United States. These textiles, moreover, highlighted the Merina kingdom's wealth, its control over silk production on the island, and Malagasy technological sophistication in silk textile production. The silk *lambas* in effect elevated a Merina cultural identity to the status of a national identity, thereby supporting the royal court's claim in the international arena to dominion over the island, as well as superseding the cultural identities and claims of other Malagasy groups.

Diplomatic Exchanges between Madagascar and the United States

The queen's gift to President Cleveland and his subsequent gift to her several years later were only two moments in a series of diplomatic gifts that marked the political and commercial relationship between the Merina royal court and the United States, a relationship that spanned much of the nineteenth century. The first recorded diplomatic exchange took place in 1837 between Richard P. Waters and Queen Ranavalona I, the Merina monarch who reigned between 1828 and 1861. Waters had been appointed the first American consul to Zanzibar following the ratification of a commercial treaty with the Sultan of Muscat authorizing the United States to establish a consulate at Zanzibar (Duignan and Gann 1984: 72–74). En route to Zanzibar, he disembarked at the port of Majunga on the west coast of Madagascar, which was then the heart of the island's commercial activities. Waters held several meetings with Governor Ramananama, the queen's representative. He presented the governor with gifts of delicacies including "Lemon Syrup and Cheese" (Bennett and Brooks 1965:190). On the last day of his visit, the governor presented Waters with several gifts, which Waters described as "a present of a shawl and a gold chain" (Bennett and Brooks 1965:191). Waters gave no detailed description of the textile, but it might have been a silk or cotton *lamba*.

The gift exchange between Queen Ranavalona I and Waters is illuminating in terms of Merina political strategies. In 1835 Queen Ranavalona I had made Christianity illegal in Madagascar, and she had expelled most Europeans and missionary societies from the island by 1836. The friendly reception given to Waters a year later might seem unexpected in light of the queen's policies. Her exchange of gifts with him clearly indicates that the Merina government, while outlawing the teaching and practice of Christianity, was not at all adverse to promoting and profiting from international trade and in fact was eager to further commercial relations with Western powers (Mack 1986:55–56).[2]

In 1866, during the reign of Queen Rasoherina, an American consulate was established in

Madagascar, and Major John P. Finkelmeier was appointed to the post of consul and commercial agent of the United States. In 1867, the Americo-Malagasy Treaty of Commerce and Friendship was negotiated, and in 1868 it was ratified by the U.S. Congress and the Merina royal court (Mutibwa 1974:152). Upon its ratification, Finkelmeier wrote to the U.S. State Department: "In order to comply with an existing custom here, to offer some presents from our Government to the Queen, the Prime Minister and the Governor of Tamatan, I would respectfully recommend that the following articles may be sent here as soon as possible" (U.S. National Archives, R6 59).

During this period, the United States government had not yet established any formal protocol for diplomatic gifts. In practical terms, the State Department depended on the advice of its diplomats at post for suggestions about the types and appropriateness of diplomatic gifts to be given to a particular foreign ruler or dignitary.[3] On the basis of his knowledge of the Merina court, Finkelmeier suggested several gifts to be given to the queen and other court officials. These included, for Queen Rasoherina, a Singer sewing machine with ornamented case, a jeweled gold pen and pencil set, a decorated rosewood case with American perfumes, and a photographic album with views of the United States. For Prime Minister Rainilaiarivony and the governor, he suggested Smith and Wesson revolvers ornamented with silver, a box of cartridges, and gold pen and pencil sets. The gifts were duly sent, but they arrived as Queen Rasoherina lay on her deathbed. They were formally accepted and acknowledged by her successor, Queen Ranavalona II, through her prime minister.

As his dispatch to the State Department underscores, Finkelmeier was clearly aware of the importance of gift exchange in Madagascar and of Malagasy expectations regarding gifts between governments to mark important treaties and events. Finkelmeier's suggested sewing

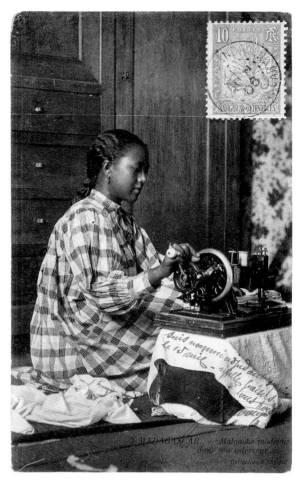

FIGURE 56 **Modern Malagasy woman inside her house** (*Madagascar—Malgache moderne dans son interieur*), **using a sewing machine.** Collotype. Photographer unknown, c. 1900. Published by Collection S. Déposé. Postcard collection, MG-4-9, Eliot Elisofon Photographic Archives, National Museum of African Art, Smithsonian Institution.

machine and perfume set for the queen and revolvers for the prime minister and governor are clearly gendered gifts in Western terms (fig. 56). Both the Singer sewing machine and the Smith and Wesson revolvers, however, also served to underscore American ingenuity, manufacturing prowess, and engineering sophistication, points that the Americans surely wanted to emphasize in their competition with other Europeans to increase American trade in the region.

In the United States and Europe, the sewing machine was seen as a mechanical marvel, and by the late 1860s the Singer company dominated the

market. Throughout the 1860s Singer, along with other American sewing machine companies, exhibited its sewing machines at international expositions in London, Paris, and Vienna, and the American machines won international approval (Cooper 1976:159). During this period Singer began successfully marketing its machines in Europe.[4] It was also during this decade that sewing machine cabinets began to be made more elaborately, with much care and attention lavished on the cabinet's ornate woodwork. As Grace Rogers Cooper noted: "It was understandable that, once the sewing machine was accepted as the mechanical wonder that it was, each manufacturer would attempt to make the packaging of his machine— the stand or cabinet—as eye catching as possible" (1976:158–59). The early home sewing machines were far too expensive for working-class women, and Singer originally targeted an upper-middle-class market. The Singer company pioneered the use of elegantly appointed showrooms intended to attract fashionable ladies who had expendable income. These first home machines were marketed as luxury goods, and in a Singer brochure dating from 1858 or 1859, the machines are advertised as "of smaller size, and of lighter and more elegant form; a machine decorated in the best style of art, so as to make a beautiful ornament in the parlor or boudoir" (Cooper 1976:34).

Like the ornate sewing machine and the revolvers, the jeweled gold pen and pencil sets and the rosewood toiletry were clearly classified as luxury goods in the United States and were deemed appropriate gifts to a ruling monarch. The inclusion of pen and pencil sets is interesting in that it acknowledges the literacy of Merina officialdom.

Photographs, too, were an appropriate category of gift, for they were desirable objects in both the United States and Madagascar during this period. In the 1850s, William Ellis, an English missionary, had taken many photographs in Madagascar and had even been allowed to take photographic portraits of the sovereign. A number of Europeans remarked on the interest the court took in photographs and illustrated news magazines from Europe. Finkelmeier's suggestion of including a photographic album of American views shows his awareness of the court's interest in photographs and their curiosity about their trading partners. From the Merina court's perspective, an interest in securing photographs was probably more than idle curiosity. While receipt of the album would confer status on the queen, it was also a politically astute strategy to attempt to accumulate information and gain understanding about the United States, a nation with which the kingdom was actively negotiating commercial treaties and establishing diplomatic relations (see Geary, this volume).

In 1869, the new monarch, Queen Ranavalona II, sent gifts to President Andrew Johnson. These included a red striped silk *lamba* in "the style worn by our ancestors," a silk and cotton *lamba*, and a silver urn. The prime minister sent a silver chain and a brown silk *lamba*. The gifts were shipped to the United States from Tamatave in July 1869 and were received by the administration (U.S. National Archives, R6 59). The final disposition of Queen Ranavalona II's gift is currently unknown.

In 1883, a delegation from Madagascar made an official visit to Washington on the occasion of the ratification of the second Americo-Malagasy Treaty, which had been concluded in Madagascar in 1881 and had recognized the queen as the sovereign of the whole island of Madagascar. The Malagasy delegation met with Secretary of State Frelinghuysen in March 1883. Its members presented gifts to President Chester Arthur, and on such an occasion it would have been customary for them to offer silk *lamba*. The Merina ambassadors asked the United States to mediate in their disputes with the French, but the United States declined to intervene. It took a hands-off approach to the French and English scramble for colonies in Africa (Mutibwa 1974:236–37).

FIGURE 57 **Pin in the shape of a bird.** Merina people. Gift to President Grover Cleveland from Queen Ranavalona III. Bone, 1.1 by 6.7 cm. Department of Anthropology, National Museum of Natural History, Smithsonian Institution, catalog no. E165,584. Photograph by Donald Hurlbert.

FIGURE 58 **Basket with lid.** Merina people. Gift to President Grover Cleveland from Queen Ranavalona III. Reed, 9.0 by 10.0 by 6.5 cm. Department of Anthropology, National Museum of Natural History, Smithsonian Institution, catalog no. E165,582. Photograph by Donald Hurlbert.

In 1886, Queen Ranavalona III sent her formal congratulations to Grover Cleveland upon his election as president. Accompanying her letter, which was presented by General Digby Willoughby to the American legation in London, were gifts of two silk textiles (figs. 52, 53), a carved bone pin (fig. 57), a gold brooch, a silver chain, and a small basket (fig. 58). In 1856, U.S. federal legislation had reorganized the American foreign service and made it illegal for American officials to accept gifts from any government for their personal use. In a letter to the American legation in London dated November 8, 1886, Thomas Bayard, the U.S. secretary of state, wrote:

> I am requested by the President to request you to return through General Willoughby his cordial thanks to the queen and to state that he highly appreciates Her Majesty's expression of good will towards this Government and himself, and that it is his sincere desire and purpose that the friendly relations which have hitherto existed between the two countries shall continue in the future. . . . As the Constitution of this Government inhibits the reception by its officials for their personal use of any present from the ruler of a Foreign State, the President has felt constrained to transfer these gifts to the National Museum where they will be retained for the People of the United States and in token of the friendship of

Her Majesty the queen of Madagascar. (Smithsonian Institution Archives, National Museum Accession Record 21722)[5]

In 1887, as a reciprocal gesture of goodwill, President Cleveland sent a signed, formal photographic portrait of himself and his wife to Queen Ranavalona III on the occasion of her birthday. John Campbell, the American consul in Madagascar, sent a letter dated November 4, 1887, to the prime minister along with the gift: "Permit me through your intermediaries to present to Her Most Gracious Majesty the queen of Madagascar, on the part of my country and myself as a birthday present, the latest photograph of the President of the United States and his amiable wife Mrs. President Cleveland, the first lady of our Great Country." It is interesting that he felt it necessary to explain to the prime minister in some detail the singular importance of this gift. The letter continues: "Her Majesty and Your Excellency will perceive that the picture of the President bears his autograph and that of Mrs. Cleveland hers. This is a high honor and a favor seldom obtained from the President" (Archives de la République Démocratique Malgache).

Later, in 1893, as Malagasy and French tensions escalated, the queen wrote to Cleveland:

Ranavalomanjaka III by the Grace of God and the Will of the People, Queen of Madagascar and Defender of the Law of her Country, etc. etc. etc. to his Excellency Mr. Grover Cleveland, President of the Republic of the United States of America etc. etc. etc. by these presents sendeth greeting. We learn with great pleasure from Mr. J. L. Waller, our Consul for Madagascar, that you were re-elected President of the United State of America.... [This] *is not only a guarantee for the prosperity and welfare of the*

People over whom you reign, but also for a friendly nation like ours in maintaining our independence.... People feel very proud with the friendly relations so happily existing for a long time between the two Countries, for by these relations commerce has developed and reciprocal confidence has taken place amongst the subjects and citizens of the two Nations. (U.S. National Archives, T-806; my emphasis)

The exact nature of the queen's gift and its final disposition are unknown, although it probably did include silk textiles.

At the end of the nineteenth century, neither a long history of commercial treaties, the appointment of American consuls in Madagascar, visits by Malagasy delegations to Washington, nor exchanges of diplomatic gifts between the two governments induced the United States to intervene diplomatically or militarily to aid the Merina kingdom in its struggle against the French. In 1895, France made Madagascar a full protectorate, and in 1896 it declared Madagascar a French colony. In 1897, Ranavalona III was exiled first to the island of Réunion and later to Algiers. The Merina monarchy was abolished, and the queen died in exile (Mutibwa 1974; see also Krebs and Walker, this volume).

Malagasy *Lamba Akotofahana* at the Smithsonian

On February 27, 1889, upon leaving office after his first term, President Cleveland formally transferred the two silk textiles, along with the other gifts, to the Smithsonian National Museum.[6] Following this transfer, the primary definition of the two textiles shifted from that of luxury goods inserted into the system of international diplomatic gift exchange to that of ethnological type specimens representing the arts and industries of Madagascar. The two silks are currently in the

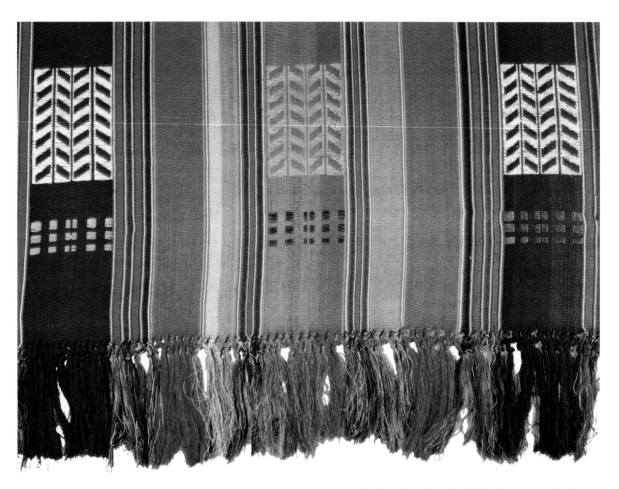

FIGURE 59 **Detail of the knotted fringe on the**
lamba akotofahana **shown in figure 52.** Photograph
by Donald Hurlbert.

African collections in the Department of Anthro-
pology at the National Museum of Natural
History.

The Malagasy make clear distinctions among
their textile types and have an elaborate textile
vocabulary. In 1996, the two silk textiles were
reclassified as a distinct type, the *lamba akotofa-
hana*, on the basis of their identification by Sarah
Fee, a Smithsonian Fellow who studied the Mala-
gasy textile collection at the museum.[7] In the
Reverend J. Richardson's 1885 Malagasy-English
dictionary, he defined *lamba akotofahana* as "[*akoty*,
a kind of cloth, *fahana*, weft], a native-made silk
cloth on which designs are woven" (Richardson
1885:373). The two textiles given by the queen each
carry elaborate supplementary weft-float designs

woven the length of each of the three panels that
were sewn together to make up the finished tex-
tile. One of the silks features multicolored motifs
(fig. 52). The other was woven from undyed,
cream-colored silk, and its motifs, too, were cre-
ated using undyed, cream-colored silk threads
(fig. 53). To finish the warp ends, both weavers
used a decorative knotting technique that is found
on many silk cloths of this period. They gathered
groups of warp threads together, knotting them
into two alternating rows ending with a loose
fringe measuring around 10 centimeters in length
(Green 1996:104) (fig. 59).

The two textiles are woven from a variety of
silk known as *landikely*. In Madagascar there are
two varieties of silk: *landibe*, which comes from
the silkworm that is indigenous to the island
(*Borocera madagascariensis*), and *landikely*, which is
produced by the Chinese silkworm (*Bombyx mori*).
In the 1820s Radama I, king of Merina, reportedly

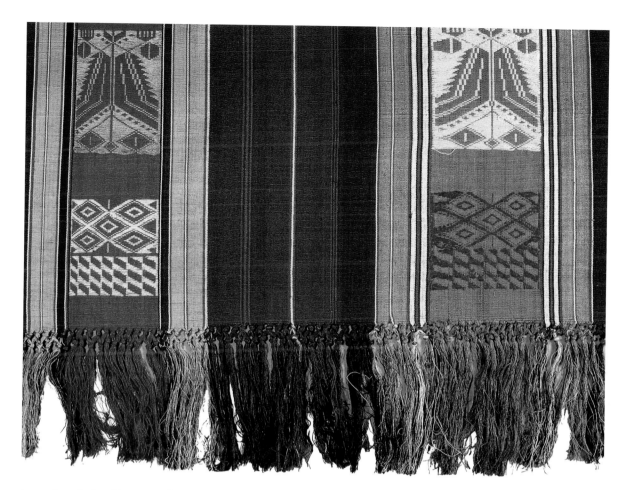

introduced the Chinese silkworm to the island.
This silkworm feeds on mulberry trees, which
were brought from Mauritius to Madagascar
expressly for this purpose. Chinese silkworms
produce a smooth, shiny white or cream-colored
fiber that readily takes natural or aniline dyes.
The indigenous silkworm yields a fiber that is
coarser and dark beige rather than white. Among
the Malagasy, *landibe* is more expensive and is
considered the more durable silk. It remains the
preferred silk for burial shrouds into the present
day (Mack 1989:14–15; see also Fee, this volume).[8]

Westerners, however, preferred *landikely* silk
because of its brilliance, the fineness of its threads,
and its ability to take dyes. Throughout the nine-
teenth century, and later during the French colo-
nial period, Westerners encouraged its production
over that of indigenous silk (Green 1996:66). The
selection of textiles made from *landikely* silk as
gifts for President Cleveland, rather than ones

FIGURE 60 Detail of supplementary weft-float
motif on the *lamba akotofahana* shown in figure 52.
Photograph by Donald Hurlbert.

made from the indigenous silk that the Malagasy
themselves preferred, seems to have been inten-
tional, for the Malagasy were certainly aware of
the Western preference for *landikely*. They were
equally aware of Westerners' interest in the elabo-
rate *lamba akotofahana* textiles.

The polychromed *lamba akotofahana* measures
177 centimeters wide by 239 centimeters long. It
is divided into three panels. The central panel
measures 73 centimeters across and is flanked by
two side panels each measuring 52 centimeters in
width. The warp stripes and colors of the two side
panels are identical, whereas the central panel's
warp stripes and colors are different. The visual
organization of this textile is carried by a series
of multicolored stripes, graduated in size, with

multicolored weft-float designs located within the fields of the larger stripes. The colors used for the warp stripes include red, purple, magenta, green, yellow, dark blue, and turquoise blue. The red, magenta, dark blue, and turquoise stripes carry the multicolored supplementary motifs. A total of 195 individual geometric motifs embellishes the surface of the cloth. The weaver created 23 unique motifs and then used repeats of them throughout the piece (fig. 60).

On each of the two side panels, two dark blue stripes and a central red stripe, each measuring about 5.5 centimeters wide, carry the weft-float motifs. On the central panel, the motifs are carried by two magenta stripes and a central turquoise stripe, each again measuring about 5.5 centimeters wide. On all three panels, the same motif is used three times across the width of the panel but is created in two different colors. On each of the side panels, the weaver chose a single color to use for the motif woven into the central red stripe and a second color for each of the motifs woven into the blue stripes that flank it. On the central panel, one color was chosen for a motif woven into the central turquoise stripe and another color for the motifs woven into the flanking magenta stripes. The warp threads on each end are decoratively knotted, and the fringe measures between 3.5 and 5.5 centimeters long. Both natural and aniline dyes were used to produce the range of colors appearing in this *lamba*.[9] Many of the geometric motifs on this polychromed *lamba akotofahana* are similar to those documented on textiles in Western museum collections elsewhere that date from roughly the same time period.[10] The juxtaposition of multicolored stripes of varying widths and the overall pattern of diverse, multicolored geometric motifs serve to energize the visual field of this textile.

The undyed, cream-colored *lamba akotofahana* measures 160 centimeters wide by 236 centimeters long. It is constructed of three panels that are sewn together along their length. The proportion of the central panel relative to the side panels is significantly different from that seen in the other textile. The central panel measures 82 centimeters wide, and each of the two flanking panels, only 38 centimeters wide. The side panels are woven from the same warp thread, whereas the central panel was created using another warp. The central panel is decorated with 180 diamond motifs organized into alternating rows of four and five. Each large diamond motif is divided into four equal diamond forms, within each of which is woven smaller diamond shapes.

Each side panel is organized into five decorative bands. Three bands of equal size each carry a continuous field of small diamond motifs. These are separated by two slightly wider bands, in each of which an elaborate motif is repeated ten times down the length of the cloth. The motif resembles either a flower or some other natural form, although its source in nature is not recorded. This particular motif appears on a number of silk textiles from this period (fig. 61).[11] The proportions of the three panels (the large central field flanked by smaller side panels) and the use of the diamond motif on the central design field in the Smithsonian textile resemble features of a polychromed silk *lamba akotofahana* that was exhibited in Philadelphia in 1906 (Philadelphia Museums 1906:5, pl. 2).

Both polychromed and undyed white or cream-colored silk *lamba akotofahana* seem to have been in fashion in the Merina royal court in the second half of the nineteenth century. Polychromed striped silk *lamba* were described regularly throughout the nineteenth century, and *lamba akotofahana* with supplementary weft-float motifs were specifically mentioned from mid-century onward. William Ellis observed: "It is with apparatus so simple and fragile that the beautiful lambas of the Hovas [Merina], with their rich colours and elegantly figured patterns, are woven" (Ellis 1858:342).

Several Merina queens wore white imported textiles and white silk *lamba* as court dress. In 1853,

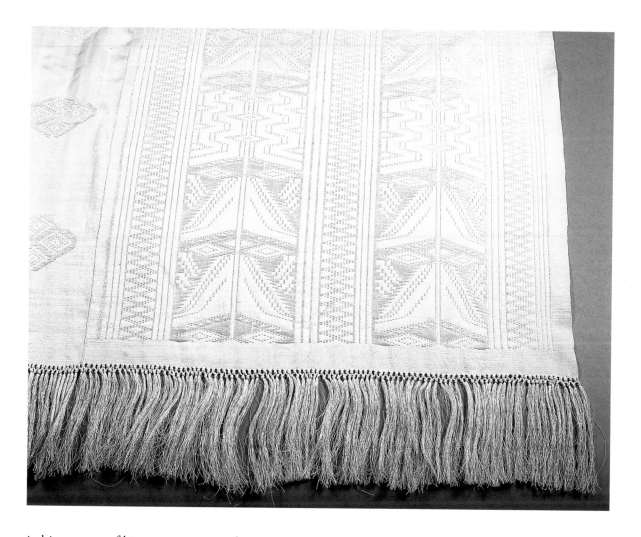

in his account of his presentation at the Merina court, Ellis (1858:381) described the attire of Queen Ranavalona I: "Her dress was a white satin lamba, with sprigs of gold, which, considering the lamba as the national Hova [Merina] costume, was quite a queenly dress." More than a decade later, James Sibree (1870:318) described the queen's dress on state occasions: "When returning from a distance, and making a state entry into the city, she [Queen Rasoherina] was always handsomely robed in silk or satin dresses—sometimes with an embroidered mantle of scarlet or white silk." In Sibree's account, it is unclear whether by "embroidered mantle" he was referring to an imported European woman's garment, then in fashion at court, or to a *lamba akotofahana*. In describing the *lamba akotofahana*, Europeans often misidentified its supplementary weft-float designs

FIGURE 61 Detail of supplementary weft-float motif on the *lamba akotofahana* shown in figure 53. Photograph by Donald Hurlbert.

as embroidery (see Fee, this volume; Geary, this volume).

In his research on Malagasy textiles, John Mack, an anthropologist and curator at the British Museum, noted the significance of color symbolism in Madagascar. White, the color of mourning, was also associated with "cooling, protective, and non-aggressive qualities." White stood in sharp contrast to red, which had "associations with mystical power, vitality, and authority." Red was the prerogative of the sovereign and the ruling classes, and it was closely associated with the ancestors (Mack 1989:43–44). It seems reasonable to assume that the undyed, cream-colored silk

lamba akotofahana sent to President Cleveland was selected because white or cream-colored textiles were especially fashionable at the time, not because they embodied deeper symbolic meanings for Malagasy.

Shaping Interpretations: Museum Cataloging and Terminology

A memorandum to the Smithsonian National Museum's registrar by a Mr. Clark, a member of Grover Cleveland's staff, as well as the official accession card, dated March 7, 1889, listed the *lamba akotofahana* given to President Cleveland as "2 embroidered linen Table-covers" (SI Archives, Office of the Registrar, Accession 21722). This identification, completing the initial registration of the objects into the museum, is not especially surprising, in that it underscores a fairly common practice whereby people reclassify foreign objects into more familiar local categories. Indeed, both of the silk *lamba akotofahana* are large, rectangular textiles that approximate the size of dining table covers, which were at this time luxury goods in the United States. Misreading the material as fine linen rather than silk is an extension of the process of domesticating the exotic, because linen was the preferred material for luxury tablecloths. In addition, both textiles are woven with elaborate patterns that loosely approximate the look of elaborately patterned damask textiles, which were regularly used in this period for table linens.

During the late nineteenth century, British missionaries working in Madagascar did organize local craft production in order to produce objects modeled on Western prototypes, which they sold to their sponsoring congregations in Britain and elsewhere in support of their missions. Weavers associated with these missions were encouraged to produce items such as table covers and other domestic furnishings for a Western market (John Mack, personal communication 2000). Although the registrar might have been familiar with mission-produced Malagasy tablecloths, his initial identification of the silk *lamba* as "linen" leads me to believe that he used the familiar American tablecloth as a type specimen when registering these textiles into the museum.

When the textiles were formally cataloged, however, they were entered into the official museum ledger as a "silk shawl (fancy colors) and a silk and cotton thread shawl (white)" (Museum Catalog, Ledger vol. 35) (fig. 62). Their collection history as diplomatic gifts to President Cleveland from the queen of Madagascar was included in the remarks section, both in the ledger and, later, on their individual catalog cards, but no specific information about local terminology, production, or use was noted.

By the late nineteenth century, the term *lamba* had been included in William Beck's draper's dictionary, where it was defined as a shawl (Beck 1882). Both of the Malagasy textiles that had been given to Cleveland had elaborate decorative fringes resembling those on shawls of the period, whereas tablecloths were generally hemmed and did not include a fringe. The Malagasy term *lamba*, however, was not entered on the catalog card, even though it was the museum's practice to record local terms for objects when they were known.

The choice of the index term "shawl" for these textiles did approximate one of the primary uses of the *lamba* in Madagascar as an item of dress. Yet it concealed the fact that in Madagascar the *lamba* was habitually worn by both men and women. In England and the United States, although both men and women regularly wore shawls from the mid-eighteenth through the mid-nineteenth century, by the late 1800s the shawl had become gendered almost exclusively as an item of women's clothing (Cunnington, Cunnington, and Beard 1968:192). The choice of the term shawl also obscured another important use of this type of silk cloth in Madagascar: its ritual use as a prestigious burial shroud.

During the 1960s, Gordon Gibson, the first Africanist curator in the Department of

FIGURE 62 Catalog ledger showing the 1889 entry for the "shawls" given to Grover Cleveland by the queen of Madagascar. Department of Anthropology, National Museum of Natural History, Smithsonian Institution. Photograph by Donald Hurlbert.

Anthropology at the Smithsonian's National Museum of Natural History, began researching these textiles. In preparation for a new permanent African exhibition, he reviewed the catalog records and consulted late-nineteenth-century European accounts for information on textile identification, production, and use in Madagascar. The results of his research led him to revise the catalog cards. He changed the index terms for these two textiles to "Silk robe (lamba)," and he added a brief physical description of each textile to the catalog record. He also sent the cream-colored piece to the Textile Museum in Washington, D.C., for examination. He noted on its

catalog card that the results of the examination revealed that the cloth was woven entirely of silk and did not include cotton threads, as had been stated in the 1889 record.

Gibson's choice of "robe" rather than "shawl" for the museum's index term was an interesting departure. Costume dictionaries generally define a robe as an item of dress used for ceremonial wear (Cunnington, Cunnington, and Beard 1968:182). In addition, in common parlance the term is more gender neutral than is "shawl." In revising the catalog cards, however, Gibson did not add the information that this type of silk textile was also used as a burial shroud in Madagascar.[12]

The two *lamba akotofahana*, identified simply as *lamba*, were included in the 1969 permanent exhibit on African cultures in a case titled "Traditional Clothing in Madagascar." This exhibit, which opened in 1969 and closed in 1992, organized Africa by regions and put Madagascar in

FIGURE 63 Exhibition case showing Malagasy
textiles in the African Cultures Hall, 1969–92.
National Museum of Natural History, Smithsonian
Institution.

and cotton. The case also exhibited a partial loom,
several caps, and tailored shirts (fig. 63). The ori-
ginal typescript for the Madagascar case stated
that the purpose of the exhibit was "to illuminate
clothing worn traditionally by various peoples
of Madagascar" (curatorial files, Department of
Anthropology, NMNH, Smithsonian Institu-
tion). The text and the diversity of textiles chosen
for the exhibit implied, without directly address-
ing the issue, that Madagascar was peopled by
more than highland cultures.

The Malagasy case stood next to a case con-
taining a large, painted bark cloth collected from
among the Haya people in Tanzania. Directly
across from it were two cases featuring the mate-
rial culture of Chagga and Maasai people living
in Kenya and Tanzania, where the only clothing
exhibited was made from animal hides. The first
line of the main text in the Malagasy case read:
"The clothing worn by Malagasy people of Mada-
gascar contrasted markedly with the clothing of
East Africa."

Within the Africa Hall, five other cases
on "traditional" textiles or clothing featured
woven cotton and silk textiles from West Africa
and woven raffia clothing and textiles from
Central Africa. Only the Madagascar case dis-
played such a diversity of materials, and only a
diorama featuring Herero people from Namibia,
although not focused specifically on clothing or
textiles, illustrated change over time in clothing
styles. Neither diversity nor change, however,
was treated adequately in the labels in either of
these installations.

The last line in the main label for the Mala-
gasy case read: "In most districts the lamba—
a large wrap—was worn over other clothing."
This generalization repeated the misinformation
provided by late-nineteenth-century European
observers such as Sibree and Ellis, which wrongly
characterized the lamba, a form of dress associated
primarily with highland cultures, as a national
form of dress in nineteenth-century Madagascar.

the East African section. The Madagascar case
was installed next to a case titled "The Origins
of the Traditional Cultures of East Africa."
Although Madagascar was identified as part
of Africa, scholars also viewed it as somewhat
anomalous. The emphasis on early Indonesian
influences on Madagascar in this "Origins" case
highlighted what had been, and continues to
be, a long-term interest on the part of archae-
ologists, anthropologists, and linguists in identi-
fying the origins of Malagasy peoples and the
various distinctive elements—African, Arabic,
and Indonesian—in Malagasy culture.[13]

The Madagascar case itself featured late-
nineteenth-century Malagasy textiles in the
Smithsonian's collections. These textiles were
woven from banana tree fibers, raffia, bast, silk,

Ironically, the statement better describes the *lamba's* role following Madagascar's independence in the 1960s, when, as part of the postcolonial process of building a national identity, it was promoted both internally and internationally as national dress (see Fee, this volume).

In a subtext devoted to the two *lamba akoto-fahana*, the label read: "Silk lambas, expertly woven by hand, are worn on formal occasions and are used as burial shrouds. The silk is spun from filaments collected from the cocoons of wild and domesticated silkworms, chiefly of species native to Madagascar. The two Imerina lambas were sent to President Cleveland by the queen of Madagascar in 1886." The interpretation of the Malagasy textiles, like that of most of the other objects in the 1969 Africa Hall, located them in a timeless ethnographic present that obscured the dynamic and complex history of production, circulation, and consumption of textiles on the island and beyond.

The Smithsonian's Late-Nineteenth-Century Malagasy Textile Collection

The Smithsonian, like most other major museums during the late nineteenth century, actively sought to increase its collections. During this period, anthropological research and exhibitions were organized according to a natural history paradigm, with the objective of understanding or presenting material culture mainly along developmental lines. For research and display, museum curators organized objects by geography, by materials, or in synoptic series. This approach was shaped in large part by the scientific philosophy of Otis T. Mason, the Smithsonian's first curator of anthropology. Mason's early training was in the natural sciences, and his subsequent approaches to ethnology were firmly rooted in natural science methods and theories.

Mason's system of museum classification was an elaboration of Gustav Klemm's "Kulture-geschichte." Klemm's method, again based in the natural sciences, demanded first that a subject be analyzed in all its developmental variety, and from these particulars the larger historical picture—progressing through the stages of savagery, barbarism, and enlightenment—could be drawn (Hinsley 1981:88). In adapting Klemm's model, Mason focused primarily on the notion of invention. According to Curtis Hinsley, "Mason defined invention broadly as changes in materials and processes, as modifications in structure and function of artifacts; as changes in the inventor of society. The concept referred, in fact, not merely to mechanical devices but to cultural processes. . . . All people invented, but primitive man saw dimly and thought imperfectly. . . . This vision produced an ambivalent judgment in which peoples received credit as human participants, but clearly inferior ones" (Hinsley 1981:88–89).

As Mason himself explained it: "By applying the methods of the natural sciences to the study of objects, the transformations of object types, like biological species, could be traced back to their source" (quoted in Hinsley 1981:89). It was within this intellectual framework that the museum articulated its late-nineteenth-century collection policy. In principle, the staff sought to bring into the museum well-documented collections, but, like their colleagues at museums elsewhere, they were not averse to accessioning objects with little or no information if it served to increase their holdings.

In addition to the textiles transferred by Grover Cleveland, twenty-seven other Malagasy textiles came to the museum around the same time. Acquired in Madagascar by Lieutenant Mason Shufeldt and Dr. William L. Abbott, they were collected in either the central highlands or the southeastern portion of the island. The two collections certainly do not represent the universe of late-nineteenth-century textile production in Madagascar. Their limitations reflect, rather, the island's unstable political situation at the time.

By the late 1800s, when Shufeldt and Abbott were in Madagascar, the central highland Merina kingdom had effectively lost control of much of the western region of the island, and the Sakalava were in open revolt against the Merina state.

Shufeldt acquired the eight Malagasy textiles that he donated to the museum while he visited Madagascar in 1884. He initially traveled from the southeast coast to Antananarivo, capital of the Merina kingdom in the central highlands. A report published in the *Madagascar Times* and quoted in the *New York Times* recounted the high points of his journey to the capital: "In every town or village through which he passed he was the object of the greatest personal attention. . . .' Presents of all kinds were lavished on him, and it is expressly added that these tokens of welcome were marks of honor 'for the flag and the Nation' which Lieut. Shufeldt represented" (*New York Times*, August 21, 1884, p. 4). It is probable that most of the cloths he later donated to the Smithsonian were those he received as gifts during his journey.[14]

The Shufeldt collection includes hemp and raffia textiles. Hemp was produced in the southern part of the central highlands, and textiles woven from it were generally worn by the poorer people (see fig. 18). Raffia textiles were much more widespread throughout the island (see Fee, this volume). As John Mack observed: "Raffia came to be identified with Madagascar to the extent that the term in European languages is reputed to be derived from the Malagasy word, which can be spelt in one of three ways: rofia, raofia, or rafia" (Mack 1989:16). Raffia fibers were derived from the leaves of raffia palms, which grew primarily in the eastern and western portions of the island, but raffia was marketed widely, and textiles made of it were produced throughout the island. In the 1850s, William Ellis observed that "the article most extensively manufactured throughout the island, both for home use and for exportation, is a coarse kind of cloth woven with the thread or

strips of the young inner leaflets of the rofia palm. . . . The color is a sort of nankeen-yellow, generally with two or three stripes of blue, produced by preparations of native indigo, extending through the whole length" (Ellis 1858:150). The raffia cloths acquired by Shufeldt in 1884 are similar in structure and design to those described by Ellis in the 1850s.

The nineteen textiles collected in Madagascar in 1890 and 1895 by William Abbott, a physician and field naturalist, are better documented than those collected by Shufeldt. They include striped raffia and cotton cloths, several shirts made of sedge, and a number of silk cloths, including two complete ones, a fragment of a *lamba akotofahana*, and a loom with a silk textile in process. These textiles were part of a larger collection of 132 objects that Abbott made in Madagascar.[15] Besides textiles, it included tools, weapons, baskets, mats, caps, a wig, a variety of musical instruments, small-scale models of palanquins and outrigger canoes, personal toiletry items such as combs and snuffboxes, and a variety of household items such as spoons and cushions. The museum saw these objects as type specimens and was eager to accept Abbott's donation. It served the museum's efforts to secure a representative sample of the arts and industries of the island, in line with the collecting philosophy outlined by Otis Mason during these decades. Mason was concerned with securing variations of universal "inventions" from throughout the world. Specimens representing a specific category of invention could then be studied and exhibited together, as the anthropologist Ira Jacknis has critically noted, in order to establish "the putative evolution of a technological type" (Jacknis 1985:77).

Abbott traveled more extensively than Shufeldt in southeastern Madagascar, although, like Shufeldt, he also spent considerable time in the central highlands. He collected textiles from various groups including the Imerina (Merina), Betsileo, Antanala (Tanala), and Antambahoaka.

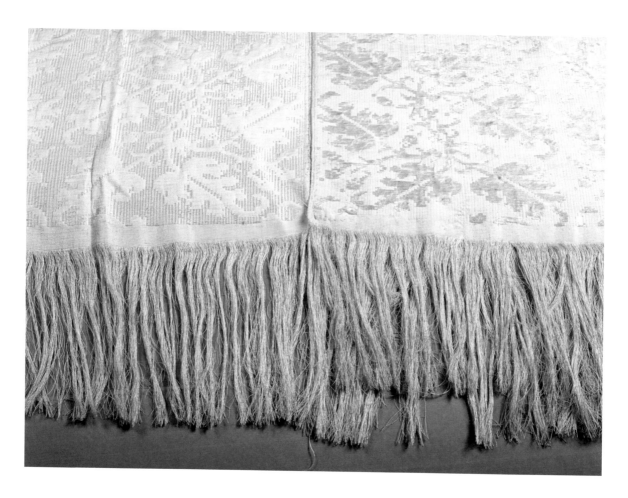

FIGURE 64 **Supplementary weft-float detail on the Sheldon *lamba akotofahana*, collected in 1904.** Merina people. Silk, 207 by 120 cm. Gift of Mary Sheldon. Department of Anthropology, National Museum of Natural History, Smithsonian Institution, catalog no. E385,729. Photograph by Donald Hurlbert.

For several of the textiles, Abbott provided minimal information on specific uses, and he sometimes recorded local names. He used the generic term *lamba* for all of the textiles, and when they were cataloged into the museum, the Malagasy term *lamba* was entered as part of the object's name.

The silk fragment and the unfinished cloth on the loom, though cataloged generically as *lamba*, are examples of *lamba akotofahana*.[16] Both are woven from undyed *landikely* silk. The weft-float motifs on these pieces, and the way in which they are organized, are copied from imported European damasks. This decoration is in the same style as that of another late-nineteenth-century

lamba akotofahana that came into the museum much later. This latter cloth is a full-sized textile woven from *landikely* silk. It had been given to Mary French Sheldon in 1904 by Queen Ranavalona III, who was then living in exile. Sheldon donated the textile to the Library of Congress, along with her papers, and it was transferred to the Smithsonian in 1947.[17] The Sheldon *lamba akotofahana* measures 120 centimeters wide and 207 centimeters long. It is constructed of three panels, all of relatively the same width.

Neither the Abbott fragments nor the Sheldon cloth displays warp stripes, the characteristic feature of most Malagasy textiles (see Fee, this volume). One of the Abbott fragments carries a floral motif, probably a rose, and various leaf patterns woven continuously across the warp face. The fragment on the loom and the Sheldon *lamba akotofahana* use a nearly identical leaf-and-vine motif inspired by a European prototype and

woven across the entire warp face (fig. 64). These European-inspired designs and their orientation across the entire warp face provide an interesting contrast to the silk textiles presented to President Cleveland. The motifs woven on the Cleveland textiles are based on older Malagasy models in the form of geometric abstractions. The European-inspired motifs on the Abbott and Sheldon cloths are rendered in a more naturalistic style. Perhaps more telling is the fact that on the Cleveland cloths, the designs are organized within the dominant warp stripes, whereas in the Abbott and Sheldon pieces, they are woven as an overall pattern across the entire warp face. Various accounts document the fact that Malagasy weavers were creating textiles in both styles throughout the late nineteenth century. In a letter from Antananarivo dated 1890, Abbott wrote somewhat begrudgingly, "Some of the silk lambas are really splendid, if the Malagasy would only stick to their *original designs*, instead of copying European patterns" (William Louis Abbott, Personal Correspondence, Document 9, Smithsonian Institution Archives).

Throughout the nineteenth century, luxury European damasks, satins, and velvets were regularly imported into Madagascar, and late in the century, European dress was fashionable at the royal court and with elites.[18] The highly skilled Merina weavers could easily reproduce designs from imported textiles, and styles and designs inspired by European luxury cloths were probably being woven for local consumption from at least the mid-nineteenth century onward.

There are two other full-size silk cloths collected by Abbott that are not *lamba akotofahana*.[19] He identified these and five other cloths as "shrouds." Although he had collected these textiles in 1890, Abbott kept them until his death and used the two silk cloths as curtains in his house. When they came into the museum, they became "type specimens"; their history as domestic furnishings while in the collector's

possession was not noted, and they were cataloged as "Shroud, lamba."[20]

The fibers of these two Abbott textiles were originally misidentified as cotton. In the 1960s, Gordon Gibson had them reexamined, and he corrected the catalog records to read "wild silk." Wild silk, a commonly used misnomer, corresponds to the Malagasy term *landibe* (see Fee, this volume). The threads of these two Abbott textiles are indeed coarser than those of the *landikely* silk used for the *lamba akotofahana* presented to President Cleveland. Although the indigenous variety of silk lacks the brilliance of the *landikely* silks, it was considered more valuable by Malagasy themselves and, conversely, less refined and thus less valuable by Westerners.

The two Abbott textiles are similar in size, 186 centimeters wide and 220 centimeters long. One is constructed of two panels of equal size, and the other, of four panels of equal size. Both are striped. The design on the first silk is carried by a central, solid red area, which is flanked on either side by two identical striped bands (black, green, red, and yellow) (fig. 65). The second silk's design, too, is predominately red, but two bands of stripes (black, red, green, and yellow) divide the cloth visually into three equal-sized sections (fig. 66). At each end of the cloth, a band of decorative motifs was created with metal beads woven across the width of the cloth. Most of the motifs are abstract geometric forms, but at one end of one of the cloths, the weaver created a more representational motif consisting of two human figures flanking a large cross (fig. 67). On the basis of photographs and descriptions in the ethnographic literature, Gibson attributed the textiles to the Betsileo, a central highland group.

FIGURE 65 *Lambamena* **collected by William Abbott, 1890.** Betsileo people. Silk, 220 by 186 cm. Gift of Gertrude Abbott. Department of Anthropology, National Museum of Natural History, Smithsonian Institution, catalog no. E378,458. Photograph by Donald Hurlbert.

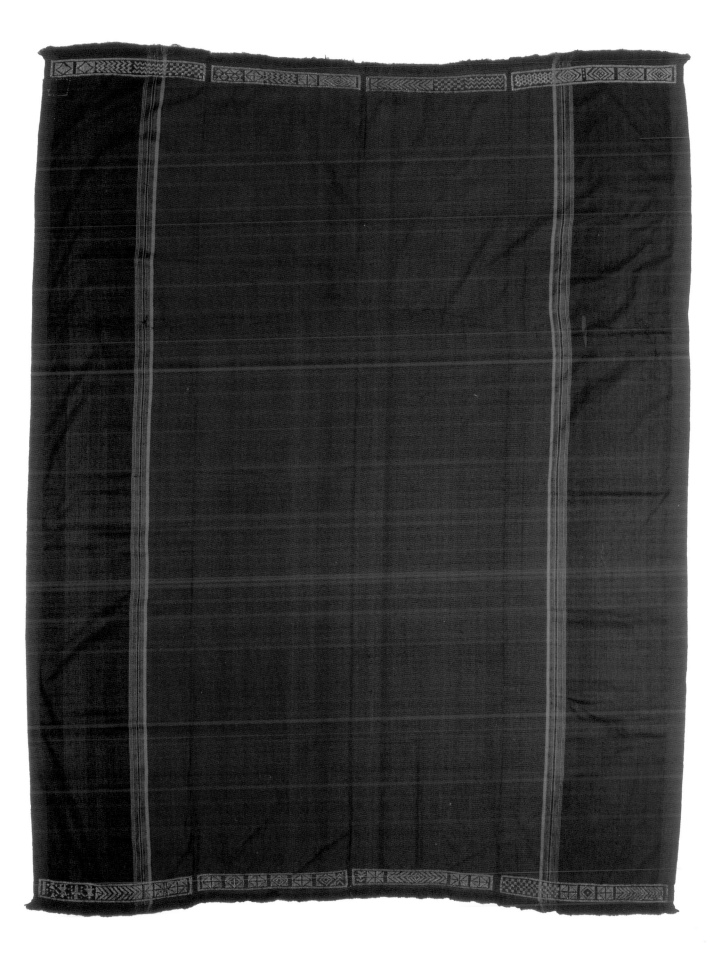

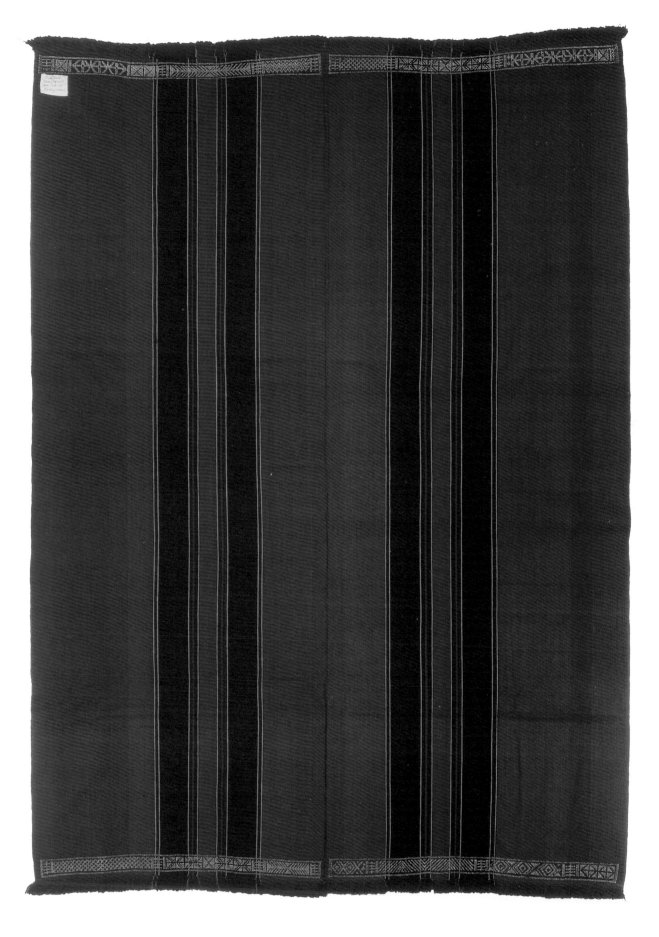

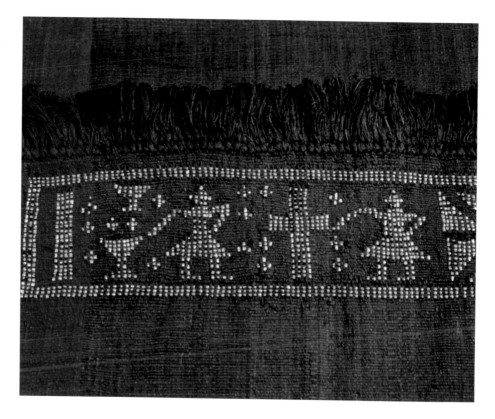

FIGURE 66 *Lambamena* collected by
William Abbott, 1890. Betsileo people.
Silk, metal beads, 220 by 186 cm. Gift
of Gertrude Abbott. Department of
Anthropology, National Museum of
Natural History, Smithsonian Institution, catalog no. E378,459. Photograph
by Donald Hurlbert.

FIGURE 67 Detail of beaded design
showing stylized human figures on
the *lambamena* shown in figure 66.
Photograph by Donald Hurlbert.

More recently, their identification has been refined, and they have been reclassified as *lambamena*,
a category of textile in Madagascar whose use
today is restricted to burial shrouds (see Green
1996; Mack 1986:42). The use of *lambamena* exclusively as burial shrouds, however, seems not to
have been the case historically. Abbott's identification of these cloths as shrouds, though not incorrect, does focus attention on only one context
within which this type of cloth was used. In the
nineteenth century, *lambamena* were also worn as
ceremonial dress by people of rank. In 1867, on
the occasion of the festival to open a new palace,
Sibree (1870:352) observed: "On Wednesday, the
3rd of April, all the town was astir, and hundreds
of people came pouring in from the country and
neighbouring towns. The older men, heads of
tribes and chiefs of villages, generally wore the
red lamba, used at marriages, at the new year feast,
and at other festivities. This lamba is made of
native silk, dyed with the bark of a tree to a dull
red colour, with borders of brighter tints. . . .

Some are ornamented with elaborate patterns in
small beads made of a mixture of tin and silver."
Later, the English missionary Samuel Oliver
(1886:82), in describing the multiple uses of the
red silks, noted: "The lambamena also is another
kind, with the body of dark red silk, and with
stripes and borders of lighter colours. These are
worn chiefly at the national festivals, marriages,
and other public rejoicings. They are also used
for wrapping the dead."

Both the *lamba akotofahana* and the *lambamena*
in the Smithsonian collections represent important categories of silk textiles in Madagascar.
Historically, both types were multivalent. Objects
used for multiple purposes have always posed a
problem for museum cataloguers, whose methodology requires a single index term to be assigned
to each object. Assigning a single index term to
each type of cloth, whether it is an item of dress
or a shroud, fails to take into account that a single
type of textile can be used differently and within
a range of different contexts. As the following

proverb makes clear, Malagasy textiles have always resisted any simple classification in terms of their use: "This is the lamba. When one is angry it is wrapped around the waist (to free one's hands to fight), when one sleeps it serves as a blanket, when one goes out it is worn as clothing, when one dies it becomes a shroud" (Radadody-Ralarosy 1946:44, cited in Green 1996:59).

Recent research on Malagasy textiles has focused on recovering and understanding the complex cultural framework within which these objects were produced, exchanged, and consumed. These studies have also added immeasurably to our understanding of the distribution of both raw materials and different types of textiles over the island and the organization of production and consumption practices. Historical studies of Malagasy textiles have revealed a dynamic context within which these textiles were embedded, and research has highlighted the changes in interpretations that these textiles have undergone at different historical moments in Madagascar. This historical research has done much to explode the myth of traditional ideal types and has contributed to undermining a static interpretation of meanings associated with the textiles. Reconstructing the life histories of the silk textiles given by Queen Ranavalona III to President Cleveland allows us to take the analysis further by explicitly examining the ways in which the meanings of these textiles came to be constructed as they were inserted into new cultural and political contexts in the West. As research on the Smithsonian Malagasy textiles and those in other museum collections in Madagascar and elsewhere continues, we must also begin to understand these cloths within the larger framework of changing production practices and contemporary interpretations of textiles in Madagascar today, and their insertion as commodities into contemporary world markets.

NOTES

1. The concept "life history of objects" is borrowed from Igor Kopytoff's study (1986) of the complex cultural biography of commodities (whether material objects or, in Kopytoff's case, enslaved people) and the transformations in their meanings over time. The analysis of the queen's gift of textiles to President Cleveland is also indebted to Nicholas Thomas's (1991) insights into the dynamics of exchange and the meanings that accrue to objects as they become "entangled" in ever-widening world systems.

2. In Madagascar, trade was deemed an appropriate activity for the royal family and nobles. Although the queen had banned the teaching of Christianity, international trade remained important for the state. In 1861, King Radama II rescinded the ban on Christianity and invited missionary societies back to the island. By 1862, Protestantism had become the official state religion.

3. This information comes from David Patterson, a historian at the Department of State (personal communication, 2000).

4. By the late nineteenth century, Isaac Merritt Singer was mass-marketing his home sewing machines worldwide, and home machines became more affordable. A photograph published in Ruth Brandon's biography of Singer shows a Singer company canvasser with a family-model machine being carried in a palanquin in Madagascar in the late nineteenth century (Brandon 1977: illustration between pp. 114 and 115).

5. Throughout its 150-year history, the Smithsonian has been designated one of the official repositories for foreign gifts given to the president or other government officials. Over the years, the majority of diplomatic gifts have been either retained for official use by the State Department or the White House or transferred to the Smithsonian Institution or the Library of Congress (Bruns 1996).

6. The two silks are cataloged in the museum's anthropology collections as E165,580 and E165,581, respectively.

7. In 1996–97, Sarah Fee was a Fellow in the Department of Anthropology at the Smithsonian Institution. She conducted research on the Malagasy textile collection, and her work inspired the exhibition on Malagasy textiles in conjunction with which this book was published. I would like to thank her for generously sharing archival and bibliographic sources with me for this essay.

8. The silk sent to President Johnson in 1869 by Queen Ranavalona II and described as a red striped silk lamba in "the style worn by our ancestors," as well as the brown silk lamba sent by the prime minister, was probably woven from indigenous silk, landibe.

9. Samuel P. Oliver (1886:82) noted: "A few native dyes are prepared in the country; but the chief part of those used by the people are purchased by European and Arab traders, and used with considerable skill in colouring the silk, cottons and rofia cloth."

10. See illustrations of textiles in the Field Museum of Natural History and the Peabody Essex Museum (Green 1996:137–38), of Malagasy textiles in the Philadelphia exhibit catalog of 1906 (Philadelphia Museums 1906:3–11), and of one in the British Museum (Mack 1986:36).

11. James Sibree (1880:262) described a motif closely resembling that on the Smithsonian cloth. He noted: "The most striking examples of native design are, however, seen in the silk lambas … with a peculiar kind of square leaf or flower introduced into the stripes, and various combinations of diamond patterns." Variations on this motif appear on silk lamba in the collections of the Philadelphia Museum (Philadelphia Museums 1906:3–11), the Field Museum, and the Peabody Essex Museum (Green 1996: 137–38), and on a silk textile in the British Museum (Mack 1986:64).

12. Many scholars now use the term "mantle" (from the French) to describe the Malagasy lamba. Mantles were worn by both men and women until the late nineteenth century. According to A Dictionary of English Costume, 900–1900 (Cunnington, Cunnington, and Beard 1968:132), a mantle is "a long voluminous cloak-like outer garment reaching to the feet and made without a hood. An everyday garment until the 14th c. Then generally ceremonial."

13. By the 1960s, the late-nineteenth-century project of classifying Malagasy peoples within a social evolutionary paradigm that sought to establish distinctive racial types and a racial hierarchy for cultures had long been abandoned (see Hinsley 1981 and Arnoldi 1992). Archaeologists working today remain interested in establishing the history of the peopling of the island. The material record from various sites suggests multiple migrations, including ones from continental Africa, the Middle East, and Indonesia. Most sociocultural anthropologists studying the Malagasy are less interested in pursuing the origins of isolated cultural, expressive, and material forms. Their work is focused more on Malagasy systems of belief and the cultural practices and matrices in which these beliefs, values, and forms are embedded.

14. When Shufeldt left the capital on his return to the United States, he did travel across the western portion of the island, but because of unrest in this zone, the journey was difficult and he traveled under the protection of Merina soldiers. It is doubtful that he made any collections at this time (New York Times, August 21, 1884, p. 4, and October 6, 1884, p. 4; Shufeldt 1891).

15. Abbott deposited the first group of Malagasy textiles in the museum in 1895. After his death in 1936, his sister, Gertrude Abbott, gave a second group of objects to the museum in 1937.

16. The silk textile fragment is cataloged as E378,448. The partial loom (weaving reed, string heddles, and various reed picks) with the silk textile in process is cataloged as E175,421.

17. The Sheldon lamba akotofahana is cataloged as E385,729.

18. Although Malagasy elites regularly wore European fashions or combinations of Malagasy and European dress in the late nineteenth century, on high ritual occasions they eschewed European dress. Sibree (1870:332) described attire at the fandroana ceremony, the monarch's ritual bath, which opens the Malagasy New Year: "Her majesty and the court were dressed entirely in native costume—the queen wearing one of the graceful striped lambas called arindrano."

19. These textiles are cataloged as E378,458 and E378,459. They were deposited in the museum by Abbott's sister, Gertrude Abbott, in 1937.

20. The two silk textiles (lambamena) underwent conservation treatments in the 1960s. Department of Anthropology conservation records indicate that the curtain loops were removed from both textiles at that time.

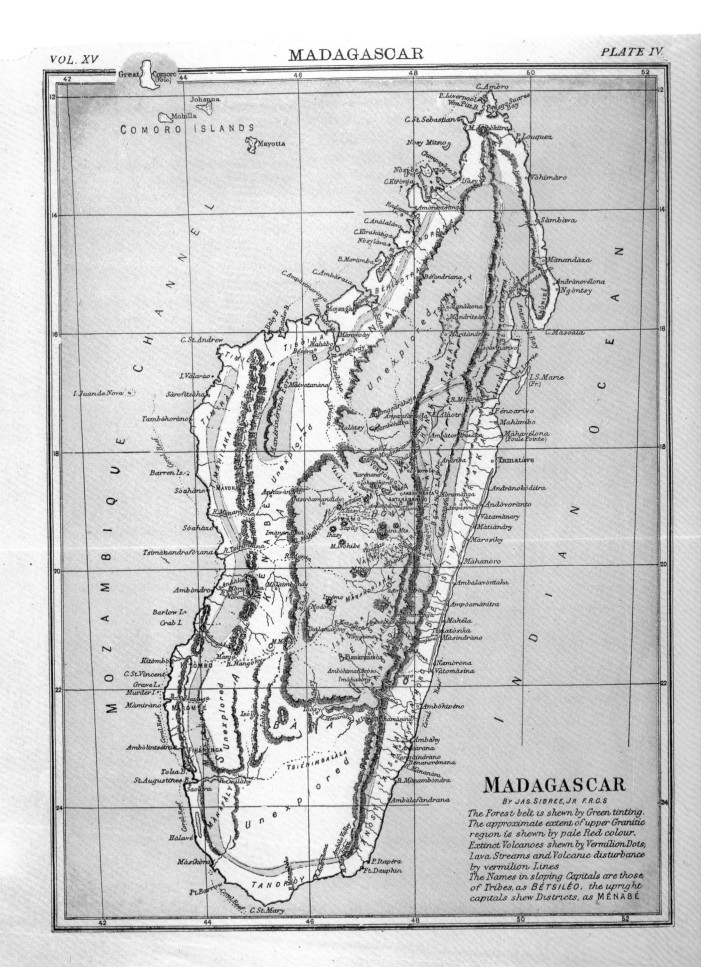

MADAGASCAR

BY JAS. SIBREE, JR. F.R.G.S

The Forest belt is shewn by Green tinting.
The approximate extent of upper Granitic
region is shewn by pale Red colour.
Extinct Volcanoes shewn by Vermilion Dots,
Lava Streams and Volcanic disturbance
by vermilion Lines
The Names in sloping Capitals are those
of Tribes, as BÉTSILÉO, the upright
capitals shew Districts, as MÉNABÉ

Edgar Krebs and Wendy Walker

4. Madagascar in the Minds of Foreigners

The Case of United States Consul John Lewis Waller, 1891–1895

The greater the distance from the capital, the looser the mask becomes. At the frontier it falls off. Going from one hemisphere to another, what does it become? Nothing.
—Diderot, *Histoire des deux Indes*, 1992 [1772]

In 1835, a flotilla of twenty-one armed ships lay at anchor in St. Augustine Bay, off the southwest coast of Madagascar (fig. 68). When the news reached Queen Ranavalona I of the highland Merina kingdom, she was so alarmed that, fearing an invasion, she dispatched a diplomatic mission to London and Paris. These particular vessels, though, were not flying European colors, nor were they part of a naval convoy. They were American ships—whaling ships from New England—going about their business.

Throughout the nineteenth century, England and France were in constant competition to incorporate Madagascar into their trading routes and colonial domains. The Merina kingdom, on the other hand, was engaged in an effort of nation building and domestic expansion, using its superior armies and its political ties with Europe to subjugate other Malagasy groups along the coasts and in the south and north of the island. The history of the fateful Merina involvement with England and France has received ample attention from scholars. The same cannot be said about the relationship between Madagascar and the United States. Yet the sheer number of American trading and whaling ships plying the west coast of the island attests to the importance of contacts and commerce between the two countries. Aware of the need to protect these interests, the U.S. State Department had, early in the nineteenth century, placed commercial agents and consular officers in Zanzibar. Through a representative in this East African vantage point, Washington attempted to monitor American concerns in the entire Indian Ocean.

The first U.S. commercial agent in Madagascar was appointed in 1866, and the first consul, in 1875. This essay deals with the history of Merina–United States relations as seen through the actions and correspondence generated by the third consul, John Lewis Waller (fig. 69). Waller was appointed in 1891, only four years before France invaded and occupied the island, dissolved the Merina monarchy, and placed Madagascar under colonial control. He was one of the first

Figure 68 **Map of Madagascar by James Sibree, c. 1891.** Private collection.

121

black American diplomats, and his aspirations in taking a position abroad were infused by feelings of frustration over the limited political rights accorded to Negroes in the United States after the Civil War. Confronted with this reality, Waller, like many others at the time, believed in the prospects of emigration and the establishment of black American colonies in Africa. In these utopian spaces they would rule their lives free of discrimination and prejudice. At the end of his stay in Madagascar, against the backdrop of a colonial war, Waller unsuccessfully sought to launch such an experiment.

The immediate appeal of Waller's failed attempt at establishing an African American colony in southern Madagascar lies in the biographical circumstances and the particular and striking details of the story. The narrative that emerges from assembling the facts, however, is far from simple or straightforward or constrained by the biographical. Yes, Waller was one of the first black Americans to serve his country as a diplomat.[1] But more significantly, the values and outlook he took with him to Madagascar in 1891 represent a fraught coming into contact of two frontiers: the American frontier and the European colonial one. To these unequal historical processes must be added the unavoidable realities of the Malagasy point of view, Malagasy history, and the effects of the physical and cultural setting in which, through Waller's personal itinerary, the two frontiers met. What begins to take shape as a result of this convergence is a study in unintended consequences, of expectations that are not met by reality, and of the types of exchanges that take place, nonetheless, between worlds apart.

A Compressed Biography

Waller's life is exemplary of the hopes, ambitions, and disappointments that many like him experienced during the Reconstruction era. He was born in slavery in New Madrid, Missouri, in 1850. His parents, Anthony and Maria, were part of the

FIGURE 69 John Lewis Waller as a young man, c. 1887–88. Courtesy of the Kansas State Historical Society. Photograph by H. T. Martin.

multiple tide of black "contrabands" and "Exodusters" who moved north and west, seeking freedom and enfranchisement, during and after the Civil War.[2] Anthony Waller became a freeman in 1862 and migrated with the family to Iowa, where they "settled down to a life of rural poverty" (Woods 1981:6). When John was twelve, his father hired him out to work for William Wilkinson, a white neighbor and farmer. Mrs. Wilkinson taught him to read and write. Plans for furthering his education at Mount Vernon College in Iowa were interrupted, however, after a few months: his father and brothers were ill and Waller was needed at the farm.

By 1874, when he was at last able to leave the family and move to Cedar Rapids, "the largest city in the area" (Woods 1981:7), Waller had already formed the determination to share fully in the promise of America. He wanted to succeed, make a place for himself in society, and through his

FIGURE 70 **Susan Boyd Bray Waller, c. 1890s–1900.**
Courtesy of the Razaf Estate and Barry Singer, New
York. Photographer unknown.

their civil and political rights" (Woods 1981:19).
This was certainly Waller's first exposure to a con-
crete example of the idea of a domestic colony for
black people.[3]

It was in Kansas during the 1880s that Waller
rose as a political figure in the black community.
He married Susan Bray (fig. 70), a young widow
of African and Cherokee descent, joined the
Republican party, and worked hard to bring out
the vote and get its candidates elected. "Six feet
tall, 180 pounds and barrel-chested . . . physically
an imposing man" (Woods 1981:9), Waller was
also a good orator and became a featured speaker
in political rallies. But neither the law nor his
activism provided a sure income. During the
1880s, to make ends meet, he opened a chain of
barber shops and started two black newspapers.

Waller's relations with the Kansas Republi-
can party bosses were complicated, laced with
speculation on both sides and with many disap-
pointments for Waller. As his biographer, Randall
Woods, put it, Waller (like many other urban
blacks) had internalized white society's criteria
for success and acceptance. He held "the merchant
class as a model for the rest of the community"
(Woods 1981:75). This posed a problem for Waller
and the Republicans because the brand of mate-
rialism and individualism they espoused did not
appeal to the majority of the black population in
Kansas, which was rural and poor. And there was
a problem, too, with Waller's notion of becoming
a "representative Negro" through his success in
white society. Republicans failed over and over
again to appoint blacks to administrative offices
of any importance. When Waller's turn came
to be rewarded in this way by the party, he was
either passed over or given menial positions such
as assistant steward at the Kansas State Prison,
steward at the Osawatomie insane asylum, and
superintendent at the School for the Blind in
Kansas City, where he was overseer of the school's
broom manufactory. After ten years of service
to the Republican party, Waller realized that

success promote the civil rights of fellow blacks.
A distinguished Republican lawyer, Judge N. M.
Hubbard, took him under his wing and taught
him law. Waller was admitted to the bar in
Marion, Iowa, but his new profession was no
guarantee of employment. Clients, even black
clients, preferred to entrust their business to
more influential white lawyers. This prompted
him to relocate to Leavenworth, Kansas, at the
time of "what was surely one of the most signifi-
cant population movements of the nineteenth
century: the three-year migration of tens of thou-
sands of oppressed blacks from the South . . .
known as the Great Exodus" (Woods 1981:19).
Many among them had the hope of forming all-
black communities in these new lands, where
"they could act out their lives relatively free of rac-
ist constraints, accumulating wealth and exercising

his skin color made his election to state office impossible.

As a means of resolving the problem of participation, citizenship, and civil rights, the idea of a utopian, all-black colony had never been far from Waller's mind. In 1879 he had "urged Congress to appropriate one million dollars for the colonization of enterprising blacks in Nebraska, Colorado, Minnesota, New Mexico and Kansas," and in 1880 he "became caught in the Oklahoma fever," where he "recommended a settlement of 100,000 Negroes" (Woods 1981:117). By the beginning of the 1890s, Waller was thinking of Africa.

During the 1890 U.S. presidential election cycle, he again worked for the Republicans, to bring about the triumph of Benjamin Harrison. The party of Lincoln, with all its shortcomings, was less unpalatable than the Democrats to Waller and a majority of black voters. Too visible among southern Democrats were some white supremacists, including fanatics such as Missouri's James K. Vardaman, who even hinted at reviving the "peculiar institution" (Woods 1981:xiv). Consistent with his idea that domestic appointments of significance were barred to him, after the 1890 election was decided in Harrison's favor, Waller began lobbying for a consulate abroad. He was backed by several white Kansas Republicans and by a former rival, Democrat C. H. J. Taylor, a prominent black lawyer and politician who in 1884 had been appointed minister to Liberia by President Cleveland. Taylor invited Waller to join the editorial page of the *American Citizen* and used his newspaper to promote Waller's expectations for a consulship. The alliance between these two conspicuous black Kansans transcended party boundaries and was no doubt meant to put pressure on the white leadership on both sides.

Waller was appointed consul to Madagascar on February 5, 1891. It was not his preferred choice. In a letter addressed to Secretary of State James Blaine, dated June 22, 1889, Waller had written:

In case you should elect to appoint another man to the Haytian Missions, I herewith submit an application for appointment as Consul to one of the following places:

Peru-Callao
San Salvador
Manila
Victoria, British Columbia
Awaiting your action I am very respectfully, etc.[4]

It is worth noting that in 1889 the Haitian mission went to the prominent African American lawyer, abolitionist, and leader Frederick Douglass, and that Waller's own thinking revolved around postings in South America, in two coastal places, Brazil and Peru, where the presence of Africans was notable.

Background: United States–Malagasy Relations

When Waller arrived in Madagascar on July 24, 1891, the relative autonomy and independence of the Merina kingdom in the highlands—which, during the nineteenth century, had managed to establish centralized control over much of the island—was about to end. England had encouraged and abetted Merina expansion and dominance over other Malagasy polities, such as the Sakalava, which in turn were backed by the French. During the last quarter of the century, when the notorious European scramble for colonial dominion in Africa accelerated, the French wanted Madagascar and left no room for doubt about it. In 1881, a dispute over the inheritance of Jean Laborde,[5] who had been given land in concession by Queen Ranavalona II, and a naval incident off the west coast of Madagascar provided France with an excuse to put pressure on the monarchy and to raise the possibility of military occupation. The French commissioner in Antananarivo demanded an indemnity for Laborde's

land and, more ominously, a recognition of French sovereignty "over the north-west coast of Madagascar, based on treaties obtained by naval officers from local chiefs between 1840 and 1842" (Brown 1978:223).

The Malagasy prime minister responded by launching a diplomatic offensive, sending missions to France, England, Germany, and the United States. The effort did not succeed. Germany and the United States saw the dispute as a British-French one and stayed out. After the opening of the Suez Canal in 1873, the British were more concerned with securing their position in East Africa than in Madagascar. This was understood by the French who, following their defeat in the Franco-Prussian War, were, by the 1880s, slowly gathering strength and reasserting their overseas presence. They would recognize England's control over Zanzibar but in exchange would get a green light for their ambitions in Madagascar. Faced with this strategic choice, British politicians decided to protect their interests in the Suez Canal and East Africa and left the door of Madagascar open to France.

The 1881 Malagasy-French War ended, short of an invasion, in a peace treaty signed in 1885. It was meant to be a compromise, but the terms favored France: "They obtained the rights to occupy the harbor of Diego Suarez, a huge indemnity of ten million francs, the right of French citizens to lease property on renewable leases of indefinite duration, and the appointment of a French Resident in Antananarivo, responsible for the conduct of Madagascar's foreign relations" (Brown 1978:231). Beyond sounding a somber note for the future of Malagasy independence, the terms of the treaty would also play a central role, just a few years later, in the trial and imprisonment of John Waller.

The history of Malagasy-American relations on which the new consul could look back was very different from that of relations tying the island to Europe. Relations with the United States, wrote

G. Michael Razi, "were not attached to aggression or ulterior motives. The Americans did not come to conquer, to exploit or to evangelize" (1983:25). Americans were interested in commerce. Prior to the Civil War, Salem merchants dominated the trade in cattle hides in northwestern Madagascar, as well as whaling off the coast (Bennett and Brooks 1965:xxvi; Razi 1983:5–6). French and English trading interests were mostly concentrated along the east coast, facing those countries' stations on the islands of Réunion and Mauritius. The queen of Madagascar, however, always set the tone for diplomatic relations. She determined who could trade and when, and who was allowed to come up to the capital to do official business. After the English and French bombarded the port of Tamatave in 1845, she banned all international commerce on the island but exempted the Americans, who were allowed to continue operating on the west coast. Through the port of Majunga, the American agent William Marks "worked in close cooperation with American trading interests in Zanzibar," which for several years enjoyed a "monopoly on foreign trade," while "Marks became a familiar figure in the Malagasy court" (Brown 1978:181).[6]

After the Civil War, the United States named John P. Finkelmeier its first commercial agent to Madagascar and sent an official U.S. naval mission to the island with the purpose of negotiating the opening of coal refueling stations for whalers. During this period the trade in American goods grew enormously, to the point that the Malagasy prime minister, Rainilaiarivony, wrote to President Chester Arthur in 1884 that "American Malagasy trade is greater than . . . all other nations combined . . . [for] our people are clothed with your cloth, our homes are lit with your oils, our soldiers are armed with your guns" (Mutibwa 1972:40).[7] In the same letter of May 20, 1884, Rainilaiarivony told Arthur: "We are a new nation. . . . it is only now that we are beginning to understand the virtues of, and the need for, modern progress, and are

FIGURE 71 **Commercial Street, Toamasina**
(*Tamatave—Rue du Commerce*). During the Merina
kingdom, Tamatave (Toamasina), a port town on the
east coast of Madagascar, was home to the American
consular office as well as all other foreign embassies.
Collotype. Photographer unknown, c. 1905. Pub-
lished by Maison P. Ghigiasso, Tamatave. Postcard
collection, MG-7-25, Eliot Elisofon Photographic
Archives, National Museum of African Art, Smith-
sonian Institution.

becoming aware of the force of a national life. . . .
We look to the vast manufacturing capacity of
the United States for meeting our demands and
to instruct us in the use of modern inventions."

The rhetorical and flattering tone of the
letter—obviously colored by the difficulties
Madagascar was experiencing with France and
England—was tempered by references to more
practical matters in a message the prime minister
sent the same day to Secretary of State Freling-
huysen. "The commerce of American products
in Madagascar," wrote Rainilaiarivony, "has sur-
passed 400,000 dollars in 1879, and if it continues
at the present rate will increase tenfold in a short
time" (Razi 1983:17–18). The great success of
American commercial practices and goods led
some Malagasy to think of Americans as people

residing in a distant land and "all engaged in
the making of brown cotton." In pursuing this
profitable trade, however, American merchants
had to bow to Malagasy tastes. Finkelmeier
observed, for example, that the locals refused to
buy yellow cloth, since that color had negative
connotations for them. When France imposed
colonial status on Madagascar, American com-
mercial activity was reduced to almost nothing.
But even today, along certain parts of the west
coast—a reminder of American trading preemi-
nence in the nineteenth century—the word for
money is *drala*, derived from "dollar."

Agent John Finkelmeier and his successor,
Colonel William Robinson, both good observers
of the island's customs and politics, were sympa-
thetic toward the Malagasy. Finkelmeier realized
the importance of gift exchanges with the Mala-
gasy to strengthen relations. Consuls were required
to live in the eastern port city of Tamatave (fig. 71)
and needed permission to visit the capital, Anta-
nanarivo, in the highlands (fig. 72). When they
did, they were made to wait some miles outside
until the queen gave the word, presumably when,
according to the astrological system used at the
court, the moment was considered propitious.[8]

Tananarive. – Vue Ouest.

The functionaries of foreign nations were then presented with gifts, which they were expected to reciprocate. When Finkelmeier went to Antananarivo in 1867 to negotiate the first United States–Madagascar treaty, the French envoy suddenly died, and Finkelmeier felt compelled to attend his funeral. This made him impure, and he had to wait a month before the queen would receive him again. Finkelmeier also understood how sensitive the issue of property in land was for the Malagasy. In a report to the State Department, he remarked that "the right to purchase land, so persistently refused to other nations as a matter of course, I could not claim and I really do not believe that American citizens will ever wish for it" (Razi 1983:41–42). The Malagasy's strong opposition to alienating land to foreigners grated especially on the French, as Waller would later come to realize all too well.

Colonel Robinson, a veteran of the war with Mexico, was in fact the first United States consul to Madagascar. He served in that capacity from 1875 to 1887. As Michael Razi pointed out, Robinson's unpublished, detailed reports to the State Department constitute an extraordinary and insightful source of information on the inner

FIGURE 72 **Western view, Antananarivo**
(*Tanarive—Vue Ouest*). Antananarivo was the seat of the Merina government in the time of Waller's consulship. Collotype. Photographer unknown, c. 1900. Postcard collection, MG-7-26, Eliot Elisofon Photographic Archives, National Museum of African Art, Smithsonian Institution.

workings of Merina politics. He was well aware of the symbolic value of the queen and of her role in the rituals surrounding Merina contacts with the outside world—an element the French missed. In 1875, Antananarivo had 200,000 inhabitants, and Robinson was impressed by it. The Queen's Palace, he reported, "is at least twice the size of the White House," and palaces for the chief notables, "equal to the best Washington residences" (Razi 1983:32). He also liked the Hova, whom he found to be good scholars "and quick to apprehend and consequently make rapid progress" (Razi 1983:32). At a time when diplomats were desperately competing with each other for the queen's favor but were unable to speak to her directly (she merely showed herself and then had a spokesman deliver her message), Robinson succeeded in carving out a privileged space for himself. He owed much of this, no doubt, to the

Merina's need for a new ally in their mounting confrontation with France, as they realized that England could no longer be counted on. When tensions between France and Madagascar escalated in the early 1880s, the queen asked Robinson to move to Antananarivo and act as an advisor. He was obviously sympathetic toward the Malagasy, and he accompanied their 1882 delegation to Europe and the United States. The French were discomfited at his presence in Paris, and he had to resort to disguises in order to remain with the Malagasy and assist their efforts. Out of his own pocket he bought winter clothes for some members of the delegation, who were neither used to nor prepared for the cold winter weather of the French capital.

The United States was, therefore, well regarded by the Malagasy in 1892, when Waller landed in Tamatave. "The policy of the Republic is neither of aggression nor aggrandizement," Queen Ranavalona III had written a few years earlier to President Arthur. "We understand," she continued, "that the policy of the American Republic is the extension of commerce, the increase of learning, the fostering of those manufactures that are of benefit to man and the upholding of laws that protect and make happy their citizens. We wish to benefit ourselves by these things, to live in peace with all men and to develop like industries, to promulgate corresponding laws and to bring our Dominions in closer commercial relations with the American Republic" (Razi 1983:35). But, as we have pointed out, there were solid and urgent reasons for the Malagasy government's overtures toward the United States. At the end of the same letter to President Arthur, the queen left no doubt about her predicament. "I . . . solicit from Your Excellency the President of the United States," she wrote, "the friendship and assistance . . . in these Our troubles [with France]. I request . . . the Mediation of the Republic in my present difficulties with the Republic of France. We request of your excellency the appointment of

a committee of arbitration consisting of equal numbers of American, Malagasy and French members to discuss the causes of my present difficulties and the just settlement of them" (Razi 1983:35).

The idea of an arbitration committee never materialized, but almost as soon as he landed Waller had to play a part in the ongoing and serious dispute between the governments of Queen Ranavalona III and France. The way in which he did so set the tone for his entire experience in Madagascar. At stake was nothing less than Malagasy sovereignty.

The New Consul Arrives

The French-Malagasy peace treaty of 1885 had, in effect, turned the island into a French protectorate. According to its terms, the Malagasy were to relinquish the administration of foreign affairs to France. Of course this was a terrible blow for the Merina: their ascendancy as a national force, their preeminence over other strong local polities such as the Sakalava and Betsileo, had been built on the ability they had shown to position themselves as interlocutors for the entire country with the rest of the world. Merina rule offered France and England, the two main overseas rivals for dominion over the island, the closest resemblance—however limited—to a nation-state's bureaucracy, and both sides derived benefits from the arrangement. Now the French were coming close to replacing the Merina altogether at the center of this structure, and the Merina fought back. Prime Minister Rainilaiarivony strove to curb the effects of article two of the 1885 treaty, which put Madagascar's foreign relations in the hands of the French resident general in Antananarivo. To that end, Rainilaiarivony succeeded in adding an appendix to the main text of the treaty. His tactic was to try to render the fiduciary role of the resident general as foreign minister a mostly perfunctory one by reserving for the Malagasy the right to engage directly with foreigners on commercial

matters. So long as the Merina could continue to sign commercial treaties with other nations, he thought, Madagascar would be able to retain a degree of leverage and independence.

A symbolic testing ground for this dispute lay in the question of who would issue exequaturs to foreign diplomats—that is, whether the credentials to execute the mission of representing a foreign nation in Madagascar would be granted by the Merina prime minister or the French resident. Waller's immediate predecessor, Consul John Campbell—an otherwise "most persistent and effective advocate" of American economic interests and someone alert to the need to counter French aspirations in the island (Woods 1981:128)—had greatly angered the Malagasy by presenting his credentials to the resident general. Waller, instead, submitted his diplomatic accreditation directly to the queen. The French protested, notifying the State Department that the new consul should reapply for an exequatur through their mission in Antananarivo. Waller argued with Washington that such an action would alienate the Malagasy and be tantamount to abandoning Madagascar to French control. Concerned about French ambitions in Haiti and Liberia, and aware of domestic support for the Merina monarchy among the American black electorate, the United States government endorsed Waller's position.[9]

After the worst of the dispute was over, Waller wrote a letter to the prime minister, dated in Tamatave on September 9, 1892, attaching a copy of a dispatch on the political situation that he had previously sent to the State Department. The purpose clearly was to ingratiate himself with the Malagasy authorities by playing up his role in the events. "The French Minister at Washington," he wrote in the cover letter, "is using every endeavor to induce my Government to withdraw the Exequatur given me by Her Majesty the Queen of Madagascar. I am doing all I can to prevent the success of the French Ambassador in this matter and I have but little

doubt that I will succeed, yet in order to do so I must have the encouragement and support of the whole Malagasy Government."[10]

In the enclosed copy of the dispatch to the State Department, Waller explained the antecedents for the crisis. He would later have cause to regret the critical references he made in this document to John Campbell, the previous U.S. consul in Tamatave. "In 1887," Waller said, "France insisted that the Government of the United States should apply for an Exequatur through her Resident General and not through Her Majesty the Queen of Madagascar, which was done by my predecessor, Hon. John P. Campbell. . . . This placed our Government in the very unpleasant predicament of being without protection. . . . property and interests amounting to millions of Dollars were subjected to the rabble in the very presence of an American Official because he was powerless to prevent it, because, having applied to a powerless source unable to fulfill the promise made to America, [he] was without protection himself."[11] The dispatch ended with words that Waller surely intended to have an effect on the prime minister: "On my arrival at this post . . . I bore instructions from the Department to apply to her Majesty's Government for my Exequatur, which instructions I obeyed and thereby drew upon myself the most bitter and unreasonable criticism from a large number of French and several American Journals, many of which demanded my recall."[12]

Following the exequatur episode, Waller further alienated the French by attempting to impede their plans to enslave Malagasy subjects by shipping them, against their will, to several points of the empire to serve as workers. The French colons in Madagascar thought "the black consul in Tamatave" was too close to the Merina and a "threat to their interests" (Woods 1981: 130–31).

Back in the United States, Waller's actions had indeed—as he mentioned in the dispatch—

brought him criticism. A certain Mr. Wilkinson, for example, provided the following commentary on the exequatur dispute, which was published in several Chicago newspapers: "I do not think that the trouble over the American Consul will prove serious, but it was a mistake to send a Negro to that country; the natives, though dark themselves, feel that the white man is their superior, and they think that a white man should be sent to represent a nation which they believe to be a nation of whites" (*Indianapolis Recorder*, July 9, 1892).

Waller somehow got copies of Wilkinson's article and responded in a letter from Tamatave, dated May 14, 1892, that it was known "to the intelligent Malagasy as well as others that are informed" that there were "10 000 000 Afro-Americans" in the United States; that no "'mistake' was made in sending an Afro-American to represent the government of the United States in Madagascar"; and that "none other should be sent to represent it in any part of Africa." Furthermore, "the Malagasy regard no people, either white or black, as their 'superiors' nor do they look up to the white man as their God. If white men were to interfere with their rights to such an extent as to become obnoxious to the government of Madagascar, the authorities would expel them from the island without ceremony, no matter to what nation they belong."

The Polemical Land Grant and What Followed

Even though Waller left behind almost no writings about his family life and private thoughts (Woods 1981:239), it is safe to assume that he saw his appointment to Madagascar as a chance to realize some of the personal goals that the climate of racial prejudice in the United States had stopped him from achieving. The widening of the U.S. frontier to encompass lands overseas had made him change his mind about plans encouraging American blacks to settle abroad. He no longer saw such

plans exclusively as ploys of white supremacists to return the descendants of African slaves to Africa or as carrying the risk of losing American citizenship. With Manifest Destiny knocking at the doors of Central and South America, as well as Cuba and the Philippines, Waller believed that it was also the right of Afro-Americans to claim their share in the new commercial prospects. In the late 1880s, two associations of black Kansans— Waller's own constituency—were formed to promote and assist emigration. One of them had Africa as its goal, and the other, Brazil and the Argentine Republic.[13]

Whether or not the newly appointed U.S. consul, as he sailed toward Tamatave, had plans already formed to launch his own colonization project in Madagascar, it is clear from records of his correspondence with the Malagasy government that he lost no time in lobbying the prime minister for a land concession.

On December 16, 1892, barely three months after his arrival, Waller sent the prime minister a private letter asking to be granted a strip of land north of Vohemar on which to raise cattle and cut timber. On June 28, 1892, with no news from the prime minister regarding his request, he wrote again. "I feel that the stand which I have taken in the interest of the Hova government," Waller said, "and the arguments which I have made with my own government, contending for a recognition of the Independence of Madagascar by the government of the United States in face of the most bitter abuse from the French press of Madagascar, Bourbon and France, should merit a reply to any communication which I . . . may be directed to place before you."[14]

On January 12, 1893, Waller wrote to the prime minister yet again, pressing his case. "Having resided in Madagascar during the past year," the letter read, "and having been placed in a position where I could and can still assist the Malagasy government in very important matters . . . I now very respectfully request that your Excel-

lency's government will kindly grant to me the following strip of land, viz. commencing at the northern boundary line of Patterson's concession, and extending to the southern line of the Osborn Timlett concession, near Vohemar . . . for the purpose of raising and breeding cattle and with the privilege of cutting, sawing and shipping . . . timber."[15]

To put Waller's demands in perspective, it is necessary to consider the political and economic circumstances of Madagascar in 1891. The Malagasy government was handicapped by a bureaucracy that concentrated too much power in the prime minister. Even though it had been reorganized in 1881 with the creation of several ministries (following the British model), this bureaucracy had no currency in which to make transactions, no functional system for collecting revenue, and not even the most elementary network of roads to unite the country and convey domestic products to foreign markets. Thus, in its attempts to consolidate independence by expanding the economy, the Malagasy government had to rely on a very vulnerable arrangement: the turning over of profits by provincial governors—who received no salaries—and by its few representatives abroad. These last were themselves foreigners and traders. With so much pressure placed on the exploitation of raw materials for revenue, it was not surprising that the Malagasy government would turn, reluctantly and cautiously, to land grants in order to develop an infrastructure of production.[16] Such policies generated a Conradian atmosphere of competition and ambition, attracting speculators and adventurers. "All the traders in that country," said Ethelbert Woodford, an American "civil, mining and consulting engineer" who had interests in Madagascar, "are engaged in the same line of business, and each of course feels anxious to cut each other out and secure their trade. . . . [They are] a low class of men, not [of] very refined ideas nor very high moral principles" (United States Foreign Relations 1895:370).

Waller tried, to a degree, to keep official business and private matters separate, and he often delivered correspondence on the prospective land concession to the prime minister through his wife, Susan, and his stepson, Paul Bray. There is some evidence that the family felt emotionally pulled apart by conflicting interests. They identified with the plight of the Malagasy and sought, at the same time, to make the most of their hard-won opportunity to improve their fortunes. Unlike notorious commercial expansionists such as Cornelius Vanderbilt and even the financier and speculator Ethelbert Woodford—representatives of the merchant class, which he held as an example—Waller and his family were almost destitute.[17] Susan Waller and Paul Bray intended to join the public opinion battle on the side of the Malagasy, against the French, by writing newspaper articles. "I wrote several articles," Susan later recounted, "but after having my manuscript prepared [my husband] would not let me send it. . . . I said to my son [Paul Bray] that I was not allowed to write on politics. He said it would make no difference about him. He was not there officially. He prepared his manuscript but when Mr. Waller heard of it, his had to go the same way as mine—to the wastebasket" (United States Foreign Relations 1895:362). Unlike his stepfather—to whom he was close—Paul Bray learned Malagasy. On the eve of the French takeover of Madagascar, Bray wanted to join the local army and resist the invasion. This caused the French to put him aboard a ship and expel him from the island.

Waller's pleas for a land concession to both the prime minister and the queen were unsuccessful until the eleventh hour of his two-year stay in Madagascar. Indeed, the prime minister did not even bother to reply to most of his letters.[18] "On the 3rd of January last," Waller wrote in frustration to Rainilaiarivony (June 16, 1983), "I handed to Mrs. Waller a private communication addressed to Your Excellency in which I had the honor to request of you a certain grant or concession of

land. . . . I have written repeatedly to Your Excellency concerning this matter but have had no response."[19] When a response arrived, it was negative. It coincided with Grover Cleveland's election to his second term as president, in 1893, after a hiatus of four years. In a letter dated July 14 of that year, Waller announced to Queen Ranavalona III that there would be no changes in U.S. policy toward Madagascar and then added, "I am very sorry to learn that I cannot have the land which I have selected and which is shown in a letter delivered to Your Excellency last February by my wife. I cannot handle land in the interior, but desire something on the coast. I will be satisfied with 40 miles square on the southwest coast including Fort Dauphin or Vohimanitra. I prefer Faradofoy. Certainly if Your Excellency is disposed to grant me a concession, you will select one for me from one of the three locations named."[20]

With Cleveland's election, Waller was going to lose his consular position. Forced to contemplate returning to the United States without having improved his personal situation, he decided to try to stay on in Madagascar as a private citizen. In a letter of July 28, 1893, in which he regrets to inform the prime minister that he has been "replaced as consul of the U.S. by a gentleman with the views and policy of the President," he surprisingly asks Rainilaiarivony whether "Your Excellency be pleased to appoint me on the legal staff of her Majesty's Government."[21] The appointment never came. Nevertheless, Waller decided to stay in Madagascar and moved with his family to Antananarivo. In partnership with George Tessier, a British subject, he opened a grocery shop to make ends meet while he continued to lobby the government for land. Finally, in March 1894, two months after stepping down as consul, Waller was awarded a big concession in the south.

It is likely that the influential British colony in the capital had a hand in bringing about this turn of events. The fate of Madagascar's independence had been decided in 1890, with the signing of the Anglo-French Convention. After a century of successful involvement in Malagasy affairs—England had assiduously supported the Merina—this document sealed Whitehall's decision to protect its interests in East Africa and India and abandon Madagascar to the French (Brown 1978:234–35). The substantial British community in Antananarivo also felt the shock, for the pact made its own future uncertain. British residents naturally looked toward the Americans as allies. The British newspapers in Madagascar had asked Mrs. Waller to write for them the articles her husband judiciously had her withdraw. Now, E. Underwood Harvey, editor of the *Madagascar Mail*, figured as Waller's partner in exploiting the land grant. With the French army already fighting the Merina in the north, French plans under way to establish a garrison in Fort Dauphin, and increasing political pressure in Paris to settle the Malagasy question once and for all with an invasion, both the Merina government and the British *colons* stood to gain from giving Waller, the private citizen, a chance in the south.

French reaction to news of the concession was not slow in coming. Control over Malagasy land had always been at the heart of France's policies on the island. The official French position was, accordingly, that "the Government of the Republic does not recognize the existence of concessions granted to individuals by the Malagasy Government on the grounds [that] . . . they constitute a monopoly and a privilege which infringes on free commerce." Then, rather paradoxically—without questioning the right to make land concessions but asserting the French themselves in the role of making them—the statement concluded: "Thus, the French Government considers null and void any concession which has not been approved by the Resident General and has not been registered at the Residence General in Antananarivo" (*Progres de l'Imerina*, May 16, 1894).

The English press in Antananarivo countered the French argument by appropriating it and

turning it upside down: "Throughout the world, in all its colonies, in all her dependencies, in all the countries where her influence is in ascendancy or striving for ascendancy, the policy of France is to so act as to endeavor to attain the monopoly of commerce and of natural resources for the sole benefit and enjoyment of French enterprise." The same article went on to say that the American-Malagasy treaty of 1883 gave the Malagasy government the right to enter into commercial agreements with American citizens, and it voiced the argument—familiar throughout both the United States and the European colonial frontiers—that land or resources that "have been dormant for centuries" would remain so for many more if not "handed over to large minded development" (*Madagascar News*, May 19, 1894).

The French public-relations war and media attacks had dogged Waller from the beginning of his posting, and they quickly got personal, in predictable terms. He had just stepped down as consul when the following article appeared in *Le Madagascar* (January 18, 1894):

> Grandeur and Decline. That is the title of a little masterpiece which Mrs. Waller, the ex-consuless of the United States of America could write. It is well known that Mrs. Waller held the magisterial pen and that the "Courrier de Madagascar" was honored not long ago by publishing her thrilling tales of travels on the Ohio and Mississippi [rivers]. In truth the "colored gentleman" has resigned his high functions to open . . . a grocery in Antananarivo. The seat of the boss behind a counter will better suit him than the consular armchair. And, since he will necessarily become purveyor to the Palais, an advantage so inestimable although only honorary, fortune cannot fail ere long to visit his shop. Mr. Waller proceeded to Antananarivo last week, after leaving his piano with one of our friends.

But setting aside the racial slurs and the high stakes of the colonial dispute in which he had become embroiled, the land grant itself was challenge enough for Waller. The terms left its location undetermined, beyond stating vaguely that it was to comprise "fifteen (15) miles square (or 225 square miles) . . . situated in the District of Fort Dauphin" (fig. 73; it would have been in the area marked "unexplored" in fig. 68). It was granted for

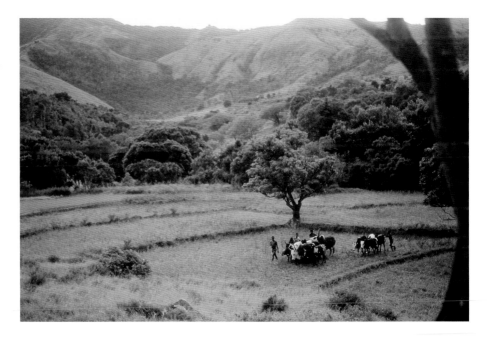

FIGURE 73 **The area of the Waller land concession and its inhabitants as they can be seen today.** Tatsimo territory, southern Madagascar, 1996. Photograph by Wendy Walker.

thirty years but could be canceled without compensation by the proprietor, the queen of Madagascar, at any time, if the laws of the country were violated. Likewise, the products to be exploited or cultivated could not "be contrary to the laws" of the country, and Waller, "his heirs or assigns" were "forbidden to dig minerals from these lands," although they retained the first option to negotiate terms for their exploitation, if any were discovered. At the end of the time allotted for the concession, Waller had to "turn over to the Malagasy Government the plantations, buildings, and all the materials that were employed . . . without any compensation whatsoever." The final article of the agreement further stated that nothing in the lease "shall be construed to interfere with . . . the prevailing customs" of Her Majesty's kingdom.[22]

Unremarked in the lease was a hard fact about Her Majesty's kingdom and the Fort Dauphin district: the Merina could hardly claim to control it. The British journalist E. F. Knight, sent by the *Times* of London to cover the impending Malagasy-French war, landed at Fort Dauphin in 1895 and had this to say about the place, a passage worth quoting in full:

> We found about a dozen Europeans in Fort Dauphin, all British and Norwegian subjects, the French having left a few weeks previously. The traders were in a despondent condition, for the civil wars raging in all the surrounding country had almost put a stop to commerce; on the one hand, no cloth was being purchased from the traders, and on the other hand, the natives were no longer bringing in india rubber—the principal article of export—from the forests. The [Merina] Governor and his garrison were practically isolated in their fort, and the Hova [Merina] rule scarcely extended outside its walls. The Tandroy tribes, who occupy the southernmost part of Madagascar

> and are wholly independent, were carrying on extensive raids at the time of my landing. They had murdered many Hova and had driven the Europeans out of Mandrare and Andrahombe, two small trading-stations on the coast, about 20 miles south of Fort Dauphin, had pillaged their stores, and were reported to be advancing on Fort Dauphin itself. There was war in fact in all directions, and on the road we had to traverse, fighting on a larger scale than usual was going on between the Queen of St. Lucia and her rebellious people. It was no wonder then that when I paid my respects to the Governor in his ruined fortress, I noticed that he had a harassed and preoccupied air. (Knight 1896:364)

In other words, the "uncultivated and dormant" land assigned to Waller was neither empty nor quiet. Nor was it an effective part of a kingdom ruled by the Merina queen. Waller, moreover, had never before been in the south. But all this mattered little to the kind of logic that underlay his project. The lease was the window of opportunity he had been waiting for, and he quickly and vigorously set about to seize it (fig. 74). He surely realized that the concession's worth depended on how it would be perceived outside Madagascar, in the metropolitan centers that saw the world hierarchically and were able—unlike Waller—to underwrite policies of development and exploitation.

To attract capital, Waller and Harvey, editor of the *Madagascar News* and silent partner in the "Wallerland" venture, together wrote a circular extolling the advantages of the concession, which they sent to the publishers of more than one hundred newspapers in the United States and Great Britain (Woods 1981:134). Waller's stepson, Paul Bray, joined him in supplementing the circular with letters they both wrote to

"blacks and influential whites" on "the economic opportunities and racial climate of East Africa" (Woods 1981:225, n. 82).

One of these prominent figures was John Mercer Langston, "the first black lawyer in the West, the first Afro-American elected to public office," and a man of many accomplishments (Cheek and Cheek 1989:2).[23] Because the concession was so resisted by the French, Waller knew he needed political support from the United States, and he looked for allies among distinguished members of the African American community. His first letter to Langston was dated in Antananarivo on March 30, 1894, just a couple of weeks after the grant had been signed. Waller was obviously hoping to get Langston involved as both a lawyer and a fund-raiser. "These lands," he explained, "are covered with rubber, the finest of timbers, plenty grass & water for grazing purposes." According to "competent judges," he continued, the land also contained gold, silver, lead, iron, and copper. As to how the concession would be exploited, "it is my intention," Waller wrote, "to colonize these lands with people from the English Colony of Mauritius . . . colored peoples the parents of whom were emancipated by the English 80 years ago. . . . The importation of "Cooly" labor into Mauritius has so reduced labor price . . . [that] the colored people of that unfortunate island will be only too glad to accept homes upon my concession."[24]

In his reply, Langston indeed read between the lines and intimated to Waller that he would be needing a lawyer.[25] "Allow me to say seriously that I am aware that I will need legal advisers," Waller promptly wrote back, and he asked Langston to become one of those advisers.[26] The other counsel he chose was W. T. McGuinn. A prominent black Kansan, McGuinn had criticized Waller in the past for "lacking a backbone" in his dealings with the state's Republican bosses. Because neither man was close to him, it is safe to assume that in choosing them for their visibility and standing

FIGURE 74 Advertisement for plots in Wallerland run in one of Madagascar's English-language newspapers, the *Madagascar News*, 1894. Courtesy of the National Archives and Record Administration, Madagascar. Photograph by Barry Singer.

among African Americans, Waller knew that support of the U.S. government for his project would not come from the white establishment. It would have to be fought for, and his best chances were to mobilize black Americans behind him.[27]

As for particulars about how he intended to obtain capital, Waller's explanations to Langston were couched in rather vague language. He claimed to be in correspondence with financial houses in England and the United States, that one unnamed Chicago firm had offered to furnish a sawmill and other machinery, and that an English firm would provide farming utensils "and all manner of merchandise and provisions for the Colonists."[28] All this was to be provided on credit and paid for with future products from the concession. Though he wanted to operate the colony "through a Syndicate of Afro-Americans," he feared that he would be "compelled to find the capital among white firms," adding, "I hope to keep the concession within the control of colored men, but I am not sure that I will be able to do so."[29]

While he wrote these letters and published propaganda articles in British, American, Malagasy, and Mauritian newspapers, Waller was planning to sail at the shortest notice to England and the United States. There, he hoped to gather financial backing for his enterprise. Paul Bray, in the meantime, began corresponding directly with Langston on specifics of the project and traveled to Mauritius on a mission to recruit colonists for Wallerland.[30]

Even while the objective basis for the concession was unsound, risky, and vulnerable, Waller and Bray acted with energy and imagination to launch and give it shape. At this point, however, E. T. Wetter, the new American consul, came unexpectedly into the picture. His intervention would put an end to Waller's prospects in Madagascar.

Imprisoned

Edward Telfair Wetter, the new American consul in Tamatave, was a Georgian, the son of a slaveholder ruined by the Civil War (Woods 1981:137). He seems to have gone out of his way, from the very beginning of his tenure, to harm Waller. The former consul's handling of the estate of W. F. Crockett offered a good excuse. When this American businessman had died in Antananarivo in June 1892, he was survived by a Malagasy common-law wife and their two children.

In a "quasi-testamentary paper," Crockett had "expressed the wish that his property might by placed in native hands" in order to escape the costs "which would result from its administration by the United States Consul" (United States Foreign Relations 1895:1895). The widow, however, wanted Waller to intervene. He asked the State Department's permission to do so, and, permission granted, proceeded to sell Crockett's properties and loan the resulting money to Malagasy subjects. The interest on the principal was supposed to go toward the upkeep and education of one of Crockett's daughters, who went to live with the Wallers. In his very first official communication, Wetter complained to the Sate Department that Waller, after selling the Crockett estate, had never accounted for the money. The implication was clear: the former consul had abused his position, embezzled the money, and—it was assumed—used it to bribe Malagasy officials to obtain his land concession. At the end of March 1894, as Waller signed with the Malagasy government the land concession document, he learned that Wetter was filing a civil suit against him on behalf of the United States government. The charges: negligence and mismanagement of fiduciary trusts.

In October 1894, Waller left his family in Antananarivo and traveled to Tamatave, where, according to his fund-raising plans, he intended to board a ship to the United States, traveling

via London. As soon as he arrived in Tamatave, Wetter had him arrested. Waller was subsequently tried in consular court, found guilty, and ordered to pay, within forty-five days, $1,964 to the Crockett family. Wetter was both judge and a member of the jury at the trial. Another member of the jury was vice-consul R. W. Geldart, who had served under Waller. The French *colons* obviously preferred him over the black Kansan. "We would be happy," *Le Madagascar* had expressed as Waller left the consulate in the interim care of Geldart while Wetter was en route, "to see Mr. Geldart confirmed by Washington in his new functions" (January 18, 1894).

On a personal level, Waller now faced an impossible situation: he was detained in Tamatave, away from his family, with no money and his fund-raising trip abroad on hold. On an international political level, the Malagasy-French conflict was entering its final phase. In November 1894 the French National Assembly voted to appropriate 65 million francs to finance a mighty expeditionary force. The days of the Merina kingdom were numbered.

As Waller tried desperately to come up with the Crockett estate's money, he continued to correspond with his lawyers in the United States. With the French invasion imminent, he needed to make sure that his government would stand behind the legality of the concession. Cleveland's administration was not forthcoming in providing it, but the State Department finally communicated to Langston and McGuinn, in October 1894, that it considered the Wallerland operation legitimate and therefore eligible for official protection, like any other American concern overseas.

Susan Waller was, in fact, bearing the brunt of collecting the Crockett money. She and her four children were living as guests of George Tessier, her husband's partner in the grocery store. When the Malagasy to whom Waller had loaned the Crockett money were unable to produce it, she turned for help to Prime Minister Rainilaiarivony himself. In a personal letter she asked him for a loan of $2,000—enough to settle the consular affair and free her husband to leave for the United States.[31]

Time and events caught up with the Wallers. In December 1894, a French naval force took Tamatave and placed the town under martial law. Waller witnessed the barbaric behavior of French soldiers, who destroyed property and raped Malagasy women. Paul Bray, then returned from Mauritius, was harassed and roughed up, because the invaders assumed he was Malagasy. "I am an American," he protested, and he was let go only after Consul Wetter corroborated the fact. Waller himself was attacked one night by French sailors who broke into the house where he was staying. He managed to escape without serious injury, but on March 5, 1895, just before dawn, the French military police arrested him. He was charged with spying for the Malagasy.

Waller had been singled out as an example. Evidence for the charges was flimsy at best; it consisted of two letters he had sent to his wife and Tessier in violation of a postal curfew imposed by the invading forces. The letters described the behavior of French soldiers during the occupation of Tamatave and talked about buying two guns in London for a couple of Malagasy friends who had requested them. On this evidence Waller was court-martialed on March 20 and, after two and a half hours, found guilty as charged. The proceedings were conducted in French, a language Waller did not speak, and without his having proper legal counsel. The sentence—twenty years in prison—was to be served in France.

Wetter did not assist Waller before the trial, and after it was over he waited for two days before inquiring about it with the French authorities. This gave credence to the notion, held by some Frenchmen, that the U.S. government would not bother about the fate of a black American.

The Cleveland administration, however, did not abandon Waller, and "Washington labored frantically to secure the ex-consul's release, even at one point threatening an open break with France" if American demands were not met (Woods 1981: 143). The government's position was no doubt influenced by the barrage of articles in support of Waller and the Malagasy that appeared in the black press. Several of these articles featured a portrait of Ranavalona III, the young, black Malagasy sovereign. Susan Waller, Paul Bray, Waller's sister, and Waller himself—sending letters from prison—participated in keeping the pressure on. "PS: John Wetter is white," said Waller in a letter to his sister, and "had he done his duty towards me I would not be here" (*Cedar Rapids Evening Gazette*, September 11, 1895).

"Here" was the Maison Central at Clairvaux, the French prison where Waller had ended up after a harrowing sea voyage spent chained to the deck in the hold of the steamer *Dejeune*.

Susan Waller's passage back to the United States had scarcely been better. Left to her own devices in Antananarivo, she had been able to reach Mauritius only with the help of Ethelbert Woodford, who paid for tickets for her and the children. Unfortunately, the U.S. consul there was John P. Campbell, the former consul in Madagascar and the man Waller had criticized in reports to the State Department. In his testimony on the Waller case in Washington, Woodford later characterized Campbell as "a very wretched specimen of a United States official." He was appalled by Campbell's lack of interest in Susan Waller's plight and by the fact that he had sent her and her young daughters home third class, "with those rough French soldiers" (Foreign Relations 1895:380).

Susan Waller arrived back in the United States in October 1895. Two months later she took her husband's case directly to Congress. Langston, in turn, sent a letter to President Cleveland.[32] Waller was released on February 20, 1896, but the terms were not favorable to him.

FIGURE 75 **John Waller in the uniform of the Kansas Volunteer Infantry prior to serving in Cuba, c. 1898.** Photographer unknown. Courtesy of the Razaf Estate and Barry Singer, New York.

He had expected the administration to back his demand of an indemnity of $10,000 from the French government. Instead, the State Department went along with the French position, which portrayed Waller's release as a grace, not as the outcome of some scrutiny of the evidence for his imprisonment. Both governments had decided to save face through a solution that would give the Americans Waller's liberty and the French a green light to take over Madagascar. To achieve this, the United States–Malagasy treaty of 1881 had to be ignored, and Waller's case had to be left unclarified. The report on the case sent by Cleveland's administration to Congress balanced all these elements, achieving the goal of claiming success in Waller's release yet allowing a cloud to float over his integrity (Woods 1981:174). This would suffice to discourage any lingering support for him at home.

The fate of Wallerland was sealed by these events. Whatever aspirations Waller might have entertained to profit from the concession were shattered by the French government. In 1898 General Gallieni, the French governor general of Madagascar, wrote to the colonial minister in Paris that in the worst of cases, had Waller brought any action against it, "the French Government would only have to provide Valler (sic) with uncultivated lands 225 square miles in extension, somewhere in the vicinity of Fort Dauphin where those vast territories are desertic, arid or populated by savages hostile to the Europeans. It would be easy to allocate the concession in such a way that the total barrenness of the land would constitute for Valler nothing but a nominal advantage!"[33]

Back in the United States, Waller settled first in Kansas. In 1898 he was again aroused by a beckoning frontier. The war with Spain, he thought, offered blacks the opportunity of joining the army, then considered a way of obtaining (or claiming) full U.S. citizenship. He was able to form a company of black men, which he commanded with the rank of captain (fig. 75). The company served in Cuba for six months, enough time for Waller to see the possibilities of moving there permanently. He formed the "Afro-American Cuban Emigration Society" and indeed returned to the island, hoping to establish a "New Canaan."[34] But that is another story.[35]

Unintended Consequences

In the year 1492
Columbus sailed the ocean blue.
What happened?
—FROM A JAZZ LYRIC BY ANDY RAZAF

We do not know how John Waller came to terms with a paradox that must have been clear to him the moment he became involved in Malagasy politics. He found himself arduously traveling back and forth between Tamatave and Antananarivo, representing a nation that had discriminated against him and that, understandably, he was trying to move away from. Yet his values, his ideas about personal success, were American, as were the projects he promoted. No matter how sympathetic he was to the Merina, Waller surely must have sensed that his aspirations and theirs were ultimately incompatible. In leaving behind the simmering hostility of his domestic environment, Waller had landed, across the ocean, in a new frontier where he was no longer one of the oppressed but a potential oppressor.

The risks of traveling to unknown settings, beyond one's own codes of behavior and civility, were a central theme of the Enlightenment's preoccupation with colonialism and the consequences of discovery. For Diderot, Europeans who left their homes for regions below the equator behaved like "domestic tigers returning to the forest," untrammeled by norms that would otherwise have bound them. "This," he argued, "is how . . . every one of them, indistinctly, has appeared in the countries of the New World. There they have assumed a common frenzy—the thirst for gold" (Diderot 1992 [1772]:178).

The essential problem undercutting contacts between different cultures remained the difficulty each had in penetrating the codes the other used and lived by and thus progressing to a true dialogue. The question was whether these cultures and peoples, brought together by discovery, were, in the language of the Enlightenment, "commensurable." The new societies arising from the inevitable and forceful current released by the voyages of Columbus were haunted by a very large shadow: the lack of a common idiom. Only commerce, the *philosophes* thought, could create the networks of reciprocity and the kinds of exchanges that might result in a new world order that was not based on unequal power and outright domination. Placed at the juncture where men engaged in "a mutual exchange of their opinions, their laws, their customs, their ills and their remedies, their virtues and their vices," trading entrepreneurs, Diderot

believed, would become the new historians of the world, the "commercial philosophers" whose hands would register the "annals of all peoples."[36]

These academic debates were fed by more than two centuries of colonialism and travel narratives, and they found their way back to the frontiers overseas, influencing behavior and inspiring action. The island of Madagascar provided a pertinent case in point.

In 1768, Count Louis Laurent de Maudave tried to settle a colony in the Fort Dauphin area. Originally a soldier in India and a planter on the island of Mauritius, he was a friend of Voltaire's who traveled with a copy of the *Encyclopédie* and had the benefit of experiencing, firsthand, like an ethnographer, the problems the *philosophes* were speculating about. His plans for the Fort Dauphin colony can be read as an attempt to execute the loftiest ideals of his intellectual mentors. Maudave abhorred slavery and believed that the only successful approach to settlement overseas was through openly accepting and encouraging miscegenation: the marrying of natives and foreigners. Intent on respecting the local point of view and acquiring land not through either conquest or usurpation, in two years he signed more than thirty treaties with regional chiefs. Of course these documents were drawn up in French, and they reflect Maudave's concerns more than what his Malagasy counterparts thought or made of them. In 1774, one of these chiefs described France as an ally to whom his people owed their power and wealth. The guns and powder the French provided allowed them not only to repel enemies but also to "gain advantage from their neighbors." "Be welcome, therefore," said this chief; "I accept your friendship with pleasure" (Foury 1956:64). This is probably also how Maudave was seen around Fort Dauphin.

Beyond the question of misunderstood projects or intentions on both sides, there was a problem with Maudave's idea of economic production. It was reduced to providing mostly livestock to the plantations in Mauritius, and it depended heavily on royal patronage and French domestic politics for both financing and white *colons*. Not unlike many modern development projects, it was top heavy. It was an official or semi-official state enterprise and therefore— good intentions notwithstanding—yet another instance of the problematic encounter between the metropolis and the antipodes, menaced by the known risks of ethical lapses and violence. When the experiment failed in 1771 and Maudave returned to his plantation in Mauritius, he took with him Malagasy slaves, a clear symbol of his defeat.

Maudave did not become the "commercial philosopher" Diderot prefigured, and he left behind no formal narrative of his failed experience. But his plan for building a local militia and putting it under the command and training of white officers was what, less than a century later, would finally open Madagascar to serious European, state-led occupation. Maudave's papers were read by Sir Robert Farquhar, the first British governor of Mauritius. In 1810 Farquhar sought an alliance with the Merina of the highlands, the most numerous and well-organized Malagasy polity, and succeeded in establishing a relationship based on Maudave's principles of military aid. The arrangement gave England a single partner through which it could control the entire island.[37] On the surface, it was a convenient confluence of the expansionist plans of the foreign empire and the domestic one.

Waller was himself a product of the violence that Maudave initially despised, and of the chaos Diderot feared would follow contact. His journey to Madagascar no doubt represented an attempt to undo or transcend that history. He was not the kind of political actor the *philosophes* had in mind. That he borrowed from the rhetoric of empire should not obscure the fact that Waller's story continued that of the Exodusters and of many other black Americans who, even before the Civil War, took to the sea as sailors in search of a freer

destiny and who rarely left behind testimonies of their lives. As the historian Jeffrey Bolster has pointed out, "until the Civil War, black sailors were central to African Americans' collective sense of self, economic survival and freedom struggle—indeed, central to the very creation of black America" (1997:2). In the first decades of the nineteenth century, the American shipping business employed around 100,000 men, of whom one-fifth were black. A few of these, such as Frederick Douglass, Olaudah Equiano, Paul Cuffe, Absalom Boston, and Denmark Vesey, became famous. But there were many others, manning whaling and trading ships that plied the route from New England ports to Africa and the Indian Ocean, whose individual lives left only the barest of traces in records and archives. We know that a good number of these black sailors reached Madagascar. They were members of an itinerant, disenfranchised community with which Waller would have felt connected.

The social worlds floating on board ships—self-contained and gravitating toward their own equilibria—provided multiple opportunities for evasion. Under the spell and cover of distant lands, not only black sailors but white sailors as well, felt capable of breaking away from their home societies. One way to do so was to become a pirate. The Indian Ocean, and Madagascar in particular, was a notorious safe haven for this novel type of man. The *philosophes* paid attention to piracy, for it constituted a telling indication of a fracture line separating the classical world from the new one brought about by discovery and travel. In the classical world, piracy was a literary topic. In the new world, it became a philosophical one, "invested with political and anthropological implications" (Imbruglia 1990:493).[38] Those who, like pirates, left behind the social contract that bound them at home invented, of necessity, other types of associations. Thus their interest for the *philosophes* and for authors such as Daniel Defoe, who stands today as the most thorough chronicler of pirate

life.[39] The pirate enclave on Ile Saint Marie, established off the east coast of Madagascar in the seventeenth century, represented the peak of this kind of life, an experiment that in many ways made real some of Count Maudave's basic ideals regarding the union of locals with foreigners.[40]

It is pertinent to bear in mind that the dreams of self-promotion and personal advancement that Madagascar inspired in Waller were consistent with an existing Western tradition.[41] It is doubtful that he would have placed himself in that tradition, or that he was even aware of it, but it is certain that he did not know that a black sailor—a real and emblematic instance of all that we have just described—had preceded him as an important figure in the Fort Dauphin area. Abraham Samuel, the son of a black slave and a French planter in Martinique, had, around 1695, joined the crew of Captain John Hoare's pirate ship in the Caribbean. Later on, while the ship was in Ile Saint Marie, the local Malagasy attacked it, and the captain and many crewmen were slaughtered. Those who escaped were led by Samuel. Their ship, headed for New York, hit a reef and sank near the abandoned Flacourt settlement in Fort Dauphin. The local chief had recently died, and his widow noticed some birthmarks on Samuel's body that matched those of a son of hers who had been taken away by his French father several years before. The widow claimed Samuel as her son and named him the new chief. The life of Abraham Samuel, from this point on, reappears in some sailors' documents. He seems to have settled as "King of Fort Dauphin," where he continued to engage in piracy until the records fall silent about him again (Rogozinski 2000:67–68).

After it was over—after he had been returned forcibly to the United States—Waller expressed plans for publishing a book on "Malagasy Customs." These plans were never carried out, but had they been, the book might have told us what he took from his experience at the Merina court. It might have told us, for instance, whether he

recognized that the Merina represented a conquering group on the island and that "Malagasy" also meant those other groups whom the Merina dominated or who, like the Tandroy and Tanosy near Fort Dauphin, lived outside their control. He knew that the Merina took and kept slaves, and he must have known, too, that the prime minister with whom he dealt constantly and who had signed his land grant owned more than two thousand of them. In a newspaper article Waller even put himself in the awkward position of defending Merina slavery practices. "Slavery," he stated in the *Indianapolis Record* of July 9, 1892, "though a mere word in Madagascar, is not confined to the 'dark people,' but as formerly in the United States, there are both white and black slaves in Madagascar; the difference between the former slavery of my country and Madagascar is that the slaves of the latter country are permitted to go where they are a mind to, and work for whom they will, master and slave living in the same house, eating rice from the same dish, and often reposing upon the same mat."

This is a gloss on what was clearly a real and complex feature of Malagasy social life, one notorious enough to have become an obstacle for the establishment of relations between England and the Merina in 1817. The treaty that King Radama I signed that year with the British compelled him to renounce the selling of slaves, a lucrative activity from which he derived the means to finance both his army and territorial expansion. A pale skin tone, straight hair, and other anatomical characteristics were associated among the Merina with high social class, the darker people figuring at the lower end of the scale.[42] There is no evidence on whether skin color had any bearing on the reception Waller, who was very black, received at the Merina court, but it is undeniable that a social taxonomy based on skin color was part of the culture in which he operated.[43]

In his newspaper articles and letters, Waller expressed himself in a tone that mixed the language of millenarian dreams and capitalist ambi-

tion with the style of combative propaganda. To find out how he represented Madagascar in his writings, we look at three examples.

Advertisements for the Wallerland concession, published in several newspapers in England, the United States, and Mauritius, expanded on the type of land being offered, the types of products it carried or could carry, and the type of foreign farmer who would find it attractive. They said not a word about the local inhabitants, who are completely missing from the picture. This creates the impression of an empty space, which, as we know, could not have been farther from the truth.[44]

When, in a newspaper article (*Madagascar News*, March 17, 1894), Waller referred to the people of the Fort Dauphin area, it was only in order to inform his readers that he would "stop the destruction of the Rubber trees and vines by the natives . . . and preserve the product by having the milk extracted in a scientific manner." To support this argument, he cited information on India rubber gleaned from the October 28, 1893, issue of *Scientific American*.[45] Of course, Waller had never been to southern Madagascar, and what he was presenting to his readers—as well as to himself—was a reduced and convenient version of reality that direct experience might have altered, had the venture been allowed to follow its course.

His correspondence with the Merina court contains an interesting exchange on Madagascar's possible participation in the 1893 World's Columbian Exposition, held in Chicago. Waller wrote several letters to the prime minister and Queen Ranavalona III, "begging to apologize for . . . urging upon Her Majesty and upon Your Excellency the importance of having Madagascar represented . . . by the side of all the other nations in the world," something that "would do more to establish its independence than any other action." In extending this invitation, Waller was probably unaware that such expositions portrayed tradi-

tional peoples as exotic entertainment and were meant mostly as paeans to progress—an idea with a hierarchy and a taxonomy to it that would have automatically shown Madagascar in an unfavorable light. Waller's offer, in any case, was not taken up by the prime minister.

The Merina had realized early on in their dealings with Europeans and Americans that it was expedient to adopt traits of their culture without identifying with or accepting the ideology behind them. But such appropriations of objects, terms, and symbols inevitably led to misunderstandings on both sides, which then took on lives of their own. These unintended consequences characterize, in an essential way, colonial history.

In allowing Christianity into their kingdom, for instance, the Merina did not fully anticipate that they would be getting more than the technologies and inventions they selectively sought from the missionaries. The ideology of the faith acted among the common folk as a ferment for democratic ideas subversive of the status quo.[46] The written language that Ranavalona I imaginatively used to assert her presence far beyond Imerina and her capacity to travel was also the language of correspondence with other nations and of international treaties that sanctioned agreements more apparent than real.

Waller must in some way have realized that in Madagascar he was witnessing the chaotic vitality of a frontier, shaken by strong undercurrents and inscrutable things, but he did not become the "commercial philosopher" able to find words to describe them. He spoke neither Malagasy nor French, and he seems not to have been as close to the Merina court as his own propaganda would have us believe. A case in point is a letter he wrote to the prime minister from Tamatave as he was trying to find money to repay the Crockett estate. In it he requested the court's permission to take with him to the United States one Andriamanantena, a young Merina whom he wanted to train in the law and who was then staying with him in Tamatave.

FIGURE 76 Andriamanantena Paul Razafinkarefo, a.k.a. Andy Razaf, on 131st Street and 7th Avenue near the Ubangi club and Connie's Inn. Photographer unkown, c. 1935. Courtesy: Frank Driggs.

Subsequent events—France's invasion of Madagascar and Waller's imprisonment—prevented this. We do not know for certain what happened to Andriamanantena, but we assume that he was the Henri Razafinkarefo Andriamanantena who soon afterward married Jennie, one of Waller's daughters. According to the family story, Razafinkarefo was a nephew to the queen and a soldier trained in a Paris academy who had ultimately died defending Antananarivo when it fell to the French. We have found no evidence in Malagasy or French archives to substantiate any of this, nor the great dynastic wedding that Waller described in newspaper articles. The letter does not refer to a son-in-law. After Waller left Tamatave for Marseille, Razafinkarefo could have joined Susan Waller

FIGURE 77 **Andy Razaf and Paul Bray, c. 1940s.**
Courtesy of the Razaf Estate and Barry Singer,
New York. Photographer unknown.

FIGURE 78 **Sheet music for "Connie's Hot
Chocolates," with lyrics by Andy Razaf and music
by Thomas "Fats" Waller (no relation), with whom
Andy did many songs.** Published by Mills Music,
New York. Private collection. Photograph by
Barry Singer.

and her family in Antananarivo, but it is hard to
imagine that an elaborate wedding took place in
the frantic months before the French invasion.
What is certain is that Jennie returned pregnant
to the United States, and that her son Andy was
born in Washington, D.C., on December 15, 1895.

Andy Razaf, Waller's grandson (figs. 76, 77),
is the unexpected final traveler in the intricate
family itinerary that began in New Madrid
County, Missouri, in 1850. Razaf became one of
the great jazz lyricists of Tin Pan Alley during the
Harlem Renaissance (fig. 78).[47] He differed from
his grandfather in that he was not a publicist or a
politician or someone urged on by the dream of
an imaginary geography. America was his home,
and he set about describing and commenting on
its culture in a language that was not millenarian
but low-key, direct, and conversational, a quiet
vehicle for intelligent irony and allusion. Within
the constraints of an industry that provided enter-
tainment, not revisionist history, Razaf used this
language as a social critic to convey a black per-
spective on America and the realities around
him. He knew how many frontiers his family had
crossed, how many worlds had been bridged: his
grandmother was a Cherokee, his father a Mala-
gasy, and John Waller, his grandfather, the son
of slaves. He wrote of an Indian chief who had
nowhere to go, "could not float," and was so angry
that "he scalped his own head." He wrote of a
black woman who was white inside but nobody
would see; of love affairs between porters and
cleaning ladies; and of black Americans as "not
exotic, nor less patriotic" than other Americans.
Unlike his grandfather John Waller, Razaf did
not pursue a grand design, but through his settled
voice we finally begin to hear the possibility of a
different history.

NOTES

We would like to warmly acknowledge the many contributions of Sarah Fee to this essay; she shared her ideas freely and worked with us in researching primary sources in several venues: in Washington, D.C, at the National Archives, the Library of Congress, and the Moorland Spingarn Research Center, Howard University; in Aix-en-Provence, France, at the Centre Archives d'Outre Mer (CAOM); and in Antananarivo, at the Archives de la République Démocratique Malgache (ARDM). Professor Allison Blakely at Howard University generously allowed us to have copies of his notes on his own research on Waller. Professor Randall Bennett Woods at the University of Arkansas patiently responded to the many questions we posed him. Barry Singer was gracious and generous in sharing materials and photographs related to Andy Razaf. To all, our sincere gratitude.

1. Randall Bennett Woods (1981) and Allison Blakely (1974, 1999) have written, respectively, a biography and two essays on Waller. Elliot P. Skinner (1992), who was a diplomat himself in Burkina Faso during the Lyndon Johnson administration, deals with Waller's consular activities in Madagascar.

2. For a history of black Americans in the western frontier, see Taylor 1998. "Contrabands" was a term coined by General Benjamin Butler during the Civil War to refer to southern blacks who fled or were smuggled behind the Union lines. "Exodusters" were the "uneducated former slaves" who, after the Civil War, "left the lower Mississippi Valley in a millenarian movement, seeking new homes in the freedom of Kansas" (Painter 1976:vii). Painter explains that "the Exodus did not enter the annals of American history" until very recently "because its protagonists were ordinary, rural folk" who left behind no personal narratives, and because of "long-standing and ultimately racist habits of scholarship." For an analysis of the political uses of biblical language among blacks in the nineteenth-century, see Moses 1993 and Glaude 2000. The latter author wrote that "no other story in the Bible has quite captured the imagination of African Americans like that of Exodus." The notion of leaving oppression by seeking a new Canaan, a promised land, provided black Americans with metaphors of resistance and endurance up to the civil rights movement and was also essential in shaping Waller's worldview.

3. For a description of the several colonies for blacks that were started in Kansas, see Woods 1981:19–40. For a broader view of black settlements in the west, see Taylor 1998:134–63. For an analysis of the role played by black leaders such as Benjamin "Pap" Singleton in the migration to Kansas, see Painter 1976: 107–17, 267.

4. John L. Waller Application and Recommendation File. General Records of the Department of State, Record Group 59, Box 158, National Archives, Washington, D.C.

5. Laborde's exploits in Madagascar have been well summarized by Mervyn Brown (1978:179–88). An architect appointed by Queen Ranavalona I to create an arms foundry in Mantasoa, it was said that he was one of the lovers of this pragmatic and imposing queen, ruler of the Merina empire from 1828 to 1861.

6. Prince Rakoto, son of Ranavalona I, ruled the Merina empire from 1861 to 1863 under the name Radama II. Toward the end of his short reign, the popular king appointed two *vazaha* (foreigners) as joint ministers of foreign affairs: the American William Marks and Clement Laborde, the half-Malagasy son of Jean Laborde. Traditionalists opposed to Radama's policies of aperture to the West had him murdered in front of his wife, a reflection of local ambivalence toward Merina involvement with overseas nations (Brown 1978:188–200).

7. Rainilaiarivony was prime minister of the Merina empire from 1864 until he was exiled in 1895, after the French invasion of Madagascar. His father and his brother had occupied the same position before him. They belonged to a powerful Hova clan, the Tsimiamboholahy, and their ascendancy reflected the increased importance of the Hova middle class in Merina affairs. In Imerina there were three classes of people: the Merina nobility, to which the kings and queens belonged; the Hova commoners; and the slaves, who were further divided according to their origin and level of bondage. Rainilaiarivony served under three queens, Rasoherina (1863–68), Ranavalona II (1868–85), and Ranavalona III (1885–96). His marriage to the three queens was largely symbolic; as a commoner, he could not, on paper, rule Imerina. For an analysis of the identification among the ancestors, the nobility, and the land in Imerina, and of the types of hierarchical reciprocities and obligations it established with the commoners, see Berg 1995. For more on Rainilaiarivony and his relationship with the queens, see Chapus and Mondain 1953.

8. This system, called *vintana*, of old and prestigious Arabic origin, was one of the trappings of power in the Merina court. For more on its history and complex significance, see Ruud 1960.

9. Despite its official endorsement of Waller's argument, the State Department's essential position toward Madagascar and Waller is well encapsulated in the following "advice from a desk officer to the Assistant Secretary of State, Josiah Quincy, on June 2, 1893," quoted in Skinner 1992:245: "It might not be expedient to give Mr. Waller any diplomatic discretion at the Hova (Malagasy) capital. The eventual supremacy of the French in Madagascar is a foregone conclusion, which is not incumbent upon us to avert or contest."

10. There are five folders of Waller correspondence, under his name, at the Archives de la République Démocratique Malgache (ARDM) in Antananarivo. They cover the period 1891–95. These folders are part of the DD16 series, which concerns Malagasy relations with the United States The correspondence is arranged by year.

11. Waller correspondence, ARDM, DD16 series.

12. Ibid.

13. On South America as a "New West," see Fifer 1991. On the origins, ideology, and diverse political meanings for whites and blacks of the "back to Africa" colonization projects, see Miller 1978, Moses 1998, and Sanneh 1999. As to the actual movement of people these projects represented, Moses wrote the following about one of them, the American Colonization Society, funded in 1816 by prominent whites: "Most thinking people eventually shared the skepticism of Alexis de Tocqueville, who observed that in the first twelve years of its existence the Colonization Society was responsible for the removal of only two thousand

five hundred free Africans while in the same period the black population of the South had increased by 700,000. If the Union were to supply the Society with annual subsidies, and to transport the Negroes to Africa in government vessels, it would still be unable to counterpoise the natural increase of population among the Blacks" (Moses 1998:xvii–xviii). The purpose of this particular society was the "elimination of the 'free colored' population" (Moses 1998:xvii). That is why most black leaders in the first half of the nineteenth century opposed the "back to Africa" rhetoric. These attitudes began to change after the 1850 passage of the Fugitive Slave Act, "which challenged the free status of every free person of African descent living in the United States" (Moses 1998:xxii). Waller's initial misgivings toward emigration were framed by this complex historical background.

14. Waller correspondence, ARDM, DD16 series.

15. Ibid.

16. In selecting Malagasy consuls abroad, the prime minister invariably chose merchants, most of them foreigners. On this topic see Mutibwa 1972:43–44 and Campbell 1988. About land grants in Imerina in the nineteenth century, it is pertinent to remember the identification that existed between the land, the ancestors, and the monarch. Through the land, the living connected to the dead in a "sacred stream" (Berg 1995:73). Access to the land provided access to the ancestors and ensured the continuity of Merina culture. As the paramount interlocutor with the ancestors, the monarch was also the primary landowner. In practical terms, this ideology represented the base for the monarch's political and economic power. Thus, as Mutibwa wrote: "All the land, whether under cultivation or not, belonged to the sovereign, and there was a complete ban, under pain of death, on the sale of land to foreigners. The sovereign did grant, however, large tracts of land to his prime minister and his close associates, who, in their turn, could grant it to their subordinates. It was the sovereign, through her prime minister, who alone could grant or lease land to the foreigners; and all the attempts at intervention made by foreign governments to force Madagascar to allow foreign nationals to acquire land in perpetuity, remained unsuccessful" (1972:35). As to the actual concessions made through this system to several Europeans in the 1880s, see Mutibwa 1972:45–46 for names of the beneficiaries, locations, conditions, and other details.

17. By coincidence, Cornelius Vanderbilt had traveled to London on the same boat that took Waller to that city en route to Tamatave. Woodford stated the differences between himself and Waller this way: "I myself moved on a larger scale than Waller, and was negotiating for several concessions, and had addressed a memorandum in 1891 to the prime minister . . . in which I outlined the whole policy of granting concessions on a very large scale to Americans, with, of course, a view to my own advantage" (United States Foreign Relations 1895:377). Also from Woodford: "There are such a lot of trading rascals running over that island that it is impossible to know who is who" (United States Foreign Relations 1895:372).

18. Rainilaiarivony was surely aware of the risks involved, vis-à-vis the French, in granting a land concession to an American then representing his country in an official capacity.

19. Waller correspondence, ARDM, DD16 series.

20. Ibid.

21. Ibid.

22. Copy of concession document in the Centre Archives d'Outre Mer (CAOM), Aix-en-Provence, France.

23. Langston was the son of a white slaveholder and a part-Indian, part-black emancipated bondswoman. Both parents died when he was four. Among the accomplishments in Langston's career, Cheek and Cheek (1989:2) noted the following: "a recruiter of black troops for the Union Army, an inspector for the Freedmen's Bureau, the first Law Dean of Howard University, the U.S. Minister to Haiti and Santo Domingo, the president of the Virginia state college for Negroes at St. Petersburg, and the first and only [black] representative of Virginia in Congress."

24. Langston Papers, Box f.12, Fisk University.

25. Ibid.

26. Ibid.

27. For more on this, see Woods 1981:146.

28. Langston Papers, Box f.12, Fisk University.

29. Ibid., July 1894.

30. Langston Papers, Box f.12, Fisk University. In several of the documents Bray sent to Langston, he appears as co-signer with Waller for Wallerland.

31. Waller correspondence, ARDM, DD16 series.

32. Langston to Cleveland, August 5, 1895, Langston Papers, Box f.12, Fisk University.

33. Gallieni to Ministry of Colonies, December 4, 1897, CAOM, Aix-en-Provence, France.

34. Under the title "The Negro's Canaan: John Waller Wants Congress to Appropriate $20 000 000," published July 8, 1899, in the *Indianapolis Recorder,* Waller argued that the solution to the "Negro problem lies in . . . partial emigration . . . to Cuba, Porto Rico and the Philippines." He found the "racial climate" in Cuba more hospitable to blacks. On the predicament of Cuban blacks at the end of the nineteenth century, see Helg 1995.

35. For details on this new turn of events, see Woods 1981:177–203. John Waller, Jr., then sixteen, enlisted illicitly and went with his father to Cuba (Singer 1992:323). Willard B. Gatewood (1987) published a selection of letters sent home by black American soldiers serving abroad. In one of them we get a glimpse of Susan Waller in Cuba, ever supportive of her husband's plans. It is signed "One Hundred Privates," Eight Illinois Infantry, U.S.V., and dated in San Luis, Cuba, on January 12, 1899: "The good Lord sent an Angel in the person of Capt. [John L.] Waller's wife, an American woman who made pies, and would bring them to our camp to sell to the men. No sooner did Marshall [Colonel John R., commander of the Eighth Illinois Regiment] discover it than she was ordered from the camp . . . thus depriving the woman whose husband was the Minister to Madagascar, appointed during Harrison's administration and reappointed under Cleveland, when the French took him prisoner to Paris because of his popularity with the natives. This little woman has been the loyal, true and honest wife for years, undergoing many and many privations to help the man she

loves.... This was her effort to help herself and help the boys with a morsel of good food, and the villain orders to fire if she insisted on coming each day. Now what do you think of that?" (Gatewood 1987:221–22). The project in Cuba did not work out, and the Wallers moved back to the United States. In October 1907, John Waller died of pneumonia in Yonkers, New York, at the age of fifty-six.

36. For an extended discussion of Diderot's ideas on commerce and colonialism, see Pagden 1993:141–81.

37. Brown (1978:131–51) provides a good summary of these events.

38. For a thorough discussion of pirates in the writings of Diderot and other Enlightenment philosophers, see Girolamo Imbruglia's essay (1990). For a social history of Anglo-American seafaring and piracy, see Rediker 1987.

39. Defoe's two-volume *A General History of Pirates*, published in London in 1724–28, is the main primary source on the topic. His *Madagascar, or Robert Drury's Journal during Fifteen Years' Captivity in that Island* (London, 1890) has been vindicated as a true ethnographic source on Madagascar, based on the experiences of a young British sailor. Although Diderot and Defoe were ambivalent about pirates, they both seemed fascinated by the activities of these "extraordinary and romantic men" (Diderot 1992 [1772]:182). The Frenchman wondered about the moral causes of their behavior and somewhat reluctantly did not condone it. Defoe, instead, considered that pirates were robbing ruthless merchants, themselves responsible for acts of greater greed and injustice to their fellow men.

40. Jan Rogozinski (2000:77–184) gives a full description of pirate life at Ile Saint Marie.

41. The current avatar of that tradition revolves around the idea of Madagascar as a "lost continent," a place unique for its biodiversity, an endangered paradise that Western conservationists must rescue.

42. Arguing against some of the assumptions in the previous literature on the topic, Campbell (1988) discussed the structure, meaning, and economic significance of forced labor in nineteenth-century Imerina, whether under the category of slavery—which reduced peasants to the service of other peasants—or *fanompoana*, an institution developed by the Merina royalty to recruit the unremunerated services of court officials and soldiers.

43. Elliot Skinner, an African American anthropologist and diplomat who wrote an essay on Waller (1992), stated that when Ghana became independent in 1957, the Ghanians "discretely let it be known" that President Nkrumah himself "would refuse to accept an American Negro as Ambassador," because he felt that "since Negroes were regarded as second-class citizens in the United States, such an appointment would reflect an equivalent judgment of his country" (quoted in Harrison and Harrison 1999:284). The Eisenhower administration faced, conversely, the problem of extending the considerations due to foreign dignitaries to black diplomats representing newly independent African countries in a city—the nation's capital—that was then segregated.

44. Henrika Kuklick's clear analysis of the myth of empty lands in immigrant societies (1991:135–69) is pertinent for this section.

45. The literature on conservation used today by NGOs operating in Madagascar similarly portrays the Malagasy as exploiters and predators of their environment and justifies outside, "expert" intervention by using the concerns and the language of science.

46. For a full development of this argument, see Raison-Jourde 1991.

47. See the biography of Andy Razaf by Barry Singer (1992).

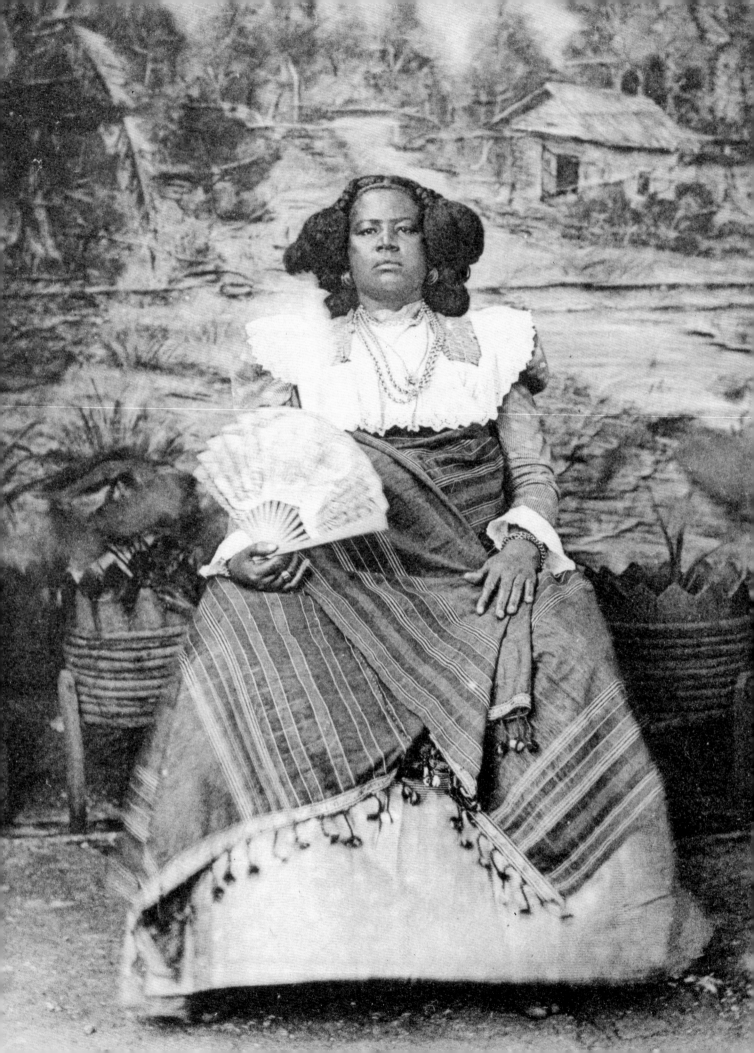

Christraud M. Geary

5. VIEWS FROM OUTSIDE AND INSIDE
REPRESENTATIONS OF MADAGASCAR AND THE MALAGASY, 1658–1935

THE PEOPLE AND UNIQUE FAUNA AND FLORA OF MADAGASCAR HAVE LONG CAPTURED the Western imagination. Since the seventeenth century, Westerners have created and perpetuated ideas about Madagascar, perceived as a world apart, that reflected observed reality but also their own biases and preoccupations. This historical process was deeply rooted in cultural practices of constructing the otherness of people around the globe, and it gave rise to powerful and pervasive discourses on race, gender, and Western superiority. Illustrations in travel, missionary, and colonial accounts helped Westerners create and visualize imaginary geographies and classifications of mankind. Some of these images took on a life of their own and had considerable resilience, recurring even into the present.

In the second half of the nineteenth century and the first two decades of the twentieth, imperialist expansion was in full gear. Throughout the nineteenth century, Malagasy peoples, in particular the Merina kingdom, remained independent and entertained economic and political relationships with Britain, France, and the United States. This period came to an end when France occupied the island and made it a French colony in 1895. Images in magazines, on postcards, and in other popular media enacted and solidified Western conceptions of regions and people who had come under Western domination. Although idiosyncracies certainly resulted from individual views and experiences, general patterns also emerged. These conceptions influenced policies and actions in the Western metropoles of empire. Thus, British, French, and American relationships with the Malagasy, discussed in the essays in this book, need to be examined not only in reference to political contingencies but also in reference to the effects of the popular image and images of the island and its inhabitants.

This essay explores some aspects of these constructions. The first part traces the history of Madagascar iconography and examines the implications that established practices in the production of images held for the ways in which views were formed. I discuss the role of photography, which arrived in Madagascar in

FIGURE 83 **Sakalava woman, Antsiranana** *(Diégo Suarez—Femme Sakalave)*. Portrait of Queen Binao (ruled 1895–1927). Collotype. Photographer unknown, c. 1900. Published by Collection Chatard, Diégo Suarez. Postcard collection, MG-20-35, Eliot Elisofon Photographic Archives. National Museum of African Art, Smithsonian Institution.

1853. Highlighting one visual theme—depictions of the *filanjana*, a type of sedan chair or palanquin for carrying noble Malagasy, which later became the mode of transportation for Europeans as well—I attempt to unravel practices and strategies underlying visualizations of the Malagasy and Madagascar.

The role of imagery in the construction and invention of foreign peoples, however, is not something reserved for Westerners. Similar processes took place in Madagascar as Malagasy tried to come to terms with the foreigners who arrived on their island and with whom the Malagasy leadership—the Merina monarchy, the rulers of other Malagasy kingdoms, and leaders of peoples across the island—entered into complex interactions. Initially, images brought by Westerners helped Malagasy to conceptualize foreign places and people. When the Malagasy, particularly Merina royalty and aristocracy, became more familiar with Western forms of pictorial representation, ranging from engravings and paintings to photography, they began to understand and exploit the power of imagery. Through visual means they created and projected distinct identities. They adopted painting and photography and made them part of Malagasy cultural expression. The second part of the chapter traces these developments.

Views from the Outside

Illustrations in accounts of distant places and peoples, ranging from engravings to photographs, serve several functions. They create lifelike representations that appeal to the viewer's senses and add an element of reality to verbal reports. Especially when based on direct observation or reproductions of photographs, they lend authority to the narrators' voices and, in the eyes of viewers, authenticate their experiences (Stafford 1984:51; Steiner 1995:206). Engravings, in particular, had a complex history of authorship. The artist, who was frequently also the engraver, had never left the realm of the familiar but based his rendering on verbal descriptions and occasional sketches by the traveler, the actual observer. In addition, the artist would use his own imagination, drawing on a repertoire of earlier images. The artist needed to conventionalize his depictions in order to make them accessible to viewers. In many instances, he was left entirely to his own devices. The combination of firsthand observation transmitted by the traveler, the tendency of artists to borrow from and copy earlier imagery, and the practice of conventionalizing produced ethnographic *bricolage* and a pastiche of symbols that, for the viewer, signified the "primitive" and "otherness" (Steiner 1995:208).[1]

Through this process, views and perceptions became fixed. Frequently repeated, some of them were generalized and applied to all foreign people; others remained specific to particular regions or peoples. These visual stereotypes were created over and over again.[2] Some of them had such longevity that they migrated from one technical medium of visualization to the next—from copperplate engravings to woodcuts and finally to photographs. Well into the first decade of the twentieth century, these types of illustrations appeared in travel accounts and descriptions of the colonies in Africa. They might appear side by side with engravings and lithographs based entirely on photographs, and they might even be halftones of actual photographs (Geary 1998; Jenkins 1992). The images formed part of a constantly recycled repertoire rendering the unfamiliar familiar to those who consumed them.

In the case of Madagascar, this process of visual construction can be traced by examining certain visual themes or topoi such as depictions of the *filanjana*, a type of palanquin or sedan chair.[3] The Merina, one among many peoples that made up the population of Madagascar, had established a kingdom in the central highlands and, by the nineteenth century, controlled large parts of the island. James Sibree, Jr. (1836–1929), a missionary

and architect for the London Missionary Society who spent forty-four years in Madagascar, provided an excellent description and an engraving of the *filanjana* (Sibree 1870:48 ff., 47, 1915:29–31). Referring to the one in which he was carried during one of his voyages, he wrote that it

> was of the same description as that commonly used by Malagasy ladies— an oblong shallow basket, with light wooden framework, and filled in with a kind of plaited material made of strips of sheepskin, and carried by poles of strong, light wood. In this I sat, legs stretched out at full length, a piece of board fixed as a rest for the back, and the whole made as comfortable as possible by means of cushions and rugs. There was plenty of space in the filanzàna. . . . When ladies travel any distance in this kind of filanzàna, a hood of coarse ròfia [raffia] cloth is fixed, so as to draw over the head and to protect from the sun and rain. (Sibree 1870:48–49)

The style of *filanjana* used by men for short journeys was different: "It is a much simpler kind of contrivance than the ladies' carriage, and consists merely of two stout poles held together by a couple of iron bars, and with a piece of untanned hide or strong cloth stretched between them for a seat. Sometimes a piece of board is suspended by rope to serve as a foot-rest, and a light iron framework is added as a support for the back and the arms" (Sibree 1870:49).[4]

Those carried in the *filanjana* were members of the Merina nobility (*andriana*) and, toward the end of the nineteenth century, wealthy Merina commoners (*hova*). The four porters of the *filanjana*, two on either side, were slaves (*andevo*), many of whom came from the coastal areas of the island. As Sibree's description indicates, the *filanjana* also became the preferred mode of transportation for Westerners.

Imagery of Malagasy, particularly Merina, being carried in the *filanjana* is abundant. On one level, these images document reality: it was a unique mode of transportation for noble Malagasy, appropriate for the difficult terrain of the highlands. On another level, the imagery becomes a visual metaphor for Merina society, indicating class distinctions and inequality, because the carried were nobles, and the porters, slaves.[5] Early observers, whose European countries of origin were mostly kingdoms often involved in the slave trade, recognized in this foreign monarchy familiar features such as hierarchy and orderly rule, aspects that *filanjana* imagery seems to embody.

The first engraving of a *filanjana* appeared in Etienne de Flacourt's *Histoire de la grande île de Madagascar* and its companion book, *Relation de la grande île de Madagascar*, in 1658. Flacourt (1607–60), a French aristocrat educated in the humanities and medicine, represented the French crown and the Societé Française de l'Orient in Madagascar from 1648 to 1655. He headed the settlement at Fort Dauphin, now the town of Taolañaro. In almost five hundred pages, Flacourt described the history, fauna, flora, and people of Madagascar and their customs. The books contain nine copperplate engravings and six plans and maps (Roth 1994:158). One copperplate intaglio, titled "Un Rohandrian avec sa Femme portée par ses Esclaves Lors quelle va en Visitte [sic] par le Païs" (A provincial chief with his wife, who is being carried by slaves at the time of her visiting the country), shows a woman in a *filanjana* (fig. 79).[6]

Upon closer examination, the engraving narrates a fascinating story of Western observation and imagination. It renders a theatrical scene, with elements familiar to the artist and his viewers. The image blends observed, borrowed, and conventionalized elements and sets the stage for a consistent and long-lasting visual discourse about the island. It alludes in a number of ways to social distinctions among the Malagasy, from noble

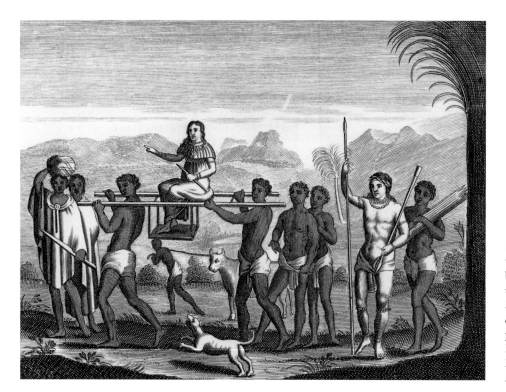

FIGURE 79 A provincial chief with his wife, who is being carried by slaves at the time of her visiting the country (*Un Rohandrian avec sa Femme portée par ses Esclaves Lors quelle va en Visitte par le Païs*). Copperplate intaglio. Reproduced from Flacourt 1661, courtesy of the Linden-Museum Stuttgart. Photograph by Anatol Dreyer.

elites to commoners and slaves. Light skin color and straight hair distinguish the chief and his wife from the other Malagasy in the picture. By contrast, the porters carrying the palanquin have darker skin and curly hair. Two men to the left have dark skin as well, although their hair is straight. Westerners used skin color to classify Malagasy people and perceived those with lighter skin as closer to themselves, thus assigning them a higher position on the evolutionary ladder. Dress and adornment also assume a role as indicators of rank. The aristocrats wear jewelry and, in the case of the woman, an intricate garment. The two men on the left—clearly of commoner status— wear togalike garments reminiscent of the *lamba*, the form of Malagasy dress that drew the attention of Westerners. Loincloths and lack of adornment indicate the slave status of the porters.

In portraying the provincial chief, the artist followed established conventions of composition and borrowed from earlier depictions of non-Europeans. The chief's slightly contrapposto position,[7] his classic facial features with aquiline nose, his elaborate coiffure, and his wreath, reminiscent of the laurel leaves associated with victorious Greek and Roman leaders, all indicate nobility. His loincloth, the beads adorning his neck and legs, and the two spears allude to otherness. This idealized depiction of the chief evokes the trope of the "noble savage." Since antiquity, perceptions of foreign people have vacillated between seeing them, on the one hand, as uncivilized, barbarous, and wild and, on the other, as representing an ideal state of harmony with nature—as noble savages (Wiener 1990:25–35). In general, though, Flaucourt correctly transmitted many ethnographic details, from dress and adornment to the depiction of the *filanjana*. Although the type of sedan chair in the image was reserved for Malagasy men rather than women, the picture nevertheless adequately depicts the object. Artistic license seems to have prevailed in some of the details, such as the way the woman sits on the sedan chair. There are only two porters instead of the usual four, perhaps again a result of the engraver's lack of firsthand observation.

The practice of constructing images on the basis of observed detail and conventionalized pictorial elements continued well into the nineteenth century, even after photography entered the stage. A much later example of such pictorial strategies is *filanjana* imagery in a book by the British lieutenant Samuel Pasfield Oliver, titled *Madgascar and the Malagasy, with Sketches in Provinces of Tamatave, Betanimena, and Ankova* (1866).[8] Artists at the London company Day and Son, Ltd., Lithographers created the illustrations. Five of twenty-four lithographs show a *filanjana*, either in use or with other travel equipment during stops. Indeed, the first lithograph in the book, "Thomasina, the Fort of Tamatave" (fig. 80), depicts in the foreground a woman in a palanquin being carried by four porters; the fort, the actual theme of the image, fades into the distance. This dynamic scene is set in the flat countryside typical of this coastal region. Palm trees and agave plants conjure up the heat and humidity of the tropical environment. The porters—two of them with typical Malagasy coiffures—

move ahead briskly. The woman, sitting in a basket-like structure appropriate for females, accentuates the movement through her forward motion. Several Malagasy, two with guns and two with spears, accompany the traveler. While the depiction of the *filanjana* borrows from older imagery, the rendering of the fort in the background might well have been based on photographs. Lieutenant Oliver was familiar with photography, and he assisted the missionary William Ellis, whose work is discussed later, with photography in 1862 (Ellis 1867:167–68). Photographs now became an additional part of the existing visual repertoire, enabling Oliver's illustrator to include more detail in the *bricolage* that characterized representations of foreign people and places.

In the history of visualizing Madagascar, the arrival of photography and the wide dissemination

FIGURE 80 **Thomasina, the Fort of Tamatave.** Chalk lithograph. Reproduced from Oliver 1866: opp. p. 4, courtesy of the Smithsonian Institution Libraries, African Art Branch.

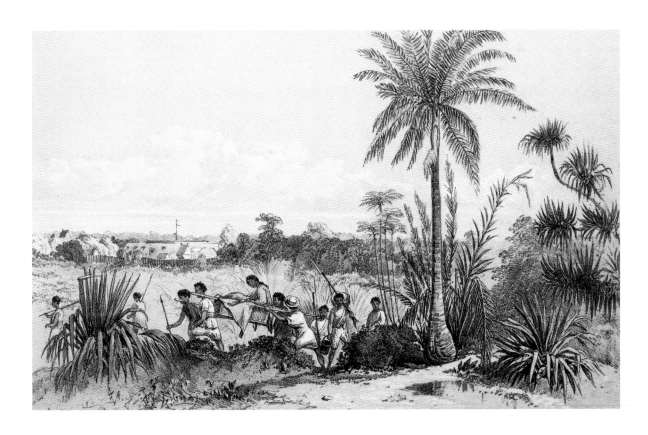

of photographic images—initially as engravings based on photographs and later as halftone reproductions—were milestones.[9] Photography, invented in 1839 and first brought to African shores in 1846–48,[10] accompanied European imperial expansion in Africa.[11] The photograph and its derivatives, in the form of engravings and lithographs, were perfect media of imperial propaganda, lending the "it is really as described" effect to countless writings about the nature of the colonies and the successes of colonization. Besides celebrating the heroics of explorers and military men, the achievements of missionaries, and the feats of engineering of colonial infrastructure, images aided in classifying and bringing into view the people of the new territories. Thus they imposed order by acquiring and recording knowledge, and they established surveillance over the colonial subject.

Photography came to Madagascar in 1853, earlier than to most other African regions. When the complex relationships between the island and the colonial powers in Europe unfolded in the second half of the nineteenth century (see Krebs and Walker, this volume), the camera was there. The motifs that captured the photographers' imaginations were no different from those in earlier illustrated accounts, as an examination of *filanjana* imagery demonstrates. Yet the popular impact of photographs went far beyond that of earlier depictions. The objectivity assigned to the new technology by enthusiastic contemporaries and the wide distribution of photographs through print media aided in fixing the image of the Malagasy. It was often a one-dimensional and biased picture.

Perhaps no writer-photographer was more responsible for forming views of the Malagasy, and the Merina in particular, in the English- and German-speaking realms than William Ellis (1794–1872), a British missionary for the London Missionary Society (LMS).[12] When, after some twenty years of protectionist policies that led to

the expulsion of most Westerners and the prosecution of Malagasy Christians, Queen Ranavalona I (ruled 1828–61) sought a rapprochement between the Merina kingdom and Great Britain, Ellis was sent to the island to reestablish the relationship. This was an appropriate assignment, for Ellis was the foreign secretary of the LMS, which had a form of cabinet system in the nineteenth century. He arrived in late 1853, equipped with a camera, and immediately began his photographic work.[13]

Ellis left an ample record of his dealings with the Malagasy and his deep involvement in Merina affairs during both of his stays in Antananarivo, the first one for no longer than a month in 1854 and the second from 1862 to 1865. His book *Three Visits to Madagascar* (1858) and the 1867 report of his second visit, called *Madagascar Revisited*, present a full account of his relationship with the Merina and chronicle his use of photography in great detail. As many passages in his books attest, it was no easy task to produce photographs in Madagascar. All the more astonishing is the technical and aesthetic quality of Ellis's images. Ellis saw photography as a valuable tool in his effort to approach the Malagasy. A visionary for his time, Ellis early on recognized the potential of new technologies to gain access to and mesmerize people to be converted to the Christian faith. In 1817, while in Tahiti, he had applied typography in this manner and printed the Bible in the Polynesian language.[14]

Photography was another way to engage the Malagasy and impress them with technical wizardry, and as will be shown later, the new technology had an immediate effect on the elites of the island (Peers 1995b:13).[15] Ellis was also aware of the role imagery might play in missionary propaganda on the home front. His two books about his experiences in Madagascar are richly illustrated with wood engravings based on his photographs, adding authenticity to the narrative. Other missionaries and the LMS followed suit

and, in the last decade of the nineteenth century, began to exploit the power of photographs in their publications.[16] Besides publishing to raise awareness and increase financial support for its missionary work, the LMS also sent "missionary caravans" to many congregations, especially in Wales. These traveling exhibitions displayed indigenous arts and crafts from the missionary field. Thus missionary collecting, too, was closely related to popularizing the missionary enterprise at home (John Mack, personal communication, 2000).

Initially, Ellis photographed fauna, flora, and physical settings by employing the wax paper process. His focus on inanimate objects arose out of necessity, because long exposure times complicated the photographing of people (Ellis 1858:136–37). Determined to use his camera as a tool to engage the Malagasy, he later changed to the quicker wet collodion process in order to portray many of the Merina officials with whom he came into contact. His photographs of the royals (figs. 81, 87) and the Merina aristocracy are an unsurpassed record. They bring the protagonists in his books to life, creating a rich tapestry of the visual aspects of the court and Merina society. They constitute a historical source yet to be mined in its entirety. Although it was not his primary goal in making photographs, Ellis was also aware of their value as study materials for the contemporary debate about the classification of the Malagasy and, more particularly, the Merina in the hierarchy of the races of mankind (Ellis 1858:140).

Ellis's largest photographic project, which never came entirely to fruition, was to document all the Christian "martyrs" in Madagascar—those early converts who had survived the persecution of Queen Ranavalona I and become the focus and pride of the renewed LMS work in Madagascar. The interest these photographs held for the public is attested by their wide dissemination in contemporary works such as Ratzel's 1890 ethnography, *Völkerkunde*, which contains two wood engravings

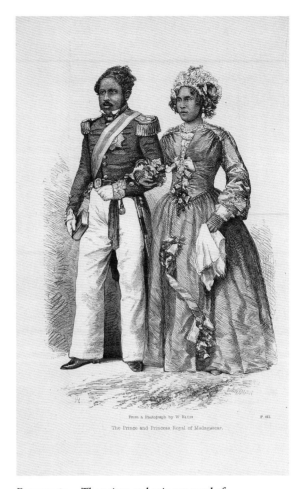

FIGURE 81 **The prince and princess royal of Madagascar.** Wood engraving from a photograph by William Ellis. Reproduced from Ellis 1858:413, courtesy of the Smithsonian Institution Libraries, African Art Branch.

based on Ellis's renderings of early Christians (Ratzel 1890:518–19).[17]

To return to the theme of this essay, the *filanjana* as a visual topos, its depiction in word and image also took a prominent place in William Ellis's record. Two plates in his 1858 monograph show modes of traveling (p. 178 and a wood engraving opposite p. 319). Throughout his account appear numerous references to this type of transportation. Describing a royal procession in Antananarivo, Ellis remarked

> The procession occupied a full half mile.... There were fourteen palanquins, ornamented with variously coloured drapery.

In one of these, a beautiful youth, the son of the prince Ramboasalama, attracted my attention. . . . Then came the prince's palanquin, with three or four officers walking on each side with drawn swords. Next to the prince came the princess, her palanquin covered with scarlet cloth,[18] ornamented with gold lace, and bordered with rich gold fringe, like that used for officers' epaulets, and the inside lined with pink satin. . . . The day was fine, the scene bright, with a light cool breeze. The union of different modes of travel characteristic of different countries, the officers on horseback as in Europe, the princes in palanquins as in Asia; . . . all these combined to afford new sources of pleasure and excitement. (Ellis 1858: 365–36)

Ellis's reference to Asian modes of transportation casts yet another light on the reasons Westerners paid such attention to the *filanjana*. It was considered "Asian" in origin and therefore a sign of more advanced civilization, because, in the eyes of nineteenth-century Westerners, Asia was a more developed continent than Africa. The *filanjana*, seen in this context, becomes a material symbol and reaffirmation of Western, particularly British, constructions of race in Madagascar, which privileged the perceived Polynesian (Asian) origins of part of the island's population over connections to the African continent.[19]

Discussions about race and its impact on culture were common in nineteenth-century Western accounts of the island. In contemporary evolutionary theories, physiognomy and skin color played important roles as classifiers. Light skin color and facial features similar to those of Caucasians indicated a high level of development. Some authors referred to the Merina as "semi-civilized," which clearly accorded them higher status than other Malagasy peoples of "African"

origin and those on the African continent.[20] Separating Madagascar—especially the Merina—from Africa, the continent, and from the "African" element on the island was common in early popular ethnographies such as Ratzel's *Völkerkunde*. He discussed Madagascar in the second volume of his work, which covered peoples of the Pacific and Indian Oceans—Australians, Polynesians, Micronesians, Melanesians, Malays—whereas Africa was part of volume one. In the LMS magazine *Chronicle*, reports from Madagascar occupied their own place, next to those from Africa, India, and Polynesia.

Ellis's involvement in British-Merina politics, his personal history as a missionary in Polynesia, and his widely disseminated writings and images were certainly among the forces that created and inscribed a Merina-centric view of the island in Europe and the United States. Other influential and widely read books, among them several works by Ellis's fellow missionary James Sibree, followed suit, covering similar themes and recycling imagery that had already accompanied Ellis's books (Sibree 1870). As shown in the other essays in this volume, political and economic constellations and alliances in the nineteenth century also contributed to this exclusive focus on the Merina.

Did the French share these British perceptions of the Merina and other peoples on the island? The Franco-British rivalry that impacted much of nineteenth-century politics toward Madagascar also shaped the two countries' respective popular discourses about the island and its inhabitants. Clearly, politics and economic interests affected French views of the Merina and the Merina monarchy. The British perceived the royals as allies, whereas the French saw them increasingly as impediments to their imperial design. The Merina shared the fate of other African peoples subjected to or involved in shifting alliances with imperial powers.[21] The Merina court's past interactions with the British deeply influenced French perspectives and actions. When the French occupied the

island and Antananarivo in 1895, exiling Queen Ranavalona III in 1897 and thus abolishing the Merina monarchy, their photographers began to direct their interest toward groups that were deemed allies. French interests focused on the Sakalava, the Betsimisaraka, and the Bara and on thriving colonial towns such as Tamatave, now Toamasina; Diégo Suarez, now Antsirana; and Majunga, now Mahajanga.

The French occupation of Madagascar and abolishment of the Merina monarchy coincided with the proliferation of a new medium for disseminating photographic imagery: the picture postcard. It accelerated the Western process of inventing Madagascar, for an increasing flood of photographic images of Madagascar and Malagasy people circulated in the West. Like few other media, these collectors' items and carriers of messages, produced by the millions, shaped popular perceptions of close and distant places and peoples (Geary and Webb 1998). France was a leader in European postcard production. There are hundreds of postcards from Madagascar that were commissioned by French merchants on the island, printed in France, and then returned to the merchants for sale to their Western patrons. Although some postcards depict the Merina, the cards' themes visually indicate the French focus on other peoples of the island. Images of "ethnic types" are common, classifying the new subjects according to perceived "tribal" distinctions. Such imagery parallels the implementation of the *politique des races*, which divided the Malagasy into artificial administrative units along the construct of ethnicities assigned by the French on the basis of race (Cole et al. 1997:82–83).

French postcards depicted other rulers, among them Impoïnimerina, a Bara king (fig. 82). Standing in the center of his *lamba*-clad entourage, he represents the authority vested in him by the French. The *lamba* grounds him in Malagasy cultural values, while the pith helmet and his Western shoes symbolize his elevated rank in the new

order. Judging by another postcard, a closeup portrait taken on the same occasion, his image and the message it sent about kingship in Madagascar and its relationship to France must have been well received by postcard consumers.

A formal portrait of Binao, queen of the Sakalava from 1895 until her death in 1927 (fig. 83), demonstrates France's alliance with the Sakalava, who, in an effort to overthrow Merina authority in their region, had aided the French. Seated in front of an ornately painted studio backdrop of a tropical landscape with a Malagasy house, the queen looks regally into the camera. She poses serenely with her legs spread apart and her hands resting on her knees. This regal pose is reminiscent of Yoruba sitters in Nigeria, who also favored the contained, frontal, symmetrical depiction (Sprague 1978). Indeed, Queen Binao's portrait is quite distinct from those of the Merina royals, who assumed dynamic stances and seem to model themselves on their European counterparts (see figs. 54, 87, 88). With the Merina sitters she shares an emphasis on presenting herself in the finest attire—an elaborately tailored dress with a wide lace collar in the fashionable style of women in Diégo Suarez, a major French commercial center— and she wraps herself in a colorful *lamba* imported from the Indian realm. Yet the postcard caption reduces her to a "femme Sakalava." In keeping with the French/Western emphasis on types, she becomes a representative of the Sakalava "race."

Many motifs familiar from English books recur in French writings and published imagery. This is not surprising, considering that the motifs had developed over centuries and that English books (sometimes in translation) and their images of Madagascar had reached large audiences in France, Germany, and the United States. Among these visuals in French popular publishing is— again—the *filanjana*. General Joseph Gallieni's authoritative description of his years in Madagascar as its first French governor-general, from September 1896 to May 1905, contains such imagery

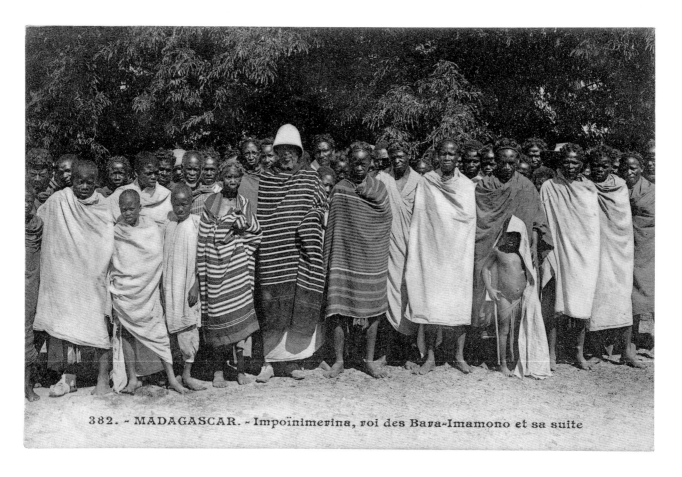

382. - MADAGASCAR. - Impoïnimerina, roi des Bara-Imamono et sa suite

FIGURE 82 Impoïnimerina, king of the Bara-Imamono, and his entourage *(Impoïnimerina, roi des Bara-Imamono et sa suite)*. Collotype. Photographer unknown, c. 1905. Publisher unknown. Postcard collection, MG-15-2, Eliot Elisofon Photographic Archives, National Museum of African Art, Smithsonian Institution.

(Gallieni 1908).[22] It features splendid illustrations: 120 photographs reproduced in halftone, and no fewer than 31 maps. With this book, the colonial "hero," Gallieni, presented his political agenda for the new colony and created a masterpiece by appropriating the colony in word and image. He showed a photograph of a fair-skinned Merina woman in a *filanjana*, entitled "Femme hova en filanzane" (Gallieni 1908: pl. 8). The image captures a noblewoman with straight hair parted in the middle, a coiffure associated with the Merina, in a sedan chair of the type used for men (fig. 84). She wears a *lamba*, as does the female attendant standing at her side. The women proudly display their *lamba*, markers of Merina identity. The four porters are clad in raffia smocks, each with a pocket, and in wide-brimmed straw hats, a mode of dress that identifies them as members of groups from the east coast (see Fee, this volume). For Western viewers unfamiliar with the intricacies of Malagasy dress, the picture simply

denotes "Madagascar." The picture is carefully staged—the Malagasy, standing motionless in front of houses very likely in Antananarivo, directly face the camera. As in the 1658 image of a woman in a *filanjana* (fig. 79), this woman, too, sits in a man's sedan chair, not in the woman's basketlike *filanjana*. In the distance, several children lean over a wall and observe the theatrical staging of the scene—a staging that allowed the photographer to transmit the essence of the Westerner's view of Madagascar, combining the *filanjana* and Malagasy dress.

How successfully the image in Gallieni's book captured stereotypes of Madagascar became evident when it was recycled in the 1930s. It alluded to familiar themes such as race, class distinctions among the Merina, and particular Malagasy styles of dress and cultural practices, and for that reason it appealed to Western consumers. In *The Secret Museum of Mankind*, a popular picture book of images from many different sources published around 1935, this picture—grayish and fuzzy

because of the poor print quality—appeared in the section "The Secret Album of Africa." The caption read:

> How Malagasy Ladies Go Swinging Down the Ways. Madagascar's distinctive vehicle is the *filanjana*. The type commonly used by native ladies consists of an oblong framework of light wood filled in with a plaited material formed of strips of sheepskin, and attached to poles cut from the midrib of the huge leaves of the raffia palm. It is carried easily by four men who keep step and shift the poles from shoulder to shoulder while trotting and, with the accomplishment of the expert, without disturbing the security of the burden. (n.p.)

Never mind that the picture does not bear out the description—the woman sits in a man's sedan chair—the *filanjana* remains an icon. It seems ironic, yet not amazing, that a reprinted

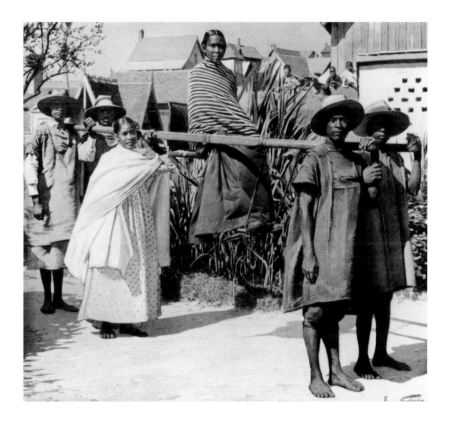

FIGURE 84 **Hova woman in a** *filanjana (Femme hova en filanzane)*. Halftone offset lithograph. Reproduced from Gallieni 1908:pl. 8, courtesy of the Smithsonian Institution Libraries, African Art Branch.

edition of *The Secret Museum of Mankind* containing the same picture appeared in 1999 in the United States. Such views of Madagascar have become fixed, and the topoi have taken on their own life through a process of constant recycling that began in the seventeenth century.

The *filanjana* (*filanzane* in French literature) acquired another history, this time as a visual metaphor for Westerners eagerly trying to establish relationships with the Merina kingdom during the nineteenth century. Late in the century it also became a metaphor of colonial conquest (fig. 85). In this context, *filanjana* imagery merged observed reality with age-old Western discourses about travel, exploration, and foreign peoples. It became the mode of travel for merchants, missionaries, military men, and political envoys—

in short, for all nineteenth-century Western visitors, who made their way from coastal towns such as Tamatave to the highlands and Antananarivo, capital of the Merina kingdom. Unable to traverse streams and move up and down steep hillsides, Western travelers had to depend on the services of agile porters. The use of slaves as porters was a major issue among British missionaries, who abhorred slavery. Missionaries had to justify and explain why they relied on slaves (Clark 1884). Travelers certainly were at the mercy of the Merina monarchs and other highly placed Merina, who controlled access to Antananarivo by providing or withholding *filanjana* services.

In the late nineteenth century, the image of the *filanjana* as a metaphor of Western expansion and appropriation drew its potency from the congruence of Western travelers' actual experiences and the conventional topoi of exploration prevalent in travel writing (Pratt 1992). Traversing difficult terrain to reach a faraway destination is part of every travelogue. The traveler in an exotic

FIGURE 85 **Colonial official in a *filanjana*.**
Albumen print. Photographer unknown, c. 1900.
Madagascar Album, Eliot Elisofon Photographic
Archives, National Museum of African Art, Smithsonian Institution.

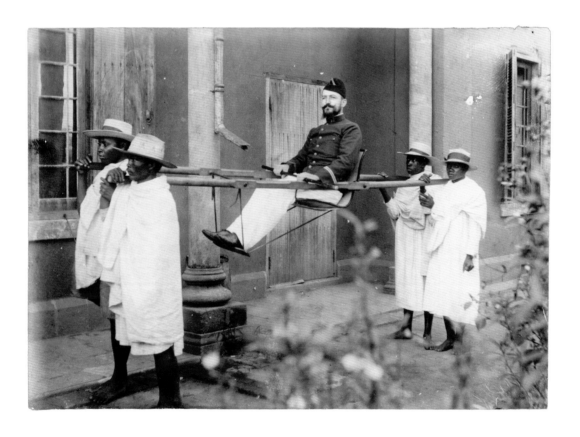

setting, in this case not just facing the challenging environment but also using an exotic mode of transportation, is the hero who confronts the unknown and the dangerous. In the Malagasy context the *filanjana* is also a powerful visual metaphor of colonial domination. The colonized—former slaves—literally carry the Westerner or colonial on their shoulders.

In French publications, imagery of the *filanjana* as an icon of imperial expansion and domination abounds. It even moves to book covers. A palanquin graces the elaborate cover of Girieud's 1897 *Souvenirs et impressions: Madagascar.* A more detailed rendering of a French colonial in a pith helmet embellishes the red, black, and gold linen cover of a book by Dr. Louis Catat, entitled *Voyage à Madagascar* (1895). Catat, who visited Madagascar from February 1889 to January 1891 on a scientific mission under the auspices of the Ministry of Public Instruction, published this lavishly illustrated, 410-page book to recount his daily explorations. Written and published during the time when French occupation of Madagascar was imminent, it captured French sentiment toward the Malagasy and the Merina kingdom in particular. The book was actually the second printing of the account. The identical text and illustrations appeared in the widely read popular magazine *Tour du Monde: Nouveau Journal des Voyages* in 1893 and 1894. The German geographic magazine *Der Globus* published an abbreviated translation the same year. Just as Ellis and Sibree held great influence in the English- and German-speaking realms, so the explorer Catat shaped French popular views of Madagascar.

The *filanjana* did not appear only in illustrations. Malagasy people filled Western desires for souvenirs and made small models of the

FIGURE 86 *Top:* **Model of a woman's *filanjana*.** Merina people. Wood, basketry, 6.5 by 45.5 by 4.5 cm. Dr. William L. Abbott Collection, National Museum of Natural History, Smithsonian Institution, catalog no. E276,328. Photograph by Donald Hurlbert. *Bottom:* **Model of a man's *filanjana*.** Merina people. Wood, leather, 6.5 by 46.5 by 3.0 cm. Dr. William L. Abbott Collection, National Museum of Natural History, Smithsonian Institution, catalog no. E276,330. Photograph by Donald Hurlbert.

palanquins (fig. 86). At the turn of the century, Betsileo artists produced little clothed wooden sculptures, each depicting a noble Merina being carried in a *filanjana* (Roth 1994:32). Westerners and Malagasy continued to use the *filanjana* until roads were built and automobiles and trains facilitated travel in the first decades of the twentieth century. Suffice it to say that writings about the *filanjana* appeared well into the 1930s, demonstrating the resilience and staying power of this metaphor.

Views from the Inside

The story of Western constructions of Madagascar and the Malagasy is a familiar one, unfolding within the larger parameters of all such constructions yet deeply influenced by particular histories and local conditions. It has an abundance of sources. The story of how Malagasy people

responded to being depicted, and of how they appropriated and transformed two-dimensional imagery for their own needs, is less well known. The following examination is based on the few writings that exist about Malagasy painting and photography, particularly the seminal book by Hemerson Andrianetrazafy, *La peinture Malgache* (1991). It also summarizes insights gained through a different reading of historical sources, both published and in archives. This type of inquiry, with its mining of the scarce existing sources, would be greatly enhanced by additional research in Madagascar. Far from being comprehensive, this section of the chapter is intended to highlight fascinating phenomena in need of further investigation.

Paintings, engravings, and, later, photographs had an immediate impact on the Malagasy from the moment the images arrived on the island. They came with Western travelers and visitors and were much in demand. Giving pictures as diplomatic gifts to Merina royals was a common gesture. Ellis, for example, followed this etiquette when he brought gifts for Queen Ranavalona I to Antananarivo during his first visit. On August 15, 1856, while waiting for an audience with the queen, he received word from the palace that it would be appropriate to send over his presents. Among them was "a large framed engraving of our own Gracious Sovereign, and of His Royal Highness the Prince Consort, together with a large coloured print of Windsor Castle, also in a gilt frame." Ellis had heard "that there were good-sized plates of portraits of the Emperor and the Empress of the French in the palace, and the [palace] officers when they saw the portraits of Queen Victoria and the Prince Consort said they thought they would be acceptable to their queen" (Ellis 1858:395). Indeed, the queen was much pleased with them (Ellis 1858:396).

Images brought by foreigners occupied an important place in the palace. In 1870, Sibree described the Tranovola, or "Silver House," the palace and residence of Radama II, in the following terms:

The large central room is very lofty, and is decorated much in the same style as the larger palace; but it contains a good many articles of furniture, and a number of pictures sent as presents from the English and the French courts. Amongst the latter is a full-length portrait of Queen Victoria, sent by her to Radama II on his accession; also a large portrait of Sir Robert Farquhar, governor of Mauritius in the time of Radama I. . . . There are also coloured lithographic portraits of the French Emperor and Empress. (Sibree 1870:348; see also Sibree 1870:238)

European leaders resided peacefully next to one another in a visual display of power and prestige indicating the Merina monarchy's alliances, closeness, and familiarity with European royalty. Later on, a photographic portrait of Grover Cleveland and his wife might well have been added to this display (see Arnoldi, this volume).

Besides portraits of European kings and queens, which intrigued their counterparts in Madagascar, views of foreign people and distant places were much in demand among Malagasy royalty. During his short stay in Antananarivo in 1856, Ellis met with Prince Rakotondradama, who later succeeded his mother, Ranavalona I, under the name Radama II. Rakotondradama asked for pictures of Ellis's family and house, making an effort to understand the foreigners and gaining inspiration for royal dress and architecture from what he saw (Ellis 1858:350). His wife, Princess Rabodo (later Queen Rasoherina), also showed considerable interest, requesting copies of the *London Illustrated News* (Ellis 1858:382). When Ellis was preparing to leave Antananarivo, the prince and princess paid him a final visit and once more asked to see the portraits of his family and an engraving of his house. The princess actually desired copies of the pictures. She then "asked about English society, about Queen Victoria,—whether she

traveled much from one part of the kingdom to another, or had many visitors in her palace; and what made the people of England so fond of her, as she had heard they were" (Ellis 1858:418).[23]

During Ellis's second stay in Antananarivo, the prince and princess, now king and queen, continued their explorations. In Ellis's own words, during a dinner on October 2, 1862,

> when the king proposed to the health of Queen Victoria, we had as usual the English national anthem. When the table was cleared, I brought out some copies of the London "Illustrated News," one of which contained a portrait of the Princess Alice, with which the queen seemed much pleased, as well as with [sic] the Prince, her husband, and accepted with expressions of pleasure the paper containing them. My guests also asked to see the negative of the photograph taken of the king that morning, and of the coronation, with both of which they seemed pleased. The queen then arranged that I should go to the palace and take her portrait the following Monday morning. I also exhibited in the stereoscope transparent views of some of our royal and other English residences, to the great satisfaction of my guests. (Ellis 1867:192–93)

Ordinary Malagasy also enjoyed imagery, as Sibree reported. In September 1863, when he was in Tamatave (now Toamasina), "the good people [members of the Christian church] were delighted to inspect a photographic album, and to see the portraits of Queen Victoria and the Royal family. This album proved of service on several occasions, for the exhibition of its contents was regarded as ample return for little acts of attention and kindness we received at the different villages on our route" (Sibree 1870:41). Ellis's and Sibree's writings mention many similar instances when Malagasy tried to gather information about the foreigners.

These views of Westerners played an important role in the Malagasy imagination. Just as pictures of Malagasy people led to Western constructions of the island and its inhabitants, so the Malagasy tried to understand Westerners and formed an image of Europe and the United States through pictures. Imagery thus helped them to explore and digest the foreign and exotic. This effect of Western images has also been observed in other African contexts. Western travelers and residents exploited imagery as a device to impress the Africans they met. Illustrated magazines, in particular, served as important tools (Fabian 2000:108). In some instances, Africans used pictorial sources of information to fashion themselves in modern ways. One of the most intriguing examples is that of King Njoya of Bamum in Cameroon (ruled c. 1886 to 1924). Inspired by photographs of the German emperor and crown prince in uniform, he equipped his guards with Bamum-made uniforms patterned after German styles. He then had a German resident colonial agent take his and the guards' photograph in a pose resembling that in a picture of the German crown prince and his uniformed comrades. In another photographic portrait, Njoya assumed a pose identical to that of the German emperor— both of them in uniforms (Geary 1996:180, 184). King Njoya not only fashioned himself after photographs but also employed the medium to create an image of modernity and to capture a moment in Bamum history through the services of a foreign photographer.

Much like King Njoya, Malagasy who came in contact with photography (especially Merina royalty) recognized portraiture's power to present the self, articulate a modern identity, and commemorate historical moments. These capabilities of two-dimensional imagery, which was unknown in the Malagasy artistic repertoire, might well have been the reasons why most members of the Malagasy upper classes readily embraced painting and photography. Portraits,

for example, helped maintain ties to the ancestors and became part of displays during funerary rituals (Randall Bird, personal communication, 2000). Andrianetrazafy confirmed that the facile appropriation of portraiture and, by extension, photography had a deeper grounding in Malagasy thought. Among the Merina, displaying portraits also opened an avenue for achieving *voninahitra* (translated as "glory and prestige"), an important concept in elitist Merina society (Andrianetrazafy 1991:105).

Merina monarchs had a long history of exploiting the effects of their portraits for their own ends, beginning with Radama I, an innovative king who ruled from 1810 to 1828. The first known portraits of Malagasy were those of two of his brothers, the twins Ratafika and Rahovy, whom Radama I sent for education to Sir Robert Farquhar, the British governor of Mauritius, in September 1816 (Brown 1995:118–19). An artist named Colombet portrayed them in elegant Western attire with fancy ostrich-plumed hats, following the canons of portraiture of the time.[24]

When the princes returned to Madagascar in July 1817, the portraits accompanied them (Brown 1995:121). Impressed, Radama I commissioned André Copalle, a painter who lived in Mauritius and held the position of professor of art at the Royal College, to create his portrait. The sittings began in November 1825. Copalle completed the portrait in January 1826 and received fifteen hundred Spanish piasters for his services. His painting, however, lacks the technical finesse, the balanced palette, and the loveliness of the portraits of Radama's brothers. Placed in an imaginary landscape, the king, in uniform, assumes a stiff pose reminiscent of contrapposto, holding a sword in his left hand. To his right is an ornate plumed hat placed on a rock.[25] Apparently Radama I was not satisfied with the work and complained about the poor rendering of his physiognomy (Andrianetrazafy 1991:18). This was but the first instance of a royal sitter's critiquing a portrait on grounds of likeness—possibly because of a lack of idealization.

When photography arrived, the Merina court was already familiar with the concept of portraiture and favored large-scale, colorful representations, which photography could not yet deliver. This was the beginning of a close relationship between photographs and painted portraits, because painting from photographs was one way to fulfil the royals' desires. To please Merina royalty, Westerners commissioned painters in their respective home countries to paint from photographs, so that the paintings could be taken to Madagascar. When Ellis returned to Madagascar in 1862, he brought several presents from friends in England for Radama II and the queen. They included an oil portrait of the king, painted from a large photograph Ellis had taken in 1856. He wrote:

> When I had taken the picture [painting] out of the case, the king and queen came to look at it, and I watched with interest the effect it produced. The king appeared at first bewildered with surprise. He smiled and looked again and again, and then came to the place where I was standing, and pressed my hand very warmly, saying, "I remember all this," pointing to the different parts of the picture. He then gazed again and smiled with great satisfaction. . . . The queen asked if I would take her portrait and send it to England to be painted in the same manner. I readily answered that I would, but this was never done. The king asked if the picture could be enlarged to the size of life. I told him it could in England, but not in Madagascar, and shortly afterwards I took my leave. (Ellis 1867:35)

This tradition of commissioning royal portraits from photographs continued throughout the nineteenth century.[26]

It is fascinating to explore the creation of the photographic portraits on which such paintings were based. In photography, different scenarios of interactions between photographers and Malagasy sitters unfolded. They provide interesting insights into the power relationship between photographer and sitter and into the subject's ability to use photography to his or her own ends. Many scholars have made a strong case that photography, which accompanied imperialist expansion, was deeply affected by and exploited unequal power relations between photographer and photographed. The choreography of the photographic encounter ranged from overt oppression to more subtle forms of coercion of people who had come under Western domination. Indeed, in the eyes of many photographic scholars, photography itself is a metaphor for the oppressive relationship between colonizer and colonial subject (Edwards 1992:6–7). Within this overall framework, however, are variations. In the case of portraiture of the Malagasy elite in the nineteenth century, the sitters asserted their influence and control. Ellis's accounts provide a case in point, among them a report about his interaction with Radama II.

On October 2, 1862, shortly after King Radama's II coronation, Ellis took a portrait he had commissioned (fig. 87) and reported:

> I was more than pleased with the proposal, because it was the day on which the king had promised to come, in order that I might take his likeness. . . . I welcomed him heartily, while he apologized for coming before the time fixed, saying he had preferred to come by a less public way, quietly in his ordinary clothes, and would dress for his portrait in my room. His attendants then laid out the different portions of regal attire, while my servants provided a cup of tea and some biscuits, which I offered him, and then went to arrange my camera, &c. His attendants

> had also brought the casket containing the new crown which he had worn at coronation, as he wished the picture to resemble his appearance on that occasion. When he came to take his position, he directed one of his officers to place his plumed hat on the ground near his feet, and to tell him when his position was correct. I then adjusted the focus, and found on developing the picture that I had obtained a tolerably good likeness. As the king was anxious to see the picture I exhibited it to him, and to two of his favourite officers, who appeared gratified with its appearance. (Ellis 1867:189–90)

Photographs, of course, had to be produced in daylight. Ellis preferred to take portraits in the cool hours between seven and eight in the morning, when the light was most suitable (Ellis 1867:166). His "photographic studio" was on the verandah of his house, which was located just below the palace, indicating Ellis's closeness to the royals. The neutral backdrop, which he usually fastened to the wall of the house, consisted of "some fine matting nailed up as a sort of background" (Ellis 1858:408). His props were reminiscent of those in European studios.

In the case of Radama II's portrait, the image was carefully arranged by both photographer *and* sitter. An ornate cloth covers the table on which the royal crown rests,[27] and a curtain is draped to the right. The feathered hat sits on the floor to the right of the king. Radama II displays a splendid British field marshal's uniform, presented to him by General Johnston on behalf of Queen Victoria, which he wore during his coronation (see Ellis 1867:176; Peers 1998:46). He stands relaxed next to the table that holds his crown, one hand resting on the table, the other on the hilt of an elegant sword. He looks into the distance and projects composure and serenity. He is very much in control. The image is reminiscent of Copalle's portrait

FIGURE 87 Radama II, king of Madagascar, age thirty-four, as photographed by William Ellis in September 1862. Albumen print from a collodion negative. Courtesy Wisbech and Fenland Museum, Wisbech, UK.

of Radama I, which was kept in the palace and might have inspired Radama II's pose. In visual terms, Radama II expresses the two rulers' similar political and social agendas. Like Radama I, the young king saw his role as that of modernizing the kingdom, an effort that had been interrupted by the rule of Queen Ranavalona I. It is obvious that the king well understood the impact and power of images and used the occasion to his end. He created an image of modernity, using dress as an important element, and he reinvented the Merina monarchy in contemporary terms. The visual vocabulary is that of the West—from setting to pose (see fig. 83, the portrait of Queen Binao, for a different approach to posing). Ellis and Radama II were accomplices in this ongoing

project of constructing a modern Madagascar, and each contributed his share to Malagasy representation.[28]

Other portraits, too, reveal the close interaction and common goals of photographers and sitters. In the LMS archive at the School of Oriental and African Studies at London University is a remarkable series of three portraits of Queen Ranavalona II (ruled 1868–83). Although the archives' records make no reference to the photographer, the pictures may have been created by John Parrett (died 1910). Parrett, an LMS missionary who specialized in typesetting, a vocation he shared with Ellis, worked in Madagascar from 1862 to 1885. Initially he assisted Ellis in taking portraits of King Radama II in 1862, using the wet collodion process. Parrett became an accomplished photographer in his own right and enjoyed a favored position at the palace. He took two pictures of Ranavalona II on the same occasion, judging by the queen's dress.

In the first image, photographed in daylight on a verandah—the ledge of the veranda and the walls of the house are visible—the queen poses in front of a plain backdrop that is nailed to the wall, and she stands on a woven mat (fig. 88). The furnishings are reminiscent of those in studios in Europe. An ornate table backed by an oval mirror or possibly a picture decorated with ribbons stands to her right. In an ostentatious display, two clocks sit on the table.[29] Ranavalona II wears a beautiful moiré dress, a velvet cloak, and an intricate bonnet, reminiscent of Queen Victoria's attire.[30] She assumes a pose similar to that struck by Radama II in his picture (fig. 87). She faces right, and her right hand rests lightly on the table. In the left hand she holds an umbrella—a cherished imported item. This image demonstrates that having one's portrait taken had become a routine process in a prescribed setting familiar since the days of Ellis's photography.

There are, however, a few hints that some Merina royals objected to being portrayed, especially

with the camera. Ranavalona I apparently believed that having her picture taken would precipitate her death, and "that the likenesses resembled the spirit of a person, and when that was gone said 'Why what is there left?'" (Ellis 1858:358; see also Peers 1995b:18, n. 27, 1997:28). Ranavalona III also felt uncomfortable in front of the camera. According to Francis Cornwallis Maude, a British colonel who lived in Madagascar from 1888 to 1893, "her majesty has never been willing to have her photo taken, as this is not in conformity with the native laws. . . . It has, therefore, been rather difficult to secure her likeness. However, some years ago one of the prime minister's friends, Mr. Parrett, obtained some excellent photographs of her by the instantaneous [wet collodion] process" (Maude 1895:22).

Maude added a footnote, which reads: "Besides which she [Ranavalona III] is excessively vain; and does not consider any likeness of her good looking enough; for which reason she rejected three separate effigies of herself, which had been struck off in Paris for the intended coinage" (Maude 1895:22).[31]

Parrett and other photographers took fine portraits of Ranavalona III in the early years of her reign, and of her husband, Rainilaiarivony, the prime minister. A lovely image of the very young queen, taken in the verandah studio setting, shows her in an ornate, thronelike chair, looking serenely into the distance (fig. 89). She wears lacey head attire above her braided coiffure and an elegant dress of precious imported fabrics. Floral patterns like the ones on her skirt were much in vogue among the elites in late-nineteenth-century Madagascar, as many contemporary portrait photographs demonstrate. This fashion even extended to wallpaper (see fig. 97). Ranavalona's crown rests on a cushion on top of a small, finely executed table. This photograph was possibly taken by Captain E. W. Dawson (Simon Peers, personal communication, 2001). It served as the basis for an oil painting in the tradition of the portraits

FIGURE 88 **Queen Ranavalona II.** Toned albumen print. Photograph attributed to John Parrett, c. 1875. Madagascar (Pictures) Box 5. Courtesy of the Council for World Mission Archives, School of Oriental and African Studies, London University.

commissioned by her predecessors. In the painting, her dress is red, the color reserved for Merina royalty (fig. 90, also published in Roth 1994:53). This portrait was in the palace museum in Antananarivo before it burned down in 1995. Fortunately, it survived the fire.

For Westerners, images of the queen and the prime minister were highly collectible, and they show up in individual albums and archive collections.[32] A photographic album in the Eliot Elisofon Photographic Archives, compiled by a French *colon* who was in Madagascar around 1900, opens with portraits of these two main Merina protagonists of the late nineteenth century. One portrait shows the prime minister (fig. 91). Often described by European observers as dapper, he sports a

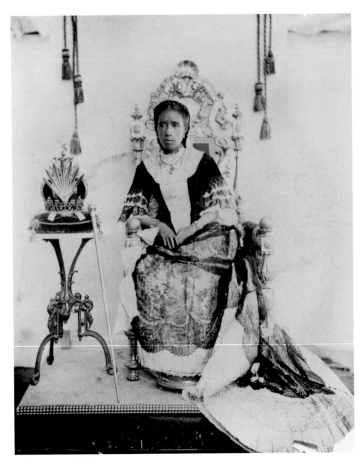

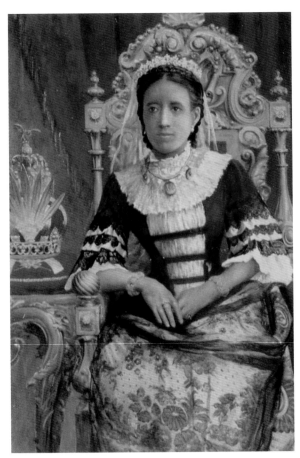

FIGURE 89 **Queen Ranavalona III.** Albumen print. Photograph attributed to Captain E. W. Dawson, c. 1888. Madagascar (Pictures) Box 5. Courtesy of the Council for World Mission Archives, School of Oriental and African Studies, London University.

FIGURE 90 **Portrait of Ranavalona III, c. 1880.** Oil on canvas, by Arthur Trevor Haddon (British, 1864–1941). Courtesy Palace, Antananarivo, Madagascar.

splendid uniform embroidered with floral patterns and richly decorated with medals, and he assumes a regal pose. As was customary in many previous portraits of the royals, his plumed helmet sits on a small circular table covered with an embroidered tablecloth. Next to his image in the scrapbook is a portrait of the queen reminiscent of Dawson's image (see fig. 54). Ranavalona III sits in the same thronelike chair shown in the earlier portrait, leaning slightly to her right and placing her feet on a footstool. She is in full regalia: an elegant dress and cape with floral embroidery, a sash, and her unique crown. The studio setting reminds one of a stage arranged with palm fronds and a small table holding the royal Bible, which indicates the faith, learnedness, and modernity of the queen.[33]

The Bible had replaced the *sampy*, those powerful talismans that protected and safeguarded the Merina kingship until Queen Ranavalona II converted to Christianity in 1869 and ordered them burned (Brown 1995:187–88).

Ranavalona III seems to have overcome her dislike of photography later in life, and she continued to cultivate her taste in Western fashions. In exile in Algiers after 1897,[34] she favored one of the largest and best photographic establishments there, the studio of J. Geyser, who specialized in Orientalist imagery and postcard production. Two of Geyser's portraits of Ranavalona III, a full-length formal image (fig. 92) and a close-up taken around 1905, show a still youngish, pretty woman in fashionable dress, with a coiffure typical

of French ladies of the time. In the tradition of producing postcards of exiled or deposed African kings—part of the imagery that demonstrated colonial achievement to postcard consumers in England and France—Geyser distributed her portraits as postcards.[35] Ranavalona III postcards are quite common, which indicates that her pictures became a popular commodity. A French fashion magazine even ran an article about the exquisitely dressed Malagasy queen in exile, who frequented French designers and purchased the latest fashions during visits to France from Algiers (Randall Bird, personal communication, 2000).

Many nineteenth-century non-Malagasy photographers, employing the wet collodion process, produced imagery right in front of the Malagasy sitters, who thus could see the photographs immediately and critique them. These images, and engravings based on them, did not always get the sitters' approval. Ellis, who depended on the support of the Merina court for his work, described such a scenario. Simon Peers (1997) quotes two letters from Ellis to his London publisher, John Murray, who had printed *Three Visits to Madagascar* in 1858 and was about to publish *Madagascar Revisited*.[36] In the first letter, written on October 10, 1866, Ellis advised the publisher to be cautious with the placement of engravings from photographs of three "leading men in the government." Apparently, these three men had seen the 1858 book and disliked the rendering of King Radama II and his wife (see fig. 81). In a follow-up letter on October 22, 1866, Ellis reminded the engravers to reduce the *African* features of Merina royalty. He based his advice on a critique by the king and queen, who disliked the way their faces were rendered in the 1858 publication (Peers 1997:28), as Radama I before them had objected to his painted portrait. Ellis was fully aware that the photographs had to please the royal sitters and took care to meet their expectations. Otherwise, his relations with the palace and consequently his political work for the LMS might have been jeopardized.

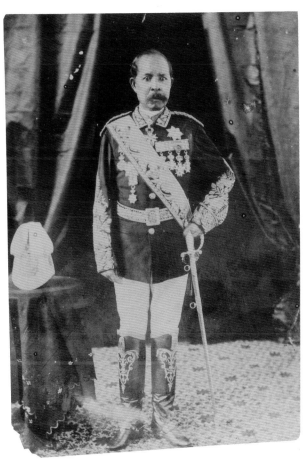

FIGURE 91 **Portrait of Prime Minister Rainilaiarivony.** Albumen print. Photographer unknown, c. 1895. Madagascar Album, Eliot Elisofon Photographic Archives, National Museum of African Art, Smithsonian Institution.

In the nineteenth century, works by foreign painters and photographers initially filled the need of the Malagasy elites to create a distinct identity and to represent themselves to people on both the inside and the outside. Besides relying on the services of foreigners, however, the Merina court devised new strategies and began to enlist Malagasy artists. In 1870, James Sibree mentioned two portraits by Malagasy artists in the Tranovola, the Silver House of the palace, then the residence of the prime minister: "There are also coloured lithographic portraits of the French Emperor and Empress, and a number of other smaller pictures, together with some curious oil-paintings of two young princes of a former reign. They are by a native artist,

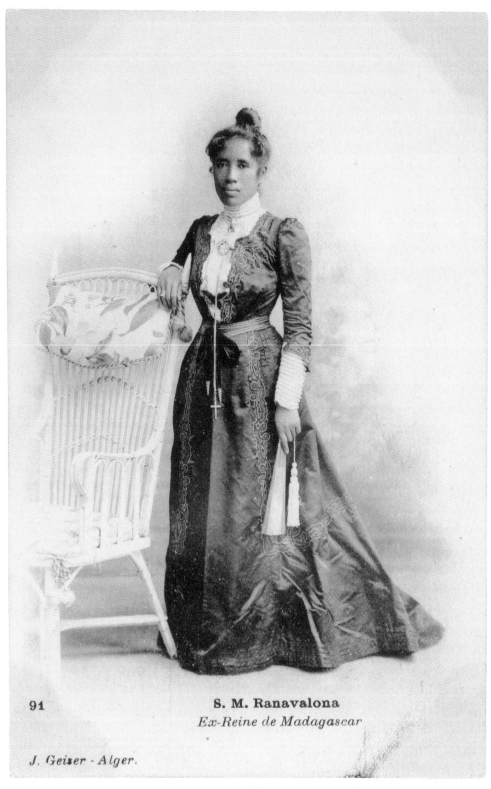

91

S. M. Ranavalona

Ex-Reine de Madagascar

J. Geiser - Alger.

FIGURE 92 **Ranavalona, former queen of Mada-**
gascar (*S. M. Ranavalona, Ex-Reine de Madagascar*).
Collotype. Photograph by J. Geyser, Algiers, c. 1900.
Publisher unknown. Postcard collection, MG-15-9,
Eliot Elisofon Photographic Archives, National
Museum of African Art, Smithsonian Institution.

and very hard and stiff in execution" (Sibree 1870:348).

In another context, Sibree wrote: "The only attempt at [Malagasy] portraiture I have seen are two paintings in the Silver House, of Malagasy princes, but exceedingly hard and wooden in execution; and in a large country house belonging to the present secretary of state is a continuous line of figures around the walls, in the gallery of the chief room. These paintings represent a variety of characters and classes—military, judicial, agricultural, etc.; they are about a foot or a little more in height, and are very rude in drawing and colouring" (Sibree 1870:225–26).

The wall paintings, genre scenes, floral designs, and portraits in the Silver House dated back to the rule of Radama I. Initially, artists painted them on (wall) paper. In the late nineteenth century they were transferred to canvas (Andrianetrazafy 1991:20–23). It was Copalle's presence that stimulated this first documented instance of Malagasy figurative wall painting.

Who were the artists, and what were their sources of inspiration? Were there any precedents for two-dimensional art in the Malagasy repertoire that they might have drawn on? According to Andrianetrazafy (1991), the only precedent for two-dimensional work in Madagascar was surface decoration. Artists of the Merina and other Malagasy groups had a tradition of embellishing beds with incised geometric motifs.[37] The seemingly easy adoption of two-dimensional painting and its transformation into a meaningful Malagasy form of expression was, therefore, fostered mainly by exposure to Western imagery and by the important role it began to play in projecting prestige and forming an elite identity.

Malagasy creation of two-dimensional imagery was also closely linked with the teaching activities of the LMS missionaries, who arrived in 1818 and opened schools. Missionary artisans instructed their students in many fields (Fee, this volume; Mack 1986:56–59). Drawing, a part of the curriculum in English schools back home, was one of the skills taught early on. Like the LMS, the Society of Friends (Quakers), who began missionary work in Madagascar in 1867, emphasized education (Brown 1995:188). The earliest Malagasy artists whose names and works are known trained at the Friends Foreign Mission Association (FFMA) school at Ambohijatovo-Atsimo in Antananarivo, under the mentorship of the school's headmaster, the Quaker missionary William Johnson, an architect. In the last two decades of the nineteenth century, Johnson taught different painting techniques and concepts of Western painting ranging from perspective to color choice (Andrianetrazafy 1991:27).

Among his first students was James Rainimaharosoa (1860–1926).[38] According to John Mack (1998:34–35), who has written the only essay on Rainimaharosoa's work, he learned lithography, architecture, and watercolor painting from Johnson himself. Rainimaharosoa gained considerable fame as the first Malagasy painter and exhibited his work at the International Exposition in Paris in 1905. Few of these works survived. Tragically, a fire at the palace in Antananarivo in 1995 destroyed seven of them.

Many of Rainimaharosoa's large oval oil paintings on cotton sheeting—both those still extant and those known through photographs—are renderings of Malagasy genre scenes. They are well composed, vividly colored in pastel shades, and so intricate in detail that they have great value as historical documents on Malagasy material culture (Mack 1998:34). One lovely work created in the first two decades of the twentieth century depicts a noble Merina woman being carried in a *filanjana* (fig. 93)—a familiar scene. On a path in front of a Malagasy house, four strong porters in straw hats carry a woman and a small child with braided hair in the basketlike palanquin reserved for women. She wears a white *lamba* and shades herself with a white parasol; one of the porters wears a striped shirt typical of people of the east

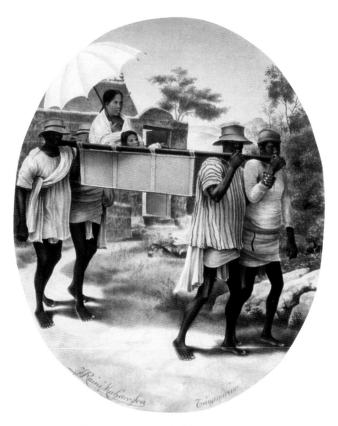

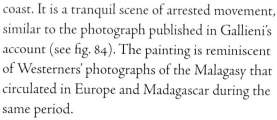

FIGURE 93 Untitled (woman in *filanjana*), by
James Rainimaharosoa (Malagasy, 1860–1926).
Oil on cotton sheeting. Photograph courtesy of the
Trustees of the British Museum.

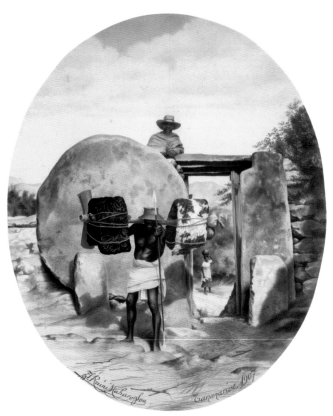

FIGURE 94 Untitled (gate of an Imerina village),
by James Rainimaharosoa. Oil on cotton sheeting.
Photograph courtesy of the Trustees of the British
Museum, reproduced courtesy of the British Ambas-
sador's Residence, Antananarivo.

coast. It is a tranquil scene of arrested movement,
similar to the photograph published in Gallieni's
account (see fig. 84). The painting is reminiscent
of Westerners' photographs of the Malagasy that
circulated in Europe and Madagascar during the
same period.

This, as it turns out, was no coincidence.
In the tradition of British painters who created
portraits of Malagasy elites from photographs
brought back to England, Rainimaharosoa
painted at least partly from photographs. A 1907
painting of the gateway to a fortified village in the
Merina kingdom, with a porter standing in front
of it, is a case in point (fig. 94).[39] It is based on a
photograph, the glass plate of which is now part
of the FJKM Church of Jesus Christ of Mada-
gascar Archives in Antananarivo. The photograph
was also published as the frontispiece in Sibree's

1915 book *A Naturalist in Madagascar* (fig. 95).[40]
Juxtaposing the photograph and the painting
demonstrates that Rainimaharosoa copied many
details in the photograph but also took artistic
license. Enhancing the composition of the image,
he eliminated three of the figures on top of the
circular stone that, when rolled across, closed the
gate, and he inserted a woman carrying a pot on
her head in the distance. The scene thus became
a narrative about Malagasy modes of carrying and
transportation set in front of a landmark. Using
photographs as inspiration for paintings was a
practice that might well have been related to the
educational activities of LMS and Quaker mis-
sionaries. According to John Mack (personal com-
munication 2000), teachers at missionary schools
used photographs to instruct their Malagasy stu-
dents how to draw.

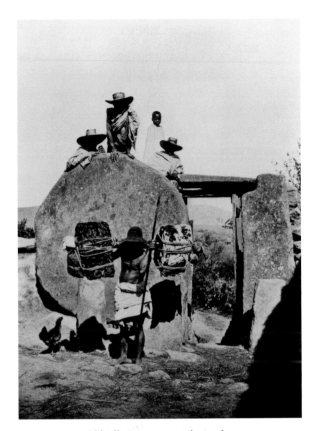

FIGURE 95 **Old village gateway with circular stone.** Halftone. Photographer unknown (possibly John Parrett), c. 1890. Reproduced from Sibree 1915 (frontispiece), courtesy of the Smithsonian Institution Libraries.

This role of photography in the development of Malagasy painting, and for that matter in other painting traditions in Africa, merits further investigation.[41] Western notions that works "copied" from photographs constitute less creative, and thus inferior, forms of expression may still stymie appreciation of these works by early Malagasy painters, and there are reasons why such perceptions should be revised. Recent studies suggest that the work of these artists must be examined in light of culturally specific notions of artistic perfection and creativity (see, among others, Vogel 1991, esp. p. 19). Painting from photographs and postcards certainly allowed the artists to refine their technical skills and develop their own styles. There is a certain irony in the artists' practice of selecting themes from Western imagery that often reduced the lived experience to the stereotypical.

Nevertheless, narrative paintings based on representations produced by Westerners accommodated Western tastes and appealed to the non-Malagasy patrons who purchased many of the pictures.[42] Establishing a secure economic base ultimately furthered the artists' careers (see Andrianetrazafy 1991:79–80).

Malagasy painters also worked for Malagasy patrons. According to Andrianetrazafy, the elites of Antananarivo in the late nineteenth century were swept up in "picturemania," following the lead of the royals. In 1888, the prime minister himself sent the Malagasy painter Philibert Ramanankirahina to Paris to attend the École des Beaux-Arts. When Ramanankirahina returned to Antananarivo in 1890, he created portraits for the palace. He painted Merina rulers from Andrianampoinimerina (ruled 1787–1810), the legendary founder of the kingdom, to Ranavalona II, the later ones likely based on photographs or other existing images (Andrianetrazafy 1991:28).

This consumption of pictures, including portraits and genre scenes, seems indicative of major parallel developments. The role of imagery in the projection of a modern identity has already been mentioned. Two other topics merit investigation but are beyond the scope of this essay. One is the role this imagery played in structuring the collective memory of Malagasy during the increasing dislocations of the colonial period. Paintings such as Rainimaharosoa's woman in the *filanjana* conjure up the recent past. Its theme and details, such as the woman wearing a *lamba*, depict a world where tradition still lives. The second topic pertains to the social uses of imagery, such as in albums for presentation. The integration of pictures into the living environment and the creation of interiors in houses with walls for the hanging of images are also of interest (see fig. 97, which depicts such a modern interior).

Besides adopting and transforming painting as a mode of representation for their own needs, Malagasy also ventured into photography. As in

the case of painting, the catalyst for the appropriation of photography as a Malagasy mode of visual expression was a convergence of Malagasy elites' desires for self-representation and commemoration with the availability of a new technology for fulfilling those desires.

Malagasy photography goes back to the last two decades of the nineteenth century. The first reference to a Malagasy photographer appeared in an article in the *Chronicle of the London Missionary Society* about the Girls' Central School in Antananarivo: "The engraving which figures as our frontispiece this month represents a group of scholars belonging to the Girls' Central School, Antananarivo. It may be said that the group is not very artistically arranged, but the photograph was taken by a Malagasy amateur who does not yet understand such matters of detail, and, in fact, some of the children were out of focus altogether, so that the picture does not represent the full number who were there by about fifty" (Bliss 1890:14).

The photograph, a classic group shot— which, despite Miss Bliss's negative comment, compares well with other group photographs in the magazine—shows the girls and their teacher. Apparently, the engravers removed the out-of-focus students by retouching the picture, a customary process in transferring photographs to the printed medium. Whether the "amateur" was Joseph Razaka, the first documented professional photographer in Madagascar, remains an open question. Certainly the date of the publication coincides with his entering the photographic profession.

Joseph Razaka (1871–1939) opened a studio in Ambatonakanga, Antananarivo, on January 1, 1889 (Izydorcyk 1998:327). He portrayed the local elites, specializing in weddings and official events. Like the painter Rainimaharosoa, Razaka sought recognition in the metropole and sent his work to France. He competed successfully in photographic competitions and proudly announced his accom-

plishments on the backs of his mounted photographs. A portrait of the missionary A. Sharman in the archives at the School of Oriental and African Studies (SOAS) shows Razaka's official studio imprint on the back, which reads: "Photographie Malagasy. Agrandissements. Reproductions. Portraits d'Enfants. RAZAKA. Paris 1900 MÉDAILLES d'ARGENT Marseille 1906. Tananarive. Les Clichés sont conservés."[43] He also seems to have had more general aspirations as an artist. His name appears among those of the first group of students admitted to an art school founded by the Frenchman Ange Supparo in late 1913 (Andrianetrazafy 1991:44–45). Razaka received frequent commissions from members of the London Missionary Society and took portraits of missionaries, Malagasy Christians, and pastors, as well as photographs of events such as meetings. Thirteen of his photographs are in the SOAS archives in London: twelve in the Hardyman Collection, which consists of records and images collected by the LMS missionary James Hardyman, and one in the Madagascar Photograph Collection, which was compiled in the LMS Editorial Office in London.

Among the images in the Hardyman Collection is that of a group of British missionaries and Malagasy Christians (fig. 96). This well-staged group photograph, taken in front of a missionary building on July 28, 1902, shows the white missionaries seated and the Malagasy standing behind them. The arrangement clearly establishes a visual hierarchy, as is often the case in photographs showing missionaries and their charges (Geary 1991:49). The photograph demonstrates Razaka's technical and aesthetic expertise, much in the tradition of Western studio photographers. Razaka also took city views, among them a set of views of the Zoma, the central market in Antananarivo, now in the Hardyman Collection.[44] Sibree credited Razaka as one of the photographers whose images he used to illustrate his 1915 book *A Naturalist in Madagascar*. In its preface, he thanked John Parrett, Henri

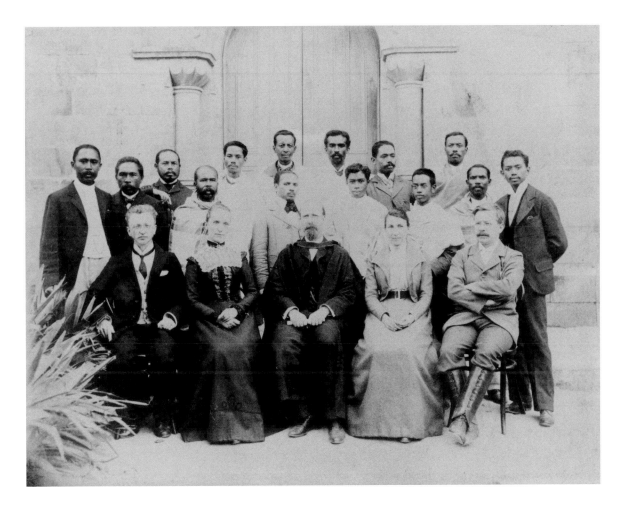

FIGURE 96 Untitled photograph by Joseph Razaka (Malagasy, 1871–1939). Dated July 28, 1902. Inscribed on the back: "With much love from Sonia Sharman." Albumen print mounted in cardboard. Hardyman Collection, PP MS 63, Box 76, file 34, School of Oriental and African Studies, London University.

Noyer, and Razaka "for their freely accorded permission to reproduce many of the photographs taken by them and used to illustrate this book" (Sibree 1915:7). Razaka's studio, among the most famous in Antananarivo, enjoyed great commercial success. When he died in 1939, his son, Jean Jafetra, took over the flourishing business.

The LMS Madagascar Photograph Collection and the Hardyman Collection contain the work of other Malagasy photographers as well. Their business names and images demonstrate that photography had become an active, established profession. There are Rasolonjatavo of Photographie du Progrès in Antananarivo; Rakotodramanitra of Antananarivo; G. Razafitrimo et Fils of Photo Hova in Antananarivo; Joseph Razafy; Jonah Rajemiba; Ramahandry; Rampianina; Rakotonirina; and Razadintsalama of Fianarantsoa. Among the best known photographers

represented in the SOAS collection is Ramilijoana (1887–1948), a politician and writer who took up photography in 1894. He maintained studios in Antananarivo and later Fianarantsoa. Like Rainimaharosoa and Razaka, he, too, exhibited in Europe; he received medals in Antwerp in 1930 and Paris in 1931 for his accomplished photography (Izydorcyk 1998:336).

A compelling portrait of a Malagasy photographer and his wife in their parlor (fig. 97) demonstrates in visual terms the role photography assumed in Malagasy society. The photographer,

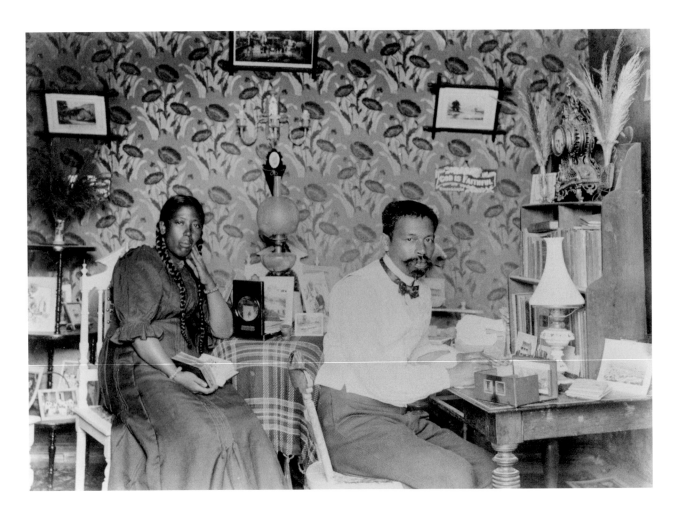

FIGURE 97 **Mr. and Mrs. Adrianantoandra.** Toned albumen print. Photographer unknown, c. 1900. Madagascar (Pictures), Box 5. Courtesy of the Council for World Mission Archives, School of Oriental and African Studies, London University.

who looks at the camera, is surrounded by his images and seems to be working with them. Stereographs in a viewer, portraits, images of groups, city views, and landscapes are displayed on small side tables and hang on the wall, which is wallpapered with a poppy motif. Victorian furniture graces the salon. A small case on the table contains books, alluding to literacy, an ornate gilded clock, and small, pretty vases. The photographer's wife, in an elegant Western-style dress, holds a book opened to a page with an illustration. On the wall hangs a small plaque with the words "God is faithful."

The image of this well-to-do Malagasy couple, taken in about 1900, evokes middle-class comfort and commercial success. It is a perfect vehicle of self-representation, a statement about a modern life-style, so much so that the photograph could have been taken in London or Paris. The identity

of the photographer remains a mystery, although the caption reads "M. et Madame Andrianantoandro." Information about another image dating from the 1920s might help to identify the photographer. It shows the same man, now older, his wife, family, and a white woman missionary. The caption on the back says: "The photographer. Randrianarisoa's family. Wife Razafindratiana. 2 daughters Lydia and Nettie and two grandschildren."[45] Four photographs in the SOAS archives are the work of a photographer named A. Randrianarisoa, who may well be the photographer in the image. Another stamp, on a photograph of a church, might relate to the same photographer's studio. It reads: Adrianarisoa Frères. IMERINANDROSO (Alaotra). Photographie—Cinema—Stereoscopie. NARSOA."[46]

Both painting and photography became deeply embedded in Malagasy cultural practice.

Malagasy painters—among them Raveloson Fidj dit Max, and Désiré Rasolofoson—established themselves and found a Malagasy audience and a worldwide one. Photographs are now part of the everyday lives of all Malagasy, not just the elites. Photographic albums and images spanning decades exist in many families. They take a prominent place in many Malagasy houses. On the east coast, for example, documents and photographs occupy the sacred northeast corner of the house, attesting to their importance (John Mack, personal communication 2000). Photographic studios are common, as is personal photography. In the tradition of their forebears, photographers such as Pierrot Men and Danny-bé bring views from the inside to the outside. The island also continues to attract Western photographers, who construct their imagery from the realities they encounter. Creating insiders' and outsiders' views of Madagascar and the Malagasy is thus an ongoing project.

NOTES

This essay is based on archival research I conducted at the Council for World Mission Archives, School of Oriental and African Studies, London University, supported by a grant from the Office of the Provost, Smithsonian Institution. Rosemary Seton, archivist at the School of Oriental and African Studies, made my research in the archives a pleasure, and I thank her for her guidance. I am indebted to many specialists on Malagasy art, history, and anthropology for their helpful comments. My thanks go to Randall Bird in the Department of Art History at Harvard University for generously sharing materials with me and commenting on the essay. I am most grateful to John Mack, senior keeper at the Museum of Mankind, London, who took time out from his busy schedule to advise me on things Malagasy. He read this essay and provided important suggestions for its improvement. Finally, I thank Carol Maryan-George, archivist at the Eliot Elisofon Photographic Archives, National Museum of African Art, and Surell Brady, a volunteer at the Eliot Elisofon Photographic Archives, for their careful reading of the chapter.

1. *Bricolage*, derived from the French *bricoler* ("to putter about"), refers to a literary, musical, or architectural work constructed from whatever comes to hand. *Pastiche* refers to a literary, musical, or architectural work that imitates and combines themes and styles from different sources.

2. According to Jan Nederveen Pieterse (1992:11), stereotypes are "schemas or sets which play a part in cognition, perception, memory and communication." They "are based on simplification and generalization, or denial of individuality." In a never-ending cycle, social *representations* based on seen and experienced reality in turn impact the way in which this reality is constructed.

3. The Greek term *topos* (pl. *topoi*) denotes a firmly established cliché that has taken hold of one's thinking.

4. For another description of the *filanjana* and *filanjana* imagery, see Roth 1994:21.

5. Nobles were not supposed to come in contact with the earth but were carried on the backs of slaves or in the *filanjana*.

6. "Rohandrian" is a title designating a provincial chief (*roandria*).

7. Contrapposto is a "way of representing various parts of the body so that they are obliquely balanced around a central vertical axis." The upper portion of the body may twist in one direction while the lower part is turned in another. The figure is dynamic and full of vitality. See Lucie-Smith 1984:58.

8. Oliver (1838–1907), later a captain, first arrived in Madagascar in the summer of 1862.

9. Until the 1880s, printers were not capable of economically mass-reproducing photographs, and skilled craftsmen had to transform the pictures into lithographs, engravings, and woodcuts. With the development of the photogravure and halftone processes, reproductions of actual photographs slowly began to be included in books toward the end of the nineteenth century. Yet the practice of rendering photographs as engravings continued into the early twentieth century. Well into the first decade of that century, engravings and lithographs based entirely on photographs appeared alongside actual halftones (Geary 1998; Jenkins 1992).

10. The helmsman, Vernet, of the *Duocouëdic*, a ship taking the French navy explorer Charles Guillain along the east coast of Africa and around Madagascar, created daguerreotypes. Many of the images were published in the form of lithographs in Guillain's later book describing the voyage (Guillain 1856–57; Theye 1989:23). Some of the daguerreotypes are now in the photographic collection of the Musée de l'Homme.

11. "Imperialism," in the context of this essay, denotes more than a process of imposing territorial, political, and economic structures upon an empire's new subjects. It is also understood as a set of "cultural attitudes toward the rest of the world informed to varying degrees by militarism, patriotism, a belief in racial superiority and loyalty to the 'civilizing mission'" (MacKenzie 1984:1–14, quoted in Ryan 1997:12ff.).

12. Ellis's writings were widely disseminated in Britain and the United States. His *Three Visits to Madagascar* appeared originally in London in 1858, and then in New York in 1859. A Philadelphia publisher, J. W. Bradley, printed yet another American edition in 1859, and John E. Potter of Philadelphia reprinted the book in 1895. In German-speaking countries, too, Ellis was a familiar figure. A book edited by Karl Andree, entitled *Südafrika und Madagaskar geschildert durch die neuesten Entdeckungsreisenden, namentlich Livingstone und Ellis*, appeared in 1859 and 1860. Later editions appeared under Livingstone's and Ellis's names in 1865 and in 1874. It placed Ellis on a par with David Livingstone, the most famous nineteenth-century missionary explorer in Africa. I thank Beatrix Heintze of the Frobenius Institut (Frankfurt am Main, Germany) for this reference.

13. Among works written about photography, Bull and Denfield's *Secure the Shadow*, a book on photography in the South African Cape, mentions Ellis for the first time (1970:55–58). More recently, Peers (1995b, 1997, 1998) discussed Ellis's work and also curated an exhibition of it.

14. In Madagascar, too, the first task of the LMS missionaries, who arrived in 1821, was to translate the Bible. They completed the New Testament in 1826 (Brown 1995:140).

15. The use of things such as music boxes and other technical gimmicks to take advantage of Africans' curiosity was a common strategy of explorers for establishing communication (Fabian 2000:101–4).

16. The *Chronicle of the London Missionary Society* is a good case in point regarding the society's use of imagery. In the years from 1853—when Ellis left for Madagascar—to 1858, wood engravings created by illustrators served as frontispieces for each monthly installment of the magazine. From 1861 to 1866, there were no images. Then 1867 brought the first engraving from Madagascar, an image of the church at Ambatonakanga. In April 1878, the first Madagascar engraving based on a photograph, titled "The Ford at Mandraka" (opp. p. 69), marked the beginning of a new era. In January 1890, the first halftone reproduction of a photograph from Madagascar, bearing the caption "The Antananarivo Girls Central School (A Group of Scholars)," on page 2, began the shift from engravings based on photographs to photographic halftone reproduction. Increasingly, photographs illustrated the journal, and they proliferated in the early decades of the twentieth century.

17. Many late-nineteenth-century ethnographies, among them Ratzel's widely distributed *Völkerkunde* (1890), based their descriptions of Madagascar on Ellis's work. Ratzel even included seven engravings copied from Ellis's illustrations (Ratzel 1890: 488–522). There is an English translation of Ratzel's definitive ethnography, and a recent reprint (Ratzel 1896, 1996).

18. The color red was reserved for royalty (see Fee, this volume).

19. To this day, the effects of this Western discourse on Malagasy constructions of race and the role of race make those subjects contested terrain in Madagascar.

20. James Sibree, referring to the reigns of Ranavalona I and her successor, Radama II, who abandoned his mother's policies, wrote: "In half-civilised governments like that of the Hovas [Merina], things are often done in extremes" (Sibree 1870:33). These Western classifications paralleled and reinforced nineteenth-century Merina assumptions about skin color and superiority or inferiority.

21. One of the most salient examples is the relationship between the French and the Bamum kingdom in Cameroon, ruled by King Njoya (ruled c. 1886–1924). The French perceived Njoya as a German ally. When the Germans were defeated in World War I and Bamum came under French rule, Njoya, once considered an enlightened king by the Germans, became the epitome of a despot in the eyes of the French, although his policies never changed. The French administration removed from him power in 1924 and sent him into exile in 1930, a fate he shared with many other African rulers (Geary 1988:126–28).

22. Joseph Simon Gallieni (1849–1916) was one of the major colonial figures, having served in West Africa and Indochina before establishing French colonial rule over Madagascar. After his years in the colonial service, he became military governor of Paris in 1914, when the First World War broke out, and he was appointed minister of war in 1915 (Covell 1995:108–9). He was of such stature that postcards with his portrait were in high demand (see card MG 43-2 in the postcard collection of the Eliot Elisofon Photographic Archives).

23. Malagasy commonly asked foreigners about customs of the British and inhabitants of other countries, especially relating to funerals (Ellis 1858:363).

24. See Andrianetrazafy 1991. The portraits are reproduced in the catalog *A Tale of Two Islands: Aspects of Anglo-Malagasy History and Culture*, published in Antananarivo in 1998.

25. Rolf B. Roth (1994:52–53) published a set of paintings of Malagasy queens and kings. Radama's I portrait was also published in Brown 1995 (illustrations following p. 128).

26. Ranavalona II, Ranavalona III, and Rainilaiarivony, the prime minister, commissioned the British brothers John and Arthur Trevor Haddon to create their portraits, which are now in the Palais de la Reine, Antananarivo (Andrianetrazafy 1991:26).

27. Joseph Lambert, a prominent French resident of the island, presented this crown to the king on behalf of Emperor Napoleon III of France (Peers 1998:46).

28. See Downer 2000 for a discussion of this portrait.

29. Clocks, among the court's prized possessions, were frequent gifts given by the British and French. The British sergeant James Hastie, who arrived in Madagascar in 1817, presented the first chiming clock to Radama I (Brown 1995:121).

30. King Radama II required the Merina elites to adopt European-style dress, an outward sign of influence, wealth, and sophistication (Ellis 1867:109). Western dress remained the court's attire throughout the nineteenth century.

31. Radama II had also commissioned Ellis to take his portrait in profile, in order to prepare a die so that currency could be struck in a mint to be established in Madagascar (Ellis 1867:166). The project never came to fruition, because Radama was assassinated a few months later.

32. The Moorland-Springarn Research Center at Howard University in Washington, D.C., for example, has images of Ranavalona III and the prime minister that came in with the William Hunt papers (Box 55-3, Folder 65). The frontispiece in Maude 1895 also shows Ranavalona III. It is based on a photograph, a print of which is now at the Council for World Mission Archives at the School of Oriental and African Studies, London University.

33. According to John Mack, this Bible was a present from Queen Victoria and remains in the palace to this day (personal communication, 2000).

34. The French exiled Queen Ranavalona III in February 1897. She spent two years in Réunion and then was moved to Algiers, where she died in 1917. The French returned her remains to Madagascar in 1938, to be buried in the royal tomb (Brown 1995:234).

35. Among the exiled African kings who graced postcards were Ovonramwen, ruler of the Benin kingdom in Nigeria (see Geary 1998:161), and Behanzin, king of Dahomey (Postcard collection of the Eliot Elisofon Photographic Archives).

36. Both letters are part of the John Murray Archives in London.

37. See Andrianetrazafy 1991:19; Boudry 1947:207–8. The connection to Swahili forms of two-dimensional design and thus to the Islamic and Indian realm is obvious, although is not mentioned by the two writers (on Islam, see Mack 1986:32–41).

38. Andrianetrazafy (1991:27) mentions several other artists who emerged from the same school: Rajafetra, Rajesy, Raoelina, Rajao, Randria, and Rahamefy Samuel.

39. This painting has been published in Mack 1986:47 and Mack 1998:30, pl. 11.

40. I am indebted to Randall Bird for pointing out the correspondence of photographs and paintings in Rainimaharosoa's work. He showed me a print of the glass plate in the FJKM Archives in Antananarivo and shared with me the Sibree reference. I also thank Mr. Bird for allowing me to publish his findings.

41. Photography as a source of inspiration and as an influence on African painters—both those who went to established art schools and those who were self-trained—has not yet been examined systematically. It comes up frequently, for example, in reference to artists such as Thsibumba Kanda Matulu (Fabian 1996:263–65) and Chérie Samba (Jewsiewicki 1995:36, 44).

42. According to Mack, the Rainimaharosoa paintings, which went from England back to Madagascar in 1985 and are depicted in the 1998 catalog *A Tale of Two Islands*, came from a missionary family in Great Britain (Mack 1998:34).

43. Hardyman Collection PP MS 63, Box 76, file 34.

44. Hardyman Collection PP MS 63, Box 74, file 23.

45. LMS–Council for World Mission Archives at SOAS, Madagascar (Pictures) Box 5.

46. Hardyman Collection PP MS 63, Box 79, file 51.

Chronology of Main Events

0–400 C.E.

Beginnings of human occupation of Madagascar

630–750

World expansion of Islam; first Swahili trading settlements on east coast of Africa

1000

Afro-Arab and other Islamic traders settle on the north and northwest coasts of Madagascar

1500

The first European, Portuguese explorer Diego Días, arrives in Madagascar

1550

Arab traders hold loose hegemony in Indian Ocean; the Sakalava Menabe kingdom is founded on the west coast of Madagascar

1642–1674

French establish colony at Fort Dauphin on the southeast coast

1685–1730

Pirates occupy the coasts, coves, and islands along the east coast

1720–1780

The Sakalava Boina kingdom emerges on the northwest coast

1712

Ratsimilaho establishes the Betsimisaraka confederacy on the east coast

1774

France tries to reestablish colony at Fort Dauphin under Count Maudave

1787–1810

Andrianampoinimerina, the Merina king, unifies greater Imerina in the central highlands

1800s

Beginning of important presence of American whaling and trading ships on Zanzibar and the west coast of Madagascar

1810–1828

Reign of Merina king Radama I, son of Andrianampoinimerina; through military conquest he expands borders of Merina kingdom to cover half the island

1815

England takes possession of the island of Mauritius off Madagascar's east coast; hoping to unify Madagscar under a single central authority, the British governor Farquhar makes contact with King Radama of the highlands, and in 1817 a treaty of friendship is signed, which entails sending Radama military aid and advisors

1818–1820

First missionaries and artisans of the London Missionary Society (LMS) arrive in the capital, Antananarivo; the Malagasy language is transcribed, and schools are established

1820–1826

Nine Malagasy boys are sent to England to receive education in the liberal and industrial arts, including weaving

1828–1861

Reign of Queen Ranavalona I, widow of Radama I; continued military conquest expands Merina kingdom to its territorial apogee of two-thirds of the island; development of administrative bureaucracy

1836

Ranavalona expels all European missionaries and suppresses indigenous Christianity; in 1837, she sends diplomatic mission to England and France to thaw relations with Europe

1845

A combined French-English force bombs the port of Tamatave; Ranavalona closes Madagascar to all trade with foreigners

1853

Ranavalona allows a brief visit to the capital by a British emissary, LMS missionary William Ellis; he takes the first photographs in the country

1861–1863

Reign of King Radama II, son of Ranavalona I; he opens full relations with European merchants, diplomats, and missionaries; following a popular uprising over this abrupt Westernization, he is assassinated

1863–1868

Reign of Queen Rasoherina, widow of Radama II; the commoner Prime Minister Rainilaiarivony marries her in 1867, consolidating his family's grip on power

1866

John Finkelmeier is named the first American commercial agent; first treaty of trade and friendship between the United States and Madagascar is signed in 1867

1868–1885

Reign of Queen Ranavalona II, also married to Prime Minister Rainilaiarivony; they and the court convert to Christianity in 1869

1882–1883

Merina court sends diplomatic mission to Europe and the United States to try to avert war with France; second U.S.–Madagascar treaty is promulgated in Washington, D.C., by President Chester Arthur and Foreign Minister Ravoninahitriniarivo on March 13, 1884

1883–1885

First French-Malagasy War; ends in stalemate, but peace treaty gives France a quasi-protectorate over the island

1885–1896

Reign of Queen Ranavalona III, chosen by and married to Prime Minister Rainilaiarivony; she sends two Malagasy delegations bearing gifts to Europe in 1886, the first led by the Englishman

Digby Willoughby, the second by the prime minister's son, Rainiharovony

1884–1888, 1892–1896
The two nonconsecutive terms of American president Grover Cleveland

1892
Arrival of the third American consul, John Lewis Waller, in Tamatave

1895
Second French-Malagasy War; the French take the capital, Antananarivo, and declare a protectorate. The American consul, John Waller, is imprisoned by the French

1896
Following an anti-French uprising, the Merina monarchy is abolished, Queen Ranavalona III is exiled to Algeria, and Madagascar is made a full colonial possession

1904
Anti-French uprising in the south, called the *sadiavahe* ("loincloth of vines")

1947
Anti-French uprising throughout the island, the worst in France's colonial history

1960
Madagascar gains its independence from France and forms the first republic under President Philibert Tsiranana

1972–1992
The second republic, called the Democratic Republic of Madagascar

1992–present
The third Malagasy republic

1995
The tombs and palace complex of the Merina monarchy are destroyed by fire

Glossary of Malagasy Terms

Pronunciation of vowels:

a = "aw," as in *saw*

e = "ay," as in *may*

i, y = "ee," as in *see*

o = "oo," as in *too*

ô = "o," as in *no*

Note: Although a common language is spoken throughout Madagascar, differences do exist in vocabulary. Regionally specific terms are noted here in parentheses.

afiafy (west coast). Tree species on which indigenous silkworms (*Borocera madagascariensis*) feed and spin their cocoons.

akanjo. Tight sleeveless shift worn by Malagasy women throughout the island before the twentieth century; also, contemporary term for all tailored clothing.

akanjobe (east coast). Raffia smock worn by men.

akondro sarika. Variety of dwarf banana whose stem could be processed into a textile fiber. Synonym *akondro lambo*.

akotofahana (variant *akotifahana*). Designs made by supplementary weft floats; also, a cloth with supplementary weft floats.

akotso (Betsileo). Weft twining.

amberivatry (variant *ambatry*) (Merina, Betsileo). Pigeon-pea bush (*Cajanus indicus*), introduced via the island of Reunion, planted by the Merina and Betsileo for indigenous silkworms (*Borocera madagascariensis*) to feed on and spin their cocoons in.

ambiasa (regional variant *ombiasa*). Malagasy traditional healer.

andriana (regional variant *roandria*). Nobles; the sovereign.

arindrano. One of the four historic Betsileo kingdoms; also, style of cloth characterized by a series of black and white stripes at the center.

ati-damba (southern Betsileo). Ceremony in which new cloth is laid on top of ancestral bodies.

drala (west coast). Term for money that may derive from "dollar."

famadihana (Merina, Betsileo). "Turning over," the ceremony in which ancestral bodies are removed from the tomb and wrapped in new cloth.

fanampoana (Merina). Royal service, notably as a soldier or skilled artisan.

fananompitoloha. "Seven-headed serpent." Betsileo kings were believed to transform into these serpents after death.

Fandroana (Merina). The Royal Bath, the annual New Year's ritual in which the sovereign bathed in water that was then sprinkled on the gathered population as a blessing.

fanto. Generic term for beaten bark cloth.

filanjana. Malagasy sedan chair.

firaka. Metal beads of silver, tin, or lead.

Fitampoha. Ritual of the Menabe Sakalava held every five years to purify the royal relics.

fole velo (south and west). "Living yarn." Newly spun cotton yarn used as a protective talisman and in a number of rituals.

foly (regional variant *fole*). Yarn.

foly tsipay (Merina). Yarn of reeled mulberry silk (from the silkworm *Bombyx mori*). Synonym *lasoa*.

hafotra (Betsileo *somangana*). *Abutilon angulatum*, tree species (particularly the variety *hafo-potsy*) whose inner bark was transformed into yarn by boiling, slicing, knotting, and twisting.

hainteny. Poetic verse of Imerina.

harea (south). Monochrome glass beads. Synonym *bije*.

harefo (southeast). Type of reed (*Eleocharis plantaginez*) used for making mat clothing.

hasina (regional variant *asy*). A mystical force of primacy invested in social superiors such as elders, ancestors, and monarchs; also, the uncut silver coin that the populace offered to Merina sovereigns as homage.

hova. Term used by Europeans in the nineteenth century to denote the Merina people; also, the free class in Imerina.

jabo. Fabric made with a warp of raffia and a weft of cotton or silk.

jaky. Imported English scarlet broadcloth, the exclusive privilege of Merina royalty.

kabary. Traditional Malagasy palaver.

katibo (Antemoro). Elected Islamic religious leader.

kilosy (Merina) (variant *kolosy*). Style of cotton cloth made in the early nineteenth century.

kisaly (west coast). Rectangular piece of cloth worn as a head cover by the women of some Sakalava groups.

kitamby. A woman's handwoven hip wrap; also, in the contemporary south, a factory-made printed hip wrap (see *lambahoany*).

koto (Betsileo). Striping style consisting of a white cotton background with wide stripes in either red (*kotomena*), black (*kotomainte*), or yellow (*kotomavo*).

laimasaka (Sakalava). "Cooked/hanging tapestry." Designs made through the technique of ikat dyeing; also, cloth with such designs.

lamba (regional variants *sikina*, *simbo*). A rectangular piece of cloth, usually composed of two identical panels; compare *akotifahana*, *arindrano*, *kilosy*, *laimasaka*, *sarimbo*, *telosoratra*, *totorano*.

lambabe. "Great cloth." The southern Betsileo wear this cloth, of the striping style *sarimbo*, at ritual events to indicate the wearer's status and descent branch.

lambahoany (regional variant *kitambe*). Printed hip wrap, made at either Malagasy or foreign factories, usually of bright color with figurative designs or scenes depicting Malagasy life, often with a proverb or saying on the hem.

lambamena. A style of cloth, primarily red with stripes of yellow and black; also, in contemporary Imerina, an all-inclusive term for burial cloth.

lambatavoangy (Merina). An imported nylon fabric used as burial cloth.

landibe (Merina). "Big silk." Indigenous silk (from the silkworm *Borocera madagascariensis*).

landikely (Merina). "Little silk." Chinese or mulberry silk (from the silkworm *Bombyx mori*), which was introduced in the nineteenth century. Synonyms *landimbazaha*, "foreign silk"; *landimboaroihazo*, "mulberry silk."

landy. Silk.

lasoa (Merina, from the French *la soie*). Yarn of reeled mulberry silk (from the silkworm *Bombyx mori*). Synonym *foly tsipay*.

mahampy. Type of reed used for making women's mat breast covers.

mavo lamba (Merina). "Yellow by their cloth," a nineteenth-century term for the poorest class of society.

mena lamba. "Red by their cloth," an anti-French uprising in the highlands that followed France's military conquest of the island in 1895.

mohara. Talisman consisting of a hollowed cow horn filled with medicines.

nato. A tree whose inner bark served in most areas of the island as a source of red dye.

pisopiso (south). *Woodfordia floribunda,* tree species on which indigenous silkworms fed and spun their cocoons.

rofia. The palm *Raphia ruffia;* also, the textile fiber had from its leaves (origin of the European term *raffia*).

rongony (Merina, Betsileo). Hemp.

sadiadiaka (east coast). A panel of woven raffia cloth ready to be sewn into a woman's wrapper or man's shirt.

sadiavahe. "Loincloth of vines," an anti-French uprising in the south of the island in 1904.

salôvana (west coast). Woman's tube wrapper.

sampy (Merina). Royal talismans, composed of bits of wood wrapped in cloth and silver chains.

sarimbo (Betsileo, southeast). Striping style characterized by evenly sized alternating stripes in red, black, white, and orange.

satrana (Merina). Goods that the population had to provide to the sovereign for certain events, mostly ceremonial.

satro-dava. "Long hat." A tall red hat with a tail down the back; historical insignia of royalty.

sikina (south). Wrapper.

simbo (east coast) (variant *sembo*). A rectangular piece of cloth, usually composed of two identical panels; also, the woman's tube wrapper.

somangana (Betsileo). See *hafotra.*

sorom-batritra (southern Betsileo). "Blessing the weaving sword." The ox given to the wife's family in exchange for the "great cloth" that it weaves for the groom.

tafitsihy (southeast). "Mat cloth." Plaited reed mats used as clothing. Synonym *sembo tsihy.*

tandapa (Merina). Workers in direct employ at the court.

Tantara ny andriana. The royal history, a collection of nineteenth-century narratives concerning the Merina kingdom compiled by the French Jesuit priest François Callet in the 1860s and first published in Malagasy in 1870.

tapia. Chrysopia microphylla, tree species on which indigenous silkworms (*Borocera madagascariensis*) feed and spin their cocoons.

telosoratra. Style of cloth.

totorano (Merina). Style of cotton cloth made in the early nineteenth century.

vahotse (south). Weft twining.

vakana (Merina, Betsileo). Monochrome glass beads.

vintana. Astrological system of Arab origin.

voara. Ficus sp., variety of tree commonly used for beaten bark cloth.

voninahitra. "Flower of the grass," a ranked system of honors developed by Merina sovereigns in the nineteenth century; also, honor, recognition.

References

ALLEN, PHILIP
1987 *Security and Nationalism in the Indian Ocean: Lessons from the Latin Quarter Islands.* Boulder, Colo.: Westview Press.

1995 *Madagascar: Conflicts of Authority in the Great Island.* Boulder, Colo.: Westview Press.

ANDREE, KARL (EDITOR)
1859 *Südafrika und Madagaskar geschildert durch die neuesten Entdeckungsreisenden, namentlich Livingstone und Ellis.* Leipzig: Lorck.

ANDRIAMANJATO, RICHARD
1951 *Le Tsiny et le Tody dans la pensée malgache.* Paris: Présence Africaine.

ANDRIANETRAZAFY, HEMERSON
1991 *La peinture malgache dès origines à 1940.* Antananarivo: Foi et Justice.

ANDRIANTSIETENA, FALY RAZAFINDRANGITA
1994 Se vêtir à Antananarivo à la fin du XIXe siècle. Master's thesis, Department of History, University of Antananarivo.

APPADURAI, ARJUN
1986 Introduction: Commodities and the Politics of Value. In *The Social Life of Things: Commodities in Cultural Perspective,* edited by Arjun Appadurai, pp. 3–63. Cambridge: Cambridge University Press.

ARNOLDI, MARY JO
1992 A Distorted Mirror: The Exhibition of the Herbert Ward Collection of Africana. In *Museums and Communities: The Politics of Public Culture,* edited by Ivan Karp, Christine Mullen Kreamer, and Steven D. Lavine, pp. 428–57. Washington, D.C.: Smithsonian Institution Press.

ARNOLDI, MARY JO, CHRISTRAUD M. GEARY, AND KRIS L. HARDIN
1996 *African Material Culture.* Bloomington: Indiana University Press.

AUJAS, L.
1912 Notes historiques et ethnographiques sur les Comores. *Bullétin de l'Académie Malgache* 14:139–52.

AYACHE, S.
1976 *Raombana, l'historien 1809–1855.* Fianarantsoa: Ambozontany.

BALLARIN, MARIE-PIERRE
2000 *Les reliques royales à Madagascar.* Paris: Karthala.

BEAUJARD, PHILIPPE
1983 *Prince et paysans: Les Tanala de l'Ikongo.* Paris: L'Harmattan.

1988 Les couleurs et les quatres éléments dans le Sud-est de Madagascar: L'héritage indonésien. *Omaly sy Anio* 27:31–48.

BECK, S. WILLIAM
1882 *The Draper's Dictionary: A Manual of Textile Fabrics, Their History and Application*. London: Warehousemen and Drapers' Journal Office.

BENNETT, GEORGE
1887 Funeral Customs at the Burial of Radama I (part 3). *Antananarivo Annual and Madagascar Magazine* 3(11):311–23.

BENNETT, NORMAN, AND GEORGE BROOKS (EDITORS)
1965 *New England Merchants in Africa: A History through Documents, 1802–1865*. Brookline, Mass.: Boston University Press.

BERG, GERALD
1995 Writing Ideology: Ranavalona, the Ancestral Bureaucrat. *History in Africa* 22:73–92.

BLAKELY, ALLISON
1974 The John L. Waller Affair, 1895–1896. *Negro History Bulletin* 37:216–22.

1999 John L. Waller. In *American National Biography*, vol. 22, edited by John A. Garraty and Mark C. Carnes, pp. 551–52. New York: Oxford University Press.

BLISS (MISS)
1890 The Girls' Central School, Antananarivo. *Chronicle of the London Missionary Society*, January, pp. 14–18.

BLOCH, MAURICE
1971 *Placing the Dead: Tombs, Ancestral Villages and Kinship Organization in Madagascar*. London: Seminar Press.

1986 *From Blessing to Violence: History and Ideology in the Circumcision Ritual of the Merina of Madagascar*. Cambridge: Cambridge University Press.

BOHANNAN, PAUL
1955 Some Principles of Exchange and Investment among the Tiv. *American Anthropologist* 57:67–70.

BOLSTER, W. JEFFREY
1997 *Black Jacks: African American Seamen in the Age of Sail*. Cambridge, Mass.: Harvard University Press.

BOUDRY, ROBERT
1947 Art et artisanat malgaches. In *Madagascar*, vol. 2, edited by Marcel de Copet, pp. 199–210. Paris: Encyclopédie de l'Empire français.

BRANDON, RUTH
1977 *A Capitalist Romance: Singer and the Sewing Machine*. New York: J. B. Lippincott.

BROWN, MERVYN
1978 *Madagascar Rediscovered: A History from Early Times to Independence*. London: Damien Tunnacliffe.

1995 *A History of Madagascar*. London: Damien Tunnacliffe.

BRUNS, ROGER A.
1996 I Have the Pleasure of Presenting. In *Tokens and Treasures: Gifts to Twelve Presidents*, edited by Lisa A. Auel, pp. 1–3. Washington, D.C.: National Archives and Record Administration and White House Historical Association.

BULL, MARJORIE, AND JOSEPH DENFIELD
1970 *Secure the Shadow: The Story of Cape Photography from Its Beginnings to the End of 1870*. Cape Town: Terence McNally.

CALLET, FRANÇOIS (EDITOR)
1981 [1873] *Histoire des rois: Documents historiques d'après les manuscrits malgaches*. 4 vols. Translated by G. S. Chapus and E. Ratsimba. 2d ed. Antananarivo: Trano Pritinim-Pirenena.

CAMPBELL, GWYN
1988 Slavery and *Fanampoana*: The Structure of Forced Labour in Imerina (Madagascar). *Journal of African History* 29:463–86.

CAROL, JEAN
1898 *Chez les Hova (au Pays Rouge)*. Paris: Paul Ollendorf.

CATAT, LOUIS
1893 Voyage à Madagascar. *Tour du Monde: Nouveau Journal des Voyages* 1:1–64 (chapters 1–8). Paris.
1894 Voyage à Madagascar. *Tour du Monde: Nouveau Journal des Voyages* 1:337–401 (chapters 9–25). Paris.
1894 Catats Reisen im nördlichen Madagaskar. *Globus* 66(12):85–190, 67(13):200–203.
1895 *Voyage à Madagascar (1889–1890)*. Paris: Administration de l'Univers Illustré.

CHAPUS, G. S.
1925 *Quatre-vingt années d'influences européennes en Imerina*. Antananarivo: Bulletin de l'Académie Malgache.

CHAPUS, G. S., AND G. MONDAIN
1954 *Rainilaiarivony: Un homme d'état Malagache*. Paris: Editions d'Outre Mer.

CHAPUS, G. S., AND G. MONDAIN (EDITORS)
1940 *Quelques rapports du gouvernement Malgache avec les étrangers*. Antananarivo: Imprimerie moderne de l'Emyrne.
1954 *Le journal de Robert Lyall*. Antananarivo: Mémoires de l'Académie Malgache.

CHEAL, DAVID
1988 *The Gift Economy*. London: Routledge.

CHEEK, WILLIAM, AND AIMEE LEE CHEEK
1989 *John Mercer Langston and the Fight for Black Freedom, 1829–65*. Chicago: University of Illinois Press.

CLARK, H. E.
1884 How We Travel in Madagascar. *Antananarivo Annual and Madagascar Magazine* 3(8):340–47.

COLE, J., R. E. DEWAR, G. FEELEY-HARNIK, M. ESOAVELOMANDROSO, AND N. G. WRIGHT
1997 Madagascar. In *Encyclopedia of Africa South of the Sahara*, vol. 3, edited by John Middleton, pp. 73–89. New York: Charles Scribner's Sons.

COOPER, GRACE ROGERS
1976 *The Sewing Machine: Its Invention and Development*. Washington, D.C.: Smithsonian Institution Press.

COPPALLE, ANDRÉ
1909 [1826] Voyage dans l'intérieur de Madagascar pendant les années 1825–1826. *Bulletin de l'Académie Malgache* 7:17–46; 8:25–64.

COVELL, MAUREEN
1995 *Historical Dictionary of Madagascar*. African Historical Dictionaries, no. 50. Lanham, Md.: Scarecrow Press.

CUNNINGTON, CECIL W., PHILLIS CUNNINGTON, AND CHARLES BEARD
1968 *A Dictionary of English Costume, 900–1900*. London: Adam and Charles Black.

CZERNIN, PHILIPPA
1994 Weaving a New Tradition. *Sotheby's Preview*, October–November.

DARISH, PATRICIA
1989 Dressing for the Next Life: Raffia Textile Production and Use among the Kuba of Zaire. In *Cloth and Human Experience*, edited by Annette B. Weiner and Jane Schneider, pp. 127–40. Washington, D.C.: Smithsonian Institution Press.

DE LA VAISSIÈRE (RÉVÉREND PÈRE)
1885 *Vingt ans à Madagascar: Colonisation, traditions historiques, moeurs et croyances.* Paris: Société de Jésus.

DEWAR, ROBERT E., AND HENRY T. WRIGHT
1993 The Culture History of Madagascar. *Journal of World Prehistory* 7(4):417–66.

DIDEROT, DENIS
1992 [1772] *Political Writings.* Edited by John Hope Mason and Robert Wokler. Cambridge: Cambridge University Press.

DOMENICHINI, JEAN-PIERRE
1985 *Les dieux au service des rois: Histoire orale des sampin'andriana ou palladiums royaux de Madagascar.* Paris: CNRS.

DOWNER, CHRISTINE
2000 King Radama II of Madagascar. *History of Photography* 24(2):185.

DRURY, ROBERT
1729 *Madagascar, or Robert Drury's Journal During Fifteen Years Captivity on That Island.* London: Impr. W. Meadows.

DUBOIS, H. M.
1938 *Monographie des Betsileo.* Paris: Institut d'Ethnologie.

DUIGNAN, PETER, AND L. H. GANN
1984 *The United States and Africa: A History.* Cambridge: Cambridge University Press.

DUMAINE DE LA JOSSERIE
1810 Voyage fait au pays d'Ancaye dans l'ile de Madagascar, en 1790. *Annales des Voyages, de la Géographie, et de l'Histoire* 11:146–218.

EDMONDS, W. J.
1896 Bygone Ornamentation and Dress among the Hova Malagasy. *Antananarivo Annual and Madagascar Magazine* 22:469–78.

EDWARDS, ELIZABETH
1992 Introduction. In *Anthropology and Photography, 1860–1920,* edited by Elizabeth Edwards, pp. 3–17. New Haven, Conn.: Yale University Press.

ELLIS, WILLIAM
1838 *History of Madagascar, Comprising Also the Progress of the Christian Mission Established in 1818, and an Authentic Account of the Persecution and Recent Martyrdom of the Native Christians.* 2 vols. London: Fischer, Son, & Co.
1858 *Three Visits to Madagascar during the Years 1853–1854–1856: Including a Journey to the Capital, with Notices of the Natural History of the Country and of the Present Civilisation of the People.* London: John Murray.
1867 *Madagascar Revisited.* London: John Murray. Reprint. Freeport, N.Y.: Books for Libraries Press, 1972.

FABIAN, JOHANNES
1996 *Remembering the Present: Painting and Popular History in Zaire.* Berkeley: University of California Press.
2000 *Out of Our Minds: Reason and Madness in the Exploration of Central Africa.* Berkeley: University of California Press.

FEE, SARAH
1997 Binding Ties, Visible Women: Cloth and Social Reproduction in Androy, Madagascar. *Etudes Oceans Indiens (Actes du Colloque Etienne de Flacourt)* 23–24:253–80.
2002 Textile Traditions of Southwest Madagascar. In *Unwrapping the Textile Traditions of Madagascar,* edited by Chaprukha Kusimba, Judy Odland, and Bennett Bronson. UCLA Fowler Museum Textile Series, no. 6. Los Angeles: UCLA Fowler Museum of Cultural History.

FEELEY-HARNIK, GILLIAN

1984 The Political Economy of Death: Communication and Change in Malagasy Colonial History. *American Ethnologist* 11(1):1–19.

1988 Dancing Battles: Representations of Conflict in Sakalava Royal Service. *Anthropos* 83:65–85.

1989 Cloth and the Creation of Ancestors in Madagascar. In *Cloth and Human Experience*, edited by Annette B. Weiner and Jane Schneider, pp. 73–126. Washington, D.C.: Smithsonian Institution Press.

n.d. Clothing as an Historical Medium in Northwestern Madagascar: A Preliminary Account. Michigan Discussions in Anthropology. Ann Arbor: University of Michigan.

FIFER, J. VALERIE

1991 *United States Perceptions of Latin America, 1850–1930: A "New West" South of Capricorn?* Manchester: Manchester University Press.

FLACOURT, ETIENNE DE

1661 *Histoire de la grande isle Madagascar, composée par le Sieur de Flacourt, directeur general de la Compagnie Française de l'Orient, & commandant pour sa Majesté dans la dite isle & les isles adjacentes: Avec une relation de ce qui s'est passé les années 1655, 1656 & 1657, non encore veuë par la première impression.* 2d edition. Troyes: Nicolas Oudot; Paris: Pierre L'Amy. (1st edition 1658.)

1995 [1661] *Histoire de la grande isle Madagascar.* Edition presenteé et annoteé par Claude Allibert. Paris: Karthala.

FOURY, E.

1956 *Maudave et la colonisation de Madagascar.* Paris: Société de l'Histoire des Colonies Françaises.

GADE, D.

1985 Savanna Woodland, Fire, Protein, and Silk in Highland Madagascar. *Journal of Ethnobiology* 5(2):109–22.

GALLIENI, JOSEPH

1908 *Neuf ans à Madagascar.* Paris: Librairie Hachette.

GATEWOOD, WILLARD B., JR.

1987 *"Smoked Yankees" and the Struggle for Empire: Letters from Negro Soldiers, 1898–1902.* Fayetteville: University of Arkansas Press.

GEARY, CHRISTRAUD M.

1988 *Images from Bamum: German Colonial Photography at the Court of King Njoya, Cameroon, West Africa, 1902–1915.* Washington, D.C.: Smithsonian Institution Press.

1991 Missionary Photography: Private and Public Readings. *African Arts* 24(4):48–59, 98–100.

1996 Political Dress: German-Style Military Attire and Colonial Politics in Bamum Kingdom (Cameroon). In *African Crossroads: Intersections between History and Anthropology in Cameroon*, edited by Ian Fowler and David Zeitlyn, pp. 165–92. Oxford: Berghahn Books.

1998 Nineteenth-Century Images of the Mangbetu in Explorers' Accounts. In *The Scramble for Art in Central Africa*, edited by Enid Schildkrout and Curtis Keim, pp. 133–68. Cambridge: Cambridge University Press.

GEARY, CHRISTRAUD M., AND VIRGINIA-LEE WEBB (EDITORS)

1998 *Delivering Views: Distant Cultures in Early Postcards.* Washington, D.C.: Smithsonian Institution Press.

GELL, ALFRED

1998 *Art and Agency: An Anthropological Theory.* Oxford: Clarendon.

GIRIEUD, J.

1897 *Souvenirs et impressions: Madagascar.* Rouen: Emile Deshays.

GLAUDE, EDDIE S., JR.
2000 *Exodus! Religion, Race, and Nation in Early Nineteenth-Century Black America*. Chicago: University of Chicago Press.

GRAEBER, DAVID
1995 Dancing with Corpses Revisited: An Interpretation of *Famadihana* (in Arivonimamo, Madagascar). *American Ethnologist* 22(2):258–78.

GRANDIDIER, ALFRED
1971 *Souvenir de voyages d'Alfred Grandidier 1865–1870 (d'après son manuscrit inédit de 1916)*. Documents Anciens sur Madagascar, no. 6. Tananarive: Association Malgache d'Archéologie.

GRANDIDIER, ALFRED, AND GUILLAUME GRANDIDIER
1908 *Collection des anciens ouvrages concernant Madagascar*, vol. 1. Paris: Imprimerie Nationale.

1914 *Histoire physique, naturelle et politique de Madagascar*, vol. 4, *Ethnographie de Madagascar*, vol. 2. Paris: Hachette et Société d'Editions Géographiques, Maritimes et Coloniales.

1917 *Histoire physique, naturelle et politique de Madagascar*, vol. 4, *Ethnographie de Madagascar*, vol. 3. Paris: Hachette et Société d'Editions Géographiques, Maritimes et Coloniales.

1928 *Histoire physique, naturelle et politique de Madagascar*, vol. 4, *Ethnographie de Madagascar*, vol. 4. Paris: Hachette et Société d'Editions Géographiques, Maritimes et Coloniales.

1956 *Histoire physique, naturelle et politique de Madagascar*, vol. 5, *Histoire des Merina (1861–1897)*, vol. 2. Paris: Hachette et Société d'Editions Géographiques, Maritimes et Coloniales.

GREEN, REBECCA L.
1996 Addressing and Redressing the Ancestors: Weaving, the Ancestors, and Reburials in Highland Madagascar. Ph.D. dissertation, Indiana University.

GUILLAIN, CHARLES
1856–57 *Documents sur l'histoire, la géographie et le commerce de l'Afrique Orientale*. 3 vols. Paris: A. Bertrand.

HARRISON, IRA E., AND FAYE V. HARRISON
1999 *African American Pioneers in Anthropology*. Urbana: University of Illinois Press.

HEIDMANN, P.
1937 Les industries de tissage. *Revue de Madagascar* 17:93–120.

HELG, ALINE
1995 *Our Rightful Share: The Afro-Cuban Struggle for Equality, 1886–1912*. Chapel Hill: University of North Carolina Press.

HEURTEBIZE, G., AND J. A. RAKOTOARISOA
1974 Notes sur la confection des tissus de type Ikat à Madagascar: Les *laimasaka* de la région de Kandreho et d'Ambatomainty. *Archipel* 8:67–81.

HINSLEY, CURTIS M., JR.
1981 *Savages and Scientists: The Smithsonian Institution and the Development of American Anthropology, 1846–1910*. Washington, D.C.: Smithsonian Institution Press.

IMBRUGLIA, GIROLAMO
1990 Diderot e le immagini della pirateria nel '700. *Belfagor* 45(5):493–511.

IZYDORCYK, FRÉDÉRIC
1998 The Great Island. In *Anthology of African and Indian Ocean Photography*, pp. 326–49. Paris: Editions Revue Noire.

JACKNIS, IRA
1985　Franz Boas and Exhibits: On the Limitations of the Museum Method of Anthropology. In *Objects and Others: Essays on Museums and Material Culture*, vol. 3, edited by George Stocking, pp. 75–109. Madison: University of Wisconsin Press.

JENKINS, PAUL
1992　The Earliest Generation of Missionary Photographers in West Africa and the Portrayal of Indigenous People and Culture. *History in Africa* 20:89–118.

JEWSIEWICKI, BOGUMIL
1995　*Chérie Samba: The Hybridity of Art.* Westmount, Québéc: Galerie Amrad African Art Publications.

JOLLY, ALISON, AND FRANS LANTING
1987　Madagascar: A World Apart. *National Geographic* 171(2):148–83.

JULIEN, G.
1908　*Institutions Politiques et Sociales de Madagascar.* 2 vols. Paris: Editions Guilmoto.

KARP, IVAN, AND STEVEN D. LAVINE (EDITORS)
1991　*Exhibiting Cultures: The Poetics and Politics of Museum Display.* Washington, D.C.: Smithsonian Institution Press.

KENT, RAYMOND
1970　*Early Kingdoms in Madagascar, 1500–1700.* New York: Holt, Rinehart and Winston.

KNIGHT, E. F.
1896　From Fort Dauphin to Fianarantsoa: Notes on a Journey in Southern Madagascar (part 4). *Antananarivo Annual and Madagascar Magazine* 22:396–401.

KOECHLIN, B.
1987　Esquisse pour un lexique iconographique de gestuelle culturelle: Le port traditionnel du vêtement masculin chez les Vezo du Sud Ouest de Madagascar. In *De la voûte céleste au terroir, du jardin au foyer*, edited by Bernard Koechlin, pp. 557–71. Editions de l'Ecole des Hautes Etudes en Sciences Sociales.

KOPYTOFF, IGOR
1986　The Cultural Biography of Things: Commoditization as Process. In *The Social Life of Things: Commodities in Cultural Perspective*, edited by Arjun Appadurai, pp. 64–91. Cambridge: Cambridge University Press.

KUKLICK, HENRIKA
1991　Contested Monuments: The Politics of Archaeology in Southern Africa. In *Colonial Situations*, edited by George Stocking, pp. 135–69. Madison: University of Wisconsin Press.

LANTING, FRANS
1990　*Madagascar: A World Out of Time.* New York: Aperture.

LARSON, PIER
1992　Making Ethnic Tradition in a Precolonial Society: Culture, Gender, and Protest in the Early Merina Kingdom, 1750–1822. Ph.D. dissertation, University of Wisconsin, Madison.

LINTON, RALPH
1933　*The Tanala: A Hill Tribe of Madagascar.* Chicago: The Field Museum of Natural History.

LUCIE-SMITH, EDWARD
1986　*The Thames and Hudson Dictionary of Art Terms.* London: Thames and Hudson.

MACK, JOHN

1986 *Madagascar: Island of Ancestors*. London: Trustees of the British Museum.

1987 Weaving, Women and the Ancestors in Madagascar. *Indonesian Circle* 42:76–91.

1989 *Malagasy Textiles*. Bucks, UK: Shire Publications.

1998 James Rainimaharosoa. In *A Tale of Two Islands: Aspects of Anglo-Malagasy History and Culture*, pp. 24–35. Antananarivo.

MACKENZIE, JOHN M.

1984 *Propaganda and Empire: The Manipulation of British Public Opinion, 1880–1960*. Manchester: Manchester University Press.

MAUDE, FRANCIS CORNWALLIS

1895 *Five Years in Madagascar*. London: Chapman and Hall.

MAUSS, MARCEL

1990 *The Gift: Forms and Reason for Exchange in Archaic Societies*. Translation by W. D. Halls of *Essai sur le don* [1923–24]. London: Routledge.

MAYEUR, NICOLAS

1913a Voyage dans le Sud et dans l'intérieur des terres et particulièrement au pays d'Hancove, Janvier 1777: Rédigé par Bathélemy de Froberville. *Bulletin de l'Académie Malgache* 12:39–76.

1913b Voyage au pays d'Ancove (1785) par M. Mayeur: Rédaction de M. Dumaine. *Bulletin de l'Académie Malgache* 12:14–49.

MILLER, RANDALL M.

1978 *"Dear Master": Letters of a Slave Family*. Ithaca, N.Y.: Cornell University Press.

MONDAIN, G.

1913 Note sur l'emploi de l'écriture arabe à Madagascar. *Bulletin de l'Académie Malgache* 1:189–98.

MOSCA, LILIANA

1995 The Merina Kingdom in the Late 1870s as Reported in the Despatches of Colonel William W. Robinson, U.S. Consul in Madagascar. *Omaly sy Anio* 37–38:109–40.

MOSES, WILSON JEREMIAH

1993 *Black Messiahs and Uncle Toms: Social and Political Manipulations of a Religious Myth*. University Park: Pennsylvania State University Press.

1998 *Liberian Dreams: Back-to-Africa Narratives from the 1850s*. University Park: University of Pennsylvania Press.

MULLENS, JOSEPH

1875 *Twelve Months in Madagascar*. 2d edition. London: J. Nisbet.

MUNDY, PETER

1919 *The Travels of Peter Mundy, 1608–1667*, vol. 3, part 2, series 2, vol. 46. Cambridge: Hakluyt Society.

MUNTHE, LUDVIG, CHARLES RAVOAJA-NAHARY, AND SIMON AYACHE

1976 Radama I et les Anglais: Les négotiations de 1817 d'après les sources malgaches ("sorabe" inédits). *Omaly sy Anio* 3–4:9–102.

MUTIBWA, PHARES M.

1972 Trade and Economic Development in Nineteenth-Century Madagascar. *Transafrican Journal of History* 2:33–64.

1974 *The Malagasy and the Europeans: Madagascar's Foreign Relations, 1861–1895*. London: Longman Group.

NIESSEN, SANDRA

1999 Threads of Traditions, Threads of Invention: Unraveling Toba Batak Women's Expressions of Social Change. In *Unpacking Culture: Art and Commodity in Colonial and Postcolonial Worlds*, edited by Ruth Phillips and Christopher Steiner, pp. 162–77. Berkeley: University of California Press.

OLIVER, SAMUEL PASFIELD

1866 *Madagascar and the Malagasy: With Sketches in the Provinces of Tamatave, Betanimena, and Ankova.* London: Day and Son.

1886 *Madagascar: An Historical and Descriptive Account of the Island and Its Former Dependencies,* vol. 2. New York: Macmillan.

PAGDEN, ANTHONY

1993 *European Encounters with the New World.* New Haven, Conn.: Yale University Press.

PAINTER, NELL IRVIN

1976 *Exodusters: Black Migration to Kansas after Reconstruction.* New York: W. W. Norton.

PEERS, SIMON

1995a Weaving in Madagascar. In *The Art of African Textiles,* edited by John Picton, pp. 46–47. London: Lund Humphries.

1995b *The Working of Miracles: William Ellis, Photography in Madagascar 1853–1865.* London: British Council.

1997 William Ellis: Photography in Madagascar 1853–65. *History of Photography* 21(1):23–31.

1998 William Ellis in Madagascar, 1853–1865. In *A Tale of Two Islands: Aspects of Anglo-Malagasy History and Culture,* pp. 40–53. Antananarivo.

2002 Aspects of Hand-Loom Weaving in the Highlands of Madagascar: History and Revival. In *Unwrapping the Textile Traditions of Madagascar,* edited by Chaprukha Kusimba, Judy Odland, and Bennett Bronson. UCLA Fowler Museum Textile Series, no. 6. Los Angeles: UCLA Fowler Museum of Cultural History.

PFEIFFER, IDA

1862 *Voyage à Madagascar.* Paris: L. Hachette.

THE PHILADELPHIA MUSEUMS

1906 *Notes on the Madagascar Collection.* Philadelphia.

PICTON, JOHN, AND JOHN MACK

1989 *African Textiles.* 2d ed. London: British Museum Publications.

PIETERSE, JAN NEDERVEEN

1992 *White on Black: Images of Africa and Blacks in Western Popular Culture.* New Haven, Conn.: Yale University Press.

PIOT, CHARLES

1996 Of Slaves and the Gift: Kabre Sale of Kin during the Era of the Slave Trade. *Journal of African History* 37:31–49.

PRATT, MARY LOUISE

1992 *Imperial Eyes: Travel Writing and Transculturation.* London: Routledge.

PRUDHOMME, EMILE

1906 *La sériciculture aux colonies: Etude faite à Madagascar.* Paris: Augustin Challamal.

PUBLIC BROADCASTING SERVICE (PBS)

1998 *Madagascar: A World Apart.* PBS home video. ABC/Kane Productions International, Inc.

RAHERISOANJATO, DANIEL

1984 *Origines et évolution du royaume de l'Arindrano jusqu'au XIXe siècle.* Travaux et Documents 22. Antananarivo: Musee d'Art et d'Archeologie.

RAISON-JOURDE, FRANÇOISE

1991 *Bible et pouvoir à Madagascar au XIXe siècle: Invention de l'Etat et construction nationale.* Paris: Karthala.

RAJAONARIMANANA, N.

1979 Achèvement des funérailles et offrandes de linceuls. *Objets et Mondes* 19:180–93.

RAMAROZAKA, M.

1990 *Le lamba: Etamine de l'unite nationale.* Antananarivo: Ministere des Affaires Etrangeres.

RAOMBANA
1980 *Histoires*. 2 vols. Fianarantsoa: Ambozontany.

RASOANASOLO, RAYMONDE
1989 Ny tenona lamba landy. Master's thesis, Department of Malagasy, University of Toliara.

RATZEL, FRIEDRICH
1890 *Völkerkunde*, vol. 2, *Die Naturvölker Ozeaniens, Amerikas und Asiens*. 2d ed. Leipzig: Verlag des Bibliographischen Instituts.
1896 *The History of Mankind*. Translated from the 2d German edition. 3 vols. London: Macmillan.
1996 [1890] *The Races of Mankind: Religion, Customs, and Civilization*. Delhi: Radah Publications.

RAVELOJAONA, AND F. GABRIEL RAJAONAH (EDITORS)
1965 *Firaketana ny Fiteny sy ny Zavatra Malagasy (Dictionnaire-Encyclopédique Malgache)*. Antananarivo: Fiainana-Firaketana.

RAZAFIARIVONY, MICHEL
1995 Société et litérature orale Betsimisaraka d'Anosibe An'Ala. Ph.D. dissertation. Paris: INALCO.

RAZAFINTSALAMA, ADOLPHE
1983 Les funérailles royales en Isandra d'aprés les sources du XIXe siècle. In *Les souverains de Madagascar*, edited by Françoise Raison-Jourde, pp. 193–210. Paris: Karthala.

RAZI, G. MICHAEL
1983 *Malgaches et Américains: Relations commerciales et diplomatiques au XIXe siècle*. Antananarivo: Centre Culturel Americain.

RAZOHARINORO
1979 *Soratra Vavolombelona 2: Madagasikara sy Eoropa 1868–1887*. Antananarivo: Arsivampirenena.

REDIKER, MARCUS
1987 *Between the Devil and the Deep Blue Sea*. Cambridge: Cambridge University Press.

RENNE, ELISHA P.
1995 *Cloth That Does Not Die: The Meaning of Cloth in Bunu Social Life*. Seattle: University of Washington Press.

REVUE NOIRE
1997–98 Special Mode. *Revue Noire 27* (December–February).

RICHARDSON, JAMES
1885 *A New Malagasy-English Dictionary*. Antananarivo: London Missionary Society.

ROGOZINSKI, JAN
2000 *Honor among Thieves: Captain Kidd, Henry Every, and the Pirate Democracy in the Indian Ocean*. Mechanicsburg, Penn.: Stackpole Books.

ROTH, ROLF B.
1994 *Madagaskar: Land zwischen den Kontinenten*. Exhibition catalog. Stuttgart: Linden-Museum Stuttgart.

RUUD, JURGEN
1960 *Taboo: A Study of Malagasy Customs and Beliefs*. Oslo: Oslo University Press.

RYAN, JAMES R.
1997 *Picturing Empire: Photography and the Visualization of the British Empire*. Chicago: University of Chicago Press.

SANNEH, LAMIN
1999 *Abolitionists Abroad: American Blacks and the Making of Modern West Africa*. Cambridge, Mass.: Harvard University Press.

SCHNEIDER, JANE, AND ANNETTE B. WEINER

1989 Introduction. In *Cloth and Human Experience*, edited by Annette B. Weiner and Jane Schneider, pp. 1–29. Washington, D.C.: Smithsonian Institution Press.

The Secret Museum of Mankind (NO AUTHOR)

c. 1935 New York: Manhattan House. Reprint. Salt Lake City: Gibbs Smith, 1999.

SHUFELDT, MASON

1891 A Protected Queen. *The Cosmopolitan* 10(5):581–91.

SIBREE, JAMES

1870 *Madagascar and Its People: Notes of Four Years' Residence, with a Sketch of the History, Position, and Prospects of Mission Work amongst the Malagasy.* London: Religious Tract Society.

1880 *The Great African Island: Chapters on Madagascar. A Popular Account of Recent Research in the Physical Geography, Geology, and Exploration of the Country, and Its Natural History and Botany.* London: Trübner.

1915 *A Naturalist in Madagascar: A Record of Observation, Experiences and Impressions Made during a Period of Over Fifty Years' Intimate Association with the Natives and Study of Animal and Vegetable Life of the Island.* London: Seeley, Service and Company.

SINGER, BARRY

1992 *Black and Blue: The Life and Lyrics of Andy Razaf.* New York: Schirmer Books.

SKINNER, ELLIOT P.

1992 *African Americans and U.S. Policy towards Africa, 1850–1924: In Defense of Black Nationality.* Washington, D.C.: Howard University Press.

SPRAGUE, STEPHEN

1978 Yoruba Photography: How the Yoruba See Themselves. *African Arts* 12(1):52–29, 107.

STAFFORD, BARBARA MARIA

1984 *Voyage into Substance: Art, Science, Nature, and the Illustrated Travel Account, 1760–1840.* Cambridge, Mass.: MIT Press.

STEINER, CHRISTOPHER B.

1995 Travel Engravings and the Construction of the Primitive. In *Prehistories of the Future: The Primitivist Project and the Culture of Modernism*, edited by Elazar Barkan and Ronald Bush, pp. 202–25. Stanford, Calif.: Stanford University Press.

STOCKING, GEORGE W., JR. (EDITOR)

1985 *Objects and Others: Essays on Museums and Material Culture.* History of Anthropology, vol. 3. Madison: University of Wisconsin Press.

TAYLOR, QUINTARD

1998 *In Search of the Racial Frontier: African Americans in the American West, 1528–1990.* New York: W. W. Norton.

THEYE, TOMAS (EDITOR)

1989 *Der geraubte Schatten: Eine Weltreise im Spiegel der ethnographischen Photographie.* Munich: Bucher.

THOMAS, NICOLAS

1991 *Entangled Objects: Exchange, Material Culture, and Colonialism in the Pacific.* Cambridge, Mass.: Harvard University Press.

TYSON, PETER

2000 *The Eighth Continent: Life, Death, and Discovery in the Lost World of Madagascar.* New York: William Morrow.

VÉRIN, PIERRE

1985 *The History of Civilisation in North Madagascar.* Boston: A. A. Balkema.

VERNIER, ELIE

1964 Etude sur la fabrication des *lamba mena. Journal de la Société des Africanistes* 24(1):7–34.

VINCENT, FRANK
1895 *Actual Africa, or the Coming Continent: A Tour of Exploration.* New York: D. Appleton.

VOGEL, SUSAN
1991 *Africa Explores: Twentieth-Century African Art.* New York and Munich: Center for African Art and Prestel.

WEINER, ANNETTE B.
1992 *Inalienable Possessions: The Paradox of Keeping-While-Giving.* Berkeley: University of California Press.

WEINER, ANNETTE B., AND JANE SCHNEIDER (EDITORS)
1989 *Cloth and Human Experience.* Washington, D.C.: Smithsonian Institution Press.

WIENER, MICHAEL
1990 *Ikonographie des Wilden.* Munich: Trickster Verlag.

WILLS, J.
1885 Native Products Used in Malagasy Industries. *Antananarivo Annual and Madagascar Magazine* 9:91–99.

WOODS, RANDALL BENNETT
1981 *A Black Odyssey: John Lewis Waller and the Promise of American Life, 1878–1900.* Lawrence: Regents Press of Kansas.

CONTRIBUTORS

ZINA ANDRIANARIVELO-RAZAFY has served as Ambassador Extraordinary and Plenipotentiary of Madagascar to the United States since January 1999. He holds a master's degree in business administration from Ball State University in Indiana and has long been active in developing cultural and trade relationships between Madagascar and the United States. He is also a member of Rotary International. He is married and has two children.

SHIRLEY E. BARNES was United States ambassador to Madagascar from August 1998 to July 2001. A career foreign service officer, she was U.S. consul general in Strasbourg, France, and also served in Cairo, Dakar, Berlin, and Sophia. She holds a master's degree in business administration from Columbia University and studied at the National War College. Her avocations include art of the African diaspora, jazz, and the study of African and African American history.

MARY JO ARNOLDI is the curator of African ethnology in the Department of Anthropology at the National Museum of Natural History, Smithsonian Institution. She has done extensive research in Mali on performance and the arts. She has also written on museum collections and on the history of representations of Africa at the Smithsonian. She holds a Ph.D. in art history from Indiana University.

SARAH FEE has been conducting field research on weaving, gender, and social life in Androy, southern Madagascar, since 1988. She is co-creator of the ethnographic museum of Androy (Arembelo, Berenty) and co-author of a Tandroy-French dictionary (Asiatheque, 1996). She is currently completing her doctorate in anthropology and African studies at the University of Langues Orientales (INALCO), Paris.

CHRISTRAUD M. GEARY is curator of the Eliot Elisofon Photographic Archives, National Museum of African Art, Smithsonian Institution. She has published extensively on photography in Africa and the art of the Cameroon grassfields. Her most recent book is *Delivering Views: Distant Cultures in Early Postcards*, co-edited with Virginia-Lee Webb (Smithsonian Institution Press, 1998). She earned her doctorate in cultural anthropology and African studies at Frankfurt University in Germany.

CHRISTINE MULLEN KREAMER is a curator at the National Museum of African Art, Smithsonian Institution. She has conducted extensive research in Togo on art, gender, and ritual and has developed museum exhibitions in Ghana and Vietnam. She has also written articles on museums and communities and the representation of Africa in museum exhibitions. She holds a Ph.D. in art history from Indiana University.

EDGAR KREBS is a research associate in the Department of Anthropology, National Museum of Natural History, Smithsonian Institution. He has done fieldwork in Madagascar, Argentina, and Guatemala. He studied anthropology at Oxford University in England, where he is completing a Ph.D. in modern history.

JEAN-AIMÉ RAKOTOARISOA has been director of the University Museum of Antananarivo, Madagascar, since 1973. He wrote his first doctoral thesis on the human geography of Mwali, an island of the Comoro archipelago, and his second on the archaeology of the Anosy area of southeastern Madagascar. For three decades he has contributed to a wide variety of activities and research projects focusing on the cultural aspects of Malagasy society. He was born in Toamasina, Madagascar, and is married with three children.

WENDY WALKER holds a Ph.D. in anthropology from Johns Hopkins University and an M.Phil. from Oxford University. She has done extensive fieldwork in southern Madagascar concerning Malagasy views of the environment, and she has conducted historical research on the impact of French colonial rule on local memory and on the landscape of the south of the island.

Index

Bold typeface indicates photos and illustrations.

Abbott, Gertrude, 119 nn15, 19
Abbott, William L., 111, 112–14, 119 nn15, 19
Adelaide (British Queen), **16**
Adrianantoandra, Mr. and Mrs., **176,** 176–77
African Cultures Hall (Smithsonian), 104, 109–10
African Growth and Opportunity Act (AGOA), 7–8, 11
Afro-American Cuban Emigration Society, 139
akanjobe, 39, 41, **42,** 61, **70**
akanjo zaky mena, 93 n57
akotofahana cloth: as diplomatic gifts, 15, 20, 67, 95–119 passim;
 fine art market, 78–79; historic uses, 98, 103–8; Lamba SARL-
 produced, **14, 79, 80, 81**; modern burial wraps, 77; origins, 55,
 90 n22; production techniques, 54–55, **55, 56.** *See also* lamba
 akotofahana (Ranavalona III's gifts)
akotso twining, 53, 71
akoty cloth, 55
Ambalavao weaving project, 82, 93 n61
Ambohimahamasina market, **74**
Ambositra area weaving, 78
American Citizen (newspaper), 124
American Colonization Society, 145–46 n13
Americo-Malagasy Treaty of Commerce and Friendship (1867
 and 1883), 100, 101
ancestors, and ancestor rituals: Kuban, 23 n5; and land grants,
 146 n16; modern, 70, 74–75, 91 n35, 93 n62; New Year's cere-
 mony, 61, 90 n27; overview, 39, 62–65, 91 n39; photographs
 for, 163–64. *See also* burial cloth
Andina weaving, 75, 93 n59
Andree, Karl, 178 n12
Andriamanalianrivo, 90 n24
Andriamanantena, Mirana, 84–85
Andriamanitra, 60, 90 n26
andriana: ancestor rituals, 90 n27; *filanjana* uses, 151, 177 n5
Andriamamboninolona noble clan, 60, 77
Andriampoinimerina, 35, 65, 66, 90 n24
Andriandranando noble clan, 60, 77
Andrianetrazafy, Hemerson, 162, 164, 171, 173
Anglo-French Convention (1890), 132
Antakarana people, 69–70
Antambahoaka people, 42, **75,** 89 n3
Antananarivo, **26, 40, 68, 127**
Antefasy people, 89 n3
Antemoro people: Betsilo-produced cloth, 74; gender and weav-
 ing, 89 n3; modern king's costume, 93 n57; reed-plaiting, 70;
 reed clothing, 42

Antsiranana dress, **59**
Appadurai, Arjun, 23 n6, 99
Arab origins, 28–29
arindrano striping style, **37,** 49, **72**
Arivonimamo area weaving, 75, 78
Arthur, Chester, 6, 101, 125
Arthur administration and Waller, 124, 129, 145 n9
Asian origins, 28–29
Association of Young Malagasy Designers (ACJM), 78
ati-damba ceremony, 63
Avaradrano area weaving, 77

backstrap loom, 48, **48**
banana-stem tradition, 45–46, 69, 89 n10
Bara people, 42, 44, 157
bark cloth tradition, **40,** 42–43, **43,** 69, 89 n9
basket, **102**
Bayard, Thomas, 102–3
beadwork: Abbott textiles, 114, **116, 117**; types, **24,** 53, **54,** 90 n21
Beaujard, Philippe, 93 n58
Beck, William, 108
Behanzin (Dahomey king), 179 n35
Betsileo people: Abbott's collection, 114, **115–16, 117**; ancestor
 rituals, 63, 91 n39; beadwork, 90 n21; burial cloth striping, 49,
 50; fiber traditions, 42, 43, 44, 45–46; historic government
 structure, 90 n17; Merina relations, 90 n24, 97; modern weav-
 ing, 71, **73,** 74–75, **76**; weft twining, 53; wood *filanjana,* 161
Betsimisaraka people: ancestor rituals, 63; Merina relations, 97;
 modern weaving, 70, **70,** 74–75, 92 n55
Bible, royalty's copy, 168, 179 n33
Binao (Sakalava Queen), **148,** 157
bird pin, **102**
black colony aspirations: organizations for, 130, 145–46 n13;
 U.S. citizens, 122; Waller's, 124, 134–35, 139, 146 n34
black sailors, 140–41
Blakely, Allison, 145
blessing ceremony, **85**
Boina Sakalava, 58
Bolster, Jeffrey, 140–41
Bradley, J. W., 178 n12
Bray, Paul, 131, 134–35, 136, 137, 146 n30
Bray, Susan Boyd (later Waller). *See* Waller, Susan Boyd
 (earlier Bray)
British-Merina relations: Farquhar's overtures, 140; and French
 ambitions, 67, 124–25; and Merina empire dominance, 17, 29;
 Ranavalona I's overture, 154; trade, 125; treaty, 142; visit to
 London, **16**; Waller's land grant, 132–33

Brown, Sir Mervyn, 9
burial cloth: Betsileo, 49, **50**, 75, **76**; *hafotra* fiber, 43; modern
 weaving, 71, **72, 73,** 74–75, **76,** 77; social purposes, 39, 62–65,
 91*n*36, 91*n*39, 98. *See also* ancestor rituals; *lambamena*
burial rites, 39, 51, 53, 56, 62–65, 74, 75, 98

Cameroon, 163, 178*n*21
Campbell, John, 103, 129, 138
Catat, Dr. Louis, 161
Center for Malagasy Artisans (CENAM), 82
Center for Professional Training, 82, 93*n*61
central highlands region. *See* highlands region
chains, 60, 66, 67, 91*n*44
circumcision, 44, **75**
Clark, Mr., 108
Cleveland, Grover, 95, **97,** 98, 99, 102, 103, 114, 118. *See also lamba*
 akotofahana (Ranavalona III's gifts)
Cleveland administration, Waller's arrest/imprisonment, 137–38,
 145*n*9
climate regions, overview, 25–28
clocks as gifts, 179*n*29
cloth functions: diplomatic ties, 66–67, 92*nn*48–52, 95–96;
 kinship ties, 35, 61–65, 91*n*33, 91*n*39; love/romance, 36, **37,**
 62, 91*n*34; overview, 17–18, 23*n*7, 33–34; social identity, 57–61,
 69–70; sovereign/subject relations, 65–66, 91*nn*40–45, 92*n*47
clothing. *See lamba;* weaving traditions, historic
coffin decorating, 75
Colombet (painter), 164
colonialism and commercial philosophy, 139–40
color symbolism, 51, 59, 61, 107
Columbian Exposition (1893), 142–43
commerce as reciprocity, 139–40
commercial cloth, 69–70, 77, 85
"Contrabands," 122, 145*n*2
contrapposto, 178*n*7
Cooper, Grace Rogers, 101
Copalle, André, 164
cotton fiber tradition, **40,** 44–46, **68,** 89–90*n*14
"crazy" works (Razakaratrimo's), 86, **87,** 88
Crockett, W. F., 136–37
Cuba, 139, 146*n*34, 146–47*n*35

Dawson, Captain E. W., 167
Day and Son, Ltd., 153
Defoe, Daniel, 141, 147*n*39
Días, Diego, 29
Diderot, 121, 139, 147*n*39
diplomacy, uses of cloth for, 19, 20, 22, 66–67, 92*nn*48–52,
 92*n*48, 95–119 passim
discovery/exploration tradition, 139–41, 147*n*41
Douglass, Frederick, 124
Duocouëdic (ship), 178*n*10
dyes, 48, 75, 90*n*16, 106, 119*n*9

east coast region: described, **26,** 27–28; raffia tradition, 41, **42.**
 See also weaving traditions, modern
Ellis, William: arrival in Madagascar, 154–56, 162; on beadwork,
 90*n*21; influence, 155, 178*n*12; on *lamba,* 106–7, 110, 112; oil
 painting gift, 164; Oliver and, 153; photographs of royalty, 101,
 155, 165–66, **166,** 169; on raffia cloth, 112; royalty's requests for
 European images, 162–63

England. *See* British-Merina relations
engravings: authorship complexity, 150; Ellis's photographs, **155;**
 Flacourt's book, 151–52, **152;** LMS journal, 178*n*16; and pho-
 tography, 153–54, 178*n*9. *See also* photography
Enlightenment, 139
European dress mandate, 61, 90*n*29, 179*n*30
executions and cloth, 60
"Exodusters," 122, 123, 140–41, 145*n*2

faha-gasy ("Malagasy time"), 69
famadihana rituals, 63–65, **64**
fanampoana service, 65
fanto cloth, 42
Farquhar, Sir Robert, 140, 164
fashion designers, 78, 84–85
Fee, Sarah, 15, 104, 119*n*7
Feeley-Harnik, Gillian, 69, 89
female identity. *See* identity, female
Fianarantsoa dress, **37, 59**
fiber art, 86, 88
fiber traditions, historic: decorations, 51–56; mapped, **40;** mate-
 rials, 41–48; striping styles, 48–51. *See also* weaving traditions,
 historic
Fiherenena, 89*n*9
filanjana, wood, 161, **162**
filanjana imagery: as colonial domination metaphor, **160,**
 160–61; Ellis's photographs, 155–56; Flacourt's book, 151–52,
 152; Gallieni's book, 157–60, **159;** Oliver's book, 153, **153;**
 Rainimaharosoa's painting, 171–72, **172,** 173; Sibree's descrip-
 tion, 151; wood models, 161, **161**
fine art market, 78–79
Finkelmeier, John P., 10, 100, 125, 126–27
firaka beads, 53, 114, 115, 116, 117
Firaketana (Rajaonah's encyclopedia), 6
Fitampoha ritual, 74
fixed-heddle ground loom, 48
Flacourt, Etienne de, 151
fole velo yarn, 44
foreign fabrics and social identity, 58, 61, 90*n*27, 90*n*29
Fort Dauphin, 29, 134, 140
fossilized shell as state gifts, 67
France: arrival in Madagascar, 29; Njoya's exile, 178*n*21. *See also*
 French-Malagasy relations
Frelinghuysen (Secretary of State [1883]), 101, 126
French-Malagasy relations: arrest of Waller, 137, 138; diplomatic
 credentials conflict, 129; grave goods, 90*n*28; Great Britain's
 role, 124–25, 132; Laborde-based dispute, 124–25; Maudave's
 role, 140; and Merina gift giving strategies, 67; occupation
 period, 17, 30, 51, 61, 103, 126, 137, 156–57; peace treaty, 125,
 128–29; silk production, 81; trade, 125; U.S. role, 103, 128, 129,
 145*n*9; Waller's land grant, 132–33, 138–39
Friends Foreign Mission Association (FFMA), 171
funeral rites. *See* ancestors, and ancestor rituals; burial cloth

Gallieni, Joseph, 81, 139, 157–58, 178*n*22
Geldart, R. W., 137
Gell, Alfred, 49
gender associations and weaving: historic, 34–36, 89*n*3, 89*n*6;
 modern, 70, 77, 92*n*54
geographical regions, overview, 25–28

geometric motifs: *akotofahana* cloth, 53–56, **55, 56**; European-based, 114; Ranavalona III's gift, 94, **96, 104, 105,** 105–7; Sheldon's *lamba akotofahana*, **113,** 113–14. *See also* weft twining

Geyser, J., 168–69

Ghana, 147n43

Gibbs, Mifflin, 10

Gibson, Gordon, 108–9, 114

gift-giving: commercial cloth, 69–70; for diplomatic ties, 19, 20–22, 66–67, 92nn48–51, 95–96, 98–103; for kinship ties, 35, 61–65, 91n33; photographs, 101, 162; sovereign/subject relations, 65–66, 91nn40–45, 92n47; women's weaving, 35. *See also* cloth functions; *lamba akotofahana* (Ranavalona III's gifts)

The Gift (Mauss), 23n7

Girls' Central School, 174

glass beadwork, **24,** 53, **54**

Der Globus, 161

goodwill and cloth, 61–65. *See also* gift giving

Graeber, David, 63–64

Great Britain. *See* British-Merina relations

Green, Rebecca, 59, 71, 104, 105

Guillain, Charles, 178n10

Haddon, Arthur Trevor, 179n27

Haddon, John, 179n27

hafotra cloth, 43

Haiti, 124

Hardyman Collection, 174

harea beads, 53

harefo reeds, 42

Harvey, E. Underwood, 132, 134

hasina: and cloth, 58–59, 65, 66, 74

Hastie, James, 179n29

hemp tradition, **45,** 45–46, 69, 112

highlands region: described, **26,** 27; fiber traditions, 45–46, 98. *See also* weaving traditions, modern

Hinsley, Curtis, 111

Histoire de la grande île de Madagascar (Flacourt), 151

Histoire des rois (Merina writings), 89n1

Hoare, Captain John, 141

household roles, historic, 34–36

hova: described, 145n7; *filanjana* uses, 151, **159;** Robinson's comments, 127. *See also* Merina people

Hubbard, N. M., 123

iconography. *See filanjana* imagery; photography

identity, female: and weaving, 34–36, 70, 92n54

identity, national, 98–99

ikat style decoration, 51, **52,** 53, 69, 90n20

Ile Saint Marie, 141

Impoïnimerina (Bara king), 157, **158**

independence, 30, 67

jabo fabric, 46

jackets, 70

Jacknis, Ira, 112

Jafetra, Jean, 175

jaky fabric, 61, 90n27

jewelry, 60

Johnson, Andrew, 101, 119n8

Johnson, William, 171

Kala S. (fashion designer), 78

Kansas, Waller's years, 123–24

kinship ties with cloth, 35, 61–65, 91n33, 91n39

kitamby (hip wrap), 39

Klemm, Gustav, 111

Knight, E. F., 134

Kopytoff, Igor, 119n1

Kuba people, funeral rites, 23n5

Laborde, Clement, 145n6

Laborde, Jean, 46, 90n15, 124–25, 145n5

laimasaka tapestries, 53

lamba: Beck's definition, 108; children's, **31;** descriptions, 37–38, 96–97, 106–7, 117, 119n11; erotic appeal, 36, **37,** 89n5; modern shoulder wraps, 77, 78, 82–84, **83, 84;** multipurpose tradition, 37–38, 117–18; Ranavalona II's gifts to Johnson, 101, 119n8; social functions, 57, 61, 90n30, 110–11; weaving process, **35**

lamba akotofahana (Ranavalona III's gifts): described, 104–6; diplomatic purposes, 20–21, 95, 98–99, 102–3, 108; exhibits of, 109–11; museum cataloging, 15, 108–9; photos, **94, 95, 104, 105, 107;** transfer to Smithsonian, 103–4

lamba akotofahana (Sheldon's), **113,** 113–14

lambabe, 71, **73,** 74

lamba fitafy, 78, **83,** 83–84, **84**

lambahoany (hip wrap), 69

lambamena: Abbott's collection, **32,** 114, **115–16,** 117, **117,** 119n20; historic uses, 51, 65, 117. *See also* burial cloth

Lamba SARL: *akotofahana* cloth, **14, 79, 80, 81;** creation of, 79

lamba tavoangy cloth, 77

Lambert, Joseph, 92n46, 179n27

land grants, Malagasy: about, 127, 146n16; foreign traders, 131; Laborde's, 124–25; Waller's request/concession, 130–34

landibe silk, 104, 105, 119n8

landikely silk, 104–5

landy silk, 44, 90n26

Langston, John Mercer, 135–36, 137, 138, 146n23

Larson, Pier, 46

"linen" as catalog terminology, 108

Linton, Ralph, 49, 90n17

literacy, Merina, 89n1, 101

loincloths: described, 38; glass-beaded, **24,** 54; modern weaving, 71, **72;** Tandroy, **38,** 54

London Illustrated News, 162, 163

London Missionary Society (LMS): arrival in Madagascar, 154–55; Bible translations, 178n14; drawing curriculum, 171; fiber production, 46, 89–90n14; journal, 156, 174, 178n16; Razaka's photo commissions, 174, **175.** *See also* Ellis, William; Sibree, James

loom, **35, 48,** 48–49, **77, 86**

Mack, John, 23, 107, 108, 112, 171, 172, 179

Madagascar, overview: geographical regions, 25–28; human history, 17, 28–30, 180–82; modern representations of, 17, 147n41, 147n45

Madagascar and the Malagasy, with Sketches in Provinces of Tamatave, Betanimena, and Ankova (Oliver), 153

Madagascar Mail, 132

Madagascar News, 134, **135**

Madagascar Revisited (Ellis), 154, 169

Madagascar, or Robert Drury's Journal during Fifteen Years' Captivity on that Island (Defoe), 147 n39
Mahafaly people, 74–75
Malagasy-American relations, 121, 124–32, 137–39
Malagasy-French War (1881), 125
Malagasy origins, 28–29
mantle as catalog terminology, 119 n12
maps: ethnic groups, **26**; fiber traditions, **40, 68**; Sibree's, **120**
"Marimar" style, **83,** 84
Marks, William, 125, 145 n6
Maroseranana dynasty, 30
marriage and cloth: historic functions, 62, 91 n33; modern styles/ practices, 69–70, 71, 85, **85**
Mason, Otis T., 111, 112
Maudave, Louis Laurent de, 140
Maude, Francis Cornwallis, 167
Mauss, Marcel, 23 n7
Mayeur, Nicolas, 44, 90 n21
McGuinn, W. T., 135, 137
menalamba uprising, 61, 90 n31
Merina people: *akotofahana* cloth, 53–56, **55, 56**; ancestor rituals, 63; class structure, 145 n7; commercial cloth, 69; fiber traditions, 45, 46, **47, 48,** 89 n10; *filanjana* uses, 151, 177 n5; foreign cloth, 61, 63, 90 n27, 90 n29; government structure, 131; land ownership, 146 n16; modern weaving, **76, 79, 80, 81**; pre-European dominance, 17, 58, 65, 90 n17, 97–98, 141–42, 150; red colors, 51, 61, 90 n19, 90 n27, 107; romance and cloth, 36, **37,** 89 n5; royal costume, 98, 106–7; royal *hasina* rituals, 65–66; silk and sacred items, 60; white trade cloth, 58. *See also* British-Merina relations; French-Malagasy relations; photography; United States-Merina relations
metal objects: beadwork, 53, 90 n21; gift giving, 66, 67, 91 n44; as wealth displays, 60
Meyer (French consul [1881]), 92 n49
Moorland-Springarn Research Center, 179 n32
mosquito nets, 41, 53
mourning rituals and *lamba* appearance, 38, 97
mulberry or Chinese silk tradition: French-directed, 81; historic, 46, 104–5; modern, 77, 82–85
Murray, John, 169
Mutibwa, Phares M., 146 n16

Nanou (fashion designer), 78
nato bark, 51, 75
A Naturalist in Madagascar (Sibree). *See* Sibree, James
"New Canaan," 139, 146 n34
New Year's Royal Bath, 60, 61, 91 n42
NGOs and local weaving, 82, 93 n61
Niessen, Sandra, 49
Njoya (Bamum king), 163, 178 n21
Nkrumah (Ghana president), 147 n43
nobles/nobility, 45, 51, 58, 59, 60, 61, 65
north region, described, **26,** 28
Noyer, Henri, 174–75

Oliver, Samuel Pasfield, 117, 153, 178 n8
Ovonramwen (Benin king), 179 n35

Painter, Nell I., 145 n2
paintings: Malagasy, 169, 171–73, **173**; royal portraits, 164, 173, 179 n27

Parrett, John, 166, 167, 174
peace treaties: British, 142; French, 125, 128–29; U.S., 10, 100, 101
Peers, Simon, 56, 79, 169
La peinture Malagache (Andrianetrazafy), 162
pen/pencil set, 100, 101
photography/photographs: arrival in Madagascar, 178 n10; and class structure, 163–64; Ellis's impact, 154–56; as gifts, 100, 101, 162; Gallieni's book, 157–59, **159**; historical highlights of, 178 n9; as information for Malagasy, 101, 162–63; as lithographs, 153; Malagasy-produced, 173–76, **175, 176**; Njoya's interest in, 163; as paintings, 164, 172–73, **173**; portraiture of royalty, 164–69, **166, 167, 168, 169, 170,** 179 n31; role in European expansion, 154, 156–57, 160–61
Pieterse, Jan Nederveen, 177 n2
pigeon pea silk, 46, 89 n13
piracy, 141, 147 n39
plant motifs, 56, 90 n23
population statistics, 30
portrait photography. *See* photography/photographs
postcards: French-produced, 157; of Gallieni, 178 n22; royal portraits, 169, **170,** 179 n35
Potter, John E., 178 n12
prayer rugs, 41, 53
proverbs: cloth/feathers, 57; cloth/friendships, 11; cloth/people, 33; goodwill, 62; *lamba* uses, 118; weaving duties, 35
purity and silk, 60

Queen's Palace, 82, 127
Quincy, Josiah, 145 n9

Rabetafika, Nicole, 84
Rabodo (later Queen Rasoherina). *See* Rasoherina (earlier Princess Rabodo)
Rabakoliarifetra, Vero, 84, **84**
race: as diplomatic issue, 147 n43; European perspective, 152, 156; Merina culture, 142; and Waller's consulship, 130
Radama I: British treaty, 142; Chinese silk worm, 46, 104–5; clock gift, 179 n29; compared to Radama II, 166; cotton weaving production, 89–90 n14; gifting tradition, 91 n44; modern *jaky* ceremony, 90 n27; political uses of British, 29; portrait commissioning, 164; silk laws, 60
Radama II (earlier Rakotondradama): appointment of foreigners, 145 n6; assassination, 60, 145 n6, 179 n31; Christianity acceptance, 119 n2; Ellis's photographs of, 165–66, **166,** 179 n31; European dress mandate, 61, 179 n30; oil painting of, 164; photograph requests, 162–63; residence, 162
raffia tradition: clothing types, **41, 42, 47**; historic, 41, 46, **47,** 89 n8, 112; as *ikat* decoration, **51,** 52, **53**; mapped, **40, 68**; modern, 70, **70,** 78, **78**
Rafidison, Daniel, **14,** 79
Rahovy, 164
Rainilaiarivony: biographical highlights, 145 n7; clothing, 90 n19, 92 n46; Crockett issue, 137; Finkelmeier's gifts, 100; French peace treaty, 128–29; gifting traditions, 65–66; gifts to Johnson, 101; gifts to Robinson, 92 n48; portraits of, 167–68, **169,** 179 n26; slave ownership, 142; on trade with U.S., 125–26; Waller relationship, 129, 130–32; World's Fair invitation, 142–43
Rainimaharosoa, James, 171, **172**
Raisina, Eric, 78

Rajaonah, Gabriel, 6

Rakotoarimanana, Martin, **14, 79**

Rakotoarinala, Antoine, **14, 79**

Rakotoariseheno, Ramisandrazana, 84

Rakotoarivony, Samuel, **85**

Rakotondradama (later Radama II). *See* Radama II (earlier Rakotondradama)

Rakotondramanana, Emélie, **83**, 85, **86**

Rakotondravelo, Heritiana, **85**

Ralisoa, Badoly, **84**

Ramampy, Zena, 93 n61

Ramananama (Ranavalona I's representative), 99

Ramananantoandro, Suzanne, 84

Ramanankirahina, Philibert, 173

Ramarozaka, on cloth and romance, 89 n5

Ramilijoana, G., 175

Ranavalona I: British relations, 154; Christianity ban, 99; clothing, 92 n46, 106–7; death, 100; Ellis's gifts, 162; gifts to Waters, 99; Laborde relationship, 145 n5; portraits of, 167; textile production, 46, 90 n15; and U.S. whaling ships, 121

Ranavalona II: conversion to Christianity, 168; Finkelmeier's gifts, 100; gifts to Johnson, 101, 119 n8; Laborde's land concession, 124; marriage, 145 n7; photographs of, 166, **167**; portrait commissioning, 179 n27; treaty with U.S., 10

Ranavalona III: exile period, 103, 168–69, **170**, 179 n34; gift to Sheldon, 113, **113**; letter to Cleveland, 103; marriage, 145 n7; portraits of, **97**, 167–68, **168**, 179 n27, 179 n32; on U.S. relations, 128; Waller's land request, 132; World's Fair invitation, 142–43. *See also* lamba akotofahana (Ranavalona III's gifts)

Randriamampionana, Marotsiresy, **85**

Randrianarisoa, A., 177

rank/status displays: beadwork, 53; burial cloth, 63, 91 n36; clothing, 51, 58–61, 74, 98, 107; *filanjana* uses, 151, 177 n5; modern loincloths, 71, **72**; portraits, 164. *See also filanjana* imagery

Raolombelona, 89–90 n14

Raombana, 91 n44

Rasoanasolo, R., 92 n55

Rasoherina (earlier Princess Rabodo): clothing, 107; death and her name, 89 n4; Ellis relationship, 162–63; marriage, 145 n7; modern *jaky* ceremony, 90 n27; U.S. relations, 99–100

Ratafika, 164

Ratefiarison, Sylvain, **14, 79**

Ratianarijaona, Fenomanantsoa "Tiana," **77, 83**, 85

Ratrimoharinivo, Misa, **86**, 88

Ratsimbazafy, 36

Ratzel, Friedrich, 155, 156, 178 n17

Razaf, Andy, **143**, 143–44, **144**

Razafinkarefo, Henri Andriamanantena, **143**, 143–44, **144**

Razaka, Joseph, 174–75

Razakaratrimo, Zoarinivo, **86**, 86–88, **87**, 93 n63

razana. See ancestor rituals

Razi, G. Michael, 125, 127

red colors, 51, 59, 61, 90 n27, 107

reed cloth traditions, **40**, 42, **43**, **68**

Relation de la grande île de Madagascar (Flacourt), 151

Richardson, Reverend J., 104

robe as catalog terminology, 109

Robinson, William W., 10, 66, 92 n48, 127–28

rock wrapping, 63, **64**

Roth, Rolf B., 179 n25

Rowlands, John, 89–90 n14

sadiavahe uprising, 61, 90 n31

Sakalava people: ancestor rituals, 23 n5; Betsileo-produced cloth, 74–75; commercial cloth, 69–70; French alliance, 124, 157; *ikat* decoration, 51, **52**, 53; imported cloth and rank, 61; Merina relations, 58, 91 n44–45, 97–98; pre-Merina dominance, 30; raffia clothing, **41**; silk and sacred items, 60

salôvana, 39, **39**

sampy, 89 n10, 168

Samuel, Abraham, 141

Sandrandahy area weaving, 75

sarimbo striping, 71, **73**

satrana, 65

School of Applied Arts, 81

The Secret Museum of Mankind, 159–60

sedges as fiber, 42

sewing machines, 100–101, 119 n4

shawl as catalog terminology, 108–9

Sheldon, Mary French, 113

shirts (*akanjobe*), 39, **39, 70**

shoulder wraps, 69, 71, 78, 82–85, **83, 84**

Shufeldt, Mason, 111–12, 119 n14

Sibree, James: book photos, 172, **173**, 174–75; *filanjana* description, 151; *lamba* descriptions, 96–97, 117, 119 n11; on Malagasy painters, 169, 171; on Malagasy photo interest, 163; map of Madagascar, **120**; mission in Madagascar, 150–51; race perspective, 178 n20; royal costume descriptions, 107, 119 n18; on textile gifts, 95–96; Tranovola description, 162

sikina, 39

silk tradition, historic: French-directed, 81; losses of, 69; mapped, **40**; Merina control, 60, 98; regional variations, 44–46, 48, 89 n13; social identities/rituals, 51, 59–60, 90 n19. *See also* gift giving; *lamba akotofahana* (Ranavalona III's gifts)

silk tradition, modern: combination fabrics, 85, 92 n62; growth of, 82–85; *lamba* costs, 77; mapped, **68**; regional variations, 75, **76**; shoulder wraps, 78, 82–85, **83, 84**. *See also akotofahana* cloth

Silver House (Tranovola), 162, 169, 171

silver objects, 60, 66, 91 n44

simbo, 37, 39, **39**, **42**

Singer, Isaac Merritt, 100–101, 119 n4

Skinner, Elliot P., 145 n1, 147 n43

slavery, Malagasy: *filanjana* porters, 151, 160; French-Waller dispute, 129; Hova people, 145; Waller's defense of, 142

Smith and Wesson revolver gift, 100

Smithsonian National Museum: Abbott-donated textiles, **32**, 112–14, **115–16, 117**, 119 n15; as national repository, 119 n5; Ranavalona III's gift, 103–4, 108–11; Sheldon-donated textiles, **113**, 113–14; Shufeldt-donated textiles, 111–12

social identity with cloth: historic, 57–61, 69–70; modern, 69–70, 71, 82–84. *See also* cloth functions

The Social Life of Things (Appadurai), 23 n6

sodia hat, 93 n57

soherina, 36, 89 n4

southeast region, gender and weaving, 89 n3

south region: described, **26**, 28; fiber traditions, 42–46; modern weaving, 70–71

Souvenirs et impressions: Madagascar (Girieud), 161
sovereign/subject linking with cloth, 65–66, 91*nn*40–45, 92*n*47
spinning, **36, 44**
stereotypes (Pieterse's definition), 177*n*2
striping styles: Abbott's collection, 114, **115–16**; *arindrano*, **37, 49**; Betsileo burial cloth, 49, **50**; *lambamena*, 51; modern, 71, **73**; overview, 48–49; Ranavalona III's gift, **96, 104, 105,** 105–6; techniques, 48–49
supplementary weft floats. *See* weft-float motif

tablecloths, 85, 108
talimena cloth, 89*n*9
Tamatave (Toamasina), 125, **126**
Tanala people: ancestor rituals, 63; Betsilo-produced cloth, 74; clothing types, 42, **42,** 93*n*58; modern weaving, 70; raffia clothing, **42**; silk and sacred items, 60
Tandroy people: ancestor rituals, 74–75, **75**; *lamba,* **31**; loincloths, **38, 54,** 71, **72**; spinning process, **36**
Tanosy people, 74–75, 89*n*9
Tantara ny adriana (Merina writings), 60, 89*n*1, 91*n*44
Taolagnaro (Fort Dauphin), 29
tapia tree, 75
Tatsimo territory, **133**
Taylor, C. H. J., 124
Tefasy people, 42, **43,** 70
telosoratra style, 93*n*58
Tesaka people: ancestor rites, 74–75; Betsilo-produced cloth, 74; gender and weaving, 89*n*3; reed cloth, 42
Tessier, George, 132, 137
Thomas, Nicholas, 21, 119*n*1
Three Visits to Madagascar (Ellis), 154, 169, 178*n*12
Tocqueville, Alexis de, 145–46*n*13
Tour du Monde: Nouveau Journal des Voyages, 161
Trade Place (EMSF), 82
trade relationships (Merina): European, 29, 126; and land grants, 131; modern, 11, 77–78; U.S., 10, 125–26, 128
Tranovola (Silver House), 162
travel iconography, overview, 150. *See also filanjana* imagery
Treaty of Friendship and Commerce, 10
Tsimihety people, 69–70

United States-Malagasy relations, modern, 7–11
United States-Merina relations: commerce basis, 10, 121, 125–26, 128; gift exchange overview, 13, 67, 95–96, 99–101; Robinson's role, 10, 127–28; royalty's control of, 126–27; visit to Washington, D.C., 6; Waller's consulship, 10, 121, 129–30, 145*n*9. *See also lamba akotofahana* (Ranavalona III's gifts)

vadika, 58
vakana, 53
Vanderbilt, Cornelius, 146*n*17
Vardaman, James K., 124
vegetation regions, overview, 25–28
Vernet (helmsman), 178*n*10
Vernier, Elie, 75, 93*n*59
vests, 70
vintana (astrological system), 126, 145*n*8
voho, 58
Voyage à Madagascar (Catat), 161

Waller, Anthony, 122
Waller, Jennie, 143–44
Waller, John, Jr., 146–47*n*35
Waller, John Lewis: arrests/imprisonment, 136–38; compressed biography, 121–24, **122**; colony promotions, 134–36, 142, 146*n*30, 146*n*34; consular years, 10, 124, 129–32, 142–43, 145*n*9; Crockett estate, 136–37; Cuba military service, **138,** 139, 146–47*n*35; death, 146–47*n*35; land concession, 132–34, **133**; and Malagasy slaves, 141–42
Waller, Maria, 122
Waller, Susan Boyd (earlier Bray), **123**; attacks on, 133; Crockett issue, 137; on Cuba service, 146–47*n*35; marriage, 123; newspaper writing, 131, 132; return to U.S., 138
Wallerland: concession of, 132–34; French control, 138–39; modern appearance, **133**; promotion of, 134–35, 142
wall hanging (Razakaratrimo's), 86, **87,** 88
Waters, Richard P., 99
wealth. *See* rank/status displays
weaving, professional, 74–80
weaving traditions, historic: beadwork, 53, **54,** 90*n*21; clothing types, 37–39, 90*n*19; female identity and, 34–36, 70, 92*n*54; fiber options, 40–48; *ikat* decoration, 51, **52,** 53, 90*n*20; striping styles, 48–51; weft-based decoration, **53,** 53–56, **55, 56.** *See also* cloth functions; *specific fiber traditions, e.g.* raffia tradition
weaving traditions, modern: commercial cloth, 69–70; domestic-oriented, 70–71, **72–73,** 74; fine art market, 78–79, 86–88, **87;** and Malagasy identity, 82–85; mapped, **68;** professional production, 74–75, **76,** 77–78, **78,** 85; state-directed promotion, 81–82
wedding outfits, 85, **85**
weft-float motif: described, 54–56; Ranavalona III's gift, **94, 96,** 104, **105,** 106, **107;** Sheldon's *lamba akotofahana,* 113, **113**
weft twining, 53, **53**
Weiner, Annette, 20
west coast region: described, **26,** 28; fiber traditions, 41, **41,** 44. *See also* weaving traditions, modern
Wetter, Edward Telfair, 136–37
white color symbolism, 107
white trade cloth, 58
wild silk tradition, **40,** 46, 77, 89*n*13, 90*n*19
Wilkinson, Mr., 130
Wilkinson family (William), 122
Willoughby, Digby, 102
Wills, J., 90*n*19
Wilson, William, 92*n*49
women and weaving, 34–36, 89*n*3, 89*n*6
Woodford, Ethelbert, 131, 138, 146*n*17
Woods, Randall, 123
World's Fair (1893), 142–43

Zafimaniry people: ancestor rituals, 63; clothing, **39,** 43, **43;** loom operation, **48**
zana-dandy, 89*n*4
Zanadoria people, 77
Zanzibar, U.S. consulate, 99, 121